CW00496667

Popularisation and Populism in the Visual Arts

This book investigates the pictorial figurations, aesthetic styles and visual tactics through which visual art and popular culture attempt to appeal to "all of us". One key figure these practices bring into play—the "everybody" (which stands for "all of us" and is sometimes a "new man" or a "new woman")—is discussed in an interdisciplinary way involving scholars from several European countries. A key aspect is how popularisation and communication practices—which can assume populist forms—operate in contemporary democracies and where their genealogies lie. A second focus is on the ambivalences of attraction, i.e. on the ways in which visual creations can evoke desire as well as hatred.

Anna Schober is Professor of Visual Culture in the Department of Cultural Analysis at Alpen-Adria-University Klagenfurt, Austria.

Cover image: Michèle Magema, *The Triptych*, 2011, digital print on baryta paper, 160 × 120 cm. Courtesy of the artist. Copyright: Bildrecht Vienna, 2019. Photo: Adagp, Paris, 2019.

Routledge Advances in Art and Visual Studies

This series is our home for innovative research in the fields of art and visual studies. It includes monographs and targeted edited collections that provide new insights into visual culture and art practice, theory, and research.

Film and Modern American Art: The Dialogue between Cinema and Painting
Katherine Manthorne

Play and the Artist's Creative Process: The Work of Philip Guston and Eduardo Paolozzi
Elly Thomas

Film and Modern American Art: The Dialogue between Cinema and Painting
Katherine Manthorne

Bridging Communities through Socially Engaged Art
Edited by Alice Wexler and Vida Sabbaghi

Abstract Painting and the Minimalist Critiques: Robert Mangold, David Novros, and Jo Baer in the 1960s
Matthew L. Levy

Arte Ambientale, Urban Space, and Participatory Art
Martina Tanga

Theory of the Art Object
Paul Crowther

The Digital Interface and New Media Art Installations
Phaedra Shanbaum

Ecocriticism and the Anthropocene in Nineteenth Century Art and Visual Culture
Edited by Emily Gephart and Maura Coughlin

Popularisation and Populism in the Visual Arts: Attraction Images
Edited by Anna Schober

For a full list of titles in this series, please visit www.routledge.com/Routledge-Advances-in-Art-and-Visual-Studies/book-series/RAVS

Popularisation and Populism in the Visual Arts

Attraction Images

Edited by Anna Schober

LONDON AND NEW YORK

First published 2020 by Routledge

2 Park Square, Milton Park, Abingdon, Oxon OX14 4RN
605 Third Avenue, New York, NY 10017

Routledge is an imprint of the Taylor & Francis Group, an informa business

First issued in paperback 2022

Publisher's Note

The publisher has gone to great lengths to ensure the quality of this reprint but
points out that some imperfections in the original copies may be apparent.

Library of Congress Cataloging-in-Publication Data
A catalog record for this title has been requested

ISBN: 978-1-138-60588-6 (hbk)
ISBN: 978-1-03-233800-2 (pbk)
DOI: 10.4324/9780429467882

Typeset in Sabon
by Swales & Willis, Exeter, Devon, UK

Contents

Figures

Contributors

Nina Bandi is a philosopher and political theorist teaching at the Zurich University of the Arts and working as a PhD researcher at the Lucerne School of Art and Design. Her research interests include the interplay of politics and aesthetics as well as the relationship between gendered bodies, technology and materiality from a feminist perspective. She has a BA in political science from the University of Geneva (Switzerland) and an MA in social and political thought from the University of Sussex (UK). Her publications include *Kunst, Krise, Subversion. Zur Politik der Ästhetik* (2012) and *What Can Art Do. Zur gesellschaftlichen Relevanz von politisch engagierter Kunst* (2019) (both as editor and author). She is based in Zurich and Vienna.

Lynda Dematteo graduated from Sciences Po Lille (1996) and obtained her PhD in social anthropology at the School for Advanced Studies in Social Sciences in Paris (2002). After working as an assistant professor at the Charles de Gaulle University of Lille III, she won a scholarship from the Montreal Center for International Studies for a postdoctoral internship (2004–2006). In 2008, she was recruited by the French CNRS to carry out studies on the impact of globalisation on political life, and she is currently a lecturer at the School for Advanced Studies in Social Sciences (EHESS). In the book, *L'idiotie en politique*, a continuation of her PhD thesis, published by the French CNRS Éditions in 2007 and by the Italian editor Feltrinelli in 2011, she develops an anthropological study of the Northern League, based on classical analyses of the rituals of inversion. As a specialist in Italian politics, she has conducted numerous field research studies on Northern Italy, the transnational networks of the textile industry and the globalisation of *Made in Italy*. She is developing an anthropological analysis of political tensions and populist movements in the European and American contexts.

Elisabeth Fritz (Seminar für Kunstgeschichte und Filmwissenschaft, Friedrich-Schiller-Universität Jena, Germany) is assistant professor at the Chair of Art History of the University of Jena, Germany. Since her double graduation studies in art history and sociology in Vienna and Paris she has worked as curatorial assistant, art educator and author at several art institutions in Vienna. She has taught art history at the University of Vienna and the University of Applied Arts Vienna. Since 2009 she has been a doctorate fellow at the postgraduate programme *Categories and Typologies in Cultural Studies* at the University of Graz, where she received her doctor's degree in art history in 2012 with a dissertation on the

subject "Media experiments with 'real people' in contemporary art between authenticity, participation and spectacle". In her current *habilitation* project she analyses figurations of sociability in French art of the 18th century. Her last publication is *Spektakel als ästhetische Kategorie: Theorien und Praktiken* (2018), co-edited with Simon Frisch and Rita Rieger.

Raul Gschrey (GCSC, Justus Liebig University Gießen, Germany, and Frankfurt Academy of Applied Sciences) is on the academic staff of the Frankfurt Academy of Applied Sciences. He is currently working on his PhD thesis at the International Graduate Centre for the Study of Culture (GCSC) at Justus Liebig University, Gießen, Germany. His issue-specific publications include 'A surprising air of reality…' Kompositfotografie zwischen Wissenschaft und Kunst, in: Ulrich Richtmeyer (ed.), *Phantomgesichter: Zur Sicherheit und Unsicherheit im biometrischen Überwachungsbild* (2014), and Der typische Deutsche, in: *Respektive— Zeitbuch für Gegenblicke* 02 (2011): *Gewalt, Angst und Politik*.

Philipp Kleinmichel studied philosophy, art and media theory in Freiburg, Karlsruhe, and New York. He worked as a critical studies fellow at the Independent Studies Program at the Whitney Museum of American Art and as an art, business and science scholar at the Akademie Schloss Solitude. Since 2018 he has held a postdoc position on art theory and curatorial practices at the Department of Communication, Culture & Management at the Zeppelin University Friedrichshafen. He has also taught art theory and aesthetics at Justus-Liebig University Gießen, the University of Hamburg and the UDK Berlin among others. His current research focuses on the transformation of art and mass culture in the digital age. Philipp Kleinmichel is the author of *Im Namen der Kunst: Eine Genealogie der politischen Ästhetik* [In the Name of Art: A Genealogy of Political Aesthetics] (2014).

Elena Pilipets (Institut für Medien- und Kommunikationswissenschaft, Alpen-Adria-Universität Klagenfurt, Austria) is a PhD candidate in media theory and cultural studies at the Alpen-Adria-Universität Klagenfurt, to which she has recently submitted her dissertation, *POP: Mediations: (Dis)Connecting Affect and Meaning in Digital Popular Culture*. Her teaching areas and research interests are popular culture, digital media, cultural studies, the affective turn and actor-network theory. She is the author of '#QueerMemes: Von seriellen Metamorphosen und transkontextuellen Assemblagen des queeren Begehrens im Social Web', *Medienjournal* (ÖGK), 40 (4)/2016; 'House of Cards—House of Power: political narratives and narrative politics of American quality dramas in the digital age', with Rainer Winter, in: Betty Kaklamanidou and Margaret J. Tally, eds. *Politics and Politicians in Contemporary US Television* (2017); and Mainstream und Subkulturen, with Rainer Winter, in: Thomas Hecken, and Marcus S. Kleiner, eds. *Handbuch der Popkultur* (2017).

Viola Rühse (Danube University Krems, Austria) is a member of the academic staff at the Department of Image Science at Danube University in Krems. She studied history of art and German language and literature at the universities of Hamburg and Vienna. This was complemented by additional studies in museum management and practical training at various museums and cultural institutions. Her main themes of research are the art of the Reformation, the culture of the

eighteenth century, modern and contemporary art, and film theory. One of her critical essays won the Bazon Brock Essay Award. Recent publications: together with Oliver Grau and Wendy Coones (eds.), *Museum and Archive on the Move: Changing Cultural Institutions in the Digital Era* (2017), Lee Miller in Hitlers Badewanne, in: Alexandra Klei et al. (eds.): *8. Mai 1945: Internationale und interdisziplinäre Perspektiven* (2016), Eric Hobsbawms und Theodor W. Adornos Auseinandersetzung mit Jazz, in: Andreas Linsenmann and Thorsten Hindrichs (eds.): *Hobsbawm, Newton und Jazz* (2017).

Marc Rölli (Hochschule für Grafik und Buchkunst [Academy of Fine Arts Leipzig], Germany) is Professor of Philosophy at the Academy of Fine Arts in Leipzig. Marc Rölli has been a researcher and lecturer at universities in Marburg, Berlin, Bochum and Darmstadt, where he completed his doctoral qualification in 2008. Between 2008 and 2011, Marc Rölli has been Professor of Theoretical Philosophy at the University of Darmstadt, before being appointed professor at the Department of Philosophy at Fatih University Istanbul. During the autumn term 2011/12, Marc Rölli was a senior fellow at the Internationales Kolleg für Kulturtechnikforschung und Medienphilosophie (IKKM) in Weimar. Since 2013, he has been director of the Theory and Methods research cluster at Zurich University of the Arts. His recent publications include, among others, *Mikropolitik: Eine Einführung in die politische Philosophie von Deleuze und Guattari* (2010), with Ralf Krause, *Philosophie und Nicht-Philosophie* (2011), co-edited with Friedrich Balke, *Kritik der anthropologischen Vernunft* (2011), *Fines Hominis? Beiträge zur Geschichte der philosophischen Anthropologiekritik* (Transcript Verlag, 2015), editor, *Eigenlogik des Designs* (2016), co-edited with Gerhard M. Buurman, and *Gilles Deleuze's Transcendental Empiricism: From Tradition to Difference* (Edinburgh University Press, 2016), translated by Peter Hertz-Ohmes.

Anna Schober is Professor of Visual Culture at Alpen-Adria-University Klagenfurt. She studied history, art history and political sciences in Vienna and Frankfurt am Main. She was acting as Visiting Professor and Marie Curie Fellow at Verona University (2009–2011) and as Mercator Visiting and Deputy Professor at Justus Liebig University Gießen (2011–2014). Anna Schober was fellow at the IFK (International Research Center for Cultural Studies) Vienna; the Centre for Theoretical Studies in the Humanities and Social Sciences, University of Essex, Colchester and the Jan Van Eyck Academie in Maastricht. She is the author of *Blue Jeans. Vom Leben in Stoffen und Bildern* (2001), *Ironie, Montage, Verfremdung. Ästhetische Taktiken und die politische Gestalt der Demokratie* (2009) and *The Cinema Makers. Public life and the exhibition of difference in southeastern and central Europe since the 1960s* (2013).

Andrej Šprah (Slovenian Cinematheque, Ljubljana, Slovenia) is head of the research and publishing department at the Slovenian Cinematheque, Assistant Professor of the Visual Arts Programme at the Academy of Visual Arts (AVA) Institute, Ljubljana, and Assistant Professor of Film and Television History and Theory at the Academy of Theatre, Radio, Film and Television, University of Ljubljana. His research focuses on political documentary and on the cultural, political and social implications of Third Cinema. He has published widely on the relationship

between fictional and documentary representations of reality and the cinema of former Yugoslavia. He is the co-founder and co-editor of *KINO! Cinema Journal*. He is the author of (selection): *Dokumentarni film in oblast* (1998); *Osvobajanje pogleda* (2005); *Prizorišče odpora* (2010); *Vračanje realnosti* (2011); *Catastrophe, Documentary and the Limits of Cinematic Representation*, in: Carsten Meiner and Kristin Veel, eds., *The Cultural Life of Catastrophes and Crises* (2012); and *Musical Variations in Karpo Godina's Alternative Cinema*, in: Ewa Mazierska and Zsolt Gyori, eds., *Popular Music and the Moving Image in Eastern Europe* (forthcoming).

Wim Weymans (UCLouvain, Louvain-la-Neuve, Belgium) is the current holder of the Velge Chair in European Values. He studied political thought and intellectual history (MPhil) at Cambridge University and modern history (MA) and philosophy (PhD) at KU Leuven. He is chiefly interested in theories of democracy and political representation, focusing mainly on Lefort, Certeau, Gauchet and Rosanvallon. He taught human-rights history and theory at Columbia University and the philosophy of law at the University of Antwerp (UA). He was a visiting scholar at the Minda de Gunzburg Center for European Studies (CES), *chercheur invité*... scholar at NYU's Remarque Institute. He has published in journals such as *Constellations, Thesis Eleven, History & Theory, Modern Intellectual History* and *The European Journal of Political Theory*.

Veronika Zink has held a postdoc position at the Department of Sociology at the Martin-Luther University Halle-Wittenberg since 2016. Until 2013 she worked at the Languages of Emotions cluster of excellence at the Free University Berlin, where she also received her PhD. Between 2013 and 2016 she was a research postdoc at the International Graduate Centre for the Study of Culture (GCSC) at the Justus-Liebig University Giessen. As a cultural sociologist she works at the intersection of economic sociology, political theory and cultural studies, specifically by focusing on contemporary modes of symbolic production. Her recent work focuses on the cultural revaluation of ordinariness and the socio-political hopes that inform this very revaluation. Veronika Zink is the author of *Von der Verehrung: Eine kultursoziologische Untersuchung—On Worship: A Socio-Cultural Essay* (CampusVerlag, 2014).

M. Ragıp Zık (Institute for Sociology, Free University of Berlin, Germany) is a PhD candidate, working on contemporary visual practices in political struggle. His project takes a critical approach to concepts of digitality, iconography and affect. He has previously researched on artistic practices, collective memory, and resistance cultures. Before he joined academia, M. Ragıp Zık had run several community-building projects across the Euro-Mediterranean countries and in the Caucasus. He currently serves as a board member on the International Sociological Association's Visual Sociology Research Committee. Issue-specific publications: Visuals and Salient Identities: Construction of "Gezi Spirit" as a Multifaceted Identity through Images, *TransScripts*, 7 (2018); *Raising a Resistance: Reinterpreting Art within Gezi Movement,* in: Peter Weibel, ed., *Global Activism: Art and Conflict in the 21st Century* (2015).

Acknowledgements

This volume would not have been possible without the help of several people and institutions. I would first of all like to thank all the contributors for their generous support and smooth collaboration. The research upon which this book is based was funded by the Deutsche Forschungsgemeinschaft (ref. SCHO 1454/1-1). Many thanks to them for their support. I would like to thank the Justus Liebig University Giessen for sustaining me in organising a workshop on the subject in 2016 and the Alpen Adria University Klagenfurt for supporting me in curating a lecture series on this field of research in 2017: many articles in this volume came from these two events. Thanks are also due to two project collaborators, Andrea Hrastnik and Sabrina Schütt, for their help in researching sources and case studies. I would like to thank Isabella Vitti and Katie Armstrong from Routledge/Taylor & Francis for their positive response to the project and their continuous assistance in putting the volume together. Special thanks go to David Westacott for his patient copy-editing of the English manuscript and to Erec Gellautz for his valuable editorial assistance. Finally I would like to thank all the artists, photographers, museums, galleries, archives and agencies who kindly granted permission to publish their images in this volume.

Introduction

Anna Schober

When after a long break a new episode of the popular series *Commissario Montal-bano* (*Inspector Montalbano*, since 1999) was broadcast on the Italian state televi-sion channel Rai 1 in February 2019, about 11,108,000 Italians watched it.[1] One of them was the current interior minister and populist leader of the Lega Nord, Matteo Salvini. As proof, he photographed himself with a broad smile in front of the TV showing the picture of Montalbano, and sent this photo as a tweet[2] commented with "io adoro #Montalbano" (I love Montalbano). He thereby triggered a wave of polarising reactions on social media, as this episode, like earlier ones, also took up the issue of immigration: a long opening sequence showed a ship full of refugees off the Sicilian coast, close to Montalbano's home, and his compassionate guidance in rescuing the ship's occupants.

With this positive reference to a police commissioner, who represents the emotionally charged alter ego of a large proportion of Italians, Salvini intervened in a current debate on how to deal with refugees, in which he generally represents the government's pro-nounced anti-immigration position. For this he was recently once again accused of racism and xenophobia after he criticised the awarding of the Sanremo Festival's big national pop-song prize to "Mahmood", a musician with Egyptian roots. Through the alliance with the film character Montalbano, the politician positioned himself within this debate in a new, seemingly more open pose, more positive towards refugees and their guardians. At the same time, however, Salvini also assured himself of his contact with the broad base of the population and kept himself and his position in the conversation: for while the show was still running, anti-refugee opponents in online forums accused Mon-talbano of propaganda for Italian state television. Vice versa, government critics accused the former of racism and illiteracy, for instance in connection with the novels of Andrea Camilleri on which the series was based—what gives them a kind of elitist touch.

The film character "Montalbano", situated on the southern borders of Europe, addresses identity primarily in its national and gender dimension, with current conflicts being taken up in their unsolvedness and contradictoriness. With this action by Salvini, he is quoted into the political, public space as a doppelganger of the audience. Such everybodies, as Michel de Certeau, who coined the term, explains, are figures address-ing the audience, through stagings which approach everyone and with the aid of which at the same time they authenticate and prove true what is being depicted (de Certeau 1988, 1f.). In the complex process of mediatised "claim-makings" in public space, such figures make it possible to link particular faces and the universal addressing of the audience with one another and at the same time provide the messages thus con-veyed with a physical, realistic appeal.

Such everybodies' success with the audience is measured, among other things, by the actions, imitations and acts of mediation and polarisation they entail. In the case of Commissario Montalbano, the success of this character not only led to the fact that the audience's urge for more and more episodes pushed the production of the sub-series *Il giovane Montalbano* (*The Young Montalbano*, 2012–2015), that the series' shooting locations became tourist attractions in Sicily, and that Montalbano's favourite dishes are cooked and posted on blogs, but also that a populist politician could enter into an exchange with the population via the reference to this character. Through this action, Salvini enriched this contact thus established simultaneously with the quasi-authentic experience of a shared fan experience. Conversely, the reactions achieved by the tweet and the photo conveyed to the politician as well as to the wider public the extent to which and how his attitude can find an audience response.

Hence through such everybody figures, the everyday is closely connected with "commonality" (Highmore 2011, 5), which makes clear the political dimension of this figure, which, as Salvini's populist use of this figure shows, can be further accentuated in its public staging. Michel de Certeau also points out that everybodies are not only appeal figures, to which broad sections of the population then adapt and orient themselves, but that they can also trigger the creativity of the "common man" within the confusions of everyday life—which should be recognised in the analysis.[3] Hence for de Certeau, the representation of the everyday person as well as that of everyday life itself are always ambivalent operations that stage and emphasise, just as they make us forget and transform (Higmore 2006, 112f.).

At the time of its formulation, this perspective was critically used by de Certeau against the anonymisation associated with organised modernity (Wagner 1993, 73f.) and the focus of cultural theory on structures. With the transformation of the public sphere into a highly mediatised space in the course of the upheaval around "1968" however, the "consumers" increasingly become "prosumers", i.e. agents who both produce and consume (Moffitt 2016, 91). Their particularity and creativity is currently celebrated and fetishised by insisting on freedom of choice and staging the self as a star, as an expert or as an artist, especially on the internet. De Certeau was involved in a historical upheaval here, which he himself helped to drive forward as an agent and lawyer. In the face of these tendencies, the reference to him today rather raises the question of how these particularities and differences, which have come so much to the fore in recent decades, can be linked with the universal, i.e. the concern for what is common. It is these questions[4] about the connection between the particular and the universal and about how the call to search which is linked to the universal can take its place in everyday life today—which should be distinguished from a universalism understood as the only possible way of looking at things and via which a hegemony is forced upon the others—that everybodies lead us to, and that they sometimes keep present in an imaginative way. These questions were also the central impetus for undertaking the analysis outlined in this book.

Popularising and Populism: Everybodies as Figures of Mediation and Conflict

This book deals with everybodies as involving, communicating and mediating figures—with the various contributions focusing primarily on their pictorial staging. One such investigation, which focuses on the genealogy and iconography of everybodies and on

questions of the transformation of this figure in the course of modernity and post-modernity and its relevance for public, political communication, is a research desideratum. So far there have only been scattered considerations, for example on the everybody as a cinematic figure (Hölzer 2004; Kinser 1992; Martin-Jones 2011, 48; Meyer 2005) or on the genealogy of everyone (Adolf 1957; Davidson et al. 2007, 6–11; de Certeau 1988, 1–4).

From a sociological perspective such everybodies are variants of the figure of the "third person" (Krämer 2008, 114; Simmel 1992, 120f.).[5] As Georg Simmel (1992, 101f. and 124f.) showed, these figures facilitate processes such as transition, transgression, surpassing, overcoming and overpowering. Such third persons are mediators who tend to retreat behind the message they are trying to convey (Krämer 2008, 27) —even if today they usually appear as stars. Such figures give rise to powerful ambivalence, since they make it possible to thwart friend and enemy patterns as well as to increase hatred and resentment. Figurations of the third person thus serve both the unification and reconciliation as well as the disturbance and the deepening of conflicts (Freund 1971, 98; Schober 2014, 266f.).

In Simmel's own explanations (Simmel 1992, 124–143) as well as in the literature referring to Simmel or the third person (Behdorf 2010, 24f.), there are a multitude of third-person figures: the mediating third, the laughing and the ruling third, the messenger (Krämer 2008), the parasite (Serres 1987) or the rival and the scapegoat (Girard 1999). Everybodies can exhibit various aspects of such figures, but nevertheless they also represent a specification of the figure of the third person: they are figures that address and involve both the individual in the audience and the community. In doing so, they embody a position in a community and also advertise the viewpoint they are representing—which is why in the case of visually staged everybodies we can also speak of a publicity-related variant of the figure of the third person. Depicted everybodies are thus anthropomorphic, visually staged figures that are produced and "calculated" in order to establish a reference and elicit a resonance from the public. With their help, reigning as well as competing positions in public space are usually rejected and to create them visually a reservoir of already circulating images is called on, which are then adopted and transformed by users in order to position themselves (anew) and to attract attention.

In modernity, according to de Certeau, everybodies function as "popularising" figures, i.e. as targeting characters within procedures, that, "developed and insinuated themselves into the networks of surveillance and combined in accord with unreadable but stable tactics to the point of constituting everyday regulations and surreptitious creativity" (de Certeau 1988, 96). "Popularisation" refers to the mediating performance of these figures. This concept, however, also implies a hierarchy between those who know and disseminate this knowledge and those to whom knowledge is disseminated or who are called upon in respect to it. Such expertise and the hierarchies associated with it have been vehemently questioned since the 1960s by theorists such as de Certeau, among others. In the present day, each and every one of us then simultaneously demands to be taken equally seriously in his or her particularity (Rosanvallon 2013, 228)—which is why, in relation to processes of public speaking and showing, concepts such as "mediation", "messenger" or "communication" appear more appropriate today, even if they blur differences and hierarchies in the position of speech and their valuation.

As Matteo Salvini's example in front of Montalbano's television picture makes clear, the communication achieved by these figures can turn into populism. Popularisation or

communication and populism are however not separated by a sharp, strict border. As Benjamin Moffitt (2016, 45f.) has shown, populism can be understood as a "political style"[6] that has certain characteristics such as the addressing of "the people" vis-à-vis an elite, performances of the vulgar, politically incorrect and of "bad behaviour" in general, as well as a staging of crisis, collapse or danger. This style can more or less intensively dominate political communication: there is thus a gradual transition (Worsley 1969, 245) between styles of politics in which everybodies play a popularising role and other, populist ones in which for example political leaders present themselves as everyman/everywoman showing a vulgar kind of behaviour and posing as the only true embodiment of the people. Salvini's reference to Montalbano on this gradual scale is close to the populist pole. At the same time, however, the public intervention he has made testifies to the fact that political communication today usually appears in a highly stylised, mediatised and spectacular manner (Moffitt 2016, 50).

In this volume, Lynda Dematteo takes an anthropological approach to contemporary populism in Italy in the form of the Lega Nord or the Five Star Movement. Referring to Elias Canetti's investigation of mass and power, she shows how Lega Nord leaders use the mask of a particular "ordinary man", the *italiota* (an Italian idiot), that achieves a reversal of status in order to seduce the public at the expense of the elite. Questions concerning the relationship between popularisation and populism are also addressed in the chapters by Wim Weymans, Marc Rölli, Nina Bandi and Anna Schober.

In addition, everybody as a figure of popularisation and communication is at the centre of a whole series of contributions. Wim Weymans and Anna Schober deal with the role of this figure in public spaces that emerge with the political upheavals from monarchic to pluralistic democratic political systems and investigate the subsequent figurations of everybodies in different time spans and across various visual media. Raul Gschrey dedicates himself to the history and practice of composite portraiture aimed at the production of archetypical metaportraits of average types of the human species. Referring to a broad selection of historical sources he demonstrates that these figurations of ideal common faces were part of a positivistic scientific orientation towards a statistically valid average that was one of the foundations of modernity. Because of the proclamation of visual truth and sublime aesthetics that these pictures conveyed, they were—and are still today—prominently used in endeavours to popularise science to an amateur audience. The role of everybodies in recent forms of "audience democracy" which has been spreading since the 1970s and is heavily permeated by the mass media and in which a variety of new stages are open to adaptations of this figure, is then illuminated by Andrej Šprah, Ragıp Zık and Elena Pilipets. Finally, Veronika Zink and Philipp Kleinmichel follow a rather discourse-history and sociological approach by reading the iconic character Amélie Poulain in the eponymous movie herself as a popularised reflection of an artistic and academic discourse re-evaluating everybody's everyday life and portraying a creative use of it as a counter-image to and a critique of the rationalisation of modern life worlds.

Genealogies and Historic Upheavals

As the various contributions in this volume show, the figure of the everybody cannot be traced back to one single origin. Various genealogical and iconographic lines can be reconstructed with regard to such mediation and disputant figures,

although some of them can also go astray, can intersect at certain points and, depending on the question, can be accentuated in various ways. As part of such a genealogy, Michel de Certeau (1988, 1f.) mentions the fools and mortals who embarked towards a common destiny or the nobody (Fricke 1998, 77f.), a mask, with whose protection one could express unpleasant opinions and criticism in early modern times without being able to be held responsible oneself, but which could also be called on for the purpose of social discipline. Another line of tradition runs to the stage plays *Everyman* (ca. 1510–1535) and *Elckerlijc* (Delft: 1496, Antwerp: 1496/1501), which confront their audience with the experience of mortality and death, appealing both to individual responsibility and public spirit through the character of Everyman (Davidson et al. 2007, 9). Anna Schober addresses this genealogical line in her contribution, but also traces this figure back to representations of the all-seeing one, such as those shown in images of Christ. At the same time and in tension with it she follows transformations of this "long tradition" with the upheaval towards democratic societies and depicts different types of figuration of the everybody that were circulated with these upheavals.

For modernity, Michel de Certeau (1988, 2f.) characterises the "common man" or "common woman" as mediators of discourses by means of which collective or individual agents intervene in an environment and through which administrative and surveillance procedures and tactics of consumers interlace with, but also repel and separate each other. According to de Certeau, an alliance with the crowd is sought through such figures, although they can always also provoke different effects such as aversion, hatred and resentment. Everybodies are thus agents who make the ambivalence of a discourse history of modernity tangible. At the same time, de Certeau also used this figure himself to make proposals for reforms of everyday, popular cultural practices in France in the early 1980s. In *L'ordinaire de la communication* (1983), a research report for the French Ministry of Culture, Michel de Certeau and Luce Giard thus focused on a specific figure, namely the immigrant as a social figure of communication and as an exemplary figure imposed by late modernity in its role of mediating in the context of globalisation processes. Elsewhere, de Certeau (1997) also mentions the nomad or the *idiotus*, the non-specialist, as figures who today allow truth to shine through for us in the audience and challenge the order composed by theoreticians.

This double function of everybodies is central: they can be understood as analytical figures, i.e. they are used to try to understand "modernity", "post-modernity", but also "popularisation", "communication", "mediation" or "polarisation". At the same time, they are also figured in philosophical, sociological or cultural studies texts in order to operate as a critical or utopia-led lens of social analysis, but also to convey theory itself to the broadest possible circle of recipients. Zink and Kleinmichel trace this double figure through the example of Amélie Poulain, reviewing modernist cultural-scientific, philosophical and sociological discourses—including those of Michel de Certeau—that re-evaluate everyday life and its "ordinary heroes" and at the same time take a critical look at the appropriation of these discourses in contemporary popular cultural practices.

Since the 1960s, the everybody has also been used by other cultural theorists, such as Giorgio Agamben (Agamben 2008, 9f.; cf. Schober 2014), as a figure of thought through which an evaluation and a critique of contemporary society is attempted and one's own position is disseminated. The concept of *devenir tout le*

monde (becoming everybody/everything), developed by Gilles Deleuze and Félix Guattari (1980, 342f.), is currently an especially frequently discussed approach in connection with the figure of everybody (e.g. Martin-Jones 2011, 48). In their contributions Nina Bandi and Elena Pilipets refer closely to this conceptualisation. Bandi explains how the conceptual figure of *devenir tout le monde* can be related to contemporary political and art practices, reading it as a figure that counters and challenges established images and a reifying identificatory logic of politics. Elena Pilipets on the other hand explores the circulation and appropriation of images of the human face on digital visual platforms as amplifiers and modulators of affect by using the example of "contagion images" produced and shared in the context of Conchita Wurst's Eurovision victory in 2014. In doing so, she highlights the ambivalence of internet memes appropriating the image of Conchita Wurst's face by demonstrating the ways in which they highlight the singular, simultaneously situating and mediating it as part of a network collective. In a different version, Lynda Dematteo also refers to Deleuze and Guattari's approach. In her analysis of populism she links Canetti's work on paranoia and Deleuze and Guattari's schizoanalysis.

As Anna Schober explains in her chapter, the genealogy of everybodies thrives on the tension between long historical duration and historical upheavals and re-figurations. Above all, the historical upheaval that accompanies the revolutions from the 16th to the 19th century and in the course of which political power becomes dependent on the people is particularly important for the creation and dissemination of modern everybodies—intertwined with a change in self-cultures, upheavals in the orientation of faith and transformations in the field of the orderings and institutionalisation of knowledge, which goes hand in hand with a de-legitimisation of laity. Two introductory contributions provide historical and epistemological contextualisations for this change from the perspective of philosophy as well as from the perspective of political science and political history. Marc Rölli describes how the revolutions towards democratic forms of government have revealed the popular as a question and problem of philosophy—also as the downside of a crisis of metaphysics. He outlines the basic controversies about the relationship of philosophy to the people, i.e. "Joe Public", from the Enlightenment to the present day, and how, with Heinrich Heine, the popular was redefined in contrast to an understanding of popularisation as a didactic undertaking and then utopianised in various ways. Wim Weymans, on the other hand, works out the extent to which, after the democratic revolution of western societies, they differ from pre-democratic ones and what forms of representation have been imagined and translated into practice for the new, necessarily abstract and indeterminate sovereign, "the people", as well as general principles such as "equality" or "freedom". In doing so, he focuses on representations of the people in the form of symbols and images, as institutions (such as parties) and as poetic representations.

An image that stands at this historical threshold (Bühler 2013) is the famous frontispiece of Thomas Hobbes' *Leviathan* (1651, Figure 0.1). A detail in the manufacturing process of this frontispiece, makes it clear in a nutshell what the everybody figure is all about in this upheaval. In all printed versions of the book the small bodies filling out the torso of the ruler—which in their always similar size and shape and simultaneous multiple presence can be regarded as "everybodies", representing "all of us" or "the people"—turn their backs on us, the potential readers (Figure 0.1 detail). This can be explained by Thomas Hobbes' theory describing the

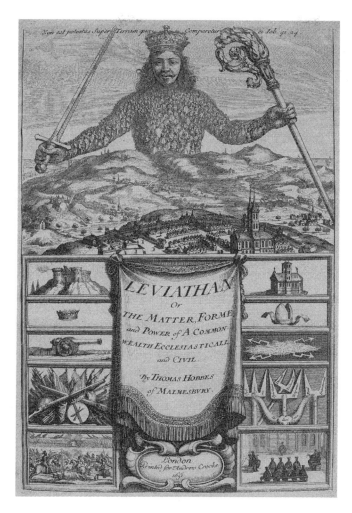

Figure 0.1 Abraham Bosse, frontispiece in: *Leviathan, or the Matter, Forme and Power of a Commonwealth Ecclesiasticall and Civil*, by Thomas Hobbes, 1651. Copyright: Herzog August Bibliothek Wolfenbüttel: (Sf 4° 5).

Leviathan as a body politic that is constituted through a contract between the people. But there is one drawing in which the small everybody figures are not turning their backs on us and looking towards the ruler who they are about to constitute through this gesture, but are instead looking at us, the public. It is a drawing on the frontispiece (Figure 0.2) of the parchment manuscript that Thomas Hobbes handed to Charles II in October 1651, after the latter had returned to his Paris exile following his defeat in Worcester (Bredekamp 2012, 53).

This drawing of the Leviathan confronts us with a change in address: here the everybodies become reduced to faces and are looking at the audience (Figure 0.2 detail) as if they were trying to establish eye contact and inviting all potential

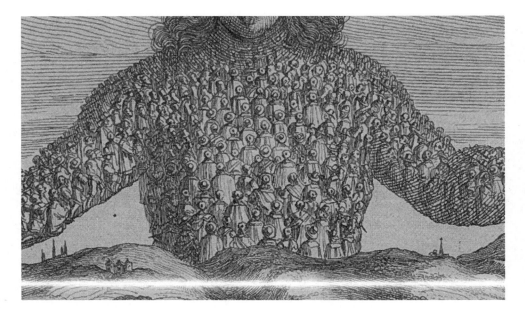

Figure 0.1 (detail)

readers to participate in the constitution of the body politic (Bredekamp 2012, 55). This was possible because Hobbes was giving the drawing to a very particular reader: King Charles II, who would perhaps have been offended being confronted with an image in which the people, in the course of their political, socialising activity, were turning their backs on him. With the revolutions of the 17th, 18th and 19th centuries in several countries the position of the king was abolished and the addressee of images changed in a similar way (Lefort 1986, 302f.; Schober 2009, 67f.) as was to some extent presaged in this drawing. With these upheavals, the bodies filling out the big torso of the monstrous ruler break free and become political agents, representing a variety of positions. They are thus no longer all turning in the same direction towards the ruler as in the various printed versions of the frontispiece but incorporate a variety of societal and political viewpoints that also come into conflict with one another. Hence the displacement of the small "bodies" forming the Leviathan in this drawing to some extent anticipates a broader transformation concerning the role of "the people" in the political, public sphere, which with the upheaval of the people's revolutions in the 17th and 18th century was coined in a new way.

As the drawing by Jacques-Louis David *Sermont du Jeu de Pomme* (*The Tennis Court Oath*, 1790–1791, Figure 0.3) shows, in this process, the bodies forming the newly constituted public sphere have to establish contact with the audience, i.e. they have to attract and to hold attention and to invent aesthetic tactics and devices in order to deal with audiences. This drawing, however, still integrates the representative of the bourgeois everyman into an ensemble of small groups, formed by contingent individual figures arranged in relief. Each of these realises itself gesturally and mimetically, simultaneously offering the audience a viewing position that displays an attitude

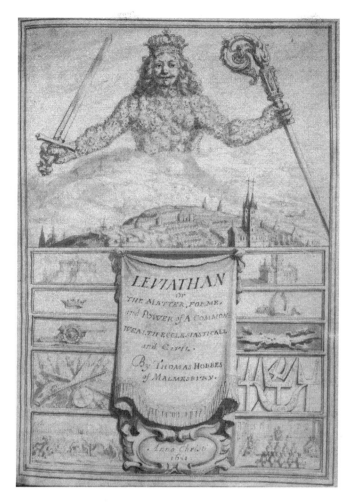

Figure 0.2 Abraham Bosse, frontispiece in: *Leviathan, or the Matter, Forme and Power of a Commonwealth Ecclesiasticall and Civil,* by Thomas Hobbes, 1651. Copyright: British Library Board (Egerton 1910).

of distanced observation of the events (Kemp 1973, 265). However, this was soon confronted with other pictures such as *L'Emeute* (*The Uprising*, 1848–1879, Figure 4.6) by Honoré Daumier, in which, as Anna Schober shows in her contribution, the viewer becomes an accomplice of upheaval and revolt by close up, dynamically staged reference figures.

Following these upheavals, visual media act both as stages for the mise en scène of "the people" and as channels for the voice of "ordinary folks" (Moffitt 2016, 110). This can overlap in figurations of the everybody: as Anna Schober again points out in her contribution, after these upheavals they are often staged as figures who have been singled out from the people but are simultaneously shown

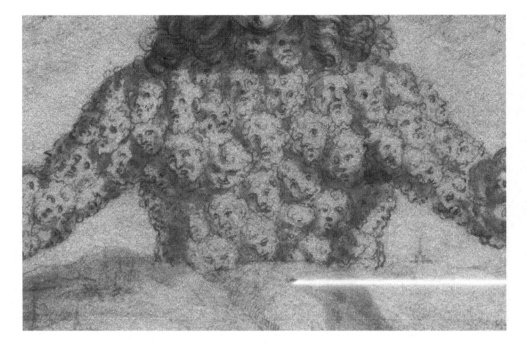

Figure 0.2 (detail)

as being connected to it, thus creating presence and persistence for the myth of the people as a powerful agent transforming society (Figure 0.4). At the same time, with these upheavals towards a society shaped in a new and generally democratic way (Lefort 1986, 302f.) ordinary men and ordinary women become more active in the constitution of the public sphere as producers and consumers at the same time. Both in the course of revolts and of reforms that are always addressed "to all", they are correspondingly also spurred to activity and involvement.

Various articles in this volume deal with how everybodies operate within such a "rendering present of 'the people'", which proves to function either in a rather technocratic or in a rather populist way, and through which the myth of the people as a society-transforming agent is constantly updated (Arditi 2007, 64). Raul Geschrey, Andrej Šprah, Ragıp Zık, Viola Rühse, Elena Pilipets and Anna Schober show that these figures usually short-circuit the distance between what is represented and the public by being staged as having an immediacy or intimacy with "the people" or by accentuating the physical dimension or aspects of authenticity and truth with respect to the representation. Lynda Dematteo deals with the populist variant of such a "rendering present of 'the people'", characterised by a rapport between leader and followers, which also relies on a symbolic or mystifying directness. Elisabeth Fritz by contrast examines how in the last two decades the notion of "realness" connected to the use of "everybodies" in participatory art was questioned together with the ethical, social and political imperatives that had been implied in socially engaged art since the 1960s. She discusses the main fields of critique that contemporary

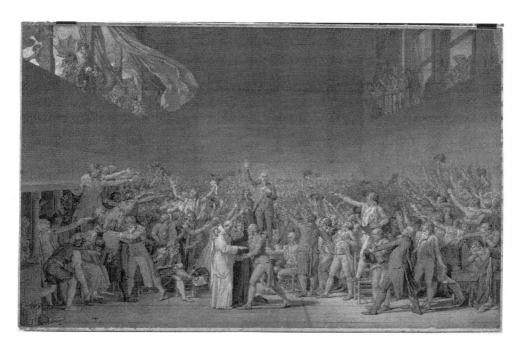

Figure 0.3 Jacques-Louis David, *Serment du Jeu de paume* [20 June 1789, Tennis Court Oath], 1789. Copyright: RMN-Grand Palais (Château de Versailles).

Figure 0.4 Violation of the National Assembly by the riot in Paris, 15 May 1848. Copyright: Roger-Viollet.

participatory practices are confronted with as well as selected artworks that digest this critique and productively respond to the challenges posed by it.

Iconic Figurations and Discourse Research

This volume enters new ground in that it examines the figure of the everybody for the first time from a visual studies perspective and across various media. Michel de Certeau, who originally put forward this concept, analysed the role everybodies play in modern discourses without explicitly addressing the visual figuration of the ordinary man or the ordinary woman. Nevertheless, his works offer starting points for a history of the pictorial representation of the everybody. These can be found, for example, where he addresses the everyday use of a wide range of media channels by consumers (de Certeau and Giard 1983, 137) or where he analyses the visual aspect of processes of conviction in the public sphere and the relation between seeing and believing in late-modern societies (de Certeau 1988, 179–183).

In order to approach visually staged everybodies analytically as figures through which discourses are conveyed and disseminated, another theorist can be used as a bridging figure: Friedrich Kittler (1993, 84–87). In his work on the history of "writing systems", he examined how in German literature around 1800 "heroes like you and me" increasingly emerged, programming the readership to perception based on identification. At the same time, he explains how the "empirical-transcendental double human" (Kittler 1993, 96) was redefined around 1900 in an interplay of science and industry, psychoanalysis and film. The shadows and mirrors of the subject or the doubles of the viewer (see Hölzer 2004) are now technically realised on the media stages of cinema, which also implies a changed perception training of the audience. Even in early cinema, the camera lingered on the faces of passers-by, who thus assumed the role of the everyone who happened to be present in the scene. Especially in the direct cinema of the 1960s, close-up shots of faces appearing contingently at a scene, through which spontaneous interactions and mimetic reactions to the environment become clearly visible, intensified the contemporary reference of films and helped to blur the border between image and viewer (Meyer 2005, 138–140). Andrej Šprah analyses such cinematic stagings of the everybody using the example of newsreel practices emerging in the 1930s as part of various forms of social and political struggles and spreading more widely in the course of militant protest activities since the 1960s. He also examines the recent revival of politically committed newsreels in the last two decades in the context of a "new protest politics" and "civil citizenship" (Rosanvallon 2008, 21 and 24f.). Similarly to Raul Gschrey, Elena Pilipets, Elisabeth Fritz or Anna Schober he shows that today everybodies are no longer designed in a heroic way, pushing back their particularity, but appear in a more sharply particularised form as transition figures: as migrants, nomads, transsexuals, ethnically diversified figures or outlaws such as Guy Fawkes, who became the common face of the Occupy movement.

As an image by Srdjan Živulović from September 2015 (Figure 0.5) also demonstrates, immigrant children today particularly often become mirror images in which we as spectators can recognise ourselves and our contemporary existential situation marked by precariousness and fragility. Such representations do not deal mainly with the condition of those represented, but—as this photograph also demonstrates—by way of sometimes carefully staged details, such as soap bubbles blown by a refugee

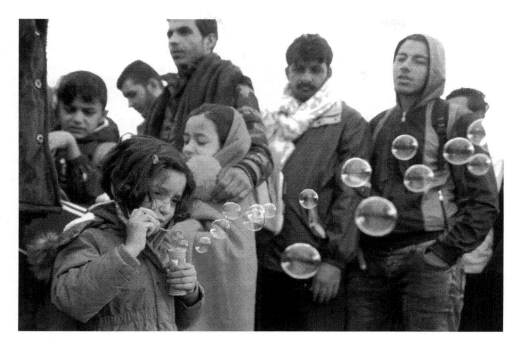

Figure 0.5 Srdjan Živulović, A young girl blows soap bubbles as migrants wait to board buses to take them onwards to the train station, from the border crossing in Nickelsdorf, Austria 6 September 2015. Copyright: REUTERS/Srdjan Živulović.

girl that float freely right across the foreground of the photograph, they direct the audience's attention towards sometimes absorbing self-reflection.

In the face of everybody a relation to social normality usually also takes very concrete, different forms (Meyer 2005, 140). Social and political power relations thus become visible in these figures, but they also act as agents in how such relations change—which is why some of these images trigger conflict and sometimes even result in heated political discussions (Figure 0.6). Hence through figurations of a "general person" rejecting the reigning hegemonial orders and classifications, who provides what is being shown with a universal horizon and yet addresses the specific and particular to everyone in the audience, dominant conditions can be challenged and something different and new can be helped to break through (Reckwitz 2010, 69f. and 79). As various chapters in this book show, everybodies are therefore also more or less utopia-led "new people", with whose help social groups challenge existing world views and make new ones available.

Even if in relation to everybodies in this way there are connections to discourse theory, in their visual staging they cannot simply be subsumed into discourses. Images have their own logic and respond to an inherent law of seeing that is related to a productivity of the imaginary and to processes of affecting and becoming affected. Pictures display, create presence and make evident. They can trigger events of perception and even actions and deploy figurations in which the subject can look at themselves and reflect on their own desires and fears (Schober 2016). In this way,

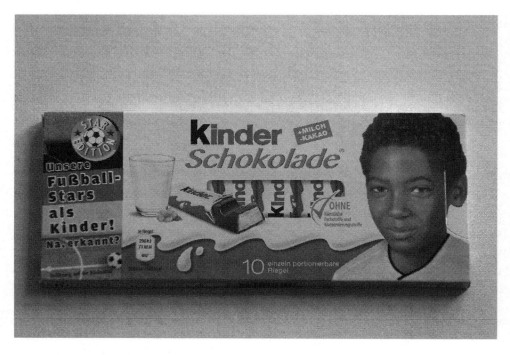

Figure 0.6 In Germany, on the occasion of the 2016 European Soccer Championship Ferrero children's chocolate packages were designed with youth photos of national soccer players, here Jérôme Agyenim Boateng. Photo: Norbert Schmidt. Copyright: Imago/Norbert Schmidt.

they confirm existing norms and attributions, but may also elicit, mediate or contest transformations of society. Various contributions in this volume choose an explicitly visual studies approach to such mediation and disputant figures. In relation to these figures, Raul Gschrey, Andrej Šprah, and Anna Schober analyse the image media's own proclamations of truth, creation of presence and durability and the production of effects of immediacy and closeness. Viola Rühse provides us with a close art-history reading of a life-sized sculpture by Duane Hanson, *Man on Mower* (1995), which she analyses as the embodiment of the American everyman in the 1990s. She discusses Hanson's approach to stereotypes, especially in respect to physical appearance and social background and his compassionate attitude towards who is represented, exposing alienation by way of an expression of an iconically shaped "quiet desperation". Rühse also sketches out how this sculpture of a white middle-class everyman differs from previous works by the artist but also from former allegorical depictions of gardeners, for instance Christ as gardener. In parallel she also points out which artworks replaced such representations in the course of the economic crisis around 2007. In his chapter Ragıp Zık also confronts us with a close reading of a single image, the photograph *Lady in Red*, which went viral and gained international recognition in the course of the Gezi Park protests in Istanbul in 2013. The focus of his contribution is on multiple appropriations of this iconic image as an

illustration highlighting some of the visual qualities by masking others and in the process also shifting its role from a dissident to a docile one by transforming into an allegory of the nation. Finally, Nina Bandi and Elisabeth Fritz examine contemporary art practices that are entangled in a "lure of the real" challenging the audience to take a stand in relation to what is staged through representations of "everybody" and entering unusual and unexplored paths in how to connect particular faces and universal address.

In the various contributions, everybodies thus appear as figures that can set affects or feelings and attitudes, desire and hatred, aspirations and fears in motion and are able to trigger touching encounters, in the sense of a material connection and a concatenation of images associated with it, but also aversion, drifting apart and demonising. In this way, they are agents of the reproduction of the social, but also of its transformation and displacement. From a political point of view, since the upheavals towards democratic forms of society, they have functioned as figurative forms in which it has been possible to experiment with an intertwining of similarities and singularities, the particular and the universal. However, variants of everybodies, in which leaders and people appear welded and are circulated as the only true representation of such a "people", also remind us that societies are repeatedly haunted by the danger of an authoritarian closure.

Notes

1 These are viewing figures of 44.8% (Volpe 2019).
2 The photograph also appeared on his Instagram and Facebook accounts.
3 Accordingly, de Certeau (1988, 48; cf. Bocken 2012, 304) also focuses on the ordinary man or ordinary woman in order to reject and criticise approaches to cultural studies that exclusively observe everyday practices and figures from the outside.
4 On the challenge of the universal in contemporary society dominated by the "individualism of the singular" (Jullien 2016, 26–30; Rosanvallon 2013, 289).
5 This emerged in the social sciences at the beginning of the 20th century as a personalised third person (Fischer 2004).
6 For Moffitt (2016, 46) the opposite of populism is a technocratic political style.

References

Adolf, H., 1957. From Everyman and Elckerlijc to Hofmannsthal and Kafka. *Comparative Literature*, 9 (3), 204–214.

Agamben, G., 2008. *La Comunità Che Viene*. Turin: Bollati Boringhieri.

Arditi, B., 2007. *Politics on the Edges of Liberalism. Difference, Populism, Revolution, Agitation*. Edinburgh: Edinburgh University Press.

Bocken, I., 2012. Le rire des mystiques: Der Standpunkt der Kritik bei Michel de Certeau im Hinblick auf Michel Foucault. *Coincidentia. Zeitschrift für europäische Geistesgeschichte*, 3 (2), 301–326.

Bredekamp, H., 2012. Die Brüder und Nachkommen des Leviathan. *In*: P. Manow, F. W. Rüb, and D. Simon, eds., *Die Bilder des Leviathan: Eine Deutungsgeschichte*. Baden-Baden: Nomos, 45–75.

Bühler, B., 2013. *Zwischen Tier und Mensch: Grenzfiguren des Politischen in der Frühen Neuzeit*. Munich: Wilhelm Fink.

Davidson, C., Walsh, M. W., and Broos, T. J., 2007. Introduction to Everyman. *In*: C. Davidson, M. W. Walsh, and T. J. Broos, eds., *Everyman and Its Dutch Original, Elckerlijc*. Kalamazoo, Michigan: Medieval Institute Publications (TEAMS. Middle English Text Series), 1–14.

de Certeau, M., 1988. *The Practice of Everyday Life*. Berkeley, California: University of California Press.

de Certeau, M., 1997. Foucaults Lachen. *In:* M. de Certeau. *Theoretische Fiktionen. Geschichte und Psychoanalyse* ed. by L. Giard. Vienna: Turia + Kant, 44–58.

de Certeau, M. and Giard, L., 1983. L'ordinaire de la communication. *Réseaux* (eds. Dalloz, Ministère de la Culture), (1) 3, La communication au quotidien, 3–26.

Deleuze, G. and Guattari, F., 1980. *Capitalisme et Shizophrénie 2: Mille Plateaux*. Paris: Les Éditions de Minuit.

Fischer, J., 2004. Figuren und Funktionen der Tertiarität: Zur Sozialtheorie der Medien. *In:* J. Michael and M. K. Schäffauer, eds., *Massenmedien und Alterität*. Frankfurt am Main: Vervuert, 78–86.

Freund, J., 1971. Der Dritte in Simmels Soziologie. *In:* H. Böhringer and K. Gründer, eds., *Ästhetik und Soziologie um die Jahrhundertwende: Georg Simmel*. Frankfurt am Main: Verlag Vittorio Klostermann, 90–104.

Fricke, H., 1998. *"Niemand wird lesen, was ich hier schreibe". Über den Niemand in der Literatur*. Göttingen: Wallstein Verlag.

Girard, R., 1999. *Figuren des Begehrens. Das Selbst und der Andere in der fiktionalen Realität*. Vienna et al.: Thaur and LIT Verlag.

Highmore, B., 2006. *Michel de Certeau. Analysing Culture*. London and New York: Continuum.

Highmore, B., 2011. *Ordinary Lives. Studies in the Everyday*. London and New York: Routledge.

Hölzer, H., 2004. Der Schatten des Spiegelbildes. Action-Film Sequels als Unheimliche Doppelgänger. *In:* M. Bernold, A. B. Braid and C. Preschl, eds., *Film, Fernsehen, Feminismus*. Marburg: Schüren, 210–220.

Jullien, F., 2016. *Il n'y pas d'identité culturelle: Mais nous défendons les ressources culturelles*. Paris: Éditions de L'Herne.

Kemp, W., 1973. Das Bild der Menge (1789–1830). *Städel-Jahrbuch NF*, 4, 249–270.

Kinser, S., 1992. Everyday Ordinary. *Diacritics*, 22 (2), 70–82.

Kittler, F., 1993. Romantik – Psychoanalyse – Film: Eine Doppelgängergeschichte. *In:* F. Kittler, ed., *Draculas Vermächtnis: Technische Schriften*. Leipzig: Reclam, 81–104.

Krämer, S., 2008. *Medium, Bote, Übertragung: Kleine Metaphysik der Medialität*. Berlin: Suhrkamp.

Lefort, C., 1986. The Image of the Body and Totalitarianism. *In:* C. Lefort, *The Political Forms of Modern Society: Bureaucracy, Democracy, Totalitarianism*, ed. by J. B. Thompson. Cambridge: Polity Press, 292–306.

Martin-Jones, D., 2011. *Deleuze and World Cinema*. London and New York: Continuum.

Meyer, F. T., 2005. Jedermann. *In:* J. Barck et al., eds., *Gesichter des Films*. Bielefeld: Transcript, 137–146.

Moffitt, B., 2016. *The Global Rise of Populism: Performance, Political Style, and Representation*. Stanford, California: Stanford University Press.

Reckwitz, A., 2010. *Das hybride Subjekt: Eine Theorie der Subjektkulturen von der bürgerlichen Moderne zur Postmoderne*. Weilerswist: Velbrück Wissenschaft.

Rosanvallon, P., 2008. *Counter-Democracy: Politics in an Age of Distrust*. Cambridge: Cambridge University Press.

Rosanvallon, P., 2013. *The Society of Equals*. Cambridge, Massachusetts and London: Harvard University Press.

Schober, A., 2009. *Ironie, Montage, Verfremdung: Ästhetische Taktiken und die politische Gestalt der Demokratie*. Munich: Wilhelm Fink.

Schober, A., 2014. Everybody: Figuren "wie Sie und ich" und ihr Verhältnis zum Publikum in historischem und medialem Umbruch. *In:* J. Ahrens, Y. Kautt, and L. Hieber, eds., *Kampf um Images*. Wiesbaden: VS Verlag für Sozialwissenschaften, 241–270.

Schober, A., 2016. *Gender* ins Bild gesetzt: Kollektive Imagination und öffentliche Auseinandersetzung im postmodernen Europa. *In:* A. Schober and A. Langenohl, eds., *Metamorphosen von Kultur und Geschlecht. Genealogien, Praktiken, Imaginationen.* Munich: Wilhelm Fink, 169–201.

Serres, M., 1987. *Der Parasit.* Frankfurt am Main: Suhrkamp.

Simmel, G., 1992. *Soziologie: Untersuchungen über die Formen der Vergesellschaftung.* Frankfurt am Main: Suhrkamp (Collected Works, vol. 11).

Volpe, M., 2019. Montalbano, Migranti Nella Fiction. Salvini: «Lo Adoro» e Scatta la Polemica Sui Social. Boom di Ascolti. *Corriere della Sera*, 12 February [online]. Available from: www.corriere.it/spettacoli/19_febbraio_12/montalbano-migranti-fiction-scatta-polemica-social-437acca4-2e99-11e9-9800-d9788a74058f.shtml [Accessed 9 April 2019].

Wagner, P., 1993. *A Sociology of Modernity: Liberty and Discipline.* London and New York: Routledge.

Worsley, P., 1969. The Concept of Populism. *In:* G. Ionescu and E. Gellner, eds., *Populism. Its Meanings and National Characteristics.* London: Weidenfeld & Nicolson, 212–250.

1 The Popular in Philosophy

Notes on a Pluralistic Concept of Democratic Enlightenment

Marc Rölli

The popular in philosophy has it hard. Shallow, not serious, politically suspect—it belongs in the same box as the cultural industry and the mass media. Good enough for guidebooks, newspaper supplements and talking heads, but nothing for the venerable chairs at the universities. The rabble on the street, the gullible, hypnotisable, unconsciously acting masses who are blindly taken in by the prevailing ideologies; the man with everyday worries, who seeks employment and wants to be entertained; popular cultures that make what decency and character once were disappear; the *Homo economicus*, who has forfeited his moral sense; right-wing conservative nationalisms and *Kulturkampf* conspiracy theories—all of these and many other popular tropes make it clear that popularity has no place in philosophy.

But is it true? Doesn't the popular have a place in philosophy, because if there is to be an ascent to light and sun then there must be a cave and its inhabitants? The pathos of the past and the crisis of the present—or the miracle of the future? Is a metaphysical concept conceivable without talking about the empirical surface of what is comprehensible to everyone—and about an essential depth that transfigures the empirical into the illusory? One might also think of the great subject of ideology, which keeps the structures of subjugation alive—or of everyday life, which is opposed to actually resolute existence. Are these not all conceptions of the popular that are philosophically not just constructed, but needed—in a sense that stabilises the whole enterprise?

In the following I turn to the topic of the popular in philosophy initially by placing it in the "popular philosophy" of the Enlightenment (I). In a second step I come to Heinrich Heine, who, in his notorious text on the history of religion and philosophy in Germany, rehabilitates the popular philosophy that had been discredited in German idealism from Kant to Hegel (II). Finally, I would like to draw a line to the present and argue in favour of perceiving the popular in all its ambivalence, not least its historically determined ambivalence. But this means finding criteria that make it possible to distinguish between pluralistic-democratic processes and their merely anti-pluralist-populist blockage (III).

I

In the history of philosophy of the Enlightenment it is not unknown that Kant reacted to a review of his *Critique of Pure Reason* in the *Göttinger Gelehrten Anzeigen* (19 January 1782), which originated from Christian Garve (and was shortened and sharpened by Johann G. H. Feder as editor of the *Anzeigen*), with his *Prolegomena to Any Future Metaphysics That Will Be Able to Present Itself as*

a Science (2014 [1783]). The conflict between Kant and Garve sheds a bright light on the popular in philosophy. With these *Prolegomena*, which are a preface raising the question of the very possibility of metaphysics before discussing it—with these preliminary considerations or "preliminary exercises" (Kant, 2014 [1783], 11) undertakes to counter the "complaints of lack of popularity".

Kant takes these complaints seriously by executing his plan, already communicated in a letter to Marcus Herz in May 1781 (Kant, 1999, 181), "according to which even *popularity* might be gained for this study [metaphysics]". Only at the beginning does this popularity seem "ill-timed" to him, since first "the foundations needed cleaning up". To "clean up the foundations", that is: to be thorough, to allow for doubt, but to overcome it critically, thought through from the bottom up. Popularity does not come first, at most second. Anyone who develops "a completely new science" cannot entrust themselves to traditional language habits. If only for this reason will it seem "nonsensical, because one does not thereby make the author's thoughts fundamental, but always simply one's own, made natural through long habit" (Kant, 2014 [1783], 12). "Scholastic exactitude", "dryness" and "obscurity" are deficiencies that one can complain about (Kant, 2014 [1783], 11, 12). But they can only be eliminated in a popular representation after the critique has already done "the most difficult thing that could ever be undertaken in the field of metaphysics" (Kant, 2014 [1783], 10). In this sense Kant understands the *Prolegomena* as a plan to emphasise the "building of links" of the critique of reason more clearly. However, he also states: "Whosoever finds this plan itself [...] still obscure may consider that it is not necessary for everyone to study metaphysics" (Kant, 2014 [1783], 13).

Popularity in philosophy may therefore justifiably be demanded for didactic reasons. From a Kantian point of view, however, there is also a popularity that is presumptuous and incapable of penetrating the obscurity that belongs to the essence of the thing (here: metaphysics). If obscurity is hastily "decried", then it is "a familiar cloaking for one's own indolence or dimwittedness" (Kant, 2014 [1783], 13). The real critical principles are therefore usefully obscure, because they discourage those who are not given the corresponding "talents" and "intellectual gifts" (Kant, 2014 [1783], 13).[1]

According to Kant, the popular belongs in its proper place. Critical philosophy is both thorough and obscure, even if it has "the interest of human reason in general" on its side (Kant, 2014 [1783], 7). On the other hand, the complaints about lack of popularity are inadmissible if they simply ignore the difficulties that arise from the real philosophical problem. Kant combines what he sees as an inadmissible position with the more general phenomenon of a crisis in metaphysics, which has not only undermined its scientific core but has also produced a new kind of fictitious everyone. In the present situation

> it [metaphysics] has lost a great many of its adherents, and one does not find that those who feel strong enough to shine in other sciences wish to risk their reputations in this one, where anyone, usually ignorant in all other things, lays claim to a decisive opinion, since in this region there are in fact still no reliable weights and measures with which to distinguish profundity from shallow babble.
> (Kant, 2014 [1783], 2).

With this description of the situation Kant refers to the fact that Christian Wolff's school metaphysics is also losing influence and reputation in the German-speaking

world in the face of an increasingly prevalent empiricist and materialistic way of thinking. His main focus is the "Göttingen Enlightenment", which was primarily responsible for the upswing of popular philosophy in Germany (since the 1760s). It "provides a thinking that can become that of the people"—and in this sense sees itself as the real Enlightenment (Binkelmann and Schneidereit, 2015, iv). Popularity here means various things. On the one hand, the term aims at a generally under-standable form of presentation—and thus also at new literary, aesthetic and rhet-orical strategies (form of dialogue, essay, speeches to the reader, allegories, doctrinal poems, fictitious correspondence). They are associated with structures of a new kind of public (salons, magazines, review organs). On the other hand, the popular stands for a content that concerns everyone (in Johann Jakob Engel's case: a philosophy for the world), as well as for the level of justification that is discerned in the common sense. And Kant becomes polemical at the last point mentioned. In the *Prolegomena* he comes to say that David Hume "was understood by no one." (Kant, 2014 [1783], 5) Hume's "problem", however, is one that cannot be ignored because his scepticism does not stop at all at the beliefs of common sense. Kant can rightly point out that Hume's opponents are content to invoke "common sense": "this appeal is nothing other than a call to the judgment of the multitude; applause at which the philosopher blushes but at which the popular wag become triumphant and defiant" (Kant, 2014 [1783], 9). Finally, Hume had shown that the demonstrations of the existence of God, the immortality of the soul and free will common in school had become impossible. "All of its cognitions allegedly established *a priori* would be nothing but falsely marked ordinary experiences" (Kant, 2014 [1783], 7f.). Conse-quently, from Kant's point of view, a critical reason is necessary that "keeps the ordinary common sense in check, so that it does not lose itself in speculations" (Kant, 2014 [1783], 9). The ideas of theoretical reason only acquire their practical—or, as Kant says in *Logic* (1988), their "cosmopolitan" relevance in the passage through critique. And also experience as a scientific objectivity can only be guaranteed if it is possible to justify the concepts of the mind as *a priori* categorical units (in transcendental deduction).

Here two things become clear. First Kant problematises the reference to a common sense to be observed in the reaction to Hume in Reid (1764) and Beattie (1779), and then also in the popular philosophy of the Göttingen Enlightenment. In his eyes, this reference suffers from not being able to keep up with the sceptical considerations employed by Hume. Hume's radical empiricism makes it impossible simply to maintain traditional assumptions about categories of substance and sub-ject, deontological moral teachings and theological views. Secondly, by questioning these traditional assumptions, the limits of popular philosophy are drawn where it proves incapable of formulating an alternative to school philosophy. A popular philosophy *ex cathedra*, which could, for example, bring to bear its eclectic method against systematic philosophy according to its school concept, does not exist. In the German-speaking world Kant had some success with his criticism of the popular Enlightenment. Research literature points out that the popular philosophical enlightenment in its own understanding of itself after 1780 generally aimed to bring the heavy Kant text closer to a larger audience of the educated bourgeoisie (Emundts, 2000). With *Anthropology from a Pragmatic Point of View*, published in 1798, Kant once again makes clear what it means to develop a popular philosophy. Anthropology follows the school, i.e. it presupposes the principles and essential

insights of school philosophy—and in this context this means systematic philosophy in theoretical and practical orientation. It does not address the transcendental structure of will, recognition and feeling, but only the empirically comprehensible exercise of faculties in the world.

Kant's famous text to answer the question "What is Enlightenment?" (1991b [1784]) once again intervenes unconventionally and effectively in the debate about the popularity of philosophy. Enlightenment, correctly understood, serves the political progress of humankind in the historical-philosophical sense. Anyone who frees themselves from self-inflicted immaturity understands it correctly (Kant, 1991b). The Kantian motto of being courageous and thinking for oneself is initially addressed to everyone. And yet, correctly understood, criticism must precede the Enlightenment. This ambiguity manifests itself not least in the way Kant separates the public from the private use of reason. Ultimately, it is a matter of leaving immaturity behind by making *free* public use of reason—while its private use can be "very narrowly restricted" (Kant, 1991b, 4). "Thus it would be very harmful if an officer receiving an order from his superiors were to quibble openly, while on duty ... He must simply obey" (Kant, 1991b, 11).

Obedience to civil duty (i.e. the private use of reason not at all in the sense of a mere examination of conscience) is opposed by the free (and public) reasoning of the scholar—and the legitimised law results from this freedom. Perhaps one can say that at this point the impulse to leave immaturity behind is linked to a criticism of the authorities, which itself claims to be an authority. In any case, Foucault saw it this way when he proposed radicalising transcendental critique genealogically in order to make it accord with the spirit of the Enlightenment (Foucault, 1997).

II

After Kant, the critique of popularity, which already in Kant tends to inform the rationally founded Enlightenment, turns into an idealistically motivated critique of the Enlightenment. This starts with Reinhold and Fichte and does not end with Schelling and Hegel. In the *Ankündigung des kritischen Journals* (1802), which Schelling and Hegel supposedly wrote together, the esoteric nature of philosophy is played off against its exoteric appearance. In the introduction *Über das Wesen der philosophischen Kritik überhaupt und ihr Verhältnis zum gegenwärtigen Zustand der Philosophie insbesondere* Hegel (1802) says: "The Enlightenment already expresses in its origin and in and for itself the meanness of the intellect and its vain elevation above reason, and therefore no change in its meaning was necessary to make it popular and comprehensible."[2] This at least drastic, if not arrogant assessment of the Enlightenment is repeated and systematically consolidated by Hegel in the *Phenomenology of the Spirit* (1979 [1807]).

Against this background, the plea for popular philosophy in Heine's much-read text *On the History of Religion and Philosophy in Germany* stands out in sharp and clear contours:

> If any great German philosophers happen to cast a glance at these pages, they will shrug their noble shoulders at the meager scale of everything I present here. But I hope they may bear in mind that the little I say here is expressed quite clearly and distinctly, while their own works—while very thorough,

immeasurably thorough, very profound, stupendously profound—are to the same extent incomprehensible. What use to the people are these locked-up granaries, if they have no keys? The people are hungry for knowledge and will thank me for the crumbs of philosophical bread which I honestly share with them. It is not a lack of talent, I believe, which keeps most German scholars from expressing themselves about religion and philosophy in a popularly understandable manner. Rather, I think that they fear the results of their own thinking, which they thus do not dare to communicate to the people. I myself do not have this fear, for I am no scholar myself but one of the people.

(Heine, 2007a, 9)[3]

The philosophical works taught may indeed be thorough and profound, and just as incomprehensible, but it remains possible that they "express themselves popularly" in an altered form. This formula is puzzling, because it does not aim at an exoteric general understanding of philosophical esotericism. When Kant admits in the prefaces to the *Critique of Pure Reason* (Kant, 1991a, A xvii f, B xxxvii f.) that there is still much to do in the kind of popular representation for which he lacks the talent, he in principle separates the discursive or systematic from the merely aesthetic clarity.[4] The presentation remains external to the matter. According to Heine, things are almost the reverse. He opposes the idea that the essence of philosophical truths lies in the realm of the pure spirit, and from there slowly seeps into social life by being diluted.

It is not the mediation of esoteric knowledge as such but its popular transformation that he has in mind. With this radical gesture, Heine turned back to the philosophy of the Enlightenment. As Helmut Holzhey (1977, 130) once put it: "There is a lack of a concept of a philosophy that is popular in itself." Heine wants to remedy this shortcoming—at least programmatically. From his point of view, the real business of philosophy is revolution. For this reason, the "shy nature" of some scholars is to be understood. Ideas that really count are *social ideas*: ideas that do not result from the soliloquy of reason and are then to be communicated in a popular way—against the resistance of the obtuse common mind—but ideas that are expressed in a popular way in themselves or knowledge of the world. "For these reasons, I will consider only the larger questions which have been discussed in German theology and philosophy, and I will illustrate only their social importance" (Heine, 2007a, 9).[5] The concept of the social functions as a cipher for the necessary philosophy, for which it is high time—a popular philosophy that links political and intellectual activities as closely as possible. It also informs the historical view of the history of religion and philosophy chosen by Heine. German (idealistic) thoroughness has a strategic value, so to speak, because it makes possible a repetition of the revolution, which is more deep-seated in comparison with that of the French bourgeoisie.

It is obvious that the revolution in political conditions cannot and must not come to a standstill with the empowerment of the bourgeoisie. Again and again Heine refers to the "industrials" of Saint-Simon's social utopia, i.e. to the large number of underprivileged working people. But how does it all add up that a revolutionary consequence that aims to relieve the rabble of its "ignominy" is expected of bourgeois philosophy, in Germany in particular? (Heine, 2007a, 59.) Heine's answer to this question is convoluted. To put it in a nutshell, one could say that the return of the "pantheistic Spinoza" in philosophy after Kant is based on an "identity-philosophy"

approach (in Schelling's terminology) that is oriented towards the category of the social and thus breaks its immanent idealism. The last twist in Heine's thinking is to oppose the *social to the absolute*. This turn away from Hegel happens under the aegis of popular philosophy.

In his *Fragments*, written in 1844, Heine describes the following exchange with Hegel:

> When I was once unpleasant about the word "Everything that is is reasonable", he [Hegel] smiled strangely and remarked: "It could also mean: *everything that is reasonable must be*." He looked around hastily, but soon calmed down, for only Heinrich Beer had heard the word.
>
> (Heine, 1979, 290)

Is the real reasonable, or is the reasonable real? Is freedom still to be realised, or has it already been realised? While one side insists that with Hegel the world spirit has come to itself and manifests itself in all essential areas of society according to its historical development, the other side emphasises the great gulf that exists between the insights of the absolute spirit and the material and political realities. Revolutionary action would be able to bridge precisely this gap. Heinrich Beer does not understand this (fortunately?): with his incomprehension he personifies every-one who is deaf to the philosophical ambivalences and the potential for change that lies within them.[6]

According to the philosophy of history pattern of making the reasonable real, Heine is claimed in the history of philosophy, if at all, as an important figure of *Young Germany*—and thus assigned to the left-Hegelian faction. Squeezed between Hegel and Marx in this way, he causes no problems.[7] Everything beyond Hegel that is attempted in his texts then finds its fulfilment in Marx; and what became of Marx is well known. These are the prejudices. Heine's critical views on idealism, however, are directed against the "whole Hegel". True, he is aware that the present political situation is "unreasonable" and mocks the "idea". Changes are therefore necessary. At the same time, however, he breaks away from the young Hegelian tradition and stands between all stools, because he abandons the great idea of an abstract preconceived freedom, which must be realised by necessity in the course of the history of humankind, in favour of small and *socially* important ideas.[8] It is this step that gives Heine his topicality. He is preparing a political thinking that has left ideology behind. The forgotten Fourth Estate cannot simply be declared the subject of history, even if philosophy extends its claim to all so deeply sunken social strata, no matter how low. Because it is precisely the sinking perspective that makes it impossible to see the whole picture. The large subject of humanity (or national identities) is replaced by the many small actors and groups.[9] The deposing of the supreme God is connected with the secular position of reason. In an article on the February Revolution (1848 in France), Heine (1989, 756–757) writes: "But not only the world is torn from its hinges, so are the minds of individual individuals. The brain boxes burst because all of a sudden so much news, maybe even new thoughts are forcing their way in."

This is where Heine's commitment to popular philosophy comes to the fore. The cliché of the brazen market crier who takes up ideas here assumes several functions. It is used to get philosophy to descend from its "high horse". Reality is not

reasonable and nor can it be so—no twisted arguments help. Heine also uses the image of the dilettante to deform the philosophising subject. The boorish figures know that it is impossible to leave the idiotic, unconscious, compulsive side of thinking behind once and for all. Heine is not concerned with putting philosophical thought into a superficial form so that it becomes generally understandable. On the contrary, he wants to change it in such a way that it adopts the revolutionary, popular and social questions as its actual subjects. Here Heine follows the tone struck by Kleist and Müller in *Phoebus* (1808). True, the popular lecture must find an idea "in every subordinate circle of life" (Müller, 1961 [1808], 52 (own translation)). However, the precondition is that the popular philosopher "above all [understands] those who are to understand [him]" (Müller, 1961 [1808], 52). The situation reverses. It turns out that popularity is not an insignificant ingredient, which the scholastic presentation can dispense with, but rather the development of an idea is synonymous with its "popularisation".[10] This results in the following dialectic: "Only the intentional mystic sometimes has the intention of popularity; only the haughty can have the intention to condescend: false mysticism and false popularity are corresponding, interdependent infirmities of the same time and the same person" (Müller, 1961 [1808], 53).

Since Reinhold's attacks and especially since the Swabian intellectual dominance of Schelling and Hegel, it seems that the phenomenon of a German philosophy "for the world" or "for everyone" had become a thing of the past. This is probably because it acts too cautiously in its departure from scholastic philosophy and nowhere can it stand up to the newly emerging critical and idealistic philosophy in a decisive adherence to independent positions. In this context, as Heine makes clear, its enlightened approach must be radicalised: with a view to a deeper, Spinozist empiricism and with a view to a concept of the social that does not exclude "industry" from (always bourgeois) society.

With regard to Saint-Simon, these strands can be combined. The author of the *Catechism of Industrialists* provides Heine with a strategic reference point at which the orientation of "identity philosophy" merges with the concept of the social as the subject of a popular philosophy. "In the last century the most abstract questions were dealt with in order to make them understandable to *all*, to submit them to the judgement of *all*. This approach was very suited to bringing about a revolution" (Saint-Simon, 1977a, 99 (own translation)). Saint-Simon coined the term industrialists, who took a "rival attitude" towards all non-industrial classes: nobles and bourgeois.[11] "Put briefly, the industrial class makes up 24/25 of the nation. [...] no power can withstand it." (Saint-Simon, 1977a, 355, 376.) Heine adds: "Already here on Earth, through the blessings of *free political and industrial institutions*, I want to establish that bliss which, according to the pious, is to take place only on the day of judgement, in heaven" (Heine, 2007a, 17).[12]

III

Heine outlines a post-idealistic popular philosophy that understands the Enlightenment not as a bourgeois, but as a revolutionary enterprise of industry, i.e. of active social forces. It adopts the popular ethos of comprehensibility and the democratic public sphere, drawing on a philosophy that relates the absolute to the social and the pure spirit to a practice of transient and sensual life. With the focus on the social, however,

the popular body simultaneously disappears as a popular addressee. Heine speaks of the "people's spectre".[13] This manner of speaking expresses a scepticism that is directed equally at bourgeois self-confidence *and* proletarian class consciousness.

On the one hand, with Saint-Simon he criticises the exclusion of the majority of the population who are not really represented (and therefore quasi minoritarian). Kant provides a good example of such an exclusion mechanism in *Anthropology* in the section on national character. He defines the concept of the people (*populus*) territorially and relates it to the nation (*gens*). Nation means: "This multitude, or the part of it that recognizes itself as united into a civil whole by its common origin" (Kant, 1974 [1798], 174). Excluded from the nation is the rabble (*vulgus*), as "the unruly crowd within this people." (Kant, 1974 [1798], 311.)[14] A people—as a territorial unit—comprises one (or a part, or several) nation(s) in the sense of a state unit *and* the mob, which as a rabble is exempt from the laws of a bourgeois society. The vulgar crowd (or the plebeians) is part of a people, but not really part of a bourgeois whole.[15] It is not represented in the character of the people in the same way as the national people.

However, the exclusion mechanisms associated with political representation are not the only problem. They are regularly associated with a strategy of modelling a subject of history that, as a body of people, follows the voice of its "organic intellectuals". The popular is strategically constructed as a general interest to experience the social and political developments associated with liberation from heteronomy (oppression, etc.). Here it is all too easy to make use of knowledge or a higher level of insight and assert it as control or management competence. Democratic popularisation is threatened by the control modalities of such techniques of representation. Because it depends on whether the crowd of players themselves or only their (self-appointed) spokesmen come up for discussion.

Heine also describes the people as "clumsily sovereign", inasmuch as they repeatedly fall for political (religious, cultural) offers of identity. "Oh the people, this poor king in rags, has found flatterers who, far more shameless than the courtiers of Byzantium and Versailles, beat their incense burner on its head" (Heine, 1981, 42f.). Seduction and power explain the ambivalent position of a population that has no natural identity with itself.

> The poor common people are *not* beautiful. They are on the contrary quite ugly. But this ugliness comes from dirt [...]. The people, whose goodness has been so highly praised, are not good at all [...]. But their malice is due to hunger. [...] Their Majesty the people is likewise not very intelligent. [...] The reason for this perversity is ignorance.
>
> (Heine, 1981, 42f.)

And therefore Heine demands public, free schools and bread and butter for the breaks.

In any case, the path of democratic popularisation is not one that would be easy and quick to follow. Rather, in the 19th century it seems largely hopeless to popularise the idea of popularity in a radically democratic understanding. Terms such as "popular materialism", "popular Darwinism" again function in such a way that a given content, in the cases mentioned scientific findings, is made comprehensible to a bourgeois audience.[16] The peculiar (quasi-popular) translation achievement of

these texts remains hidden. After all, the development of science (and technology) is transformed into what is ideologically relevant and linked with a belief in progress. Metaphysics and religion fall behind—but *science* is seen as an authority that comes into its own and makes the mechanisms of blinding the uneducated crowd transparent. Science in the singular reflects its theoretically filtered unity in its typically popular scientific self-image of having a monopoly of interpretation in ideological questions. According to Ludwig Büchner (1932, 3), the natural sciences answer all the somehow relevant philosophical questions in the bundled form of a "natural philosophy".[17] However, the fact that in asserting its sovereignty of interpretation it abstracts from the manifold practical research references of scientific activity—and for example speaks of *one* reality, truth and knowledge—seems to it to be a harmless generalisation without consequences (Feyerabend, 1984, 36f.).[18] Yet, according to a formulation by Ernst Mach (1919, ix), the "pseudo-scientific tendencies in science", which should be addressed as dogmatic phenomena, lie precisely in this step of abstraction.

Only with the emergence of the concept of popular culture does the idea of the popular in the sense of Heine seem to be truly renewed. This is at least true when this term makes possible a differentiated cultural revaluation with socio-political relevance of mass phenomena or everyday practice, which is radically opposed to the cultural pessimism of the turn of the century (from mass psychology to the decline of the West). This distinction is not always easy to make, since the people (and the folk) can also be invoked as a primal cultural unity, which as such does not have its own political voice. In fact, the genesis of popular cultures is complex and multilayered—and their philosophical significance is enormous. It ranges from an accentuation of pragmatic and life-world dimensions at the end of the 19th century to the new relevance of ethnographic methods (e.g. field research after Malinowski) and the renewal of philosophy with Wittgenstein in the name of everyday language and its language games. The mass politics of fascist regimes, which is characterised not least by an authoritarian, population-political agenda and "the negation of the revolutionary effervescence that he [the leader] taps," (Bataille, 1979, 81) falls between the culturally pessimistic diagnosis of the crisis at the turn of the century and the slow development of democratic consciousness.

The talk about "postmodern" conditions introduced by sociologists and literary scholars in the US reflects the fundamental rebalancing of "mass culture" since the 1950s (Lyotard, 1994, 13). It is accompanied by various efforts to address and counteract the idealistic distortions of modernity—in feminist discourse, in differential thinking and in postcolonial cultural theory, in the revaluation of techniques, media, practices, things and much more. The political implications in the discourses as well as in the social movements are by no means clear, the social question associated with them is not directly and self-evidently popular. Pop alternates between Dada and commerce, subversive element and cultural industry, mainstream of minorities and the art of becoming a minoritarian (Holert and Terkessidis, 1996). One way to take up the popular in philosophy again is to distinguish what is democratic at the core of knowledge production and social practice, in the midst of theoretical and practical questions.

With Deleuze and Guattari as exemplary representatives of a philosophy inspired by popular cultures, one could at this point speak of a people that is missing. It would be a people without a fixed (cultural) identity, which is in the process of

"becoming different".[19] Perhaps it would be better to speak of a wild crowd, collective associations or multiplicities that do not unite into a subject figure. They cannot be represented organically. Under no circumstances can they be determined in an identity-related way. The claim to be a "people" always hides a technique of representation that has to prove itself against the democratic spirit that is effective in it. Jan-Werner Müller (2016, 44, 46) rightly pointed out that right-wing European populism always acts "anti-pluralistically", provided that the populist politician acts as the direct "mouthpiece" of a homogeneous people that is apparently deceived by a "corrupt and parasitic elite" through calculated foreign influences on its (unchanging) identity. Democrats, on the other hand, must "accept that the people as such can never be fully grasped", inasmuch as the will of the people is never communicated *a priori*, but always only *a posteriori* (Müller 2016, 60, 62).[20]

Becoming democratic according to Deleuze and Guattari always means a process that can be determined just as well as becoming minoritarian (Deleuze and Guattari, 1996, 130–131). The popular-philosophical authority of the people is transformed into a figuration of the minor, as long as precisely not everybody acts as its representative. When classical philosophers speak of reason as the best distributed thing in the world, Deleuze and Guattari have nothing but scorn. And not for reasons of elitist arrogance. Quite the contrary. From their point of view, the postulate of common sense establishes a dogmatic image of thinking that must exclude the inability to think—and thus all minority areas that are not part of the representation of an identity. At this point, Humean scepticism as well as Kantian criticism of certain rooted, metaphysical truths of belief are continued. And yet it is not about playing off elitist critical philosophical knowledge against the popular opinions of the misled masses. Rather, the power structures of knowledge itself contain a democratically unsustainable hierarchical position that cannot address its own conditions of development. It may therefore be true that the "subalterns" cannot speak if they are not represented in the discourse. And yet it must be about not letting oneself be represented, but finding one's own way to speak—in becoming minoritarian, to the extent that the power of representation in this becoming is broken, for example, by self-constructions of feminist science fiction according to Donna Haraway. Learn to speak, i.e. find the spaces in which speaking can become effective. Not to be patronised by speakers who speak on behalf of the "subjugated"—or who believe they are authorised to speak on behalf of X. In my view, the point of the dialogue between Foucault and Deleuze on intellectuals and power lies in a democratic repositioning of ever-situated knowledge, ever-situated language.[21] It is connected to a popular thinking that develops out of the density of heterogeneous diversity of social processes not represented in the network of stable identities.

Notes

1 With this in mind Kant closes his preface with the quotation from Virgil "They protect the hives from drones, an idle bunch." (Kant, 2014 [1783], 14).
2 "Philosophy is by its nature something esoteric, neither made for the mob nor capable of being prepared for the mob." (Hegel 1802).
3 Compare here and in the following, Rölli and Trzaskalik (2007).
4 "But why did Kant write his *Critique of Pure Reason* in such a colourless, dry, packing-paper style? [...] He wished haughtily to separate himself from the popular philosophers

of his time, who aimed at the most citizen-like clearness, and so clothed his thoughts in a courtly and frigid official dialect" (Heine, 2007a [1834],110).

5 "We shall, however, keep constantly in view those elements of philosophy to which we attach a social significance" (Heine, 2007a [1834], 59). "What we cannot know has no value to us, at least no value from a social point of view where it is a question of realising in sensible fact what the intellect perceives" (Heine, 2007a [1834], 72–73).

6 "I am here touching upon the comical aspect of our philosophers, who are perpetually lamenting that they are misunderstood. When Hegel was lying on his deathbed, he said: 'Only one man understood me,' but shortly afterwards he added fretfully: 'And even he did not understand me.'" (Heine, 2007a [1834], 92. See also Heine (1981).

7 See Löwith (1962), Krüger (1977), 111f.; Lukácz (1967), 501f. See also the differentiated presentation by Grab (1992, 40–42) and Höhn (1991).

8 See also Heine's remarks on the title of his text *Ideen: Das Buch Le Grand* (1826), *Düsseldorfer Heine Ausgabe* 6, 169–222, here 204f. "As I said, Madame, the ideas we are talking about here are as far removed from the Platonic as Athens is from Göttingen", Heine, 1979, 206 (own translation).

9 If this already applies to European communism, the mistrust in the face of the liberal freedom movements in pre-March 1848 period grows all the more. Heine is deeply opposed to the nationalistic reactions of the German *Burschenschaften* student fraternities (to the French supremacy) with their latent to manifest anti-Semitism. At the Wartburgfest (1817) not only is the history of the German Empire of Kotzebue burned, but also Saul Ascher's *Germanomania*. Addressing the Emperor (Frederick I) in *Germany: A Winter's Tale*, Heine (2007b, 69) exclaims: "Thy standard, too, no more I respect;/My love for the black-red-golden/Has been quenched by the fools of the Burschenschaft/With their rage for the so-call'd olden."

10 "And so popularity, in the real sense, is nothing other than the necessary and, without any intent, the spirit of movement and progress in all scientific and artistic *effectiveness*," (Müller, 1961 [1808], 53). At this point it would be possible to bridge the gap between revolution and democracy, provided the revolutionary movement can only take place in democracy—and only in the democratic process is there a truly revolutionary element.

11 "The bourgeois, who made the Revolution [1789; seq.] and directed it in their interest, removed the exclusive prerogative of the nobles to plunder public property and gained access to the ruling class, so that today the industrialists have to pay for nobles and bourgeois." (Saint-Simon, 1977a [1823], 345–346 (own translation)).

12 It cannot be overlooked here that Heine makes a clearly selective use of Saint-Simon. What matters to him is the concept of industry (in the broad sense of a political-economic structural minority), which does not, however, merge into an antagonistically structured philosophy of history (not even with regard to a positive, scientific and post-metaphysical stage of history)—and certainly not into a general praise of free enterprise.

13 On this shadow existence with a view to Heine, see Bodenheimer (2002, 29f.).

14 Basically, a tripartite division is made, which compares two variants of rabble with the fully fledged citizens: firstly—analogous to the term "passive citizen"—the rabble that submits to bourgeois laws, then the rabble (*qua* criminal) that evades these laws and thus acts criminally. Kant speaks of the "unlawful unification" of the "hordes", i.e. to gather in groups, in a manner contrary to the civic institutions. It is not surprising that Kant becomes aware of the plebeian in the French character trait: "The other side of the coin is [...] an infectious spirit of freedom which draws reason into its play and, in the relations of the people to the state produces an enthusiasm that shakes everything and goes beyond all bounds." (Kant, 1974 [1798], 176). On the infectiousness of enlightenment, see Hegel, 1979 [1807], 329f.

15 On this consideration from a Foucaultian perspective see M. Muhle in Rölli and Nigro (2017, 95f.).

16 Cf. the two collections by Bayertz, et al. eds. (2017).

17 Ernst Haeckel (Bonn, 1899) argues likewise.

18 The criticism of the theory of science that is far removed from practice and its exclusive concept of reality is prominently presented today by Bruno Latour. Following

Feyerabend's *Against Method*, the criticism could also be applied to the current primacy of the method in academic philosophy!

19 The relevant references for becoming minoritarian are Deleuze and Guattari (1976, 24f. and 1992, 317f.).

20 Müller refers to Pierre Rosanvallon's expression "peuple-événement", which describes an event that the masses can produce on the street, but which never expresses the "will of the people" one to one.

21 "In the most recent upheaval, the intellectual discovered that the masses no longer need him to gain knowledge: they *know* perfectly well, without illusion; they know better than he" (Foucault, 1980, 207). There is a critique of this representation critique in Spivak (2008). Considerations on a theory of situated knowledges can be found in Haraway (1988).

References

Bataille, G., 1979. The Psychological Structure of Fascism. *New German Critique*, 16, 64–87.

Bayertz, K. et al., eds., 2017. *Der Materialismus-Streit*. Hamburg: Felix Meiner Verlag.

Beattie, J., 1770. *An Essay on the Nature and Immutability of Truth*. London: A. Kincaid & J. Bell.

Binkelmann, C. and Schneidereit, N., 2015. Introduction. *In*: C. Binkelmann and N. Schneidereit eds., *Denken fürs Volk: Popularphilosophie vor und nach Kant*. Würzburg: Königshausen & Neumann, iii–xix.

Bodenheimer, A., 2002. *Wandernde Schatten: Ahasver, Moses und die Authentizität der jüdischen Moderne*. Göttingen: Wallstein.

Büchner, L., 1932. *Kraft and Stoff*. New printing of the first edition, ed. by W. Bölsche. Leipzig: Kröner Verlag.

Deleuze, G. and Guattari, F., 1976. *Für eine kleine Literatur*. Frankfurt am Main: Suhrkamp.

Deleuze, G. and Guattari, F., 1992. *Tausend Plateaus*. Berlin: Merve.

Deleuze, G. and Guattari, F., 1996. *Was ist Philosophie?* Frankfurt am Main: Suhrkamp.

Emundts, D., ed., 2000. *Immanuel Kant und die Berliner Aufklärung*. Wiesbaden: Reichert.

Feyerabend, P., 1984. *Wissenschaft als Kunst*. Frankfurt am Main: Suhrkamp.

Foucault, M., 1980. Intellectuals and Power. *In*: M. Foucault, ed., *Language, Counter-Memory, Practice*. Ithaca, New York: Cornell University Press, 205–217.

Foucault, M., 1997. What is Critique? *In*: S. Lotringer and L. Hochroth, eds., *The Politics of Truth*. New York: Semiotext(e), 58–61.

Grab, W., 1992. *Heinrich Heine als politischer Dichter*. Frankfurt am Main: Büchergilde Gutenberg.

Haeckel, E., 1899. *Die Welträthsel: Gemeinverständliche Studien über Monistische Philosophie*. Bonn: Emil Strauß.

Haraway, D., 1988. Situated Knowledges: The Science Question in Feminism and the Privilege of Partial Perspective. *Feminist Studies*, 14 (3), 575–599.

Hegel, G., 1802. On the Nature of Philosophical Criticism in General and Its Relation to the Present Condition of Philosophy in Particular, Introduction. *Critical Journal of Philosophy*, III–XXIV.

Hegel, G., 1979 [1807]. *Phenomenology of Spirit*. Oxford: Oxford University Press.

Heine, H., 1848. Februarrevolution: Artikel für die Augsburger "Allgemeine Zeitung", Paris, 3 March 1848. *In*: H. Poschmann, ed., 1989. *Heine: Ausgewählte Gedichte und Prosa*. Berlin: Verlag Neues Leben, 754–758.

Heine, H., 1979. Fragmente 1844, Briefe über Deutschland. *In*: H. Heine, ed., *Heinrich Heine Säkularausgabe* vol. 10. Berlin and Paris: Akademie-Verlag, 1169–1181.

Heine, H., 1981. *Confessions*. Malibu, California: Joseph Simon.

Heine, H., 2007a [1834]. *On the History of Religion and Philosophy in Germany*. Cambridge: Cambridge University Press.

Heine, H., 2007b [1887]. *Germany: A Winter's Tale*, trans. A. E. Bowring. New York: Mondial.

Höhn, G., ed., 1991. *Heinrich Heine: Ästhetisch-politische Profile*. Frankfurt am Main: Suhrkamp.

Holert, T. and Terkessidis, M., eds., 1996. *Mainstream der Minderheiten: Pop in der Kontrollgesellschaft*. Berlin: Edition ID-Archiv.

Holzhey, H., 1977. Der Philosoph für die Welt—Eine Chimäre der deutschen Aufklärung? *In*: H. Holzhey and W. C. Zimmerli, eds., *Esoterik und Exoterik der Philosophie*. Basel and Stuttgart: Schwabe, 117–138.

Kant, I., 1974 [1798]. *Anthropology from a Pragmatic Point of View*. The Hague: Martinus Nihjoff.

Kant, I., 1988. *Logic*. New York: Dover Publications.

Kant, I., 1991a [1781, 1787]. *The Critique of Pure Reason*. Cambridge: Cambridge University Press.

Kant, I., 1991b [1784]. *An Answer to the Question: What is Enlightenment?* London: Penguin Books.

Kant, I., 1999. *Immanuel Kant: Correspondence*. Cambridge: Cambridge University Press.

Kant, I, 2014 [1783]. *Prolegomena to Any Future Metaphysics That Will Be Able to Come Forward as Science*. Cambridge: Cambridge University Press.

Krüger, E., 1977. *Heine und Hegel*. Kronberg (Ts.): Scriptor.

Löwith, K., ed., 1962. *Die Hegelsche Linke*. Stuttgart: Friedrich Frommann Press.

Lukácz, G., 1967. *Schriften zur Ideologie und Politik*. Neuwied and Berlin: Luchterhand.

Lyotard, J. F., 1994. *Das Postmoderne Wissen: Ein Bericht*. Vienna: Passagen Verlag.

Mach, E., 1919. *The Science of Mechanics: A Critical and Historical Account of its Development*. Chicago and London: Open Court Publishing.

Muhle, M., 2017. "Il y a de la plèbe": Das Infame zwischen Disziplinen und Biopolitik. *In*: M. Rölli and R. Nigro, eds., *40 Jahre Überwachen und Strafen: Zur Aktualität der Foucaultschen Machtanalyse*. Bielefeld: Transcript Verlag, 95–109.

Müller, A., 1961 [1808]. Popularität und Mysticismus. *In*: H. V. Kleist and A. Müller, eds., *Phöbus: Ein Journal für die Kunst, Neu Kommentiert von H. Sembdner*. Stuttgart: Wissenschaftliche Buchgesellschaft, 52–53.

Müller, J. W., 2016. *Was ist Populismus? Ein Essay*. Berlin: Suhrkamp.

Reid, T., 1764. *Inquiry into the Human Mind on the Principles of Common Sense*. London: A. Millar and Edinburgh: A. Kincaid & J. Bell.

Rölli, M. and Trzaskalik, T., eds., 2007. *Heinrich Heine und die Philosophie: Vier Beiträge zur Popularität des Denkens*. Vienna: Turia + Kant.

Saint-Simon, C. H., 1977a [1823]. Katechismus der Industriellen. *In*: L. Zahn, ed., *Ausgewählte Schriften*. Berlin: Akademie-Verlag, 344–380.

Saint-Simon, C. H., 1977b [1813]. Abhandlung über die Wissenschaft vom Menschen. *In*: L. Zahn, ed., *Ausgewählte Schriften*. Berlin: Akademie-Verlag, 96–132.

Spivak, G., 2008. *Can the Subaltern speak? Postkolonialität und Subalterne Artikulation*. Vienna: Turia + Kant.

2 From Marianne to Louise

Three Ways of Representing the (European) People in Democratic Societies

Wim Weymans

Democracies are by definition forms of society in which the people are deemed sovereign. Yet, unlike other forms of society, democracies have a hard time imagining what its sovereign—the people—looks like. In this chapter I will try to examine how democracies in their relatively short history have tried to represent the people (in the sense of visualising or creating an image of). Inspired by work by Rosanvallon and others, I will schematically differentiate between three ways of representing the people that were subsequently developed: the people as an abstraction (represented by symbols like a flag), a pluralist vision of the people (through institutions such as political parties) and, lastly, a "poetic" representation of the people (through stories). Although the use of these three modes of representation has varied over time, I believe that, if combined, they all still remain relevant today. This becomes clear when applied to attempts to represent the people at a European level.

A Democratic Revolution

To understand the democratic revolution that has taken place in Western societies over the past centuries we need to contrast it with the pre-democratic societies it replaced. These pre-democratic societies still inferred their shape and structure from a natural or supernatural foundation that gave everyone their stable place in a hierarchical society. Yet, as a result of religious wars for example, the idea of a shared substantial foundation, that legitimised social inequalities, gradually lost its appeal. Once there is no longer a legitimate substantial reason to treat someone in an unequal way, then everyone, in principle, becomes formally equal, as the modern idea of equal rights shows. Whereas pre-democratic societies were still structured on the basis of factual differences in gender, profession, family or place of origin, democratic societies deliberately abstract from such differences, seeing individuals instead as formally equal. As Rosanvallon writes, "abstraction is in this sense a condition of social integration in a world of individuals [...] whereas in traditional society concrete differences were a factor of insertion" (2006, 42). Even when factual income and power inequalities do live on in democratic societies, they now arguably lack the legitimacy they used to have in premodern societies. This is why persisting income inequalities are now rarely seen as legitimate.

Furthermore, unlike their premodern counterparts, democratic societies no longer attribute sovereignty to a special caste or group that rules in the name of God, but instead they assume that sovereignty lies in the people or the nation. The people are now seen as a collection of free and equal individuals who express their will

and shape society through elections, which became the main way of distributing legitimate power. Today the prestige of elections is such that even most non-democratic regimes at least pretend that their legitimacy derives from elections, which is why they try to hide the fact that they are often rigged.

It is important to note that modern democratic societies are still held together by a shared reference to general principles such as "the people" or "the common good"; but unlike pre-democratic societies, democratic societies can no longer attribute a substantive content to these abstract entities. As a result, modern societies stop experiencing themselves as a substantive body and instead see themselves as an individualised "disincorporated" whole. As Lefort writes, "democracy inaugurates the experience of an ungraspable, uncontrollable society in which the people will be said to be sovereign, of course, but whose identity will constantly be open to question, whose identity will remain latent" (1986, 303–304). In other words, what "the people" wants remains subject to debate. The same is true for equality. Whereas everyone is deemed formally equal, the exact nature of this equality likewise remains indeterminate. As Rosanvallon puts it: "Equality? Very well, but what equality? And what, in fact is equality? 'Equal pay' or the 'reduction' of inequalities? A 'just' distribution of the fruits of growth? Fine, but how does one define 'justice' in this case?" (1988, 212). As a society's new abstract guiding principles—popular sovereignty or formal equality—thus become subject to political debate, its form and identity now also become open-ended, thus creating a lack of social form.

Democracy's abstract and formal foundations indeed come at a price. As Rosanvallon explains, "if in democracy [...] formalism is [...] a positive principle of social construction, it makes the constitution of a tangible people more uncertain at the same time" (2006, 42–43). Whereas guiding principles not only guarantee equality and sovereignty but also conflict—different people mean different things by sovereignty, the common good or equality—they also imply a lack of collective will or form. Although no one doubts that sovereignty in democratic societies legally lies in the people, nobody knows for sure what the people exactly wants or looks like. Whereas premodern societies still expressed their "natural" form in their divine or royal representatives, modern democratic societies lack such a "natural" visibility. As Rosanvallon puts it: "the transition from a corporatist to an individualist society makes society less representable. For how to give a form [...] to an agglomeration of individuals?" (2006, 85). The new sovereign—the people—is thus as powerful as it is indeterminate.

The expression of popular sovereignty through elections illustrates this problem. On the one hand, universal suffrage shows that people are now seen as equal, despite factual differences. "One man, one vote", the slogan goes, and this ideal of formal equality, independent of actual differences, is why someone who does not follow politics still has the same vote as a political science professor. Elections thus show that sovereignty lies in the people as a unified fiction of equals—despite all the factual differences. Yet, on the other hand, elections are also an illustration of the fact that modern equality and sovereignty fail to generate a clear will or form. Through elections the people's voice is indeed expressed in a wide range of numbers, parties and candidates, which is why election results often require an at times complex negotiation process in order to make sense of "the will of the voter". This is why Lefort writes that "universal suffrage [...] breaks down unity" and even "destroys identity" (1986, 303). What the people gain in sovereignty and equality

in modern democratic societies, they lose in sociological certainty over their form (on all this see Rosanvallon 1998, 9–18).

Abstractions and Their Limits

To what extent can a democratic society based on abstract principles be represented by abstract symbols? And if so, what does such a representation look like? To answer these questions the debates and practices following the French Revolution are very helpful. At the time it was mistakenly believed that a society actually coincides with its abstract founding principles. Once the juridical idea of a unified sovereign people composed of equals is said to coincide with reality, there is hardly any room left for conflict, divisions and differences. Given that these revolutionaries thus radically rejected conflict and pluralism, they had to look for ways to represent the people devoid of conflict, particular attachments or plurality. So what did they come up with?

Initially, the people still appeared as a seemingly unified historical "actor, whether in the tumult of the street or in the good behaviour of patriotic festivals" (Rosanvallon 2006, 92). As time went on, French revolutionaries also represented the allegedly unified people and its values, such as liberty, by using abstract symbols or emblems depicting figures such as Marianne, "the feminine civic allegory" wearing the liberty cap (Hunt 1986, 92–93) (Figure 2.1). Other ideas to represent a people included an assembly of the people "deployed in the form of a circle, 'to represent eternal

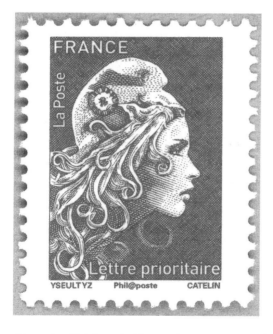

Figure 2.1 Marianne as France's official symbol has undergone many stylistic updates. Here she is pictured as *Marianne l'Engagée* by Yseult Digan and engraved by Elsa Catelin for a French stamp, 2018. Copyright: La Poste, Paris, Yseult YZ Digan and Bildrecht Vienna, 2019.

equality'" without any "stage or platform" leaving "only a simple stone in the center of the circle to signify that the place of power was empty" (Rosanvallon 2007, 40).

Likewise, parliamentary architecture of those days preferred the horseshoe or the hemicycle rather than a rectangular chamber, because the latter "seemed to lend itself more easily to divisions" as was the case in the British House of Commons (Rosanvallon 2007, 42–43). Attempts to "illustrate and celebrate the appearance of the people as the central actor of history" on stage did not prove easy, because: "though everyone on stage [...] refers to the people, the people never appears. [...] The people is simply an abstract and collective character, deprived of life and of theatrical plausibility" (Rosanvallon 2006, 81). Rosanvallon observes that:

> as the Revolution progressed [...] the abstraction of representations of the people continuously grew. In the end it was evoked only symbolically or allegorically: in the strength of a Hercules with his uplifted club, the haughty presence of the inquisitorial eye [...]. An obscure principle from which everything nevertheless derived, it ultimately became unrepresentable [...]. It is thus available simply as a word [...] the silent evocation of an impenetrable mystery.
>
> (2006, 79–80)

Similarly, citizenship was seen in abstract terms. Being part of a larger whole as an equal citizen meant giving up one's concrete flesh-and-blood identity, which involves particular values and attachments. This also explains why, back then, for example differences in gender were not acknowledged. As Rosanvallon writes, the "gendered condition of men and women could not be recognized in the public sphere, for to do so would have been to concede that the public sphere did not transcend all differences" (2007, 31). The only legitimate identity of the individual was that of an abstract citizen, equal to others.

The French revolutionary experiment is still instructive today. Firstly, because their main mistake—their undemocratic belief that the abstract notion of a unified nation actually exists—is still made today. Like their revolutionary predecessors, today's populist parties likewise pretend that the unified immediate voice of the people actually exists. Except that this time the people is not embodied by impersonal abstract emblems but by strong leaders. In either case the juridical notion of the sovereign people as a unity is said to coincide with society, which means that conflict and differences are seen as illegitimate. Moreover, both oppose the undistorted immediate voice of the "unified" people to the alleged distortion of this voice by "traditional parties". Either way, representation, mediation and conflict are rejected in the name of a seemingly immediate and unified will of the people.

Secondly, with hindsight we now know that, unlike what the revolutionaries believed and populists still believe, abstractions can be highly compatible with diversity, as long as these abstractions are not said to coincide with reality. Provided they merely guide social reality—without coinciding with it—they are very useful tools to represent the people's unity while inviting conflict rather than suppressing it. Abstractions, after all, have a unifying force that at the same time *enables* political and social conflict. To this day all nations still use abstract symbols and representations of unity such as a flag or an anthem and invoke a set of abstract values. Precisely because these symbols remain abstract, many different groups and ideologies can identify with them. If an emblem like Marianne has endured as a symbol of France

to this day (Figure 2.1), it is probably "thanks to her abstraction and impersonality" (Hunt 1986, 93).

Given its highly diverse and complex nature, the European Union is especially fond of stressing unity by using abstract symbols that avoid particular national features. It was quite telling that on the banknotes of its currency, the euro, "national appropriation was feared", which is why there are not only no human faces but not even existing buildings, as they were seen as "having too many national connotations". Eventually, "every possibility of historical identification was eliminated", which is why we ended up with the euro notes as we know them today, showing imaginary bridges and windows abstracted from real buildings (Van Middelaar 2013, 238–244). Like nation-states, Europe gave itself an image and identity through a flag or an anthem or by invoking abstract values such as peace and human rights. Interestingly, like Marianne, Europe too is sometimes depicted as a somewhat vulnerable woman dressed in a blue dress with yellow stars (think of Peter Schrank's drawings for the *Economist's* weekly Charlemagne column, Figure 2.2).

In a similar vein, and like its revolutionary predecessors, Europe also likes to appeal to a transnational identity that often implies physically transcending one's national borders. Think of the Erasmus or Marie Curie programmes, which require students or researchers to move to a different country, as if one can only be a good European once one leaves one's existing particular national identity behind (see Weymans 2009, 572–573). To be truly European, a citizen apparently needs to be transnational. Yet such concept of transnational citizenship limits its appeal to the few who actually do regularly change countries, excluding the average citizen.

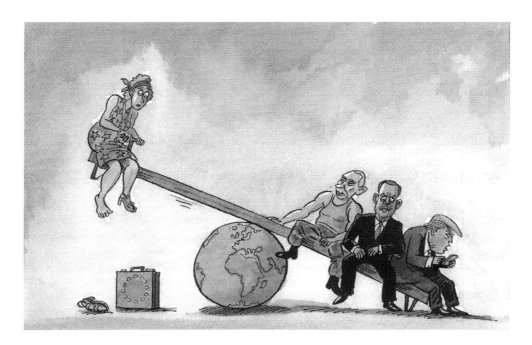

Figure 2.2 Europe embodied as a woman. Copyright: Peter Schrank, 2017.

Likewise, Europe's protection of rights and freedoms of those who travel or work in other European countries is "good news for cosmopolitan elites or for those with nothing to lose, but is not experienced as beneficial by a majority of the public" (Van Middelaar 2013, 260). As the French experiment showed, the idea of citizenship that abstracts from particular identities indeed has its drawbacks.

Provided they are not confused with the diverse social reality they represent, abstractions such as a flag, emblem, banknote or an anthem can be highly useful to represent unity while guaranteeing a pluralistic society. Yet, although abstractions *enable* diversity, they have a hard time *representing* it. Abstract symbols, after all, *abstract from* diversity, which is why they have difficulty representing that very diversity. These limitations had already become clear during the French Revolution, which is why alternatives were called for.

Political Parties and Pluralist Representation

If abstract representations in themselves cannot represent social diversity, how then can diverse societies be represented in a democratic era? Given that the destruction of old intermediary bodies was said to partly cause society's lack of form and visibility, it was hardly surprising that "numerous voices called for restoring or reinventing intermediary bodies to overcome the difficulties caused by the crumbling of the social bond" (Rosanvallon 2007, 7). New mediating institutions and practices that help democratic societies to compensate for their lack of social order include unions, political parties, associations or an independent bureaucracy. Such institutions add a pluralistic representation of the people to a purely abstract representation of the people. In this pluralistic vision people are not only recognised as abstract citizens, but also as people with particular attachments, as members of a specific class, gender, group or region.

For example, one remedy to the dissolution of society was "to *constitute* a population of isolated workers *as a class*" (Rosanvallon 2007, 105). But the most striking example of a new artificial group that shapes society while respecting its pluralism is probably the modern political party. Seen from a broader perspective, political parties not only play a political but also a social role, as they offer an innovative way to meet a social challenge and represent the people. They can be seen as part of a "movement that compensates for the loss of substance of the old intermediary bodies [*corps*]" and even change the way in which "society could be thought and represented" (Rosanvallon 1996, 452, 1998, 175, my translation).

But how, then, are political parties able to compensate for the loss of traditional corporations and stable social identities? The answer is simple: by creating new political and cultural identities. It is precisely in their "original function related to identity (*fonction identitaire inédit*)" that their originality arguably lies (Rosanvallon 1998, 181, my translation). But why do individuals still need collective and political identities, even in an individualised era, and how do political parties provide it? One answer to these questions lies in the fragility of an individual's identity, which explains why "security and stability are sought in collective identity: the individual can only, in fact, perceive himself as the same over time if other individuals perceive him thus. Uncertainty disappears when it is shared" (Pizzorno 1990, 327). Pizzorno further explains:

if we fear that the value of our person (the significance of our identity) is not recognized [...] we will minimize uncertainty by identifying with a collectivity of reference in order to find a stable source of recognition which is itself indifferent to failures, setbacks and individual defeats.

(1990, 321)

Political parties provide such a collective identity by producing "symbols which allow the members of a collectivity to recognize themselves as such, to communicate their solidarity with each other, and to agree on proposed collective actions" (Pizzorno 1990, 322). In political science the party identification that may result from this is often called party ID. By this, political scientists mean "an individual voter's avowed affiliation with a political party" (Rosenblum 2008, 323). "[These] partisans know that there is a 'we' out there. They vote with allies, not as sole individuals. Partisanship is about who 'we' are" (Rosenblum 2008, 342). The practice of voting then appears in a different light. Voting is not just a tool to express one's voice, but also a way for an individual to pledge allegiance to the group. As Pizzorno explains: "by going to vote, one is bearing witness to membership of a certain collectivity. [...] The individual will add his vote in order to demonstrate the existence and the strength of his group" (Pizzorno 1990, 316). This collective identification in an era of individualisation probably also explains why many party sympathisers still remain loyal to their party even when they "actively disagree with elements of their own party's platform and prefer one or another position taken by the opposition" (Rosenblum 2008, 357).

But how is this any different from traditional religious or interest groups? Three differences stand out. Firstly, political parties are much more compatible with modern individualism than premodern intermediary bodies. A political party admittedly still embodies a collectivity that precedes and transcends its members and voters and thus operates in a way which is similar to traditional intermediary corporations or bodies. As we have seen, voting and becoming a party member is indeed more than just expressing given individual interests. It also offers individuals a community they can identify with and "cultural reference points". Political parties thus prevent individual preferences from becoming too dispersed. Yet, unlike traditional given collective entities (social, religious, territorial), an individual *chooses* his or her party—as a voter or a member—in a radically individualistic way, expressed in the secret ballot and guided in part by one's changeable opinion, not just by natural stable interests. One is not born into a political party the way one is born into a certain class, church or region. In this way, a political party breaks with the rigidity of the old corporations, which expressed seemingly naturally given identities.

Secondly, not just the individual but also the party itself plays a creative role. Pizzorno admits that there may be "a partial correspondence between a community of interests or a religious community and a political party" (1990, 325). But he then goes on to explain that

a political party, in its discourse and, above all, in the decisions it takes, does not confine itself to the defense of these interests. Collective political identity [...] does not simply bring together pre-existing social interests, but also sorts them, adds to them, invents them, and, if necessary, neglects or suffocates them.

(Pizzorno 1990, 325)

Seen from this perspective "parties create, not just reflect, political interests and opinions. They formulate 'issues' and give them political relevance. Party antagonism 'stages the battle'; parties create a system of conflict and draw the lines of division" (Rosenblum 2008, 7). In modern societies the nature of diversity thus changes as "it can no longer be grasped as a given [*un donné*], inscribed in a stable way into the social" as was still the case in traditional social intermediary bodies (Rosanvallon 1998, 184, my translation). Instead, this diversity is now in part *created*.

Political parties are thus able to create new social identities that are based on *both* identification and choice. By reconciling the idea of modern individualistic choice with an older need to belong and be part of a larger community, the modern political party avoids two extremes: either a fragmentation of an individualised society that becomes unrepresentable (*infigurable*) or else the vain dream of a return to rigid traditional corporations (Rosanvallon 1998, 182–184).

There remains a third difference between parties and other interest-groups. Political parties may not only be seen as more creative than traditional intermediary bodies, but also the identities which they create naturally differ from those created by other intermediary actors. Unlike trade unions or employers' associations, which are supposed to defend the particular interests of their members, political parties in part transcend particular interests. Parties after all have to convince as many voters as possible. In so doing, parties create new political identities that reach out to individuals who no longer feel part of a natural group, class or religion. Traditional political parties are therefore typically not radical or exclusive as they, in principle, try to appeal to everyone, not just one class or particular social or religious group. They do this by transcending particular positions and by offering some more general narrative with which they can gain support from new voters. Rather than merely representing particular views, thus potentially destroying social unity, they can now be seen as "an adequate means to express totality" (Rosanvallon 1998, 177, my translation). Parties tell "a story of what the nation requires that weaves a constellation of elements in general terms that appeals to citizens in general" (Rosenblum 2008, 360). Through difference and conflict, they somehow allow a society to read itself as different and yet structured and thus also offer some form of unity or identity through difference. Even if a political party offers an inclusive story that tries to appeal to everyone, it still remains partisan as it does not pretend to embody the whole. Party supporters "do not think they could or should speak *for* the whole while still thinking they should speak *to* everyone" (Rosenblum 2008, 365).

Political parties thus combine seemingly mutually exclusive elements: they are the result of personal choice and yet offer a sense of belonging; they serve particular needs and yet tell a narrative that is inclusive and refers to society in its totality (Rosanvallon 1998, 182–184). Political parties are thus an original intermediary actor "between modern individualism and old social forms" (Rosanvallon 1998, 186, my translation). Political parties represent "a new type of intermediary body that in a way sums up and absorbs all those that preceded it" (Rosanvallon 1996, 451, my translation). Parties help "to give form and shape (*figure*) to differences in a society of individuals" (Rosanvallon 1998, 183, my translation) and thus allow individuals to feel at home in a pluralist society. Interestingly, political parties do not require a special virtue on behalf of voters or party officials to perform all these tasks. When party members defend the party's interest they at the same time

unwittingly keep modern democracies alive. As Rosenblum puts it: "parties do a lot of this work [...] even if that is no partisan's noble intention" (2008, 8).

As their impersonal programmes, logos and colours show, parties can technically work independently of strong personalities. In our contemporary mediatised societies, however, parties often depend on charismatic leaders to represent them and give them a face (Figure 2.3). Party leaders who debate each other on TV thus concretely represent the people in their diversity (Figure 2.4). Although party leaders are important, they still depend on the party and its many representatives and members throughout the country. Even populist leaders can only obtain and maintain power thanks to a party that backs them.

If we turn again to today's Europe, one can see how this form of pluralist representation through political parties is practised in for example the European Parliament, where different European political groups are slowly trying to transcend existing national divisions. The current lack of identification with truly European political parties shows how hard it is to leave existing national differences behind. Yet if one looks at the role political parties play at a national level, one can imagine their potential at a European level in offering European individuals new partisan points of identification that partly replace national differences with transnational ideological ones. Recent proposals to have pan-European electoral lists or to have EU-wide *Spitzenkandidaten* in elections may enforce this dynamic, as would initiatives to strengthen the European Parliament. This could be particularly effective if voters can see how leading politicians and heads of state, representing

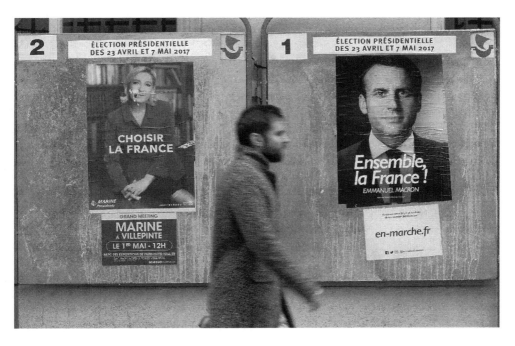

Figure 2.3 New posters of France's presidential candidates Emmanuel Macron and Marine Le Pen are displayed in Paris, 2017. Photo: Chesnot and Getty Images.

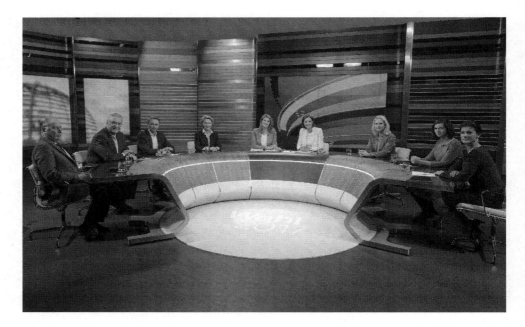

Figure 2.4 The final TV debate (*Die Schlussrunde* (ARD/ZDF)) in Germany's 2017 election: Alexander Gauland (AfD), Joachim Herrmann (CSU), Christian Lindner (FDP), Ursula von der Leyen (CDU), the hosts Tina Hassel and Bettina Schausten, Manuela Schwesig (SPD), Katrin Göring-Eckardt (Bündnis 90/Die Grünen), Sahra Wagenknecht (Die Linke). Archive number: 67257-2-24. Copyright: ZDF and Harry Schnitger. Photo: Harry Schnitger.

various parties (and not just countries), not only disagree with each other on the European stage in often dramatic ways (especially in times of crisis) but also how they are often forced to act in a unified way when facing common threats and crises that risk undermining "Europe" (see Van Middelaar 2013, 302–305). As Van Middelaar writes: "the public […] will become excited only if it can once again see Europe as a joint response to a great history that affects 'us'" (Van Middelaar 2013, 305). In this way Europe would include not just abstract symbols like a flag or a currency but also a pluralistic political sphere of transnational political parties and politicians that potentially appeal to *all* European voters.

Poetic Representation

Unlike revolutionary abstractions, political parties represent difference, conflict and plurality, represented by party leaders and candidates. Parties have thus become an essential part of pluralist democratic societies. Despite all the talk about the disappearance of political parties, or about parties being replaced by "movements", political parties still remain a necessity for modern democracies. It is indeed hard to imagine a modern democracy without political parties. Even new social movements and other more recent grassroots movements (from the Tea Party to the Occupy

movement) often either want to influence political parties or else end up becoming regular parties themselves (think of the Green political parties since the late 1970s or more recently *Podemos* in Spain).

None of this is to deny that traditional political parties and the democracies in which they operate are currently under pressure. One reason parties are under pressure has to do with changes in democratic societies. Although parties in part construct new social realities and points of identification, they also depend on existing classes and stable social structures. But as democracies became more successful in supporting individuals through the welfare state, and as the nature of economic production changed, democratic societies become more diverse and individualised and therefore become harder to decipher, know, predict and represent. This also means that: "the 'people' can no longer be apprehended as a structured whole. It is felt to be rather a series of separate histories, an accumulation of specific situations" (Rosanvallon 2011, 4). The long-term unemployed for example are today less linked by their socio-professional characteristics but increasingly "share a biographical profile: an identical series of social or family breakdowns, the same type of professional setbacks" (Rosanvallon 2000, 98). As a result, society has "become more opaque [...] and therefore less easily represented than the old class society with its well-defined gradations and boundaries" (Rosanvallon 2018, 13). This increased individualisation since, roughly, the 1970s, has meant that stable classes are disappearing, which is why representation through unions and political parties has become harder.

Moreover, we face "the inability of individuals today to see themselves as members of a collectivity" (Rosanvallon 2008, 308). In the past, individuals derived their identity from a larger entity such as a political party or a nation. Today becoming part of a group or cause—for example on social media—often simply means that one's individual preference is *expressed* rather than *transcended* as part of a larger narrative, as was still the case with modern political parties or nation-states. Instead, by treating everyone equally, procedures, elections and the rule of law all abstract from particular groups and circumstances. Likewise, political parties aim to transcend singular concerns in order to tell a broader more general story. As a result, individuals are often disappointed, because they feel that their particular problems are not taken into account. The everyday concerns of a large part of the population thus risk not being heard sufficiently.

One way to tackle these problems is by looking for alternative ways of representation. Alongside new intermediary bodies such as political parties, the 19th century also produced other ways to represent society's identity and give people the feeling that they are part of a larger whole. Representation not only means that someone acts or deliberates for someone else while seeking the common good, for example through political parties, but also that someone's particular story or situation is expressed, shown or recognised (e.g. Rosanvallon 2014, 9–12). Instead of more deliberation, procedures or traditional forms of representation, people often also simply want their particular voices to be heard and recognised.

A historian like Rosanvallon demonstrates how in the period before the breakthrough of elections, many attempts were made to give the people and society a voice outside politics. 19th-century writers such as Balzac, Zola or Hugo, but also many journalists, used literary means to shed light on hidden, ordinary lives

and to make sense of a society that had lost its natural form. Similarly, the social sciences emerged as an attempt to help society understand itself by understanding and representing it. Using a 19th-century novelist's term, one can call this "poetic representation" (Rosanvallon 1998, 279–301, 2014, 35–47, 56–57).

Given that the changing socio-economic context has created increasingly individualised or "flexible" life trajectories and professions, we arguably need more individualised narrative categories and approaches in order to recognise and do justice to these phenomena. In today's individualised societies, poetic representation thus becomes relevant again. To the extent that individuals are often no longer part of a clearly visible class, their need to belong to a larger group can thus partly be met through literary means. If social exclusion or poverty is now not only related to class, but also to certain life events (e.g. divorce or illness), then making sense of social exclusion also means narrating such events. Social scientists but also—in the wake of Orwell—writers, journalists, novelists and filmmakers, show, map, recognise and analyse these new forms of exclusion, life trajectories or hidden groups and practices in society. As they focus on "the analysis of life trajectories" they can grasp "a more refined individualization" (Rosanvallon 2000, 101). For example, they describe the challenges a divorced parent has to face, what it means to work in a call centre or as a Deliveroo or Uber Eats cyclist. Telling stories about typical yet unknown lives allows individuals to feel heard and recognised again. Rosanvallon, for example, launched a book series and a website that publishes hitherto invisible life stories and analyses of hidden parts of society, thus constituting a "parliament of the invisible" (*le parlement des invisibles*) (Rosanvallon 2014).

Poetic representation not only makes people feel heard again, allowing them to become part of a larger group, but it also helps society as a whole to better understand itself. By analysing social reality, researchers can indeed highlight hidden conflicts and stimulate intellectual and societal debate (Rosanvallon 1998, 354–361, 2000, 96–102, 2014). Stories that highlight the precarious situations in which certain workers (or the unemployed) find themselves, for example, can thus also generate social and political debate and even actual reforms.

Moreover, these stories also have the potential to help people take an interest in—and even foster empathy with—stories about others who may be living in very different circumstances. Unlike political party programmes, narratives or movies "invite voluntary participation in a story and, in the process, have the potential to generate empathy for hitherto unfamiliar characters in particular material circumstances" (Rigney 2012, 621; see also Hunt 2008, 38–58).

Think for example of Leïla Slimani's recent novel *Lullaby* [*Chanson douce*], in which the reader discovers the often-unknown world of nannies—whose presence in households "is intimate but never familiar" (2018, 47)—through the character of the introverted and troubled Louise. By entering into her world, the reader for example learns about places where poor and lonely people like her meet, such as "parks, on winter afternoons" where, "on benches, on narrow paths, you see the people the world doesn't want any more […] vagabonds, drifters, tramps, the elderly and unemployed, the sick, the vulnerable. Those who do not work, who produce nothing" (95–96). Once the winter ends, the nannies take the children to these parks to play, while they sit on park benches "for hours on end […] as if

they were co-workers sharing an open-air office" (177–178). Such a novel also highlights the problems that Louise's bourgeois employers face. Such as the challenge of communicating with someone like Louise, who lives in the same household yet still appears to come from a different world (which is why Louise feels like "an exile who doesn't understand the language being spoken around her" (52)). Or the tensions and uncertainties generated by the many pressures in their own busy bourgeois lives, trying to combine a career with parenthood. Like so many others, this novel in that sense also serves a sociological and even political function in so far as it makes otherwise invisible tensions and the precariousness of various lives inside our contemporary societies visible.

When applied to Europe, poetic representation may for example mean telling life stories that can be seen as "typically European", with which people from different nations can identify. These may involve common challenges in life that people in Europe share, for example the journey to find a stable job, holiday experiences or attempts to deal with a shared past, but also specific stories of immigrants who are trying to make a living in Europe. By comparing different life trajectories in different European countries one might get a sense of what it means to "be European" (beyond being French or Polish) as opposed to being American for example (e.g. a European's attachment to the welfare state, to multilingualism, the often age-old layout of historic cities or the availability of high-speed trains etc.). Analogous to "Humans of New York", an online format that shows pictures of random ordinary people alongside their life stories (see Stanton 2015 and Figure 2.5), one may for example think of "Humans of Europe". Just as these particular stories represent the hugely complex city of New York in a very concrete way, so an even more diverse and complex region like Europe might perhaps be represented and be given a face by telling such stories.

But apart from focusing on commonalities, stories at a European level can be particularly helpful when it comes to highlighting differences. European identity, after all, lies in part in its ability to acknowledge (and overcome) sometimes traumatic differences and controversies, both past and present. In that context one can wonder what: "narratives could connect debt-ridden Portuguese and their prosperous German fellow citizens of Europe? More critically, what stories connect so-called 'new' Dutch citizens from Morocco with their indigenous counterparts? Or with French citizens?" (Rigney 2012, 621).

Rather than representing nations or Europe as a whole trying to transcend differences—through symbols like a flag—or by finding a balance between particular interests and the common good—which is what parties try to do in parliaments—stories represent wider identities without needing to transcend particularities. Broader issues and identities are represented thanks to particular stories, not in spite of them. It is precisely because of their specificity that readers or viewers identify with stories, even with characters whose story is different from one's own. Through stories, particularity and generality are no longer opposed but partly overlap and even reinforce each other. The "people" in democratic societies are not just represented by abstractions (through symbols like a flag or Marianne) or by a plurality of political parties, but also by a collection of individual stories that are both unique and recognisable, singular and general.

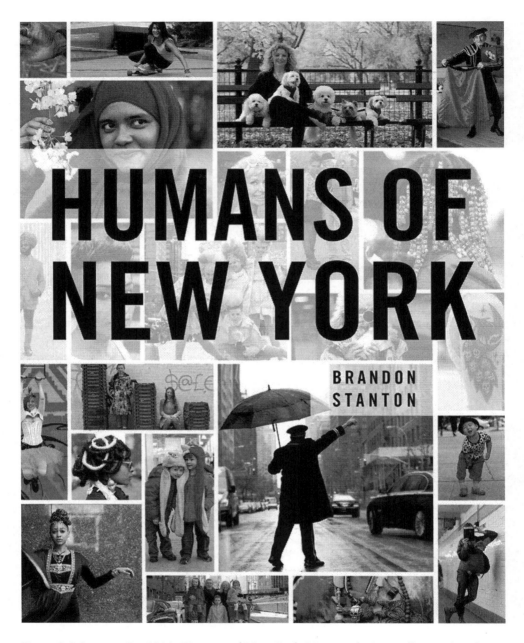

Figure 2.5 Stanton, B., 2014. *Humans of New York*. New York: Macmillan. Jacket design: Lauren Harms. Cover photographs: Brandon Stanton.

References

Hunt, L., 1986. *Politics, Culture, and Class in the French Revolution*. London: Methuen.

Hunt, L., 2008. *Inventing Human Rights: A History*. New York and London: Norton.

Lefort, C., 1986. *The Political Forms of Modern Society. Bureaucracy, Democracy, Totalitarianism*, ed. by J. B. Thompson. Cambridge: Polity Press.

Pizzorno, A., 1990. On Rationality and Democratic Choice. *In:* P. Birnbaum and J. Leca, eds., *Individualism: Theories and Methods*. Oxford: Clarendon Press/New York: Oxford University Press, 295–331.

Rigney, A., 2012. Transforming Memory and the European Project. *New Literary History*, 43 (4), 607–628.

Rosanvallon, P., 1988. The Decline of Social Visibility. *In:* J. Keane, ed., *Civil Society and the State: New European Perspectives*. London and New York: Verso, 199–220.

Rosanvallon, P., 1996. Partis. *In:* P. Raynaud and S. Rials, eds., *Dictionnaire de philosophie politique*. Paris: Presses Universitaires de France, 449–453.

Rosanvallon, P., 1998. *Le peuple introuvable: Histoire de la représentation démocratique en France*. Paris: Gallimard.

Rosanvallon, P., 2000. *The New Social Question: Rethinking the Welfare State*. Princeton, New Jersey: Princeton University Press.

Rosanvallon, P., 2006. *Democracy Past and Future*. New York: Columbia University Press.

Rosanvallon, P., 2007. *The Demands of Liberty: Civil Society in France since the Revolution*. Cambridge, Massachusetts and London: Harvard University Press.

Rosanvallon, P., 2008. *Counter-Democracy: Politics in an Age of Distrust*. Cambridge: Cambridge University Press.

Rosanvallon, P., 2011. *Democratic Legitimacy: Impartiality, Reflexivity, Proximity*. Princeton, New Jersey: Princeton University Press.

Rosanvallon, P., 2014. *Le parlement des invisibles*. Paris: Seuil.

Rosanvallon, P., 2018. *Good Government: Democracy Beyond Elections*. Cambridge, Massachusetts and London: Harvard University Press.

Rosenblum, N., 2008. *On the Side of the Angels: An Appreciation of Parties and Partisanship*. Princeton, New Jersey: Princeton University Press.

Slimani, L., 2018. *Lullaby*. London: Faber & Faber.

Stanton, B., 2015. *Humans of New York*. New York: St. Martin's Press.

Van Middelaar, L., 2013. *The Passage to Europe: How a Continent Became a Union*. New Haven, Connecticut and London: Yale University Press.

Weymans, W., 2009. From Coherence to Differentiation: Understanding (Changes in) the European Area for Higher Education and Research. *In:* R. Cowen and A. Kazamias eds., *International Handbook of Comparative Education*. Dordrecht: Springer, 561–577.

Weymans, W., 2019. On the Critical Potential of Rosanvallon's Wide Definition of Democracy. *In:* O. Flügel et al. eds., *Pierre Rosanvallon's Interdisciplinary Political Thought*. Bielefeld: Bielefeld University Press, 99–118.

3 Becoming Ordinary

The Ludic Politics of the Everyday

Veronika Zink and Philipp Kleinmichel

As the title of the 2001 French film (by Jean-Pierre Jeunet) suggests, Amélie Poulain lives a fabulous life. She enjoys the seemingly trivial pleasures that lie dormant in the midst of everyday life. Be it the sensual experience of slipping her fingers into a sack of grain, the enjoyment of skimming stones on the Canal Saint-Martin in Paris, or the excitement of breaking the crust of a flambéed crème brûlée, Amélie rejoicingly enchants ordinary life. Endowed with an exceptional sense for the magical charm of the unimposing, she transgresses the pragmatic valuation of ordinariness and transforms the vapidity of quotidian life into a creative playground. In terms of her socio-structural position Amélie figures as a contemporary everybody of no exceptional status. Born in a Paris suburb, the daughter of a teacher and a doctor, working as a waitress, she embodies the notion of the usual petit-bourgeois girl. To follow Anna Schober (2015), the everybody is a central icon in modern discourses, serving as a popularising figure to address each and everyone. The cinematic message thus seems obvious: the privilege of leading a life of leisure devoted to the affective delightfulness of everyday reality is not the privilege of the leisure class, but a common good available to everybody who is willing to divulge the hidden secrets of ordinariness. *The Fabulous Destiny of Amélie Poulain* suggests that in the immanence of our routinised everyday life everybody can detect flights that transcend daily banality.

The film's commercial success indicates that the promise of revaluing ordinary life, which the image of Amélie augurs, has appeared highly attractive to large sections of society. This success draws on "the imaginative value" (Beckert 2010, 8f.) conveyed by the figure of Amélie. It reveals a prevailing societal wish for a conquest of the present, and with it an aspiration for a re-enchantment of everyday life (see Maffesoli 1998). Understanding Amélie as a prism for contemporary cultural imaginaries, the film highlights the fact that the idea of a ludic life of leisure is a mainstream popular desire. In face of the multitude of companions—such as Victoria Moran's guide to *Living a Charmed Life* (2010) or "The Ideology of Small Pleasures" (The School of Life 2016, 236) summoning the belief in the worth of the "overlooked things [...] that are all around us"—one can witness a *culte de banal* (Jost 2007) encouraging us to appreciate the priceless luxury of the infra-ordinary. All these cultural goods replicate a cultural need to ameliorate ordinary life and, simultaneously, to participate in producing the cultural imperative of an everyday practice of enchanting banality. That said, the figure of Amélie serves as prototype of a contemporary model of subjectivity dedicated to the formation of a creative self that aesthetically valorises ordinary reality (Reckwitz 2010, 591f.).

Presuming that these examples reveal an ongoing cultural model, this article aims to analyse the production of the imaginative value of revaluing profane life. The need for an enchanted life reacts to prevailing cultural tensions in modern societies. Based on this assumption, we will question the critical value inherent in this popularised imaginary of the everybody. At first sight, this cultural imaginary seems to be informed by an ongoing aesthetico-political discourse moulded by artists and theorists who envision a liberating counter-image to the rationalisation of modern lifeworlds. The intellectual valorisation of the everyday is to be understood as a reaction to and as an involvement with imaginaries of modernity dedicated to a profanation of culture honouring the ideal of a democratised society. But to an even greater degree the popularity of this cultural model points to the fact that the critical discourse on the ludic politics of ordinariness has now spread into mainstream culture. If this discourse becomes an everyday, democratised good potentially accessible to everyone, one must ask how this critical discourse is appropriated in mass culture. The central question we would like to address is how to understand the popularisation of this imaginary of cultural critique? We will show that the popular re-enchantment of modern life functions as a mystification of social reality. Extricated from its acclaimed critical value, these ludic strategies of enchantment, on the one hand, produce the experience of an auspicious exit from the functionally rationalised society, but, on the other hand, they reproduce the bourgeois ethos of the leisure class and affirm the socio-cultural order of modern societies (Figure 3.1).

On Doing Being Ordinary

In one of his lectures the ethno-methodologist Harvey Sacks notes: "Whatever it means to be an ordinary person in the world, an initial shift is not to think of 'an ordinary person' as some person, but as somebody having one's job, as one's constant preoccupation, doing 'being ordinary'" (1985, 414). How to describe this preoccupation within contemporary society? When asking what it means to do, to practice, this "being ordinary", one might immediately refer to images depicting the monotony of everyday routines and the banality of the "metro-work-sleep" life famously outlined by Lefebvre:

> Common denominator of activities, locus and milieu of human functions, the everyday can also be analysed as the uniform aspect of the major sector of social life: work, family, private life, leisure. These sectors, thought distinct as forms, are imposed upon in their practice by a structure allowing us to discover what they share: organised passivity.
>
> (1987, 10)

According to Lefebvre, in modern societies the alienating structures of functional rationalisation preordain everybody's preoccupation of "doing being" ordinary. For Lefebvre, the functional rationalisation impinges on the everyday as a totality. The logic of organised passivity permeates all aspects of everybody's lifeworld, even those realms that appear as the everyday antipode to the productive sector of life and, as Marx (1990, 711f.) has shown, serve the function of reproduction. Lefebvre's portrayal of modern everyday life in part anticipates Habermas' diagnosis of modern societies characterised by the "colonisation of lifeworld" (1987, 332f.). Modern

NEWS

NEUES MODELL

DIE FABELHAFTE WELT
DER AMELIE

Welch lässiger Familienzuwachs! Mit Stuhl
„Amelie", dessen Sitz- und Armlehnen wie
aus einem Stück Polster gefaltet scheinen,
begann 2011 die Erfolgsgeschichte der
Lemgoer Sitzmöbelmanufaktur Freifrau.
Jetzt neu in der inzwischen vielfältigen
„Amelie"-Stuhlfamilie: die Lounge-Variante.
Preis auf Anfrage **www.freifrau.eu**

Figure 3.1 Amélie as seen by product designers and marketing agents. Editorial article on the "Amélie" chair produced by the seating furniture manufacturer Freifrau selling the trope of the revaluation of the everyday with the touch of an aristocratic life of leisure as a mass model. Published in: *Schöner Wohnen*, 2/2018. Photo: Freifrau.

everyday life is depicted as the product of the bureaucratisation and monetarisation of the lifeworld imposed on us through the systemic imperatives of the administrative–economic complex. Within late capitalist societies, the functional rationalisation inherent in the process of modernisation acquires an image of everyday life synonymous with the private sphere and embodied by everybody's role of "doing being" an employee and a consumer. Interpreted in terms of an alienation of the lifeworld (Lefebvre 1991), as the expression of being an anaesthetised "one-dimensional man" (Marcuse 1991), as the societal condition for the "reification of communicative relations" (Habermas 1987, 386), or as the experience of a loss "of the sense of what is beautiful and valuable" (Boltanski and Chiapello 2007, 38), this critique of market-based societies has become a commonplace. The success of *The Fabulous Destiny of Amélie Poulain* shows that the reference to the pathologies of lifeworld is not a privilege of intellectuals, but by now a popular cultural good reproduced in the mass media.

The character of Amélie transfigures the historic moment in which the popularisation of this cipher of criticism is completed. The film visualises a certain desire to disrupt the common notion of the administered anaesthesia of quotidian life. The search for situations that fracture monotony aims to "reveal the extraordinary in the ordinary" (Lefebvre 1987, 9). The extraordinariness that lies dormant in the immanence of everybody's everyday life serves as the imaginary of authenticity promoting liberation from the functionalised daily routine. By means of estrangement[1] (Lefebvre 1991, 21) the everyday appears as a hyperbolic phenomenon obscuring the drabness of life, de-familiarising the alienating passivity and querying its one-dimensionality. Here the everybody de-trivialises the taken-for-granted with the objective to capture the presumed indefinite curiosities of everyday reality. In this way the strategy of estrangement aims to fracture the position of the nobody, who indifferently transforms everything into functional usualness (see de Certeau 1988, 1f.; Schober 2015). This mode of estrangement is dedicated to the "revaluation of the particular" and aims to withdraw from "the painful manifestations of deprivation in a culturally impoverished and one-sided rationalised practice of everyday life" (Habermas 1987, 395). The imaginative value of this cultural endeavour derives from its promise of serving as an exit strategy from the colonisation of the lifeworld. In this vein, the figure of Amélie can be understood as a model for a cultural practice reacting to the process of disenchantment and cultural rationalisation inherent to the modernisation of the world. The mass-media distribution of this narrative is, as will be shown, the historic product of the intellectual work of an academic and artistic discourse portraying mundane reality as the valuable locus of critique.

The Value of Everybody's Everyday

In his essay "On the Concept of Everyday Life" Elias (1998) reflects upon an theoretical conjuncture of the subject of the everyday in the 1970s, not only revaluing ordinary life, but also to a greater degree querying the unquestionable reality of the banal: stripped of its former familiarity, the everyday, Elias notes, has become anything but everyday. Ordinary life is turned into a valuable phenomenon of academic elucidation renouncing its triviality. Instead of understanding society as the mere product of the noble deeds of the heroic figures of history, the turn to the everyday emphasised the "unmarked" (Brekhus 1998, 34) ground of reality with the objective

of revealing the daily practices of ordinary people in reproducing and reshaping society. The academic shift of perspective marks

> a countermovement to all those tendencies that degrade the societally and historic-ally mediated subjectivity to a residual category within the greater framework of a theory of the production factors of history or the model of a becoming cyber-netic of society.
>
> (Prodoehl 1983, 14, own translation)

The everyday is the prevailing sphere of experience for everybody and the concrete locus of social action. Accordingly, everybody's everyday is subject to a cultural political revaluation and turns into an auspicious object of research. However, the perspectives on the everyday differ greatly with respect to the political and epistemological tradition of research.

By de-familiarising and bewildering the mundane (Garfinkel 1967, 38) socio-phenomenological and ethno-methodological approaches (Berger and Luckmann 1967; Goffman 1959; Schütz and Luckmann 1973) accentuate the craftsmanship of ordinary people in understanding, constructing and staging their everyday lives. Defying the portrayal of the everyday subject as a weak-willed executor of a systemically induced order, these accounts are concerned with the implicit ration-ality of everyday actions and, thus, valorise everybody's everyday potentialities. Neo-Marxist accounts, on the other hand (Heller 1984; Kosík 1976; Lefebvre 1991), shed light on the ordinary mechanisms of rationalisation and the daily modes of reproducing an alienating social strata with the aim of searching for ways to revolutionise these structures from within. Accordingly, Heller reflects upon the revolutionary potentials of everyday life by rhetorically posing the question: "is everyday life necessarily alienated, and therefore, is a radical restructuring of every-day life possible within the continuity of its fundamental structure?" (1970, 213). Taking both strands further, authors such as de Certeau (1988) as well as members of the Birmingham Centre for Contemporary Cultural Studies (see Hall 1984; Wil-liams 1989) focus on everyday practices that resist the belief in a uniform culture. Whether by looking at the refuse of popular culture or by considering the creative practices of everyday consumption, these approaches acknowledge the virtuosity of everybody's everyday lives. The culture-critical value of these approaches derives from the accentuation of the emancipatory and dis-identificatory potentials of ordinary artistry. This latter critique affirms the cultivation of banal life with the objective to liberate the re-creative potential inherent in ordinariness.

The academic negation of the acquiescence to consumer culture and the re-evaluation of the quotidian are taking place, as Perec puts it, against the historic backdrop of a society adhering to the surrogates of the extraordinary:

> What speaks to us, seemingly, is always the big event, the untoward, the extra-ordinary [...]. The daily papers talk about everything but the daily. [...] How should we take account of, question, describe what happens every day and recurs everyday: the banal, the quotidian, the obvious, the common, the ordinary, the infra-ordinary, the background noise, the habitual?
>
> (1997, 205)

While in Perec's literary writings the turn to the ordinary aims to indicate a critical attitude towards cultural valuations, the movie about Amélie's lifeworld institutes this critical practice of capturing the insignificant noise of the everyday as a popular object of the spectacle (see Debord 1994).

The Logics of Profanation

Despite the differences between these theoretical approaches, these discourses are characterised by a cultural political programme that informs the belief in the revolutionary potential of ordinariness and refers to the modern ideal of an egalitarian culture. Beyond just affirmatively embracing everyday flights from the delusion of mass culture, the critical potential of the turn to the everyday was driven by the idea of a profanation of culture (Agamben 2007). Conceived as a cultural strategy of revaluing the previously established symbolic economy of society, the notion of profanation dissolves the classificatory distinction between "the distinguished and the vulgar" (Bourdieu 1996, 6) with the objective "to overcome the value boundary" (Groys 2014, 71) between the worthless and the valuable. The becoming ordinary of the intellectual discourse reflects this very notion of profanation. The shift of the academic focus from supposed high culture and the sacred values of the leisure classes to the profane values of ordinariness re-evaluates the banal reality of everybody's quotidian practices.

This strategy of profanation follows an attempt to appreciate the formerly devalued, vulgar status of everybody's mundane culture in order to challenge the cultural superiority of the handed down ideals of the upper classes (Bourdieu 1996, 486). In this line of thought, the appearance of the everybody can be understood as the "return of the other (everyone and no one) into the place which had been so carefully set apart from him" (de Certeau 1988, 4). The academic turn to everybody's everyday life aims to demystify the belief in a hierarchical stratification of value creation from high to low culture, and thus functions as a critique of a symbolic economy governed by class institutions of distinction. In this way the ideal of a profanation of culture not only opposes cultural models that build on the sacralisation of specific cultural ideals, but also derives from its culture-political endeavour for a "democratisation of symbolic value creation" (Beckert 2010, 4).

According to Thorstein Veblen the "conspicuous leisure" (2007, 49) and the demonstrative being at ease marked the cultural status of the societal elite. After the bourgeoisie had successfully replaced the aristocratic estate as the ruling class, the sacred privilege of an aristocratic life of leisure was preserved as a class institution of culture by the bourgeoisie. The privilege of a life of leisure expresses the imaginative value system of a pecuniary culture and symbolically reproduces the belief in the exclusive cultural status of the bourgeois elite. In contrast to the ideal of a reputable life of leisure, the petit-bourgeois ethos of a puritan productive life at work devoted to utility and lived by the salaried masses of the Industrial Age appeared as an expression of cultural worthlessness and vulgarity. Thus, by turning the perspective from distinguished culture to the creative culture of the ordinary, the turn to mundane life aims to subvert a symbolic economy that builds on the sacralisation of the imaginative values of the leisure classes and legitimates their superiority.

Overcoming the line that separates the life of leisure driven by the "taste of liberty" (Bourdieu 1996, 6) and the life at work driven by daily necessities, Amélie's fabulous

life seems to embody this notion of revaluation. Amélie embodies the ideal of a playful culture transcending the necessity of a productive "metro-work-sleep" life by promising everybody a life of leisure. On this account, one should ask whether the iconic character of Amélie serves as a popularised reflection of the culture-political promise of profanation? In order to understand this popular model, it is worthwhile investigating the genealogy of this imaginary of critique as a contested object of intellectual discourses.

The Dialectics of Profanation: Functional Averageness and Marvellous Ordinariness

The cultural imaginary of a creative turn to ordinariness marks a specific cultural model of profanation. Within modern discourses one can detect two antagonistic models of profanation: an avant-gardist vision and a functionally rational paradigm. The notion of estranging everyday immanence is the aftermath of a playful aesthetic critique on the disenchanting, functionally objective notion of profanation (see Boltanski and Chiapello 2007). Both models conjure the modern emancipatory aspiration for a secular being turning to its immanence and thus emphasise the value of mundane life. In this regard, both follow the same politico-cultural logic, but they are driven by fundamentally different visions of how to realise the egalitarian promise of profanation.

Adolphe Quételet's (1842) positivistic measurement of the mean values of the average man (*l'homme moyen*) may serve as a paradigm for an instrumentally rational ideal of profanation transfiguring the process of disenchantment (Weber 1995). Promoting the demography of society and the anthropometry of man, Quételet's theory was often criticised—also among his contemporaries—for its deterministic perspective on man: "an absurd overextension of the quantifying fetish", as Donnelly (2015, 135) summarises the criticism. Nonetheless, the vision of mean mediocrity acquires a peculiar connotation in Quételet's work. For Quételet the average man was not a vulgar being, but represented an ideal figure:

> If the average man were completely determined, we might [...] consider him as the type of perfection; and everything differing from his proportions or condition, would constitute deformity and disease; every thing found dissimilar [...] would constitute a monstrosity
>
> (1842, 99)

Studying the physical and the moral faculties of man, for Quételet the mean everybody seemed to be a "type of perfection", aesthetically and morally superior. Quételet's idolisation of averageness serves as an informative example with respect to the emancipatory hope that drives the belief in a functionally rational profanation of culture as well as with regard to the homogenising effects of this very vision. By idealising factual mediocrity, Quételet transfers the highest values that define the culture of a society from its symbolic and economic pinnacle to the common mean of ordinariness. Seen from this perspective, the average man seems to be an attack on the cultural dominance of the bourgeois elite, inasmuch as the self-legitimising reference to the extraordinariness of the ruling class was disguised as a systemic defect distorting the ideas of beauty and morality: a monstrous deformation.

The ideal of objectivity constitutes this notion of profanation and the underlying imaginary of a demystifying rationalisation of culture. Under a different aegis one can recognise this imaginary of profanation in "Veblen's attack on culture" (Adorno 1997, 73) and his criticism of the cultural institution of the leisure classes. Following a puritan ethos, Veblen (2007) portrays the exuberant lifestyle of the leisure classes in terms of a barbaric vestige undermining the development of modern societies. According to Veblen, the belief in a life of leisure erodes the modern ideal of rationality, which for Veblen finds its ideal expression in the useful productivity of labour. For Veblen the symbolic economy of useless ornamentation and aestheticism embodied by the bourgeoisie of the Industrial Age "becomes menacing as it becomes increasingly similar to old models of repression" (Adorno 1997, 79). In his critique of Veblen's interpretation of culture Adorno states:

> For his [Veblen's] belief in progress, the images of aggressive barbarism which he saw in the nineteenth-century kitsch, and particularly in the decorative efforts of the years after 1870, represented relics of past epochs or indication of the regression of those who were not producing anything, those exempt from participation in the industrial labor-process.
>
> (1997, 79)

For the sake of a pacified and democratised society, Veblen's hope in a profanation of culture is driven by the attempt at transvaluing the institutions of symbolic value under the law of functional rationalisation.[2] Beyond doubt, what may appear as an emancipative critique of the legitimacy of established social and cultural order not only entails the risk of reifying social life, but also, according to *The Dialectic of Enlightenment* (Horkheimer and Adorno 2002), leads to the mythology of the factual and to a homogenising order governed by the control of calculating rationality. The imaginary of the functional rationalisation of culture inherent to the modern hope in profanation thus turns into a mythical belief system facilitating a repressive, anaesthetised culture.

Indeed, the contemporary imaginary of a flight from the rationalised modern reality follows the opposite attempt. Amélie embodies a model of profanation by means of aestheticising mundane reality, which one can, for example, easily associate with the surrealistic fascination with the overlooked adornments of everyday life (Lefebvre 1991). One of the first manifestations of such avant-garde attempts to revolutionise ordinariness by aesthetic means can be found in Schiller's (2004) *On the Aesthetic Education of Man*. Unlike Winckelmann (2013) before him, Schiller is not only disappointed with the poor aesthetic lifestyle of his contemporaries, but also his programme builds on a clear concept of a disenchantment of the world. Much like the authors who follow this tradition, including Nietzsche, Freud and Weber, Schiller traces the beginning of the history of disenchantment back to ancient societies. After 2000 years of an advancing division and specialisation of labour and an equally progressing rationalisation of the world propelled by professionalised intellectuals, this irreversible tragedy of an increasingly objectified culture (see Simmel 1997, 55) led to a state of "transcendental homelessness", as Lukács (1971, 41) later put it. The belief in the irreversibility of these developments is central to the revolutionary aesthetic programmes that follow the "logic of the avant-gardes" (Kleinmichel 2014) and differentiates them from projects like Rousseau's return to a genuine state of

nature: if a return to a cultural *arche* is no longer possible, the only way out can be found in the future, in which culture has been turned into a perfect second nature. To attain this future, the rationalisation of everyday life has to be radicalised. From this point of view, the production of art needs to be professionalised in order to turn the alienated contemporary culture into a beautiful aestheticised second nature that enables everyone to release the play drive, as Schiller famously coined it. Seen from this perspective, one could claim that the film represents the realisation of this ideal of an aesthetic revolution of everyday life: the transformation of ordinariness into the playground of everyday life.

Banal Strategies: The Cultural Economy of the Leisure Class

Consciously or not, the figure of Amélie as a contemporary cultural model is informed by this complex tradition of critique, conjuring the imaginary of an aestheticised being that cannot be reduced to its function in the administrative–economic complex. While the endeavour of enchanting the quotidian can function as a promising flight from everybody's being in a technocratic society, it can also be depicted as a popularised surrogate of the aesthetic critique and its emancipatory claims: "Today everyday [...] reality", to quote Baudrillard (1993, 74), "has already incorporated the hyperrealist dimension of simulation so that we are now living entirely within the 'aesthetic' hallucination of reality". For Baudrillard, the current aesthetic realisation of reality denotes a "banal strategy" (2008, 81) that simulates critique and thus stands in opposition to the revolutionary potential of an aesthetic sublimation of reality—a concept that Baudrillard borrows from Marcuse. For Marcuse (1978) in his thoughts on the political potential of art, the dissenting potency of art rests upon its aesthetic form transcending and sublimating reality, opening up "a new dimension of experience" (Marcuse 1978, 7). The aesthetic sublimation is not conceived as a mystification of reality, but, on the contrary, it attempts to desublimate and divest the misery of social life by experientially revealing the difference between artistic play and everyday reality. In contrast to the aesthetic sublimation, the aestheticising re-enchantment of reality portrayed by Amélie does not reveal the difference between artistic play and everyday reality. It creates the myth of a synthesised everyday lifeworld by sublimating the difference between art and life. The cinematically represented model appears as a strategy to mystify the banal routine of the "metro-work-sleep" life that still characterises contemporary society. It does so by creating a reality *sui generis* devoted to the authenticity of everyday extraordinariness. Conjuring the multitude of everyday possibilities to transgress mundane reality, the ordinary turns into the aestheticised reality of the spectacular. Amélie documents a "perpetual expectation", as Lefebvre put it,

> of something extraordinary, an ever disappointed and ever-rekindled hope, in other words a dissatisfaction, which seeps into the humblest details of day-to-day existence. How can we fail to believe in the marvellous [...] when there are people who lead marvellous (or seemingly marvellous) lives everyday, lives full of departures, lives which we see carefully reflected in the cinema.
>
> (1991, 121)

Media such as movies or self-help books offer normative representations of everybody's ideal life. Today, these models of subjectivity do not just trickle down the

social strata, but are also equally dispersed through social networks. The film shows how the critical operation of the aestheticisation of everyday life once proclaimed by the avant-gardes turns into a mystification of mundane reality, in which everybody produces and consumes the iconic image of everyday extraordinariness. The inverted cultural model invokes the imaginary of a reality of ordinary spectacles treating the monotony of profane life with indifference. Seen from this perspective, this model does not divest, but annuls the reality of the internal colonisation of the lifeworld (Habermas 1987). And it does so by affirming the supposed reality of the leisure classes, of those who are able to lead a marvellous life free of factual necessities.

This affirmation goes hand in hand with a devaluation of factual, ordinary life. The cultural imaginary employs "an aestheticism" that, according to Bourdieu (1996, 5), "takes the bourgeois denial of the social world to its limits" inasmuch as everything follows the rule of "a stylization of life [...]. And nothing is more distinctive, more distinguished, than the capacity to confer aesthetic status on objects that are banal or even 'common'". The popularised model of enhancing the ordinary upholds the symbolic difference between the distinguished, stylised life and the profane life of necessity, which favours the economically functional. For Bourdieu, the denial of necessity depicts a general attitude towards social reality "which is the paradoxical product of conditioning by negative economic necessities— a life of ease—that tends to induce an active distance from necessity" (Bourdieu (1996, 5). The imaginary embodied by the everybody figure of Amélie thus reproduces the imaginative value of "bourgeois ethics and aesthetics" (Bourdieu 1996, 486) as a legitimate model of subjectivity available to the salaried masses of contemporary society through various media.

In face of Amélie's fabulous life, conspicuous leisure is portrayed as a cultural promise for the average man and woman to free themselves from their rationalised, culturally worthless being. This promise of everyday artistry informs the imaginative value of this cultural model. The idea of an aesthetic everybody opposes the once hegemonic ideal of the organisational man and delegitimises the rationalised culture of modern societies (Reckwitz 2010). Nonetheless, this model of revaluing ordinary life does not query the symbolic or the economic logics of late modern societies. The figure of Amélie may appear as the ideal type of an expressively creative subjectivity that serves as a counter-cultural model to the self-disciplining organisation of modern petit-bourgeois culture. But this cultural figure, in fact, upholds an ethos that already informed the formation of modern subjectivity, appropriating the aesthetic and economic norms that Weber portrayed as the driving forces in the development of modern capitalist societies. In terms of aesthetics, the puritan ethos that, according to Weber, formed the modern imaginary of subjectivity profiled the "pleasures of cultural goods, which contributed to purely aesthetic [...] enjoyment" (Weber 2005, 114) as a legitimate practice of subjectivation. However, the life of aesthetic pleasures rested upon a "characteristic limitation": "they must not cost anything" (Weber 2005, 114). And it is precisely this moral restriction of an aesthetic configuration of everybody's lifeworld that recurred in the cultural model transfigured by Amélie, who conjures the priceless pleasures of ordinary life. In terms of economics, the mediatised model of subjectivity comes together with an entrepreneurial promise to commodify the priceless luxuries of banal life, as one companion book, entitled *Small Pleasures* (2016, 242), suggests: "There are vast industries waiting to emerge around all the things we could enjoy, and benefit from, but don't as yet because we are not systematically encouraged

to pay attention to their charms". In this respect, the model of an everyday life of leisure manufactures the value system of a pecuniary culture and the belief in bourgeois ethics.

The ideal of such an aesthetic enchantment may appear as a rejection of the modern ideal of profanation based on the belief in factuality and useful functionality. Nonetheless, the mainstreamed promise to lead a privileged life of leisure realises itself only insofar as it is restricted to the constraints of pricelessness, not immersing in an exuberant lifestyle of conspicuous consumption. In this regard, this model does not reject the puritan ethos of the petit-bourgeois subject, but updates its legitimacy by disseminating the semiotics of the priceless aesthetic pleasures of the ordinary. Everyone can see the priceless charms of everyday life and thus uphold the belief in an exit strategy from the "metro-work-sleep" life by producing and consuming the fictitious value of this ludic lifestyle. Regardless of whether this life of leisure is the expression of a delusion or a matter of fact, the production and the consumption of its appearance follows a socio-structural logic, maintaining and legitimating the hegemonic ideology. The cultural model portrayed by the film does not just affirm the belief in the value of the institution of the leisure class. It rather addresses the middle-class everybody in his or her preoccupation with becoming the member of a derivative leisure class, "whose office", according to Veblen (2007, 37), "is the performance of a vicarious leisure for the behoof of the reputability of the primary or legitimate leisure class". Regardless of the cultural political conclusion Veblen draws from his diagnosis, his analysis of the social function of the derivative, salaried mass reveals the basic social law of recognition and distinction (Bourdieu 1996; Kracauer 1998). The imaginative value of a ludic life at ease presupposes an intermediate distinction between the devalued status of necessity and the appreciated lifestyle of liberty. Concurrently, everybody's realisation of this imaginative value comes up against a necessitative limitation of an affordable life of pleasure. In this way, the democratic revaluation preserves the factual differences between the restricted life of pleasure, on the one hand, and the exuberant lifestyle reserved to the economic and symbolic peak of society on the other. The promise to enchant profane life resembles an invocation of the middle-class everybody to become ordinary. To become ordinary, however, means participating in the production and consumption of the imaginative value of the leisure class and reproducing the social and the symbolic order of late bourgeois culture.

Notes

1 With respect to Brecht, Lefebvre uses the German term *Verfremdung* to describe a strategy of estranging oneself from alienation (*Entfremdung*) with the objective of dis-alienation.
2 Following Marcuse (1978), the same holds true for the aesthetic imperative of profanation of vulgar Marxism, which aims at the factual representation of the social relations of production.

References

Adorno, T. 1997. Veblen's Attack on Culture. *In:* T. Adorno, *Prisms*. Cambridge, Massachusetts: MIT Press, 73–74.
Agamben, G., 2007. *Profanations*. Brooklyn: Zone Books.
Baudrillard, J., 1993. *Symbolic Exchange and Death*. Thousand Oaks and London: Sage.

Baudrillard, J., 2008. *Fatal Strategies*. Los Angeles, California: Semiotext(e).

Beckert, J., 2010. The Transcending Power of Goods: Imaginative Value in the Economy. *MPIfG Discussion Paper* 10/4, 1–26.

Berger, P. and Luckmann, T., 1967. *The Social Construction of Reality: A Treatise in the Sociology of Knowledge*. Garden City: Anchor Books.

Boltanski, L. and Chiapello, E., 2007. *The New Spirit of Capitalism*. London and New York: Verso Books.

Bourdieu, P., 1996. *Distinction: A Social Critique of the Judgment of Taste*. Cambridge, Massachusetts: Harvard University Press.

Brekhus, W., 1998. A Sociology of the Unmarked: Redirecting Our Focus. *Sociological Theory* 16 (1), 34–51.

de Certeau, M., 1988. *The Practice of Everyday Life*. Berkeley, California: University of California Press.

Debord, G., 1994. *The Society of the Spectacle*. New York: Zone Books.

Donnelly, K., 2015. *Adolphe Quetelet, Social Physics and the Average Men of Science, 1796–1874*. Oxford: Routledge.

Elias, N., 1998. On the Concept of Everyday Life. *In:* J. Goudsblom and S. Mennell, eds., *The Norbert Elias Reader*. Oxford: Blackwell, 166–174.

Garfinkel, H., 1967. *Studies in Ethnomethodology*. Englewood Cliffs, New Jersey: Prentice Hall.

Goffman, E., 1959. *The Presentation of Self in Everyday Life*. New York: Anchor Books.

Groys, B., 2014. *On the New*. Brooklyn, New York: Verso Books.

Habermas, J., 1987. *The Theory of Communicative Action. Vol. 2, Lifeworld and System: A Critique of Functionalist Reason*. Boston, Massachusetts: Beacon Press.

Hall, S., 1984. The Culture Gap. *Marxism Today* 28 (1), 18–22.

Heller, A., 1970. The Marxist Theory of Revolution and The Revolution of Everyday Life. *Telos* 6, 212–223.

Heller, A., 1984. *Everyday Life*. London: Routledge.

Horkheimer, M. and Adorno, T. W., 2002. *The Dialectic of Enlightenment: Philosophical Fragments*. Stanford: Stanford University Press.

Jost, F., 2007. *Le culte de banal: De Duchamp a télé-realité*. Paris: CNRS Edition.

Kleinmichel, P., 2014. *Im Namen der Kunst: Eine Genealogie der Politischen Ästhetik*. Vienna: Passagen.

Kosík, K., 1976. *Dialectics of the Concrete: A Study on Problems of Man and the World*. Dordrecht and Boston, Massachusetts: D. Reidel Publishing.

Kracauer, S., 1998. *The Salaried Masses: Duty and Distraction in the Weimar Republic*. London: Verso Books.

Lefebvre, H., 1987. The Everyday and Everydayness. *Yale French Studies. Everyday Life* 73, 7–11.

Lefebvre, H., 1991. *Critique of Everyday Life*, Vol. 1. London: Verso Books.

Lukács, G., 1971. *The Theory of the Novel*. Cambridge, Massachusetts: MIT Press.

Maffesoli, M., 1998. *La conquête du présent: Pour une sociologie de la vie quotidienne*. Paris: Desclée de Brouwer.

Marcuse, H., 1978. *The Aesthetic Dimension: Toward a Critique of Marxist Aesthetics*. Boston, Massachusetts: Beacon Press.

Marcuse, H., 1991. *The One-Dimensional Man: Studies in the Ideology of Advanced Industrial Society*. Boston, Massachusetts: Beacon Press.

Marx, K., 1990. *Capital: A Critique of Political Economy*, Vol. 1. London: Penguin Books.

Moran, V., 2010. *Living a Charmed Life: Your Guide of Finding Magic in Every Moment of Every Day*. New York: Harper Collins.

Perec, G. 1997. Approaches to What?. *In:* G. Perec, *Species of Spaces and Other Places*. Harmondsworth: Penguin Books, 205–207.

Prodoehl, H. G., 1983. *Theorie des Alltags*. Berlin: Duncker & Humboldt.

Quételet, L. A., 1842. *A Treatise of Man and the Development of his Faculties*. Edinburgh: W. & R. Chambers.

Reckwitz, A., 2010. *Das hybride Subjekt: Eine Theorie der Subjektkulturen von der bürgerlichen Moderne zur Postmoderne*. Weilerswist: Velbrück.

Sacks, H., 1985. On Doing "Being Ordinary". *In:* J. Atkinson, ed., *Structures of Social Action*. Cambridge: Cambridge University Press, 413–429.

Schiller, F., 2004. *On the Aesthetic Education of Man*. Mineola, New York: Dover.

Schober, A., 2015. Everybody: Figuren "wie Sie und ich" und ihr Verhältnis zum Publikum in historischem und medialem Umbruch. *In:* J. Ahrens, Y. Kautt and L. Hieber, eds., *Kampf um Images*. Wiesbaden: VS Verlag für Sozialwissenschaften, 241–270.

The School of Life, 2016. *Small Pleasures*. London: The School of Life Press.

Schütz, A. and Luckmann, T., 1973. *The Structures of the Life-World*. Evanston, Illinois: Northwestern University Press.

Simmel, G., 1997. The Concept and Tragedy of Culture. *In:* G. Simmel, D. Frisby, and M. Featherstone, eds., *Simmel on Culture*. London: Sage, 55–74.

Veblen, T., 2007. *The Theory of the Leisure Class*. Oxford: Oxford University Press.

Weber, M., 1995. Science as Vocation. *In:* H. H. Gerth and C. W. Mills, eds., *From Max Weber: Essays in Sociology*. Oxford: Routledge, 129–147.

Weber, M., 2005. *The Protestant Ethic and the Spirit of Capitalism*. London and New York: Routledge.

Williams, R., 1989. *Resources of Hope: Culture, Democracy, Socialism*. London: Verso Books.

Winckelmann, J., 2013. Thoughts on the Imitation of Greek Works in Painting and the Art of Sculpture. *In:* D. Carter, ed., trans., *Johann Joachim Winckelmann on Art, Architecture, and Archaeology*. Woodbridge: Boydell & Brewer, 31–56.

4 Particular Faces with Universal Appeal

A Genealogy and Typology of *Everybodies*

Anna Schober

Anthropomorphic figurations are often used in visual media in order to generate a public presence for one's own position and to address the audience.[1] Individual or group portraits and also full-body or half-body figures are created for this, but sometimes other parts of the body, such as the hands, are used. These figurations can become quite stylised: a white surface with two black dots creates a face and turns into a medium (Deleuze and Guattari 1980, 205f.); but also greatly enlarged red lips on a poster carried in a demonstration can function as an interface around which everybody gathers. Such figurations entice us as viewers to move into the space of representation and through them we relate to what is depicted, with different physical-material levels being involved (Schober 2014, 248f.).

An everyday example of such an addressing of the audience is a picture from a campaign conducted in 2010 in Vienna by the international non-profit organisation *Humana: People to People*, which collects and resells second-hand clothing in order to support international development projects, especially in South Africa and India. In the course of this campaign, clothing collection boxes covered with giant posters showing a close-up of a female face were placed throughout Vienna (Figure 4.1). The portrait of the woman who we encounter on these boxes is slightly tilted to the side, she is looking us straight in the eyes and smiling, revealing bright white teeth in stark contrast to her dark skin, brown eyes and black hair. Through her concentrated, open gaze and the slight smile she radiates kindness and invites us in the public to look back at her.

Here we encounter the image of someone like you and me, who seems in no way located in a more milieu-specific way—except that her dark but, on the poster, shining golden skin, her dark eyebrows, black hair, brown eyes and a red dot (*bindi*) on her forehead indicate that she probably comes from outside Europe, most likely from India. The picture frame cuts off the part of her face—which is generally moved very close to us—on the right, accentuating the eyes and smile even more. Over the upper third of the picture, across her forehead and eyebrows, but carefully leaving the expressive eyes free, is the blue and white text: "The future of your clothing donation: equality for women." This mise en scène of a face is potentially addressed to everyone passing through the urban area. It seeks to generate authority for the campaign and its goal of promoting gender equality by conveying a contact between us as passers-by in public, urban space and the *Humana* non-profit organisation.

Michel de Certeau (1988, 1–3) has shown that strategies of public, political seduction that happen in everyday practices, often operate via such a figure of the "ordinary man" or the "ordinary woman". In this campaign, the close-up face of a foreign-looking woman functions as such an "everybody" in the de Certeau

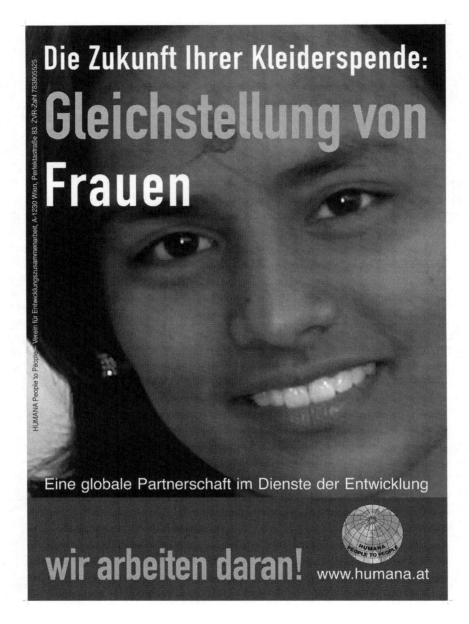

Figure 4.1 Humana poster campaign, Austria 2010, concept/design/text: Spunk Grafik, www. spunk.at. Copyright: Humana People to People Austria.

sense. Through the features that become present in it it is "guaranteeing the validity" (de Certeau 1988, 4) of what is in the picture and providing it with authenticity—with the text giving what is depicted an explicit meaning.

Such figures make it possible to potentially address "everybody" and to bridge existing boundaries between milieus, i.e. through them an attempt is made to form an alliance with the broadest circle of recipients possible. Simultaneously such figures ensure the particularity of the interventions they are used in (de Certeau 1988, 39): in the case of the *Humana* poster, the representation remains as an emancipatory text-image intervention distinct from other such interventions in public space. The universal dimension inherent in the portrait on the *Humana* boxes is underscored above all by the peace and kindness it radiates, the human empathy it seeks to create and the global network of references it invokes by inserting a foreign-looking face into Viennese urban space. Particularity and universality are thus equally present in this combination of image and text, but at the same time the poster also refers to a gap between the "now-time" of the observation and what could be—specified as future "women's equality".

Such "general persons" are also used to reject existing certainties and to help something different and new to achieve a breakthrough (see Reckwitz 2010, 69f and 79), which is why existing images of the socially foreign or marginalised are often employed in the design of such attraction figures. In the course of this process, the one or the other who is contrasted with the previously dominant culture is always at the same time subjected to a certain aesthetic form by being inserted into the cultural criteria of a "new man (woman)" who belongs to a new subject culture (Reckwitz 2010, 79). Everybodies are thus also more or less utopia-led figurations of a "new man (woman)", with whose help social groups challenge existing worldviews and put new ones up for consideration. In the case of the Figure 4.1, it is the image of a woman from outside Europe, a dark-skinned and dark-eyed foreign looking figure, which is appropriated in order to address "everyone" and to assert a closeness to reality.

The Authority of Bodies and Faces: Traditions of Long Duration and Historic Upheavals and Refigurations

What, however, is the difference between attraction figures that are aimed at as large an audience as possible, as we encounter them in the *Humana* poster and historically earlier iconic figurations that generate public authority? As an example of such a comparison, I choose a propaganda poster showing a general, Lord Kitchener, calling viewers face to face to enlist in the British Army (Figure 4.2). According to Carlo Ginzburg (2015, 132–141), who analysed this poster and its iconography, it combines two traditions: one that depicts all-seeing frontal figures (Figure 4.3), which the author already finds described in the texts of Pliny the Elder, but also in the writings of the late medieval philosopher Nikolaus Cusanus. Among them, for example, is an image of Christ by Antonello da Messina (1430–1479). The second tradition consists of images depicting gestures of call, such as Michelangelo Buonarroti's *The Creation of the Sun and Moon* (1508–1512) or *The Calling of Saint Matthew* (1599–1600) by Caravaggio.

The most striking difference compared to the latter tradition is that in the staging of the everybody as found on the *Humana* poster, the outstretched, foreshortened finger is absent. The invocation of a counterpart is based solely on the appearance of the anthropomorphic figure, its facial expressions or other details of its physical

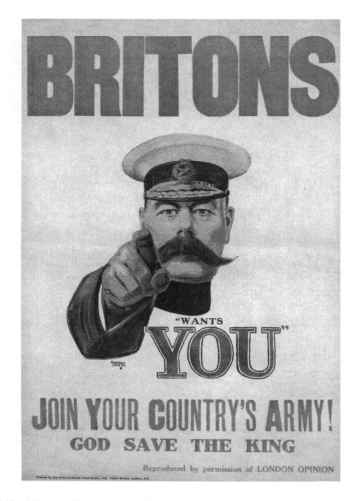

Figure 4.2 Alfred Leete, *Britons: Join Your Country's Army*, 1914, monochrome lithograph
and two-tone letterpress, 74.6 cm × 51.1 cm. Copyright: Imperial War Museum
(Art.IWM PST2734).

presence, and on the effect these have on the audience. The latter can perceive such
an appeal due to similarities or other forms of resonance experienced.

The second difference to both lines of tradition that Ginzburg mentions lies in
the fact that the everybody, as found on the *Humana* poster, is not located in any
socially or religiously elevated position vis-à-vis the observer: as a general, Lord
Kitchener's social position already made him a widely known figure of authority.
And the Messiah (or even God) is accorded a different position in religious writings
than the earthly, mortal observer. The figure of everybody, on the other hand, is
characterised by the fact that each and every one can become a figure embodying
significance for each other, generating authority and allegiance but also triggering
imitation and adaptation. Such figures can awaken a desire that is related to an

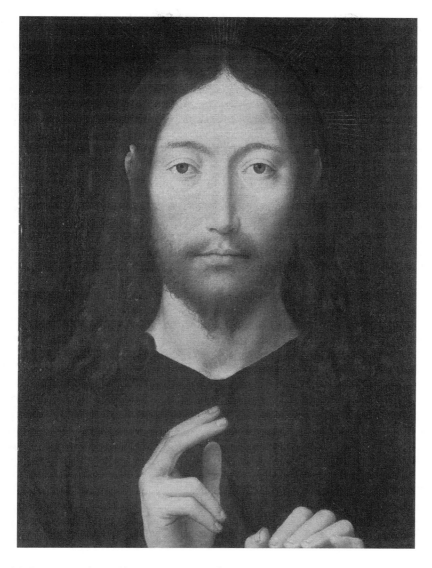

Figure 4.3 Hans Memling, *Christ Giving His Blessing*, 1478, oil on oak panel, 36.5 × 26.7 cm (panel: 38.4 × 28.3 cm). Copyright: Norton Simon Art Foundation, Gift of Mr. Norton Simon.

experience of resonance, as well as practices of mimesis, but can also trigger hatred and resentment.

As the French philosopher Michel de Montaigne (1998, 1) wrote, in order to address a public, one has to "vie for the world's favour". In contrast to an embellished and boastful style of doing so, he associated this with the "simple, everyday way of being" that he generally emphasises. In everybodies we are thus dealing, in Montaigne's words, with specific, arbitrary, everyday figures that entice similarly

arbitrary and everyday viewers to enter into a relationship and to constitute themselves as perceiving and possibly also acting subjects (see Balke 2009, 277f.). Authority is thus generated by figurations of everybodies through resonances of perception—whereby existing hierarchies and demarcations may be crossed.

Authors such as Carlo Ginzburg, but recently also Valentin Groebner (2015, 34) or Marie-José Mondzain (2011, 189), emphasise historical continuity in relation to anthropomorphic pictorial figures of appeal. According to them, faces and bodies that address and involve us in public are in the tradition of icons and images of Christ. Deleuze and Guattari (1980, 215f.) have also advocated a similar thesis by demonstrating that certain power structures produce faces and encrypt themselves over them, also regarding the medium of the face of Christ as elemental for such processes of signifying and subjectivation. But even if aspects of such a long duration of image traditions can be shown in connection with visual figurations of addressing an audience, above all—and in a state of tension with it—it is mainly drastic historical upheavals that are responsible for the fact that these mediating and disputatious figures have such a central function in modern and contemporary public life.

The most important of these upheavals concerns the field of politics and the public sphere, which was redefined with the revolutions of the 17th, 18th and 19th centuries. The heads and bodies that dominated the social pyramid in the monarchy and papacy were questioned in various places during the course of the Protestant Reformation of the 16th century, for example. At the same time, theories were spreading that justified resistance on the basis that power came from the people (Canovan 2005, 17).[2] The American Revolution represented an important turning point in this regard: the people were no longer merely a reserve, which in times of need was of particular importance for the legitimation of power, but were now also able to win the right to formulate a constitution and present a programme for a "popular" form of government (Canovan 2005, 20–29). At the same time, the sovereign people in the US was increasingly equated with those who were seen as "common people"—with which an inclusive form of governance spread, which, already in the early 1830s, was then described as a "democracy" by travellers such as the French diplomat Alexis de Tocqueville (1976, 197).

Geographically and historically characterised by great asynchronicities, a new paradigm emerged through such self-empowerment, but also through reform projects, which soon became institutionally anchored in the form of a parliament: political power was now dependent on the people and could thus only be taken temporarily, i.e. the political representatives were determined through an election that involved a number of candidates and, above all, were deselectable. The political, public space was created in a new way both through political action on the newly established stages of politics in the narrower sense, as well as through initiatives that launched political and social questions beyond that and on a broad basis (Lefort 1986, 302f.; Schober 2009, 67f.).

This historic and political upheaval was accompanied by changing practices of addressing "everyone", in which everybodies played an important role. Because these were thus brought into the foreground of public debate as figures associated with the people, who could make it possible to address "everybody" and generate resonance, and in so doing were refigured in a variety of ways. Due to its own inclusive, ambivalence-integrating quality and its power to generate evidence, pictorial

representation was highly effective in lending presence and duration to the powerful and authoritative political actions of the people that had led to these upheavals. The modern, western myth of "the people" emerging in the course of these revolutions was characterised by a dual figure of "everydayness" and the representation of the myth of salvation, a collection of concrete, mortal individuals in political mobilisation and timeless abstraction (Canovan 2005, 120f.). Images that took up and translated this myth themselves went back into the collective memory and formed a reservoir of images and narratives that could constantly be updated.

In this context, an image that has become deeply anchored in collective group memories, especially in the western world, is *La Liberté guidant le peuple* (*Liberty Leading the People*, 1830, Figure 4.4) by Eugène Delacroix. Here we encounter a semi-allegorical figure, i.e. half a figuration of the abstract idea of freedom in the form of an idealised, bare-breasted female body and half a "common woman" reminiscent of the participation of women in the early days of the Revolution (Schober 2009, 65) and of their active role on the barricades erected during the uprisings of 1827 in Paris. In a strictly pyramidal composition, this mixed figure functions as the leader of the people, the latter consisting of a collection of contingent male heroes like you and I present at the scene, who appear strongly typified (a street urchin, a student, a worker, a peasant and a craftsman) (Allard and Fabre 2018, 74). The group of figures is characterised by a strong forward movement, with the dynamics of the scene being emphatically underlined by the waving flag cut off by the upper edge of the picture. Supported by the enormous size of the picture (2.6 × 3.2 m), which already means that the specators perceive themselves as being engulfed, this forward movement enhances an orientation towards the audience and implies a kind of confrontation (Allard 2010, 132): in view of the advancing, self-emancipating people, we in the public are given the choice only of either joining the uprising or being trampled underfoot by it.

In a similar scene, which refers to the American Revolution and was captured in the painting *Molly Pitcher at the Battle of Monmouth* by Dennis Malone Carter (1854), such a semi-allegorical figure is then completely replaced by the image of a specific contemporary witness: Molly Pitcher, who was mentioned by Robert Lincoln at the end of *Lives of the President* as "Captain Molly" under the heading "Anecdotes of the Revolution" and shown as a female fighter firing a cannon (Fitz 2010, 243). As an "everybody" associated with "the people"—like the many other citizen soldiers, for example in the form of the yeoman farmer, which can be found on the pamphlets and graphics dealing with the American Revolution—she lends a sensual physical presence and permanence to the myth of the self-empowering people.

But also in Europe, for example in France, the depiction of concrete, sometimes even named individuals who appear to be linked to or are part of a rebellious crowd soon replaced (semi-) allegorical figurations like those we find in Delacroix's painting.[3] An example of this is *L'Emeute* (*The Uprising*, 1848–1879) by Honoré Daumier, a painting in the face of which the viewers—for instance through overlaps at the front edge of the painting, but also through the emphatically rough, impressionistic application of paint—are no longer distanced observers or opponents of the depicted insurgent crowd, but rather approaching components of it, in a certain sense "accomplices" (Kemp 1973, 265).

With the shift towards modernity, in parallel to this establishment of political and public space, the splitting up of fields of knowledge and the differentiation of

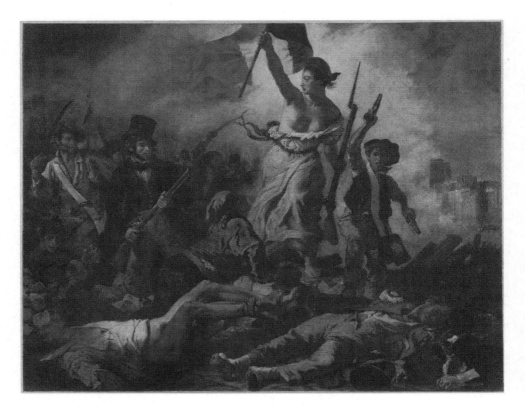

Figure 4.4 Eugène Delacroix, *Le 28 juillet 1830: la Liberté guidant le peuple* [*Liberty Leading the People*], 1830, Paris, musée du Louvre. Photo: Michel Urtado. Copyright: RMN–Grand Palais (musée du Louvre).

scientific and social locations, on which Michel de Certeau (1988, 40–43) focuses so closely, also emerged. In order to bridge the gap between the "institutionalised" knowledge produced in the establishments created by the Enlightenment and the everyday knowledge of broad sections of the population, specific events and techniques of "popularisation" emerged. For these, too, everybodies were central. Especially in "organised modernity" (ca. 1890s to 1960s, Wagner 1993, 73f.), the resulting visual forms often assumed features of a strongly universalising pictorial language that suppressed particularities as much as possible—as shown by the stencil-like, anthropomorphic forms used in the symbolic "Isotype" language developed by Otto Neurath and his circle in the 1920s (Figure 4.5).

Intertwined with these transformations, the figurations of the everybody also played a central role in the formation of modern cultures of the self. For example, the United Kingdom at the end of the 17th century and Germany and France in the 18th century developed milieus in which a first self-confidently modern form of appearance and conduct emerged as a generally binding one, i.e. increasingly gained dominance over an aristocratic one (Reckwitz 2010, 73f. and 97–101). Biographies and novels spread new forms of self-observation, which were

Figure 4.5 Gerd Arntz, logo of the Isotype Institute around 1925–30, linocut. Copyright: Österreichisches Gesellschafts- und Wirtschaftsmuseum.

associated with an autobiographical consciousness and the experience of a differentiated inner world. As early as the 18th century, in relation to a search for meaning and direction, heroes like you and I as doppelgängers of the readership (Kittler 1985, 86f.) came to the fore as central elements in this literary culture. Since the beginning of the 20th century, the medium of film has increasingly replaced novels as stages for such mediating figures—in them, the recipients now found the representation of the most varied emotions as well as desires, fears or longings, which were further processed through acts of mimesis and the associated crafting of their "own" style (Schober 2001, 36f.).

This new self culture is supported by upheavals in the orientation of faith and in the experience of insecurity and fears that also accompanied and shaped the refiguration of everybodies in modernity. Since the 18th century, what was destabilising, disturbing and frightening was no longer primarily the constant, concrete threat of death, as it was in the 16th century, when the mortality rate in some areas, such as the urban centres of England, was higher than the birth rate (Davidson et al., 2007, 5). Now, an uncertainty associated with the new paradigm of political power, but also with fears of social decline or confusion over a new openness of meaning and significance, was perceived as being increasingly threatening. The point of reference for dealing with these various manifestations of uncertainty was the being in the world, on which the search for reality, authenticity and truth or ineluctability now concentrated. In the process, a reference to and confrontation with everybody figures that adapt the traits of the previously foreign and different increasingly assumed the

task of integrating world views and facilitating experiences of wholeness, truth and closeness to reality.

This relates to another line of tradition in connection with the figure of the everybody, which is influenced by the 16-century English play *Everyman* (ca. 1510–1535) and its Dutch model *Elckerlijc* (Delft: 1496, Antwerp: 1496/1501). These pieces always confront their audiences with the existential experience of death, with the figure of the everyman directly addressing the audience concerning both individual responsibility and public spirit (Davidson et al., 2007, 9). The shift that takes place with the transition to modernity is that the other is no longer primarily death or God (or the muse as the incarnation of the divine), but the anonymous that is located within the earthly world (de Certeau 1988, 37). Within self-transforming, social and, above all, political communication processes, figurations of everybody—reinforced by the above-mentioned myth of the people, into which they were interwoven and which they maintain—thus have the role both of invoking individual responsibility and conveying desire and the associated experiences of belonging. But precisely because the social spheres of mediator figures and their disciples overlap much more closely in modernity than they did in the Middle Ages, for example when social belonging was still primarily determined by birth and was less mobile, these mediator figures are now increasingly perceived also as rivals. Associated with this the desire fuelled by them often turns into violence and persecution (Girard 1999: 15 and 20; Schober 2014, 266f.)—something that in today's social media networks, where fan communities easily turn into cyber cascades driven by hate speech, achieves even greater visibility.

Michel de Certeau (1988, in particular 13f.) argues against ideas and practices that have produced "anonymity" in the form that it has come to predominate in modernity and sides with the "ordinary man" or the "ordinary woman", whose patterns of activity he puts centre stage in all their creativity and particularity. His writing is itself entangled in historic upheavals since the historic event of "1968". Everybodies thereby once again prove to be controversial figures by means of which a dispute about the appearance and meaning of the world is conducted. With these above-described shifts towards modernity, which took place on various levels, a new necessity arose to make society readable, comprehensible and negotiable (see Rosanvallon 2018, 169) and to lend a sensual presence and permanence to public political initiatives. For all these operations and in the various fields of action associated with them, figurations of everybodies assumed an important function, with these figures of mediation and dispute having been created in many different ways, with various image-types emerging over time in this respect.

Types of Figuration of Everybodies in Modernity

The above-mentioned painting, *L'Emeute (The Uprising*, 1848–1879) by Honoré Daumier, stands for a type of figuration that shows an everybody picked out from the crowd but staged at the same time as being connected with it (Figure 4.6). The young man in a white shirt, enlarged in the foreground and dynamically extending his arm, dominates the picture, with the bright light that falls on his shoulders, forehead and arm cutting across the picture, increasing its dynamism and emphasising the presence of the figure whose white shirt identifies him as a worker. Other people gather behind him: workers and townspeople, women and children, who

with a forward movement all connect with the young man in the foreground to form a collective body. The dark wall on the right and a lighter row of houses in the background define the pictorial space, making the crowd appear even more compressed and "explosive". The people thus appear as a collection of concrete individuals, with each outline of face and body appearing sharply contoured but through their movement forming a quite compact collective body in stark contrast with the lighter row of houses in the background. As a doppelgänger of the viewer, however, the protester in the foreground keeps our attention on the fact that it is our presence and physicality (connected to our mortality) that has the potential to perform the powerful, authoritative and immortal collective body of "the people"—here again invoked as an abstraction, with their potential for action being given sensual visualisation and durability.[4]

Especially since the 19th century, a multitude of iconic compositions have spread in which everybodies (as individual figures or in small groups) that are more or less close to us are offered to the viewers as resonators connected to the people. Giuseppe Pellizza da Volpedo staged this double figure in the painting *Il Quarto Stato* (*The Fourth Estate*, 1898–1902) through bodies and faces that represent the people as a "stratum" (Figure 4.7). Similar to the insurgents in *Liberty Leading the People* by Delacroix, they are marching towards us in the audience and confronting us

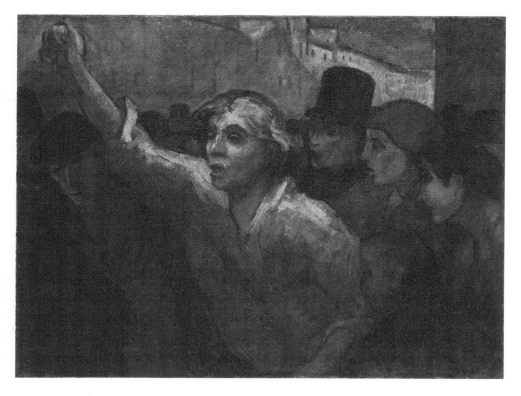

Figure 4.6 Honoré Daumier (1808–1879), *The Uprising*, 1848 or later, oil on canvas, 87.63 × 113.03 cm. Copyright: The Phillips Collection, Washington, DC.

solely through their physically decisive posture and their direct gaze, since there is no emphatically outstretched arm or a dynamically waving flag.

This type of figuration can turn out in such a way that the collective body of the people occupies most of the pictorial space. In addition, however, there are also depictions of the everybody as a space-filling, individually staged figure, in which a reference to the myth of the people is maintained, but is sometimes only hinted at in various ways in the picture or the accompanying text. These two poles are also visible in contemporary political stagings. A march against terrorism in Paris on 11 January 2015, in which over a million people took part, for example, featured multi-part posters showing the larger-than-life, bespectacled pair of eyes of one of the victims of the assassination, the journalist and cartoonist Stéphane Charbonnier (known as "Charb"). On these posters, which particularly often attracted the attention of the photographers, the everybody was reduced to the recognisable detail of the bespectacled pair of eyes, which functioned as a kind of logo for the journalist, and the dense crowd, which can be seen in all these photos, was thus provided in a collage-like way with eyes, which, like other everybody figurations, bring the viewer into the pictorial space (Figure 4.8). In this way, the slogan of these protests, *"Je suis Charlie"* (I am Charlie), was simultaneously translated into pictorial form.

On the other hand, there are image compositions that mark the second pole of this type of display. An example of this is a poster series produced by *The Amplifier Foundation* for counter-demonstrations during Donald Trump's inauguration in 2017 (Figure 4.9). The posters distributed during the demonstrations each show an everybody in the form of large individual portraits, which, through the "We the People" text on all the posters, are again connected with the myth of the people as a powerful collective actor. Even though the posters in the series always have the same formal framing, colour scheme and spatial arrangement of the figures in the

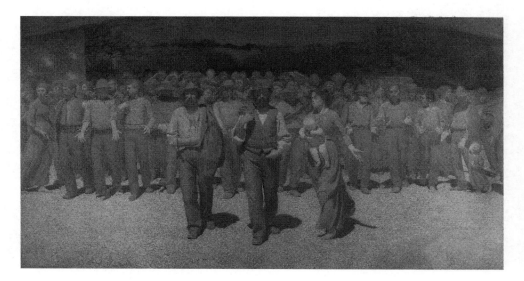

Figure 4.7 Giuseppe Pellizza da Volpedo, *Il Quarto Stato* [*The Fourth Estate*], 1898–1902. Museo del Novecento, Milan. Copyright: Comune di Milano—all rights reserved.

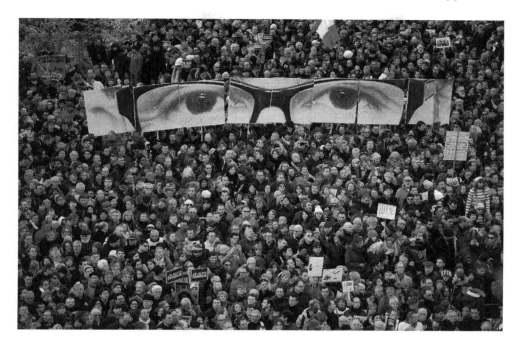

Figure 4.8 Charles Platiau, people hold panels to create the eyes of late Charlie Hebdo editor Stéphane Charbonnier, known as "Charb", 11 January 2015. Copyright: Reuters/ Charles Platiau.

pictorial space, the emphasis is on the theme of difference and how it relates to or is in tension with the strong universalising invocation that is peculiar to the everybody in this tradition of representation. Because all the pictures show women from different ethnic or religious backgrounds who are looking at us frontally or facing slightly to the side out of the picture. In the process, stereotypical classifications are both reproduced and challenged: on one of the posters a young woman with wavy hair and a flower behind her ear evokes Latino culture, on another a black woman with braided plaits Afro-American culture and on another a woman in headscarf indicates a culturalised Islam, with the religious difference mentioned here, however, being simultaneously challenged or broken by the pattern of the US flag with which the headscarf is printed, as well as by heavily made-up eyes and lips. Like the differentiation of the portraits, the captions also vary: for example, the picture of the woman with the headscarf is combined with the lettering "WE THE PEOPLE. ARE GREATER THAN FEAR" and the African-American woman wearing braids with "WE THE PEOPLE. PROTECT EACH OTHER".

Through this intertwining with differences the universal appeal to "everybody" embodied by these portraits is not one that simply imposes its hegemony on others or claims undivided universality. Rather, here we are dealing with an invocation that is searching and militant (Jullien 2016, 26f.), i.e. lives strongly from what is problematic or experienced as a lack in the present, and tentatively seeks to connect the visual presence of various particularities with the myth of the people as action

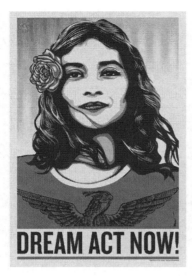
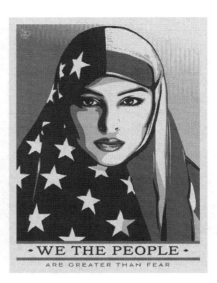
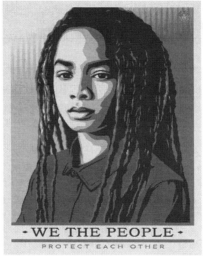

Figure 4.9 Shepard Fairey for Amplifier, Los Angeles, *We the People: Public Art for the Inauguration and Beyond*, 2017, poster campaign, silkscreen, 45.72 × 60.96 cm. Copyright: Shepard Fairey for Amplifier.org.

and authority. Universality is therefore not used here to neutralise or repress diversity. The images rather pose the question of the relationship between similarities and uniqueness, equality and difference, or the possible simultaneity of being equal and being unequal (see Rosanvallon 2013, 289).

Apart from this type of figuration of everybodies as a figure connected with the crowd, i.e. the actions and authority of the people, there are others, yet mostly remaining intertwined with it in one way or another, but which I can only go into in

rudimentary detail within the context of this chapter. One of them has to do with the magical power of naming, which transforms a collection of individuals into a mystical body (Bourdieu 1991, 209; Canovan 2005, 133f.). Whether in the form of Leviathan, Ned Ludd, who gave the Luddite movement its identity, or Marianne, who is still current today as the embodiment of the French people (Agulhon 1981), everybodies are also figured as collective faces that are given names and so hold a community together and lend it characteristic traits and recognisability as well as anonymity (Deseriis 2015, 24). The resulting figures each function as a kind of mask for the collective that gathers behind them. Repeatedly, a name that is common in broad sections of the population or is associated with spectacular action is transformed into such a collective mask ("Marianne", "Alice" or "Guy Fawkes"), which also testifies to the re-politicising potential of this tradition. To the extent that in authoritarian or populist movements, but also in totalitarianism—despite all the differences that exist between these political phenomena—a political personality (a face and a name) is always staged as the perfect or only true embodiment of the people, this type of figuration is related to "Caesarist" or "Bonapartist" forms of governance (Rosanvallon 2018, 216f.).

The emergence of new creative-artistic movements since the 1970s has given an emphatic boost to the figuration of such collective faces—as can be seen, for example, in "Alice" or "Viola" as reference figures for creative-artistic collectives in Italy in the 1970s and 1980s. But even today, political movements—often quite short-lived—frequently spread via reference bodies identifiable by name and face and using the media network of live performance, mobile phone and internet. Today, one mask in particular represents the current generation of insurgents: it shows "Anonymous", which grew into a political "we" in the course of collective, anonymised activities on the net between 2005 and 2008 (Deseriis 2015, 177) and for which the features of Guy Fawkes, a seditious 17th-century Catholic officer, who was first popularised by a comic strip[5] and then by the figure of a dissident in a science-fiction film (*V for Vendetta* by James McTeigue, 2006) were appropriated (Figure 4.10). Especially in the course of the 2010 to 2013 Arab Spring, but also in the context of protest in Europe during the economic crisis of the early 2010s, this mask functioned as an "assemblage of enunciation" (Deseriis 2015, 210), which conveyed desire for change as well as anger at the existing order. This mask allows these global-local and usually only short-lived movements to oscillate between gaining physical presence and a simultaneous blurring of identity within social networks.

These movements are characterised above all by a form of activism that has an inherent tendency to vote out, i.e. to vote against something instead of being for something. As the many photos of appropriations of the Guy Fawkes mask circulating on the net show, such a "negative politicisation" (Rosanvallon, 2008, 186) implies that, at the same time as demonstrating his or her commitment against the existing order, the individual wants to be perceived as unique, as a star. The internet offers a multitude of platforms for this, where the presence of these movements is now being negotiated in a highly polarised manner: attention and recognition can rapidly turn into agitation and rejection, fuelling new fears and making anonymity all the more desirable—which in turn calls for and confirms Anonymous in its dual role.

Alongside concrete individuals staged as being connected to "the people" and as named collective faces, a further type of figuration of everybodies is the representation of figures whose masks are more or less fixed and which traverse a variety of

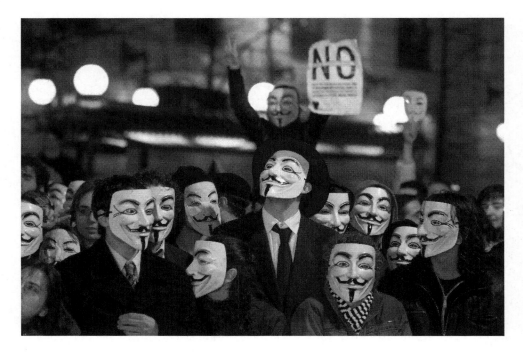

Figure 4.10 Sergio Perez, demonstrators wearing Guy Fawkes masks protest against Spain's culture minister Gonzalez-Sinde in Madrid, 13 Feb. 2011. Copyright: Reuters/ Sergio Perez.

contexts, guiding the audience to different locations of society and simultaneously pointing towards society in general (Figure 4.11). Since the 1960s such figures are, for example, street musicians, clowns, but also the tramp or the cowboy—they can all be quickly identified by clothing and a code of conduct and, above all in films, are created in various ways as doppelgänger figures of the audience, usually associated with identities in transition. Their relative detachment from the milieus they move in identifies these figures as being part of an aesthetic of attraction, where the narrative is of less importance than the, often discontinuous, spectacle it enables and supports their transnational appeal (Martin-Jones 2011, 48). This type of figuration has its own genealogy that, for example, implies the iconic representation of angels as messengers and bearers of revelation (Held 1995, 15).[6] However, it also indicates that an explicitly political claim is not necessarily constitutive for the figure of the everybodies, with the emphasis here being more heavily on the aspects of mediating and leading to society connected with such figures as well as the possibility of mirroring oneself.

A more recent genre that has emerged in connection with this type of figuration is films in which taxi drivers assume the role of everybodies, acting quite literally as transmitters, leading us to the various sites in society, simultaneously observing them and making them narratable. These figures thus connect us as viewers to the world in which we live—with this usually being a very concrete, urban world in

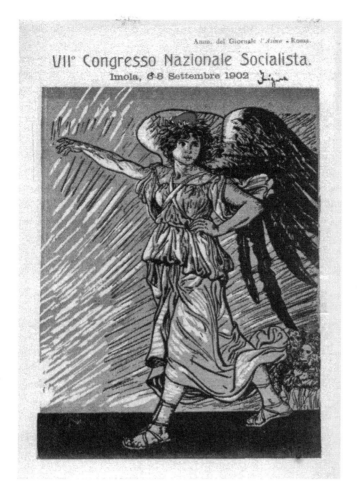

Figure 4.11 Colour picture postcard showing a winged woman in a red Phrygian cap walking in front of a crowd. VII° Congresso Nazionale Socialista, Imola, 6–8 September 1902. Copyright: Collection Amsab-ISH.

such films. As a person, he or she repeatedly retreats into the background and thus tends to become a mediator figure in themselves (Krämer 2008, 27). More recent examples, such as *Ten* (2002) by Abbas Kiarostami, show in detail that these intermediary figures often, however, become star-like actors in the present. In *Ten*, the action centres around a female driver[7] (Mania Akbari), with her hair loosely covered by a scarf (Figure 4.12). Like her passengers, who apart from her son are all women (her sister, a woman who regularly prays at the mosque, a prostitute), she is filmed during her journeys through Tehran via two small digital cameras attached to her dashboard. In three of the ten scenes into which the 23-hour footage has been cut and edited, we see the driver in conversation with her son, about her divorce and remarriage, self-determination, but also about competing values in

relation to coexistence between the genders. At times, for example at the beginning of the film, she is completely absent and we are confronted solely with the physical presence of her son and his reactions to her statements; at other times, details of her appearance, such as the colourful, modern clothing, her lipstick, the slipping headscarf and the matter of course with which she drives through the city—in addition to her voice, which is sometimes loud and excited, especially towards her son—are presented in visual detail. The confined space of the car, which is simultaneously both private and public, becomes a place where not only the tensions between mother and son, but also between modern, emancipatory demands and the patriarchal tradition, self-assertion and self-doubt or insecurity play out. At the same time, however, the car is also used here as a vehicle through which Kiarostami, who carefully prepared and edited the film but was sometimes completely absent during the shooting, relates us as the audience, the cameras, the actresses and the son to one another without completely taking control.[8] Here, in the emotionally charged space of the car, close-ups of the Madonna-like face of the driver (Király 2010, 139), but also of the face of the child, who repeatedly puts his hands over his ears or turns away in rage, function as a kind of "gap" to be filled by the viewer's imagination, judgement and interpretation.

As was shown at the beginning of this chapter, everybodies are usually figured by drawing on the representation of social otherness, for example in the form of the figuration of people who are socially marginalised or located on the margins

Figure 4.12 Abbas Kiarostami, *Ten*, 2002, colour, sound, film still. Copyright: mk2.

of the dominant orders. The resulting figure presents a "new man (woman)" who at the same time rejects the existing order—for example by making it seem unattractive and outdated. In this respect, since the 1960s, a figuration that can be described as "the other as a mirror of the self" (Morrison 1992, 80)[9] has gained more pronounced visibility and public presence—and thus becomes a kind of type of its own. This is due to the fact that, with the historical moment of upheaval of "1968", in general an emphatic turn towards particular differences (gender, cultural, ethnic, sexual) sets in—differences which have been playfully appropriated by postmodern subjects in order to realign and stylise themselves, with these subjects always remaining open in trying out the appropriation of ever new areas of otherness (Reckwitz 2010, 463f.).

Examples of this type are the stagings of women, of migrants or of nomadic or hybrid figures as doppelgängers of the audience and lenses of self-analysis and social observation. These everybodies continue to represent a universal dimension, even if this often only becomes apparent at second glance due to the heavily accentuated particularity of these figures. We also encounter this type in the taxi driver in *Ten*, where she enables us to trace the tensions between a striving for independence and attachment, between the desire for self-determination and being imprisoned in tradition. The *Humana* poster discussed at the beginning can also be located here: In it a foreign-looking woman is figured as an everybody, as a resonance body for everyone walking past. However, the woman portrayed could also be a migrant, which would simultaneously evoke other milieus, and her transnational, mediating appeal would come to the fore. Besides, through its caption "The future of your clothing donation—women's equality", this picture is also connected to the genealogical line in which everybodies are staged as a figure connected to the people as a powerful actor transforming society. This reminds us once again that the types of figuration mentioned do not fit neatly alongside one another, but often if not always overlap, repeatedly accentuating the myths of collective memory and triggering our imagination.

Notes

1 The research upon which this chapter is based was funded by the Deutsche Forschungsgemeinschaft (ref. SCHO 1454/1–1). On figures as media forms that migrate through the media system and in the process facilitate universal difference as well as mediation, see Leschke (2010). The concept of "figuration" reinforces the motility and processuality of these designs. Figures contrast with their context, in a state of "permanent genesis" (Boehm 2007, 36f.).
2 There are also examples of such questioning in Italian city-states such as Siena as early as the 14th century. See (Boucheron 2013, 59).
3 In France, popular representations such as "Marianne" can be found alongside allegorical figurations of "the people" as early as the 18th century (Agulhon 1981, 148). "Marianne", however, was also common as an insult, which shows that such figurations could convey very different attitudes and feelings.
4 In relation to such modes of presentation, Gustave Courbet uses the term "allegorie réelle" (Hofmann 1991, 9f.).
5 *V for Vendetta* (Alan Moore and David Lloyd, 1998–1990, New York, DC Comics).
6 This will be further elaborated in future work on the subject.
7 The protagonist is not a taxi driver in the traditional sense but rather an informal one who drives several people through the city, including strangers.
8 Here the digital camera maintains a very close relationship to the environment in which it simultaneously actively intervenes, with the preparation of the shots as well as Kiarostami's

editing being calculated in such a way as to support the active participation of the audience (see Krzych 2010, 31f.).
9 Toni Morrison (1992) points to the long tradition of this figuration. Since the 1960s, however, it has gained a new public presence, especially in an iconic form, and is often emphatically affirmed.

References

Agulhon, M., 1981. *Marianne into Battle: Republican Imagery and Symbolism in France, 1789–1880*. Cambridge and New York: Cambridge University Press; Paris: Editions de la Maison des Sciences de l'Homme.

Allard, S., 2010. Delacroix, Delaroche e il ruolo dello spettatore. *In:* B. Avanzi and G. Cogeval, eds., *Della scena al dipinto: La magia del teatro della pittura dell'Ottocento. Da David a Delacroix, da Füssli a Degas, la scène au tableau*. Paris: Skira, 130–139.

Allard, S. and Fabre, C., 2018. The Sphinx of Modern Painting. *In:* S. Allard and C. Fabre, eds., *Delacroix*. New York: The Metropolitan Museum of Art, 1–222.

Balke, F., 2009. *Figuren der Souveränität*. Munich: Wilhelm Fink.

Boehm, G., 2007. Die ikonische Figuration. *In:* G. Boehm, G. Brandstetter, A.V. Mueller, eds., *Figur und Figuration: Studien zu Wahrnehmung und Wissen*. Munich: Wilhelm Fink, 33–52.

Boucheron, P., 2013. *Conjurer la peur. Sienne, 1338: Essai sur la force politique des images*. Paris: Seuil.

Bourdieu, P., 1991. *Language & Symbolic Power*. Cambridge and Malden: Polity Press.

Canovan, M., 2005. *The People*. Cambridge: Polity Press.

Davidson, C., Walsh, M. W., and Broos, T. J., 2007. Introduction to Everyman. *In:* C. Davidson, M. W. Walsh, and T. J. Broos, eds., *Everyman and Its Dutch Original, Elckerlijc*. Kalamazoo, MI: Medieval Institute Publications (TEAMS. Middle English Text Series), 1–14.

de Certeau, M., 1988. *The Practice of Everyday Life*. Berkeley, Los Angeles: University of California Press.

de Montaigne, M., 1998. An den Leser. *In:* M. de Montaigne, *Essais: Erste Moderne Gesamt-übersetzung*. Frankfurt am Main: Eichborn, 5.

de Tocqueville, A., 1976. *Über die Demokratie in Amerika*. Munich: DTV Klassik.

Deleuze, G. and Guattari, F., 1980. *Capitalisme et Shizophrénie 2: Mille Plateaux*. Paris: Les Éditions de Minuit.

Deseriis, M., 2015. *Improper Names: Collective Pseudonymes from the Luddites to Anonymous*. Minneapolis and London: University of Minnesota Press.

Fitz, K., 2010. *The American Revolution Remembered, 1830s to 1850s: Competing Images and Conflicting Narratives*. Heidelberg: Universitätsverlag Winter.

Ginzburg, C., 2015. *Paura, Reverenza, Terrore: Cinque Saggi di Iconografia Politica*. Milan: Adelphi.

Girard, R., 1999. *Figuren des Begehrens: Das Selbst und der Andere in der fiktionalen Realität*. Vienna et al.: Thaur and LIT Verlag.

Groebner, V., 2015. *Ich-Plakate: Eine Geschichte des Gesichts als Aufmerksamkeitsmaschine*. Frankfurt am Main: Fischer Verlag.

Held, H.-G., 1995. *Engel: Geschichte eines Bildmotives*. Cologne: DuMont.

Hofmann, W., 1991. *Das Irdische Paradies: Motive und Ideen des 19. Jahrhunderts*. Munich: Prestel.

Jullien, F., 2016. *Il n'y pas d'Identité Culturelle: Mais Nous Défendons les Ressources Culturelles*. Paris: Éditions de L'Herne.

Kemp, W., 1973. Das Bild der Menge (1789–1830). *Städel-Jahrbuch* NF 4, 249–270.

Király, H., 2010. Abbas Kiarostami and a New Wave of the Spectator. *Acta Universitatis Sapientiae, Film and Media Studies* 2, 133–142.

Kittler, F., 1985. Romantik—Psychoanalyse—Film: Eine Doppelgängergeschichte. *In:* J. Hörisch and G. Ch. Tholen, eds., *Eingebildete Texte: Affairen zwischen Psychoanalyse und Literaturwissenschaft.* Munich: Wilhelm Fink, 118–135.

Krämer, S., 2008. *Medium, Bote, Übertragung: Kleine Metaphysik der Medialität.* Berlin: Suhrkamp.

Krzych, S., 2010. Auto-Motivations: Digital Cinema and Kiarostami's Relational Aesthetics. *The Velvet Light Trap* 66, 26–35.

Lefort, C., 1986. The Image of the Body and Totalitarianism. *In:* C. Lefort, *The Political Forms of Modern Society. Bureaucracy, Democracy, Totalitarianism,* ed. by J. B. Thompson. Cambridge: Polity Press, 292–306.

Leschke, R., 2010. Einleitung. *In:* R. Leschke and H. Heidbrink, eds., *Formen der Figur: Figurenkonzepte in Künsten und Medien.* Konstanz: UVK, 11–26.

Martin-Jones, D., 2011. *Deleuze and World Cinema.* London and New York: Continuum.

Mondzain, M.-J., 2011. *Bild, Ikone, Ökonomie: Die byzantinischen Quellen des zeitgenössischen Imaginären.* Zürich: Diaphanes.

Morrison, T., 1992. *Playing in the Dark: Whiteness and the Literary Imagination.* Cambridge, Massachusetts: Harvard University Press.

Reckwitz, A., 2010. *Das Hybride Subjekt: Eine Theorie der Subjektkulturen von der bürgerlichen Moderne zur Postmoderne.* Weilerswist: Velbrück Wissenschaft.

Rosanvallon, P., 2008. *Counter-Democracy: Politics in an Age of Distrust.* Cambridge: Cambridge University Press.

Rosanvallon, P., 2013. *The Society of Equals.* Cambridge, Massachusetts: Harvard University Press.

Rosanvallon, P., 2018. *Good Government: Democracy Beyond Elections.* Cambridge, Massachusetts: Harvard University Press.

Schober, A., 2001. *Blue Jeans: Vom Leben in Stoffen und Bildern.* Frankfurt am Main: Campus.

Schober, A., 2009. *Ironie, Montage, Verfremdung: Ästhetische Taktiken und die politische Gestalt der Demokratie.* Munich: Wilhelm Fink.

Schober, A., 2014. Everybody: Figuren "wie Sie und ich" und ihr Verhältnis zum Publikum in historischem und medialem Umbruch. *In:* J. Ahrens, Y. Kautt, and L. Hieber, eds., *Kampf um Images.* Wiesbaden: VS Verlag für Sozialwissenschaften, 241–270.

Wagner, P., 1993. *A Sociology of Modernity: Liberty and Discipline.* London and New York: Routledge.

5 The Mask and the Vanity Wound

Contemporary Populism through Canetti's Insight

Lynda Dematteo

Canetti's contribution to the analysis of populism is underestimated today, but he is truly decisive for thinking the relationship between the populist leader and his followers, between the One and the Many, anthropologically (Watson 1969). He allows us to grasp why the common man's and the populist leader's images are so intertwined and how power emerges from this enigmatic relationship. The great Jewish writer refers to the archaic heritage of humanity (including myths) to explain human behaviour and contemporary social phenomena (Lawson 1991). His approach disturbs many anthropologists because it appears anachronistic.[1] More-over, the highly metaphorical dimension of his writing certainly makes theoretical uses difficult, but his "fantastic anthropology"[2] is a way to defeat the desire of each one of us for fascism and its contemporary re-actualisations. I will go back to the various interpretations of populist phenomena inspired by Elias Canetti, focus-ing on the French debate, and then I will locate my own hypothesis on idiocy in politics in this theoretical framework. We can distinguish two views in Elias Canet-ti's main opus, *Crowds and Power* (Canetti 1984): first, developments on gather-ings of people and then reflections on the chiefs' masks. In writing this essay, Elias Canetti was of course thinking of the fascist leaders of his time. Most subsequent theoretical developments concern crowds and not the mask (McClelland 1989, 1996). This is probably because the anthropological reference can seem outdated, but this is too hasty a critique. A discussion of his views allows us to better grasp some identification mechanisms in politics.

Italian Populist Leaders as Media Masks

In *L'idiota in politica* (2011), I described the public figure of Umberto Bossi as a mask, referring to the tradition of the *Commedia dell'arte*, which was at the heart of the Italian identity-making in its various regional forms. Influenced by Canetti's writings, I used the classical concepts of mask as something that covers the face and masque as a performance to better describe how the Northern League's leader succeeded (more or less) in forming a new people, his own people, who he then designed as the "Padanian people." From my perspective, the masque concerns not only the figure of the leader, but functions also as the matrix of the collective identity. The two dimensions merge into a truly elaborated symbolic con-struction which is materialised through performance. The leader manages to embody a stereotype who synthesises and solves the identity contradictions that dis-turb his supporters when they choose him. Bossi has thus succeeded in making

himself "Padan" while combining all the flaws that are usually associated with Italianness in politics.

My fieldwork began in 1998 and I continuously collected data until 2012, when Umberto Bossi withdrew from politics. To carry out my ethnography, I had to enter the party structure through a local organisation in which I engage in participatory observation. Originally, the Northern League took root in the northern provinces crossed by the motorway in the Alpine foothills from Cuneo in southern Piedmont to Pordenone in Venetia. The *leghista* vote is the political expression of a particular economic and social space: the traditionally Christian-Democrat provinces that had undergone an economic development as spectacular as it was tardy. As the Northern League's electoral base is on the margins, I chose one of its principal strongholds in foothills of the Alps, Bergamo and its province.[3] The partisan sense of belonging is indeed nourished by a provinciality complex. The stigmatisation that the militants are subjected to is deeply intertwined with their geographical origins and partly renews the satire of the northern peasant. The "specificity" of the province of Bergamo lies in its longstanding geographical and cultural isolation, in the clericalism of its inhabitants and especially in the constant mockery to which they were subjected. The *Bergamasco* dialect indeed embodies a "mocked otherness" where its very particular diction amuses other Italians, who automatically associate it with the northern peasant type. The *Bergamaschi* occupy a very special place in the national imagination: hardworking and honest to the point of stupidity, they are the opposite in every way to the negative stereotypes associated with Italianness. The clichés drawn up around their identity made them "anti-Italians" well before Padania ever appeared in the political vocabulary of the peninsula. From this point of view, the *leghismo* is the political expression of a cultural revenge of the periphery, insofar as it enhances traits that were previously mocked.

I was intrigued by these stereotypical speeches that I had collected among Bergamask militants, which is why I focused on the figure of the leader by analysing it as a semantic construct rooted in northern Italian traditions. Overnight, the everyman Umberto Bossi (Figure 5.1) became a senator promising to reform the institutional rules and thus to find a solution to the moral degradation of the nation. From this point of view, he is similar to the peasant masque, which in Italian tradition took it upon itself to publicly denounce the vices and excesses of the community in the *bosinadas*. This ritual performance in the Milanese carnival continued up until the 1950s. The *bosìtt* were farmers from the province of Varese who were employed in low-skilled jobs in the Lombard capital. The leader of the Northern League, himself a native of this province, is well versed in these cultural patterns. He began his career by holding conferences in the carnival company of Varese, the *Scuola Bosina*.

In the Italian carnivalesque tradition, masques are spoken in dialect and proudly display the characteristics of their city of origin. Peasant masques, the black masks of the *Commedia dell'Arte*, generally perform a reversal of the stigma by expressing the revenge of the weak over the powerful. Despite their diversity, these masks played an essential role in the formation of Italian identity. They are the vectors of the *Italianitude* of the excluded, those who did not belong to the high Latin culture (Bollati 1983). Benito Mussolini himself has been described as having a face like a mask by his contemporaries who wished to underline how he cleverly used his features as a Romagna native to gain the support of Italian peasants. His male

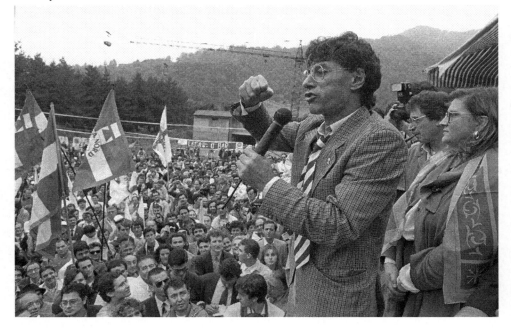

Figure 5.1 Dino Fracchia, Umberto Bossi at the first meeting of the Lega Lombarda party at Pontida, May 1990, black and white photo. Copyright: Dino Fracchia.

cockiness notably appeared as a regional characteristic (*gallismo romagonolo*). The populist leader is thus the one who puts on the mask of the ordinary man to better seduce the voters at the expense of traditional elites. In that case, the mask is not only the expression of the most irreducible autochthony, but also functions as a trick, and idiocy would be one of power's forms of trickery. The derogatory portrayals of the press also help to shape this public image, which is then used for political purposes. The leader of the League for instance reinvested this political imaginary by being photographed in a vest as Mussolini had been.

During rites of reversal, the ambivalent feelings aroused by the representatives of power are dramatised. Umberto Bossi is a totally burlesque character (so contradictory in some respects that he becomes comical). He calls himself "Padan" (Celtic), but until the age of 40, he always behaved like the worst *lazzarone*.[4] For the majority of Italians, he is an *italiota* [from the Greek: an Italian idiot]. I believe this is a real mask made by and for the media. It is a mask that violates the standards and achieves a reversal of status, enabling marginalised people from different social and/or political backgrounds to find a positive image of themselves by claiming to be Padanian despite the view of the majority of Italians. His political rise is therefore a social revenge, hence his special charisma.

In an overview of other European partisan formations, the Northern League was an atypical object. The continuing ambiguity between autonomist demands (antifascist) and populist themes (lower taxes, the fight against immigration, rejection of the institutional world) contributed to obscuring its real purposes and enabling

those who advocated the *leghista* ideology to give a moral stance to their demands: the tax revolt thus becomes the "fight against internal colonialism", the rejection of immigrants, the "defence of the identity of the northern people", the traditional southern question, the "northern question", etc. In the ideological matrix, we find an inversion strategy as I explained in *L'Idiota in politica* (2011). Padanian nationalism even seems somewhat pathetic if we look at it through the claims of nordicity, which are expressed by identification with ethno-nationalisms of Northern Europe (especially the Scottish). To obtain greater autonomy to the detriment of their southern compatriots, the elected members of the Northern League claim a cultural affinity with the German-speaking areas (hard work, pragmatism, efficiency etc.) In order to defend their own interests they disassociate themselves from the nation they belong to. This is possible insofar as, for Italians, whether from the North or from the South, the Italian is always the "other". Since demeaning stereotypes prevail in the minds of Italians, they often define themselves in opposition to these representations. I would like to underline the extreme ambivalence of this attitude, which can easily be interpreted as a desire for separatism, but also as a heightened nationalism taking the form of negative narcissism.[5]

However, the myth of northern honesty has been weakened since the 2012 financial scandals. Italian judges revealed that the League leaders had embezzled 49 million euro and Francesco Belsito, their treasurer, was close to the Calabrian mafia. To end this dangerous deadlock and strengthen his position on the right, the new leader, Matteo Salvini, complied with the European national-populism ideology, and in the process took inspiration from the Five-Star Movement to renew the League's communication style. In doing so he succeeded in regaining the favour of Italian voters and he asserted his leadership using Facebook to bypass the traditional media. Italian populist leaders have perfectly understood that class contempt for them strengthens their voters' hostility to the establishment. Anti-populist discourse therefore nourishes populism itself. The League representatives know how to use derogatory social representations by overplaying them. This is what Matteo Salvini—a person the Milanese call the "stupid son of a concierge"—did when he told reporters that Padania would become independent before he obtained his history degree. He thus returns the stigma and mocks them himself. With these games of masks, the elected populists are taking symbolic revenge on their opponents and liberating their supporters from their complexes. He acts in the same way to free his followers from their fear over the fascist past: unlike its predecessor he entirely assumes the Italian fascist heritage and he did not hesitate to quote Mussolini. In August 2018, he tweeted a famous phrase from the dictator's speeches: "So many enemies, so much honour".

The Power of Masks from Elias Canetti's Perspective

The populist leader holds up a mask-mirror to the masses because he or she is seeking a recognition that is frequently lacking. The mask is the instrument of power because it makes possible to take possession of the others. Leaders assert themselves by making the needs of crowds coincide with those they express. According to Elias Canetti, the crowd in itself is sane, it is the power that arises around it that is mad. He interprets the madness of the individual as their surrender to the mass-mind present within any of us. So Canetti's approach to power is peculiar: he attacks it without wanting to seize it; he rather wishes to avert the ossifying phenomena that characterise power. According to him,

the true mask is something which never changes, but remains perfectly and unmistakably itself, a constant in the continual flux of metamorphosis. Part of the strength of its effect is due to the fact that it reveals nothing of what is behind it.

(Canetti 1984, 373)

In his view, power in its manifestations already belongs to death. Following the animal behaviour model, he favours life and metamorphosis against the rigidity of the mask. For him, the mask is only a metamorphosis of the face that has been stopped once for all.

His reflection notably inspired the work of the British artist John Stezaker. In its fixity, the mask covers emptiness and reveals death. Such figures fascinate because they use images from ordinary life. Stezaker juxtaposes old publicity

Figure 5.2 John Stezaker, *Mask XIV*, 2006, ca. 24 × 20 cm, postcard on paper on photo-etching on paper, Tate, London. Copyright: John Stezaker. Photo: Tate, London 2019.

portraits with postcards in the German Romantic tradition of nature and the sublime (Figure 5.2). The subject's eyes are covered. The artist's collage replaces them with blanks or holes—leading to gloomy landscapes and creating the uncanny effect of seeing death beneath the features of a living person. His aim is to show the zig-zag woodland path or *holzweg*, a path leading to possible danger or death in German folklore as told by the Brothers Grimm in the early 19th century. Stezaker's characters have no eyes. Jelena Reinhardt noticed that Elias Canetti often describes cuts, amputations and wounds in his works. According to her "wounds embody a deep fear, most of the time irrational; it is the fear of castration, or to be more precise, the fear of being deprived of those qualities which define identity" (Reinhardt 2016, 2). However, wounds can be transformed into creative outcomes as Canetti himself proves through his literary work. The mask is one of the poles around which his whole work is organised. He was the first thinker to reveal the link between the manifestations of power and those of paranoia—through the Judge Schreber case, also studied by Sigmund Freud (2003). The mask expresses inner conflicts and its appearance must have a conjuring effect (inversion and purification). It allows redefining the identity (individual or even collective)—in order to appear morally superior, one attributes one's own faults to others via a psychological projection mechanism.

The man of power is animated by the passion to survive, of course, to survive his enemies but also his companions: he wants to be the only one. The best way to do this is to appear as having already returned from death, by adopting a mask (Canetti, 1979). For example, the indigenous tribes of New Guinea made their traditional masks with skulls. As Alessandro Pizzorno points out (2008, 35), the leader's Mana increased with the number of enemies killed. The mask is made of death. In this way, it is truly significant that the League's leaders seek to strengthen their power by taking up Mussolini symbols. Nothing seems to be more effective to scare their enemies. Soon, under his tyranny, rigidity extends to all his subjects because he does not support the metamorphoses that others experience autonomously. The despotic regime is enantiomorphic (Canetti 1984, 377).

The French anthropologist Marc Abélès further explored this line of thought in Canetti's masterpiece, *Crowds and Power*, focusing on state power and biopower (making live or letting die). In his researches on the displays of authority, he developed a sort of Foucauldian approach to Canetti. According to him, if power is the will to survive it implies that all power brings the life of the other into play. For example, if an outsider threatens the power of the one who holds it, he or she will make every effort to eliminate them before being dethroned. The main goal of the despot is to ensure the perpetuation of his power, generally by inciting conflicts between pretenders. Abélès identifies this as the "Laius complex" in politics. This survival device has the peculiarity of causing death all around (Abélès 2005, 76). To the extent that life is at stake, the horizon of such a logic is biopolitics. This Foucauldian perspective would undoubtedly make it possible to further explore racism and especially the populist tendency to fuelling rivalries between minorities in order to strengthen the pre-eminence of the majority group.

In *The Politics of Survival* (2010), Abélès then explored the link between power and time, and notably with survival. In his provocative analysis, he argues that the meaning and aims of political action have radically changed in the era of globalisation. As dangers such as terrorism and global warming have come to the fore in global consciousness,

foreboding has replaced the belief that tomorrow will be better than today. Survival, out-lasting the uncertainties and threats of a precarious future, has supplanted harmonious coexistence as the primary goal of politics (especially at a global level). Abélès contends that this political reorientation has changed our priorities and modes of political action, and generated new debates and initiatives. In this new political era, right-wing populist leaders can take advantage of the many fears generated by globalisation, and their decli-nist discourse probably has more to do with survival than with the "art of harmonious living together", to refer to the previous distinction established by the French anthropolo-gist. If there is indeed a populist community, it is concerned with preserving oneself and one's family, not with living together. Wherever they assume the reins of power, populist parties mobilise their followers by dividing and creating sharp conflicts. It is also very significant that the most extreme of them are apocalyptic and adhere to survivalist move-ments like those that appeared in the north-western United States.

Populist parties are characterised by their "paranoid style", as the American his-torian Richard J. Hofstadter well understood (1964), and on this specific point Elias Canetti was more insightful than Sigmund Freud himself. Canetti's work on paranoia notably inspired the schizoanalysis of the French thinkers Gilles Deleuze and Félix Guattari:

> Elias Canetti has clearly shown how the paranoiac organizes masses and "packs". The paranoiac opposes them to one another, maneuvers them. The paranoiac engineers masses, he is the artist of the large molar aggregates, the statistical formations or gregariousnesses, the phenomena of organized crowds. He invests everything that falls within the province of large numbers.
>
> (Deleuze and Guattari 2004 [1972], 279)

Against the despot's propensity to grasp, to immobilise, to monumentalise crowds, it is thus necessary to invent lines of escape which bring the fascisising masses to explode into multitudes.

The distinction between *molecular masse* and *molar masse* in *Anti-Oedipus* is also clearly inspired by the criteria defined by Canetti to distinguish different kinds of masses. According to Deleuze and Guattari, the same elements that exist in the fluxes, in the strata and in the assemblages, can be organised according to a *molar model* or a *molecular model*. The *molar order* corresponds to the stratifications that delimit objects, subjects, representations and their reference systems. The *molecular order*, in contrast, is that of fluxes, becomings, transitions of phases, of intensities. On the one hand we can observe solid assemblages and on the other hand transversalities. The French philosopher Jean Baudrillard subsequently led us to see crowds as the prefiguration of mass societies and mass culture. Interestingly, he reverses the perspective by arguing that it is the leaders who seek crowds and not crowds that make the leaders. According to him, the masses can no longer be represented by the classical instances, they can only be simulated:

> Model of simulation and imaginary referent for use by a phantom political class which now no longer knows what kind of 'power' it wields over it, the mass is at the same time the death, the end of this political process thought to rule over it. And into it is engulfed the political as will and representation.
>
> (Baudrillard 1983, 23)

This interpretative thread was obviously reinvested by Toni Negri and still continues today through some anthropological studies of contemporary social movements. Post-Marxist thinkers have sought to break with the old social bodies (people, working class, proletariat) in order to conceive of a new non-sovereign mode of organisation based on the model of the carnival as conceived by Mikhail Bakhtin (Hardt and Negri 2004, 208). Powerful contemporary movements cannot be interpreted by the yardstick of a monologic story and the multitude cannot but be carnivalesque. As a matter of fact, we can see the masks of Matteo Salvini and Guy Fawkes dancing together in this great anti-globalisation carnival. In December 2015, Matteo Salvini's Facebook profile was hacked by *Anonymous Italia* (Figure 5.3). His followers immediately understood that something must have gone wrong when the sharp and accusatory posts of the League leader stopped appearing on their bulletin boards and were replaced by a Guy Fawkes mask and the battle song of the hackers: "We are Anonymous. We are legion, We do not forgive, We do not forget, Expect us." According to some commentators, Matteo Salvini would have been self-hacked. For example, "Mike the meme" was convinced that Salvini was already preparing for the Venice carnival. This was clearly a tactic to return the effects of this hacking. However, in February 2018, *Anonymous Italia* reoffended by publicising the identity of his 70,000 followers.

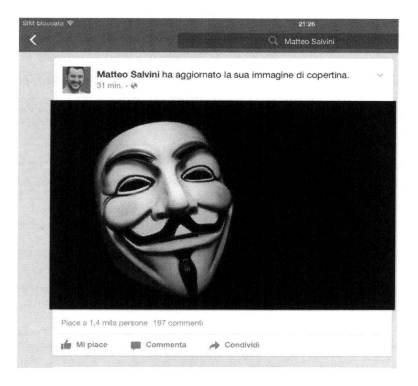

Figure 5.3 Salvini's Facebook page hacked by Anonymous Italia.

Figure 5.4 Unknown Photographer, *Riots in Vienna on 15 July 1927* (Protesters at Rathaus-park throw stones at mounted policemen), cut out horizontal strip from a black-and-white print, retouched. Copyright: ÖNB/Vienna, 449.671-B.

In my view, populism is a means for rigidifying the democratic aspirations by using stereotypes about lower classes and marginalised peoples. Populist leaders are tending to substitute symbolic representation for democratic representation (Dematteo, 2014). In *Dancing Jacobins*, Rafael Sanchez (2016) describes how populist leaders have monumentalised mass movements throughout Venezuelan history in order to better respond to the insistent return of subaltern populations in the form of crowds. In this way, populist governmentality succeeds in substituting a theatrical machinery for a weakened democracy. Images have a key role in this mythological surrogate enterprise.

As we can see, Canetti's interpretation is especially appreciated by leftist scholars. This is due to the fact that it differed from the psychological analysis of crowd phenomena elaborated by Gustave Le Bon (2009) and then reinvested by Sigmund Freud (1922). In contrast, Elias Canetti distinguishes diverse kinds of crowd and elaborates a typology. He recognises the existence of a "crowd instinct" (as opposed to a "personality instinct"), which leads to the fusion of individuals into the crowd, but he refuses to condemn these manifestations as a whole. He does not so much condemn the phenomena of the crowd as those who seek to exploit them to consolidate their power. Everybody can realise how easy it is to be carried away on a tide of mass emotion. On such occasions one might lose one's most personal self. As Stefan Johnson has underlined, all of Canetti's work was provoked by one event, the *Justizpalastbrand* (the July Revolt) in Vienna on 15 July 1927 (Figure 5.4), and he quotes in support his memoirs:

> Fifty-three years have passed, and the agitation of that day is still in my bones. It was the closest thing to a revolution that I have physically experienced. Since then, I have known quite precisely that I would not have to read a single word about the storming of the Bastille. Canetti was so influenced by this experience that he spent the rest of his life investigating the behaviour of the so-called masses.
>
> (Johnson 2013, 6).

Johann P. Arnason and David Roberts also sustain that this riot was a seminal experience for E. Canetti (Arnason and Roberts, 2004, 5). Since then, his goal was to dismantle the whole Hobbes–Le Bon's tradition, because he was convinced that crowds have a mind of their own and that in some cases they are fully responsible for some excesses.

Two Different Ways of Approaching the Crisis of Representation in Canetti's Footsteps

In her book *On the Political*, the political scientist Chantal Mouffe (2005, 23) points out that Elias Canetti was an inspiration for her, and mentioned this in several public interventions. She encountered his work when she was feeling frustrated by her specialism. According to her, political science is unable to understand the populist equation, because it is clearly an area of mass phenomena and consequently scholars should also consider irrational manifestations. Yet political science remains silent because it is dominated by rationalism. It can write the history of fascism, but it is unable to produce a theorisation of it. Chantal Mouffe illustrated how reading Elias Canetti permitted her to develop the model of agonistic pluralism. She reiterates Elias Canetti's assertion that parliamentary systems defuse partisan tensions by staging two opposed masses. Canetti notes that consensus is not what happens in a vote; each side fights for its respective interests and opposes the others. But the vote is then decisive. Nobody believes that just because their own side lost the vote the other's position was better, more moral or more correct. As Canetti puts it, the member of an outvoted party accepts the majority decision, not because they have ceased to believe in their own case, but simply because the minority admits defeat. Mouffe adds that without an arena for such contests, antidemocratic forces will prevail. In this way, parliamentary institutions transform "antagonism" into "agonism". The "mass instinct" is a threat to each democracy and it must be averted. Chantal Mouffe thinks political divides must not be avoided, but integrated and staged within the framework of the representative institutions; otherwise the system itself will be jeopardised. In that sense, she has defended left-wing populisms in order to contrast the rise of the extreme right. Finally, Chantal Mouffe's adversarial or agonistic politics looks quite familiar, but it permits her to reject the liberal discourse on the end of history and political conflict. If conflict is no longer represented in parliamentary institutions, popular discontent will grow, because an ever larger number of people will no longer feel represented. Chantal Mouffe is convinced that every shift by the left to centre reinforces right-wing populism. She sees reconciliation as a danger for democracy. If she is right, Emmanuel Macron is undoubtedly the greatest threat to French republic, because at some point the conflict he has captured will re-emerge against the democratic institutions. Neoliberalism seeks to deny antagonisms, and in doing so it tends to liquidate the political at the risk of seeing it reappear unexpectedly, erratically and even violently.

Chantal Mouffe is certainly right when she invokes the inability of political science to appropriately grasp the question of populism, but her reading of Elias Canetti is limited to the "closed crowds" (of parliament)[6] and totally neglects the other aspects of his anthropological thought. In my opinion, the logic of functioning of populism (in its most extreme forms) runs counter to classical parliamentarism. During my fieldwork in the Northern League, I was struck by the mimetic relationship between the militant activists and Umberto Bossi. They imitated him in the least of his behaviour. Elias Canetti was useful to me in grasping this kind of relationship between Bossi and his *bossini*. Today we can observe the same kind of link between Grillo and his *grillini*. I have always found the Italian diminutive significant. It denotes a particular kind of relationship between the leader and his

followers. There was no equivalent for the supporters of Silvio Berlusconi—Italians talked about *forzisti*. But the relationship between Berlusconi and the members of his party is not the same as those that Bossi and Grillo have developed with their own followers. Bossi made his *bossini* and destroyed them—most of the time. In the same way, Grillo makes the *grillini* and destroys them. The leader has been ineligible for public office since a road accident in 1980 when he was convicted of manslaughter over the deaths of three people. As a result, the Five-Star Movement's representatives are perceived as his puppets. According to both Canetti and Hannah Arendt, this logic of self-consumption (creation and destruction) is the main characteristic of tyranny (Arendt 1958, 308; Canetti 1984, 348). In both parties the expulsions are part of the everyday functioning, because the representatives of the party are only the leader's proxies. This logic of functioning is foreign to the classical parliamentarism which in contrast presumes the free will of each representative. The Five-Star Movement moreover is in favour of the imperative mandate and leaves no autonomy to its deputies.

In my view, the analytical elements that Canetti offers us go well beyond considerations on the staging of political conflictuality in democratic systems. The writer's ambition was more directly determined by the will to survive: he wanted to counter Nazism through theatrical catharsis. His literary project had a political breadth because he hoped to impact very directly on the identity complex of his contemporaries by making them aware about their own estrangement: "No fool and no fanatic will ever take from me the love for all those whose dreams were overshadowed and curtailed. Man will still become all and whole. The slaves will redeem the masters" (Canetti 1978, 9). To see this, it is not enough to read his masterpiece, *Mass and Power*, we must look at his autobiographical works (Sontag, 1980) and theatre, notably *Comedy of Vanity* (Canetti 2003 [1950]). This play was written under the direct influence of the Nazis' rise between 1933 and 1934. It deals with the simultaneous formation of mass and power; the vanity here being the principle of identity between the One and the Many in a dependency relationship to the image in which everybody is convinced of finding their true essence.

In this theatrical parable, mirrors and photographs are the target of an auto-da-fé and then prohibited under penalty of death. This new regime deprives man of his own image and thus makes him uniform and unconscious. For Canetti, only the "mass instinct" can generate such a monstrosity. People become incapable of representing to themselves who they are, and this generates a sort of "disease of the mirror" as Youssef Ishaghpour (1990, 85) pointed out. In this system, each manifestation of vanity has a sexual connotation; the word "mirror" even becomes dirty. To recover their health, people must overcome their inhibitions. Those who can afford it go to a clandestine clinic to look at themselves in the mirror, the most fortunate have access to luxury cabins completely made of mirrors, while those who have no money form a mass of unfortunates who crawl on the ground, begging for glances and compliments, because they are totally ignorant about who they are. The One who found himself and who convinced himself of his mission to restore past authenticity also feels connected to this obscure mass, whose needs and gazes have constituted him. So at the end the clinic collapses and patients come out waving their mirrors and shouting "ME! ME! ME!" while on the horizon the figure of the One in which they have recognised themselves rises. This chief is generally a common man similar to them.

This play may in fact be Canetti's most important work, but is perhaps too hard and despairing to be generally recognised as such. It deals with the irresistible seduction exerted by the "mass instinct". It allows us to understand how the link between a crowd and a leader stabilises. According to Canetti, crowds predate the leader. Paranoid people are inhabited by the will to control the others' movements and are in search of a crowd to increase their power. Canetti's parable allows us to think the centrality of images in the formation of the people of populism. The people who see themselves as no longer represented in our democratic systems resemble this obscure and suffering mass in Elias Canetti's play: they are no longer able to see themselves as a community, they are searching for a figure to identify with. They will find him or her in the vainest of them. It is enough for some kind of megalomaniac to present himself (or herself) to embody their identitarian fantasies and they will follow him shouting "ME! ME! ME!"

It is not insignificant that it is vanity that is at stake in this parable. In his play written during the rise of Nazism, Elias Canetti established a link between individual vanity wounds and the personality cult. According to him, the causes of the Hitlerian movement would have included a process of devaluation, a vanity wound, an identity trouble that was diagnosed as a "disease of the mirror" (Ishaghpour 1990, 85). The appearance of the charismatic figure would somehow stitch together all the narcissistic injuries of the community. The mask would then function as a communitarian mirror. Beyond the economic difficulties caused by the financial crisis of 2008, the suffering generated by a vanity wound is probably central to grasping what was at stake in the 1930s as well as in the present-day. In my view, the same kind of "fool"-like style of acting operates with Donald Trump. In the post-Obama world, the white male hegemony seems weakened: the balances of power are geopolitically upset by the economic rise of China and also intimately challenged (as the #MeToo movement revealed). The mask functions as a bandage over the wounded egos of the crowd: humiliated, annihilated, they recover self-esteem by identifying themselves with a character as worthless as themselves, but displaying disproportionate pretensions.[7] The mask thus responds to a need for recognition and serves to redefine the identity of the group in depth. This dimension remains substantially unexplored in Chantal Mouffe's work, but it is truly central to understanding what is happening in the United States as well as in Europe today.

Notes

1 Elias Canetti has been accused of relying on an obsolete evolutionist anthropology, but this is unfair, because he never developed a thesis about general developmental trends in history and he is clearly an anticulturalist. A more convincing critique was formulated by Axel Honneth (1996) when he underlined that all of Canetti's interpretation refers to bodily impulses that would characterise the archaic nature of the human being.
2 In *Elias Canetti: Métamorphose et identité*, Youssef Ishaghpour wrote that the richness of ethnological examples diverts the reader, who can be led into "a kind of fantastic anthropology" (Ishaghpour 1990, 91). In 1963, the communist critic William Phillips sought to delegitimise *Crowds and Power*, describing it as a poem and furthermore one of poor quality.
3 During my fieldwork, I divided my time between the *leghista* microcosm of the town of Bergamo and the town halls of small towns in the province. I took part in the activities of militants between the mountain sections and the via Bellerio headquarters in Milan,

I interviewed locally elected members of the League, their political opponents, and followed various militant actions: torchlit processions, the ritual of the vial, various events and major annual meetings.

4 A *lazzarone* is a Neapolitan word for someone who does not work and devotes himself to a life without commitments. Until he was elected senator at age 42, Umberto Bossi was supported by his wife, a school teacher of southern origin.

5 Elias Canetti also explores the consequences of negativism in schizophrenia in *Crowds and Power* (1984, 321).

6 In *Crowds and Power* (1984), Elias Canetti introduced a distinction between "open crowds" and "closed crowds", whose dynamics are totally different. The open crowd is open in the sense that it has no boundaries. Open crowds grow and then disintegrate as soon as they are no longer able to do so. In contrast, closed crowds have a boundary and strive to be permanent.

7 As I recalled in *L'idiota in politica*, Elias Canetti was inspired by the observations of the French Huguenot pastor Philippe De Felice (1947, 354).

References

Abélès, M., 2005. *L'Échec en Politique*. Belval: Circé.

Abélès, M., 2010. *The Politics of Survival*. Durham: Duke University Press.

Arendt, H., 1958. *The Origins of Totalitarianism* (2nd revised ed.). New York: Meridian.

Arnason, J. P. and Roberts, D., 2004. *Elias Canetti's Counter-Image of Society: Crowds, Power, Transformation*. Woodbridge: Camden House (Studies in German Literature, Linguistics, and Culture).

Baudrillard, J., 1983. *In the Shadow of Silent Majorities*. New York: Columbia University Press.

Bollati, G., 1983. *L'Italiano: Il carattere nazionale come storia e come invenzione*. Turin: Einaudi.

Canetti, E., 1978. *The Humane Province*. New York: Continuum Books/Seabury Press.

Canetti, E., 1979. *The Conscience of Words*. New York: Continuum Books/Seabury Press.

Canetti, E., 1984. *Crowds and Power*. New York: Farrar, Strauss and Giroux.

Canetti, E., 2003 [1950]. *Comedy of Vanity and Life-terms*, trans. Gitta Honegger. New York: PAJ.

De Felice, P., 1947. *Foules en délire, extases collectives*. Paris: Albin Michel.

Deleuze, G. and Guattari, F., 2004 [1972]. *Anti-Oedipus*, trans. R. Hurley, M. Seem, and H. R. Lane. London and New York: Continuum.

Dematteo, L., 2011. *L'idiota in politica. Antropologia della Lega Nord*. Milan: Feltrinelli.

Dematteo, L., 29 April 2014. *Les masques du populisme* [online], Raison publique. Available from: www.raison-publique.fr/article687.html [Accessed 19 March 2019].

Freud, S., 1922. *Group Psychology and the Analysis of the Ego*. New York: Boni and Liveright.

Freud, S., 2003. *The Schreber Case*. New York: Penguin Random House.

Hardt, M. and Negri, A., 2004. *Multitude, War and Democracy in the Age of Empire*. New York: Penguin Press.

Hofstadter, R., 1964. *The Paranoid Style in American Politics, and Other Essays*. New York: Alfred A. Knopf.

Honneth, A., 1996. The Perpetuation of the State of Nature: On the Cognitive Content of Elias Canetti's. Crowds and Power. *Thesis Eleven*, 45 (1), 69–85.

Ishaghpour, Y., 1990. *Elias Canetti: Métamorphose et Identité*. Paris: La Différence.

Johnson, S., 2003. Masses, Mind, Matter: Political Passions and Collective Violence in Post-Imperial Austria. In: R. E. Meyer, ed., *Representing Passions: Histories, Bodies, Visions*. Los Angeles: Getty Research Institute, 6.

Johnson, S., 2013. *Crowds and Democracy: The Idea and Image of Masses from Revolution to Fascism*. New York: Columbia University Press.

Lawson, R. H., 1991. *Understanding Elias Canetti*. Columbia, South Carolina: University of South Carolina Press.

Le Bon, G., 2009. *The Crowd: A Study of Popular Mind*. Southampton: Sparkling Books.

Mac Giolla Leith, C., 2008. *John Stezaker: Masks*. London: Ridinghouse.

McClelland, J., 1989. *The Crowd and the Mob: From Plato to Canetti*. London: Unwin Hyman.

McClelland, J., 1996. The place of Elias Canetti's *Crowds and Power* in the History of Western Social and Political Thought. *Thesis Eleven*, 45 (1), 16–27.

Mouffe, C., 2005. *On the Political*. London: Routledge.

Phillips, W., 1963. History on the Couch. *New York Review of Books*, 1 (2) [online]. Available from: www.nybooks.com/articles/1963/02/01/history-on-the-couch/ [Accessed 10 April 2019].

Pizzorno, A., 2008. *Sulla maschera*. Bologna: Il Mulino.

Reinhardt, J. U., 2016. The Grotesque Masks of Elias Canetti: Monads with No Doors or Windows. *Between*, 6 (12) [online]. Available from: http://ojs.unica.it/index.php/between/article/view/2169/2241 [Accessed 19 March 2019].

Sanchez, R., 2016. *Dancing Jacobins: A Venezuelan Genealogy of Latin American Populism*. New York: Fordham University Press.

Sontag, S., 1980. Mind as Passion. *New York Review of Books*, 25 September, 47–52.

Watson, I., 1969. Elias Canetti: The One and the Many. *Chicago Review*, 20 (21), 184–200.

6 Facing Everybody? Composite Portraiture as Representation of a Common Face

Raul Gschrey

The combination of facial features in composite portraiture was aimed at deducing average characteristics from individual photographs and at the production of an archetypical meta-portrait. Its typifying gaze was directed at phenomena such as criminality, "race", mental and physical illnesses, but also at health, beauty and family resemblance. The technique was based on the assumption that inner characteristics could be read from the outer features and it is thereby linked to other forms of deciphering the human face in physiognomy and phrenology, which enjoyed considerable popularity in the 19th century. The technique united the quest for the visualisation of the invisible with a positivist scientific orientation towards a statistically valid average. Its founder, Francis Galton, construed the technique as pictorial statistics in relation to the work of Adolphe Quetelet and his statistical figure of the *homme moyen*, the average man (Figure 6.1).[1] The technique thus oscillates between picturing the average and the type, between the visualisation of no one and everyone. These artificial facial constructions constituted remarkable visual experiments; they produced images that were published in scientific and popular journals, shown in exhibitions and thus influenced the 19th-century public imagination of typical collective bodies and the figure of everybody.

Galton's generic portraits[2] show striking similarities to the ideal arithmetical person proposed by Quetelet, whose statistically averaged person constitutes a central but ambiguous reference for current understandings and representations of the concept of "everybody". The everybody figure has been described as a self-validating intermediary character that is not necessarily an average construction, but rather a discursively constructed representative figure, which exhibits two major functions: addressing as well as involving the public (Schober 2015). "Everybodies", furthermore, link the universal and particular and constitute projection screens for the superimposition and negotiation of the self and the other and are often used by artists as identificatory devices that can evoke affirmative as well as dissociative reactions (Schober 2015). The term everybody, in contrast to the more commonly used denominations "everyone" or "everyman", proves particularly useful for my argument and topic. The term highlights the connection of the common, intermediary figure to the body and its physical appearance. This focus on the body as a locus of identification and typification is particularly relevant for composite portraiture, which visually—and implicitly materially—links the individual body and face to a larger collectivity. The technique proclaims the embodiment of characteristics, the externalisation of invisible traits and features—and it constructs symbolic collective bodies of social, ethnic and national groups that are related to but distinct

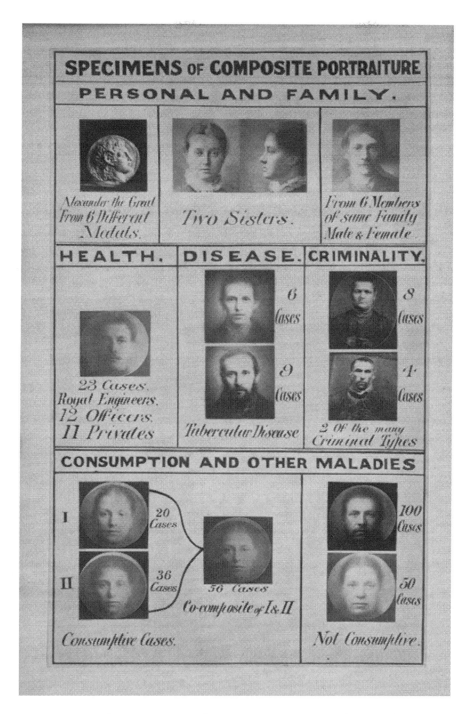

Figure 6.1 Francis Galton, *Specimens of Composite Portraiture*. Chart published in Galton, Francis (1883). *Inquiries into Human Faculty and its Development*. London: Dent.

from older conceptions of an embodied, common multiplicity, such as Thomas Hobbes' famous figure of the Leviathan.[3] And even though composite portraits show differences in terms of the popularising and addressing function of everybody figures, some of the artificially constructed composite faces adapted the affirmative, universalising role of "everybodies", as well as their identificatory and representative power.

I will begin with a historical perspective on the ideal, common faces produced by means of composite portraiture, followed by a discussion of their relationship to Adolphe Quetelet's figure of the average man and their potential as everybody figures. In the final part I will discuss current artistic works and an advertising campaign that both make use of the technique of visualisation and examine whether these current composites can be conceptualised as everybody figures.

"No Man in Particular": Synthesising the Common Face

In 1878 the scientist Francis Galton, a cousin of Charles Darwin and the founder of eugenics, proposed a new technique of scientific visualisation: the photographic superimposition of a set of full-face—in a few cases profile—portraits in one photographic print. The composite portraits were described in terms of generalised images (Galton 1879) and were considered an instrument to produce a visual average of a group of people by condensing numerous individual facial features into an ideal, common face.[4] Galton cautions against reading these combined or generic portraits as actual faces. Even though he observes a "surprising air of reality" (Galton 1883, 341), he stresses their nature as visual constructions and affirms that they represent "no man in particular, but [portray] an imaginary figure, possessing the average features of any given group of men" (Galton 1878, 97). A French contemporary, Arthur Batut, who made extensive use of the technique, described the images as *portrait de l'invisible*, a portrait of the invisible (Batut 1887, 17). The technique is thus a form of artificial visualisation that produces images that have no referent in the real world. But in the framework of positivist science this visualisation of the invisible, an endeavour we would now probably relegate to the realm of the arts, was accorded far-reaching evidential value. In this respect, it is important to keep in mind that when Galton speaks about "features", he means outward signs of hereditary traits and genetic disposition—signs that were used as arguments for the understanding of the fundamental difference of human "races" and of classes in society. An idea of a biological essence that developed very real consequences.

Confronted with new theories on the origins and development of the human, 19th-century science sought to (re-)position humankind in relation to the surrounding world. The visual taxonomic technique of composite portraiture became part of this massive semiotic venture of Victorian science (Scholz 2013, 15). The normative visualisations sought to hierarchise groups of people and construed images of the criminal, of racial physiognomies, as well as mental and physical pathologies. The technique was thus attributed explanatory power in the fields of criminology, biology, anthropology and ethnology, medicine and psychology, but also for Galton's most sombre and "practice-oriented" project of eugenics, the improvement of the genetic quality of humankind. Through the claim of the presence of visual truths in the human face and the assertion of their evolutionary make-up, the visualisations were construed as a means of synthesising hereditary dispositions. The technique was aimed at deciphering characteristics of an ancestral genetic past, as well as

visualising signs of an evolutionary future. Composite portraits were therefore not only understood as static representations of genetic, moral or "racial" types, but also as instruments to recover the past and devices for projecting the future. As a result, they constituted an appealing medium for eugenic movements around the turn of the 20th-century, and as role-models for the construction of new and enhanced "everybodies". However, even though composite portraiture was conceived in terms of generic and typical portraits, these are far from assuming a universalising function, a basic principle of everybody figures. Composite faces seem to depict specific moralist, classist and racist "everybodies" that could assume a popularising function only for a particular audience.

Facial Statistics: Countenances of the Average Man

Francis Galton conceived of the photographic superimpositions as a form of visual statistics, deducing the average, typical characteristics of a set of specimens. He highlights the proximity of composite portraiture to the work of the Belgian mathematician, statistician and sociologist Adolphe Quetelet (Galton 1879, 162), who in his "social physics" pioneered the statistical enquiry into the social sciences in order to study the distribution of physical properties of the human body, as well as social phenomena such as criminality, poverty and education. Drawing on the normal distribution of human characteristics in society and mean statistical values, he introduced a common statistical figure and the concept of the "average man":

> The average man is not merely a matter of speculative curiosity; it may be of the most important service to the science of man and the social system. It ought necessarily to precede every other inquiry into social physics, since it is, as it were, the basis. The average man, indeed, is in a nation what the centre of gravity is in a body; it is by having that central point in view that we arrive at the apprehension of all the phenomena of equilibrium and motion.
>
> (Quetelet 1842, 96)

The statistical enquiry into the characteristics of the average man allowed for the abstraction from the individual, and to "regard him as a fraction of the species" (Quetelet 1842, 5) in order to describe an imaginary but statistically valid common figure. In analogy to visual perception, Quetelet describes how, in this process of zooming out and looking at the whole, individual peculiarities that have no or little influence on the mass become effaced and disappear (Quetelet 1842, 5).

Subscribing to Quetelet's conceptualisation of a supra-individual figure and the equilibrating, "effacing" function of statistics, Galton positions composite portraiture as a process of "pictorial statistics, suitable to give us generic pictures of man just as Quetelet obtained in outline by the ordinary numerical methods of statistics" (Galton 1879, 162). Composite portraits were identified as a visual equivalent of the beautiful symmetrical form of the binomial curve, or as Allan Sekula has put it: "the symmetrical bell curve now wore a human face."[5] Compared to statistical graphs, Galton argues, composite portraits did not produce a mere outline but a picture (Galton 1878, 162). And taking up Quetelet's argument, he was convinced that the dominant contours were to reveal the general characteristics, while the individual peculiarities left little or no visible trace. Galton treats his photographic compositions as analogous to numerical statistical

enquiries. The images are proclaimed as a means of verifying hypotheses (Galton 1907 (1883), 11–12) and statistical constancy is claimed whenever a sample is large enough (Galton 1881, 144).

Yet, in all their fuzziness, the composite portraits were credited with providing even more information than statistical averages, since they contained not only the adjusted numbers but also the raw visual data: "They are the pictorial equivalents of those elaborate statistical tables out of which averages are deduced" (Galton 1879, 163). Here the claim for a pre-eminence of visuality over numeracy is established that characterises the 19th-century understanding of composite portraiture.

Even though the composite portraits attempted to provide a visual equivalent to the archive,[6] the informative value of composite portraiture remained low. For instance, in the first series of composites produced from prison portraits, Galton merely used two dozen individual portraits, selected from several hundred that had been made available to him from a still much larger archive of tens of thousands of portraits in the British judicial archives. These quite apparent contradictions to basic principles of statistical validity were not questioned by the scientific community. Neither was the tautological nature of the visualisations, their components carefully chosen to fulfil the visual prerequisites for which the result was supposed to provide evidence. Taking into account the underlying assumption of the fundamental and aligned phenotypic and genotypic, physical and mental differences of human groups, the selection criteria for compiling samples are obvious: within a predefined group, be it criminals, soldiers, Jewish schoolboys or Baptist ministers,[7] whatever looks alike necessarily is alike and is thereby suitable as a component for a photographic composition. Caught in this circle of self-fulfilling prophecies, composite portraits are positioned as proclamations of visual truths and sublime aesthetics; their soft focus and fuzzy nature provided no clue, no grounds for critique within the framework of positivist science. This is probably why they were frequently employed as figures in the popularisation of science, a function that is attributed to everybody figures. This is attested by the publication of composite portraits in popular photographic and scientific journals that were addressed to an amateur audience. The visualisations were often used as frontispieces and eye-catchers, such as Hamilton Wey's composite of inmates of the American Elmira Reformatory in Havelock Ellis' *The Criminal* (1890), which sought to introduce positivist criminal anthropology to a wider English-speaking audience. Composite faces thus can be read in relation to the argument that everybody figures functioned as central elements in the production of knowledge and as mediators between new scientific disciplines and the everyday life of the population (Schober 2015, 245). They constituted devices of scientific popularisation of a common figure, and the technique achieved striking acceptance in the short-lived field of positivist criminal anthropology and in 19th-century popular science.[8]

The figure of Quetelet's average man did not remain descriptive; it also gained prescriptive potential, as an ideal of beauty, as a model for physical and moral progress and as a target and marksman for ideal development (Stigler 1986, 171–172): "the average man [...] should be considered as the type of all which is beautiful—of all which is good" (Quetelet 1842, 100). This is a fundamental shift compared to older conceptions of identificatory figures and their emphasis on the exceptional and ideal. The figure of the average man was a celebration of the median and the equilibrium,

thereby accepting deviation as normal within the limits of the variety of the general population. Here Quetelet's *homme moyen* suits as an identificatory everybody figure, but likewise as a statistical variable through which the difference between individuals and groups, their progress or decline, could be measured and compared. This statistical data could in turn be employed to tackle social problems—phenomena such as criminality, birth rates and infant mortality, malnutrition, illnesses and mortality rates.

Galton's ontological picture of the human and his epistemological project is a different one: his project zooms in on the body as a readable surface, on hereditary signs inscribed on the body and face, on marks of particular physical and genetic deviancy. He focuses on specific deviations from the norm, when he constructs visual types of humanity, faces of criminality, of "races" or of physical and mental illnesses. Galton advocates against eliminating difference in society; he considered it the "reverse of improvement to make all [...] assimilate to a common type" (Galton 1883, 2). He cautions not to end at the same "dead average level" (Galton 1890, 16) and goes on to argue:

> An average man is morally and intellectually an uninteresting being. The class to which he belongs is bulky, and no doubt serves to keep the course of social life in action. [...] But the average man is of no direct help towards evolution, which appears to our dim vision to be the goal of all living existence. Evolution is an unresting progression; the nature of the average individual is essentially unprogressive.
>
> (Galton 1890, 15–16)

This casts light on Galton's ideological agenda: his eugenic research seeking to identify individuals and groups of people who were considered unfit for reproduction, or those who presented characteristics and dispositions that were deemed useful for the advancement of the "race" and nation.

Affirmative Collective Bodies

With respect to these positive eugenic ideas, Galton's facial statistics also develop an affirmative function when he directs the technique at positively connoted phenomena, such as beauty, family resemblance and the construction of what I refer to as eugenic role models. This function is clearly expressed in the composite portrait entitled *Health* (Galton 1883), the superimposition of portraits of officers and privates of the Royal Engineers.[9] The composite face of the soldier is presented as an ideal of physical and intellectual capability. It assumes the authority of a eugenic role model when Galton states that: "This face and the qualities it connotes probably gives a clue to the direction in which the stock of the English race might most easily be improved" (Galton 1883, 10). In the charts published in Galton's writings this figure is often used as a positive counter image to his visualisations of the faces of disease and criminality.[10]

The affirmative use of the technique was taken up in the US around the turn of the 20th century. In the north-eastern urban centres composite portraits of members of respected professions and scientific societies were compiled.[11] Here the aspect of a common representation in the construction of a new American elite, superior in physical, moral and intellectual qualities, is infused in the photographically

composed everybody figure. It even became fashionable to produce composite portraits of graduating classes of north-eastern American colleges.[12] The college composite faces performed a double function: to identify with a group, shared ideas and a common appearance, as well as to strive towards a utopian, eugenic ideal (Belden-Adams 2015).

The Smith College class of 1886 became acquainted with the technique through their professor John Tappan Stoddard. The class identified strongly with their composite portrait and even gave her a name: "Composita". They adopted the image as a kind of collective identity and mascot and even wrote and performed a play named after the composite heroine.[13] In this case the composite face functioned as an, albeit specific, identification figure, the visualisation of a collective everybody. This identity politics found a useful ally in a characteristic of the technique that softened the faces and thereby increased attractiveness in the production process.[14] Stoddard later published the image of "Composita" in *Science* (Stoddard 1886) together with composite portraits of sub-groups according to their scholarly achievements (Figure 6.2), giving the image further authority as a means in the scientific authentication of social status and intellectual capacity. Later his composites of Harvard graduates were exhibited in the Second International Eugenics Exhibition of 1921. But even though they were proposed as identificatory figures and collective faces they never achieved widespread popularity.

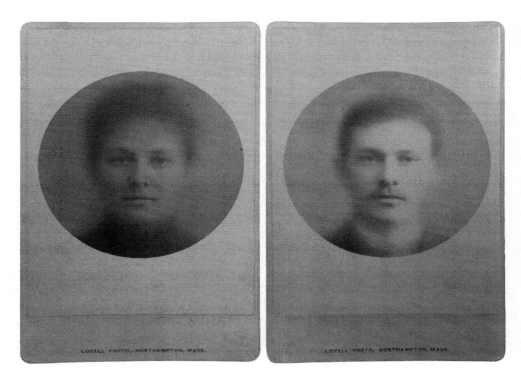

Figure 6.2 John Tappan Stoddard and John L. Lovell, Composite portraits of 287 female Harvard students and 449 male Harvard students, 1887. Galton 2/8/1/1/3, Galton Papers, Special Collections, University College London. Copyright: UCL Library Services, Special Collections.

The Artistic Revival of Composites

As we have seen, the identificatory and popularising potential of 19th-century composite portraiture remains limited. This is due to its normative dimension and its focus on deviancy on the one hand and exemplary role models on the other. This changes in adaptations of the technique in the American context around the turn of the 20th century, when composite faces begin to express a common intellectual and class identity, a visual collective self that is defined in contrast to "other" collective faces of the new world.[15] In late 20th- and early 21st-century arts and popular culture, composite portraiture expands its universalising potential and is employed for the construction of an inclusive iconic figure, a composite face of "everybody".

Apart from a few exceptions,[16] composite portraiture had fallen into disuse by the beginning of the 20th century. Only in the 1980s, at a time when, due to advances in digital recording and computerisation, the world was witnessing a veritable revolution in the production and diffusion of images, was composite portraiture revived in the visual arts. In this decade the New York-based media artist Nancy Burson produced composite portraits, among others of female and male movie actors, businessmen and militaristic statesmen, and the French artist Christophe Pruszkowski started to work with the technique of photographic superimposition and expanded the genre to the depiction of objects, buildings and indoor and outdoor views. While Pruszkowski's composites are still analogue photographic superimpositions, Burson's work was influential in bringing the superimposition of faces into the digital age: together with a partner, she developed the first morphing software that allowed for the gradual and also animated integration of two or more images.[17]

Visual arts seem to be reclaiming a technique that, as I have argued elsewhere, has a common genesis in the scientific as well as the artistic realm.[18] In the current artistic field, composite portraiture is experiencing a reinterpretation. Many of the artworks of the past 35 years oppose 19th-century modes of scientific reasoning and deliberately question the evidential value of the photographic compositions by using the technique against the grain. The work of Gerhard Lang[19] for example, who adopts historic scientific techniques and instruments and artistically revives scientific methodologies and experimental layouts, and thereby contests not only the scientific backgrounds of the composite technique but also modes of positivist scientific of reasoning and visual knowledge production in general. Other artists, such as Nancy Burson and Florian Tuercke, emphasise the averaging, universalising potential. In these cases, however, sometimes the basic assumptions of the technique, its evidential claims and ideological connotations remain unchallenged.

Uncanny Celebrations of Difference: Florian Tuercke

A number of contemporary artistic works make use of the identificatory potential of the composite portraits. The fuzzy images are used as projection screens for the negotiation of the self and the other. The diffuse faces become conscious visualisations of a shared humaneness in a common, multicultural face. The artworks draw on affirmative responses in relation to the facial compositions, but, despite their emphasis of difference, they often invite comparisons and do not explicitly challenge the explanatory power of the technique. An early example is Nancy Burson's

installation *Human Race Machine* (2000), which allowed viewers to experience their own facial features transformed into a different composite ethnicity. A celebration of difference in similarity and of diversity in the 21st-century urban population also appears in the series *The Others Are We* (2015–2016), by the Nuremberg-based artist Florian Tuercke (Figure 6.3). His video composites aim to address and include each and everyone, producing a collective face of a city. In the ongoing project, the artist superimposes the moving facial portraits that he records in different cities. Through the change of medium to video, additional layers of information are added in comparison with photographic composite representations. The cityscape in the background becomes an overexposed, rapidly moving backdrop and a sound collage of the respective cities forms the acoustic environment for the video installation. The composite faces in the monitors do not remain static; they show hints of fluctuating expression and emotional reactions that were captured during the process of recording—it seems to be not one face but a veritable multitude. This contrasts with Galton's stipulations concerning the technique: the Victorian scientist strove to capture the component faces in repose, in a neutral and unaltered, stern expression in order to compose immutable types of common physiognomies.

In the exhibition of *The Others Are We* in the video gallery con[SPACE] in Frankfurt/Main, Germany 2016, the monitors showing the slowly moving composite faces were installed at eye-level, involving the visitors in a face-to-face dialogue. But an uncanny and intangible feeling of suspicion arose in this direct encounter with the

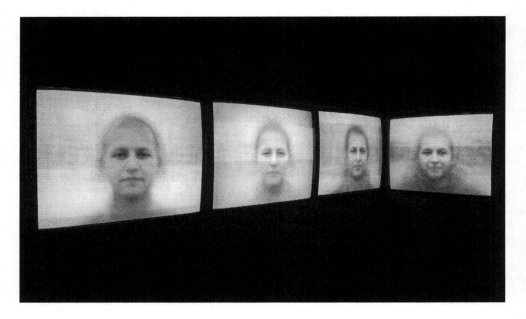

Figure 6.3 Florian Tuercke, *The Others Are We*, 2015/2016, portraits of the average faces of people in Ragusa (IT), Wakefield (UK), Schweinfurt (D) and Frankfurt am Main (D), composite single-channel videos, duration variable, colour, sound, installation view: con[SPACE], Atelierfrankfurt, 2016. Photo: Raul Gschrey.

composites. The fluctuating faces stare at the viewer, their eyes are unblinking and it seems impossible to evade their gaze. Sometimes specific traits seemed to grow stronger, giving the ghost-like faces a more human, almost individual air, which over time changed and left nothing but an opaque humanoid form. This ambiguity in the reception of composite portraits in general, and Tuercke's video composites in particular, can be addressed by the concept of the uncanny valley, proposed by Masahiro Mori in the 1970s. The Japanese robotics expert observed that the acceptance of artificially constructed figures does not increase linear to their anthropomorphic resemblance. A measurable gap in emotional responses, an abrupt shift from empathy to revulsion, can be observed when artificial human forms get close to but do not completely match a natural human appearance (Mori 2012). This may explain the strange, the uncanny feeling when looking at composite portraits, a reaction that is deliberately employed by some artists, such as Thomas Ruff and Jake Rowland.[20] But in static composite portraits this strange feeling usually goes unnoticed or remains at a subconscious level. Mori notes that the phenomenon of the uncanny valley increases though movement; this may be the reason for its particularly powerful effect in Tuercke's video composites.

In the participatory project *my_friend* (2015) Turecke transfers the technique to the sphere of social media: to Facebook, which is built around profiles and profile images and employs statistical tools and biometric recognition. From the video material provided by 45 of his online contacts, the artist composed a video composite and a still image that he released on the online platform and that many of the contributors chose as their profile picture. The project not only questions proclamations of infinite individuality that are the driving force of social media networks, but also develops a critical potential in relation to facial recognition algorithms in social media.[21] The composite face is still recognised as a face by Facebook's software, but at the same time it prevents recognition and masks individual characteristics by multiplying them. Compared to affirmative 19th-century composite portraits, Tuercke's work deliberately refrains from applying statistical reasoning; the components are uncurated, random choices in the respective spaces and contexts and they are not employed in constructing physical typologies. With his social-media composite the artist proposes an appealing everybody figure that merges the specific and the universal, as well as addressing and identificatory functions, while developing a considerable subversive potential.

Universalised Targeting: Benetton's "Collection of US"?

In spring 2016 Benetton launched its *Face of the City Campaign* to promote the new *Carnival Capsule Collection*, an example of a recent, uncritical adaptation of the technique of composite portraiture in advertising and popular culture.[22] The campaign was created by analysing ethnicity statistics of several cities using national databases and city censuses. Groups of women who were judged representative of the "city's mix of races and cultures" (Benetton 2016) were photographed and the portraits were digitally combined, proportional to the ethnical constitution, representing facial features such as skin tone, the shape of eyes and nose, hair type and the overall face shape. The composite portraits were published in a global campaign in print media, online and on posters and billboards.

The campaign's short video clip[23] begins with a slow zoom on a well-lit but empty photo set and the caption: "Our new models do not exist. They are statistically accurate representations of all the ethnicities living in some of today's key cities. Created by a custom algorithm."[24] The process of the composition of the individual composite faces is presented as an animation that starts with individual portraits and their superimposition. Layers of biometric markers and triangulation patterns are added while the image gradually merges into a representative face captioned: "This is the Face of London/Berlin/Milan/Paris/New York/Tokyo". Additionally, statistical percentiles of ethnic, racial and national composition are added, emphasising the scientific objectivity and the evidential character of the composite models. The animation retains the superimposition of the uneven frames of the photographic background, relics of a production process that were often eliminated before publication in 19th-century composites. This deliberate choice is more than a matter of design; it emphasises the origin of the composite faces in individual portraits and authenticates the production process. The relics were also part of the print versions of the advertising campaign, forming a frame around the head of the composite models whose bodies are cropped from the background.

The press release highlights the connection with the company's cosmopolitan celebration of diversity and its image as an influential contributor to popular culture:

> The resulting face for each city was then composited [...] into the final image, giving life to the capital's ideal resident. All together, the six faces are stunning portraits coming from a world in which the melting pot, so revered in thirty years of Benetton's images, has finally become the norm. Surely a software may have helped to reveal it, but there's little space for doubt: that world is finally here and diversity is even more beautiful than we imagined it to be.
>
> (Benetton 2016)

The message of the construction of statistically validated "everybody faces" of influential European, US and Japanese fashion cities seems clear: the campaign is aimed at directly addressing and involving the public not by choosing a singularly beautiful model, but by letting an ethnically averaged face of the respective cities wear the new collection. But the celebration of difference and the melting pot has a problematic downside, in particular when the company refers to the images in terms of "ideal residents" and new "norms", while arguing with highly questionable racial ascriptions and the unquestioned direct equation of the measurement of facial features with ethnic belonging. Particularly problematic are the disputable and inconsistent labels for the ethnic compositions in the video, which intermix "racial", cultural and national terminologies such as Caucasian, Latin, Arab, Black, Asian, Middle Eastern, as well as Japanese, Korean and Chinese.

So what kind of everybody is presented here? Is it really a "Collection of US", as proclaimed by the clothes producer? It seems rather like the fashion industry's self-affirmation in the guise of beautiful female faces, but also a reaffirmation of the empirical validity of a physiognomic and racial argument and of the evidential value of the historically problematic technique of composite portraiture. And the reactions in online media were mixed: while some embraced this normative representation of beauty and the utopian "melting pot", others felt excluded by the

singularly aesthetic, waxen countenances, in view of which most members society, even if they might happen to be young and female, must feel inferior and substand-ard. Contrary to Benetton's post-racial marketing ideology, the "face of the city" not only represses difference and individuality. Probably unintentionally, it also proclaims a beauty ideal of normalised average features that is not unlike Galton's work, who sought to picture ideals of classical female beauty in a series of compos-ite portraits of Greek and Roman coinage.[25]

Productive Uncanny Encounters

In my exploration of composite portraiture in relation to the everybody figure, I have traced a common conceptual basis of the photographic technique of visual-isation, Adolphe Quetelet's statistical work and his figure of the average man. The approaches share a statistical and actuarial basis and are concerned with the abstraction from the individual to the general. They endeavour to give a face to the chaotic multiplicity of the crowd in times of increasing industrialisation and urban-isation, expanding European colonialism and in the light of a secular repositioning of the human in the world through scientific revolutions such as evolutionary theory and its application to humankind.

The examination shows that, notwithstanding the proximity of the concepts, Gal-ton's composite face is far from congruent with the face of Quetelet's everybody figure. Despite his adaptations and direct references to Quetelet, Galton presents various specific "bodies", with distinct facial features, precisely in order not to see the common ground, but to construe types or classes—and a visual semiotics of dif-ference in humankind. He does so in pictures rather than in statistical tables: arith-metical means become translated into visual averages; visuality is positioned against numeracy. The averaging techniques of Quetelet and Galton address different senses; they employ different media and are based on different modes of reasoning. Even though Galton stresses the advantages of the direct and unmediated percep-tion of the faces and tries to construe the composed portraits as direct and objective representations of measurable characteristics, the fuzzy images remain opaque and open to a variety of readings.

The historical perspective reveals the proclamatory nature of composite portraits and their normative inscriptions that are not necessarily inclusive. The average faces provided prototypes against which individuals could be compared and judged: exclusionary, prescriptive figures that were mainly used as representations of a deviant physique aligned with deficient moral and intellectual qualities. Looking back on the historical examples, it becomes clear that, apart from their role as eugenic role models, most of the historical composite faces do not function as rep-resentative and affirmative visualisations of everybody figures.

Current examples from arts and popular culture seem to share a fascination with the ambiguous composite images that oscillate between the particular and the uni-versal, that show a face, but not a person. They draw on the affective potential of a common face and propose numerous average faces, a crowd of "everybodies". The ideologically tainted, segregating potential of scientific composite portraiture, however, remains prevalent alongside its affirmative potential. Contemporary artists have facilitated composite portraiture's transition into the digital age. At the same time the artworks formulate critiques of evidential claims of the technique, or

question scientific modes of positivist reasoning. Others emphasise the difference in unity of the visual constructions, as well as their potential for subversive interaction in social media.

The composite becomes a projection screen that requires performative work in an uncanny face-to-face encounter between the composite face and the viewer. Many current composite portraits offer productive redefinitions of a one-and-a-half-century -old technique. However, not all products of arts and popular culture maintain the necessary distance from their historical scientific predecessors; some embrace attributions of an explanatory power of the visual constructions or invite direct comparisons. The most recent revival of composite portraiture in the 2016 Benetton campaign, even though presented as a celebration of difference, is a confession of failure. The composite fashion faces condone racial readings of facial features and they accept the validity of a late 19th-century pseudoscientific endeavour. While trying to involve all female consumers through the singularly beautiful artificial faces, the campaign eventually disregards and excludes potential customers.

The ambiguities and ruptures that become visible in artworks and popular culture can launch productive discussions of the multifaceted technique of composite portraiture and its history, as well as its current, often unreflected utilisation. Despite all statistical reasoning and the proclaimed objectivity of the composition process, it is important to keep in mind that composite faces are visual constructions that—along with the affirmative, universalising potential—carry a dark history and highly questionable criminological, medical and eugenic connotations. In relation to these visual proclamations of collective-everybody faces, it seems more than necessary to reserve a notion of uncanniness as a productive phenomenon and reality check and a reminder of the ambivalent history of visual knowledge production and the cultural construction of ideal collective figures.

Notes

1 I will refer to the *homme moyen* as the "average man". This is the translation that was used in the English editions of Quetelet's work.
2 In an 1879 presentation, Galton uses "generic portraits" for the technique and credits the influential biologist and advocate of evolution theory Thomas Henry Huxley for proposing the term (Galton 1879, 162).
3 The Leviathan, itself a conceptual visualisation, is treated as a model for modern notions of collectivities and the everybody figure. The frontispiece shows a giant human being towering over a landscape. The figure is carrying the insignia of royal power, its chest and arms are composed of numerous tiny people whose bodies are arranged in military order, while the face exhibits an individual countenance. Hobbes describes this collective figure as an artificial man who represents the state as an allegory for the militant community and the common good, attributing a political function to this collective body. See: Hobbes (1985 (1651)). *Leviathan*. London: Penguin. For a current discussion of *Leviathan* see: Assmann 2006, 111.
4 Galton argues that in composite portraits: "All that is common remains, all that is individual tends to disappear" (Galton 1879, 163).
5 Allan Sekula observed this relationship of the composite portrait to the binominal curve and notes that: "Galton believed he had translated the Gaussian error curve into pictorial form. The symmetrical bell curve now wore a human face" (Sekula 1986, 48).
6 Allan Sekula highlighted this reading, which was also explicitly stated by Galton himself (Sekula 1986, 55).

7　These were among the subjects Galton was experimenting on by means of composite portraiture. A curious composite portrait of Baptist ministers is preserved among the Galton Papers. See: Galton/2/8/1/3/3, Galton Papers, Special Collections, University College London.

8　Composite portraits were also published in the works of Cesare Lombroso and Charles Goring (Lombroso 1888; Goring 1913).

9　Here Galton takes up a subject that had been examined statistically by Quetelet, who developed a theory of the average man through a study of anthropometric measurements of soldiers from France, Belgium and Scotland (Stigler 1986, 171–172). Also the US citizen Henry Pickering Bowditch took up this specific group of people when he produced composites of German soldiers of Wend and Saxon origin from portraits he received through the former general Bernhard von Funcke (Bowditch 2017).

10　See the chart "Specimen of Composite Portraiture" (Galton 1883, facing page 8).

11　Henry Pickering Bowditch produced composite portraits of American doctors, as well as horse car conductors and drivers (Bowditch, 1894). Raphael Pumpelly compiled composite portraits of members of the American academy of sciences (Pumpelly 1885).

12　John Tappan Stoddard produced composite portraits of college classes in the years 1886, 1887, 1889, 1890, 1891 and 1892. See: (Stoddard 1886) & (Stoddard 1887) The commercial photographer John L. Lovell produced composites of male and female Harvard students in 1887. See: (Belden-Adams 2015). School photography interestingly is the genre where composite portraiture has survived in the commercial context until today.

13　Kati Curts discusses the production and reception of the composite portraits from Smith College and the play *Composita Ocgenta Sex: A Drama in Three Acts by one of her Components*. She argues that the graduating class of 1886 embodied the composite photograph and describes it as an icon of class-devotion, femininity and whiteness. The actress of Composita in the play is characterised as an "everywoman" (Curts 2014).

14　Francis Galton had already observed the advance in attractiveness of composite portraits compared with the individual components. Interestingly, this is the field where the technique of composite portraiture and its digital equivalent of facial morphing is still used in 21st-century science: in the study of attractiveness.

15　Examples can be found in the composite portraits of Native Americans by Alice C. Fletcher and the composite portraits of inmates of Elmira Reformatory, New York State (Fletcher 1886).

16　Two notable exceptions are a study by the experimental psychologist David Katz (Katz 1953) and the composite portrait of Ludwig Wittgenstein and his family dating from the 1920s.

17　Interestingly, this process of morphing that compares and merges every single point in the respective images successively was anticipated by Francis Galton.

18　A survey of the history of composite portraiture reveals strong artistic influences, the first photographic compositions of several negatives on one photographic plate, for instance, were produced by artistic photographers (Gschrey 2014).

19　In his series of composite portraits *The Typical Inhabitant of Schloss-Nauses*, Gerhard Lang used the technique on the inhabitants of his hometown in 1992 and 2000.

20　In his series *Andere Porträts* (1994–1995) the German artist Thomas Ruff produced analogue composite portraits of two people each with an identikit picture generator that had previously been used by the German government criminal investigation department. In his group of works *Wife/self* (2005) the US-based artist Jake Rowland also draws on the contrast between individual faces and imperfection by selectively superimposing portraits in his series of family composites.

21　Biometrical face recognition measures individuality against averaged facial features. The algorithms usually work with an average visual figure, which is computed from characteristics of individual facial images and in relation to which individual characteristics that allow for the identification of individuals are defined. This *eigenface* (own face) could thus be understood as a vectorised composite portrait.

22　The campaign seems to be inspired by the project *The Face of Tomorrow* by the South African photographer Mike Mike, who in the 2010s produced a series of composite portraits of the inhabitants of various countries, regions and cities.

23 Benetton's promotional video *Faces of the City Case Study* is available online: https://vimeo.com/154965758 [Accessed 4 January 2019].
24 Captions in Benetton's promotional video, see: https://vimeo.com/154965758 [Accessed 4 January 2019].
25 Galton conducted a series of experiments with coins and medals from the British Museum collection. A number of composites of individual historical figures, such as Alexander the Great, Nero and Cleopatra as well as more general compositions of Greek and Roman women are preserved among the Galton Papers. See: Galton/2/8/1/3, Galton Papers, Special Collections, University College London.

References

Assmann, A., 2006. *Einführung in die Kulturwissenschaft*. Berlin: Erich Schmidt.
Batut, A., 1887. *La photographie appliquée à la production du type d'une famille, d'une tribu ou d'une race*. Paris: Gaulthier-Villars.
Belden-Adams, K., 2015. Harvard's Composite "Class" Pictures. *Photographies*, 8, 125–136.
Benetton, 2016. *United Colours of Benetton: Merging Colours, Merging Identities*, press release [online]. www.benettongroup.com/media-press/press-releases-and-statements/united-colors-of-benetton-merging-colors-blending-identities [Accessed 4 January 2019].
Bowditch, H. P., 1894. Are Composite Photographs Typical Pictures? *McClure's Magazine*, September 1894, 331–322.
Bowditch, H. P., 2017. A Group of Saxon Soldiers and their Composite. *Center for the History of Medicine: OnView* [online]. https://collections.countway.harvard.edu/onview/items/show/6213 [Accessed: 5 January 2019].
Curts, K., 2014. Shadowy Relations and Shades of Devotion: Production and Possession of the 1889 Smith College Photograph. *In:* S. M. Promey, ed., *Sensational Religion: Sensory Cultures in Material Practice*. New Haven, Connecticut: Yale University Press, 113–134.
Ellis, H., 1890. *The Criminal*. London: Walter Scott.
Fletcher, A., 1886. Composite Portraits of American Indians. *Science*, 7 May, 408.
Galton, F., 1878. Composite Portraiture. *Nature*, 18, 23 May, 97.
Galton, F., 1879. Generic Images. *Proceedings of the Royal Institution*, 9, 161–170.
Galton, F., 1881. Composite Portraiture. *The Photographic Journal*, 25, 24 June, 144.
Galton, F., 1883. *Inquiries into Human Faculty and Its Development*. London: Dent.
Galton, F., 1890. Human Variety: Presidential Address Delivered at the Meeting of the Anthropological Institute, 22 January 1889. *In:* F. Galton, ed., *Anthropometric Laboratory: Notes and Memoirs*. London: Richard Clay, 12–23.
Galton, F., 1907 (1883). *Inquiries into Human Faculty and Its Development*. London: Dent.
Galton, F., 1880. Galton Papers, Special Collections, University College London. Galton/2/8/1/3/3.
Goring, C., 1913. Composite Portraits: 30 Criminals. Frontispiece. *In:* C. Goring, ed., *The English Convict: A Statistical Study*. London: HMSO.
Gschrey, R., 2014. "A Surprising Air of Reality"—Kompositfotografie zwischen wissenschaftlicher Evidenzbehauptung und künstlerischer Subversion. *In:* U. Richtmeyer, ed., *Phantom Gesichter: Zur Sicherheit und Unsicherheit im Biometrischen Überwachungsbild*. Munich: Fink, 85–106.
Hobbes, T., 1985 [1651]. *Leviathan*. London: Penguin.
Katz, D., 1953. *Studien zur Experimentellen Psychologie*. Basel: Benno Schwabe.
Lombroso, C., 1888. Photographies composes galtoniennes de cranes de criminels. *In:* C. Lombroso, ed., *L'Homme Criminel: Atlas*, 2nd edn. Rome; Turin; Florence: Bocca Frères, Plate XXXVIII.
Mori, M., 12 June 2012. The Uncanny Valley (1970). *IEEE* Spectrum [online]. Available from: https://spectrum.ieee.org/automaton/robotics/humanoids/the-uncanny-valley [Accessed 28 January 2019].

Pumpelly, R., 1885. Composite Portraits of Members of the National Academy of Sciences. *Scientific American*, 5 September, 151.

Quetelet, A., 1842. *A Treatise on Man and the Development of His Faculties*. Edinburgh: Chambers.

Schober, A., 2015. Everybody: Figuren "wie Sie und ich" und ihr Verhältnis zum Publikum in historischem und medialen Umbruch. *In:* J. Ahrens, L. Hieber, and Y. Kautt, eds., *Kampf um Images: Visuelle Kommunikation in Gesellschaftlichen Konfliktlagen*. Wiesbaden: Springer, 241–270.

Scholz, S., 2013. *Phantasmatic Knowledge: Visions of the Human and the Scientific Gaze in English Literature, 1880–1930*. Heidelberg: Winter.

Sekula, A., 1986. The Body and the Archive. *October*, 39, 48.

Stigler, S. M., 1986. *The History of Statistics: The Measurement of Uncertainty Before 1900*. Cambridge, Massachusetts and London: Harvard University Press.

Stoddard, J. T., 1886. Composite Portraiture. *Science*, 8 (182), 89–91.

Stoddard, J. T., 1887. Composite Photography. *Century Illustrated Monthly Magazine*, 33 (5), 750–757.

7 Contemporary Newsreel and New Everybody Figures as Mediators in Late Democracies

Andrej Šprah

In non-fiction film-making, we can follow the development and the changes in the figure of the everybody in a number of forms of factual cinema and documentary film genres. Among them, (anti)newsreels play an important role. This is a film form that, in its key development stages, was part of various revolutionary turmoils, labour and student movements, liberationist endeavours and confrontational campaigns. It almost completely died out in the 1980s and 1990s but has experienced a strong revival in the last 20 years, making a comeback in the field of committed cinema. Such a revitalisation of the radical forms of newsreel testifies to the exceptional significance of audio-visual practices in social and political conflicts. The current newsreel activities, which are most prominent in the UK, US, France and Slovenia, take place both on a collective and individual level. The group endeavours include, among others, the British collectives Undercurrents, Conscious Cinema and Reel News, the US web portal *Now! A Journal of Urgent Praxis*, and the Slovenian ad hoc collective Newsreel Front (Figure 7.1). In the case of individual film-makers, the more prominent are Jem Cohen from the US, Donal Foreman from Ireland, Alex Reuben from the UK and Sylvain George from France. There are two essential factors that determine the renewal of newsreel practices. One is the question of how the film-makers establish their relationship to the history of the selected film form, and the other is the affirmation of a new image of the everybody, with which they replace one that is characteristic of the periods their work corresponds to or the film-makers they draw on.

The active dialogue between the current film-making practices and the past is the reason that I will start by pointing out some of the historical features that testify to the importance of images of everybodies for newsreels. I thus take Walter Benjamin as the starting point, according to whom the newsreel form makes it possible for film reproduction to belong to a broad public and not just the privileged "star system" enforced by capital. Taking the examples of works by the Russian cineaste and the "father of the newsreel" Dziga Vertov and the Dutch documentary-maker Joris Ivens, one of the key film-makers of radical political cinema, he pointed out the importance of the newsreel for everyone:

> the newsreel offers everyone the opportunity to rise from passer-by to movie extra. In this way any man might even find himself part of a work of art, as witness Vertov's *Three Songs About Lenin* or Ivens's *Borinage*. Any man today can lay claim to being filmed. [...] the distinction between author and public is about to lose its basic character. [...] All this can easily be applied to the film,

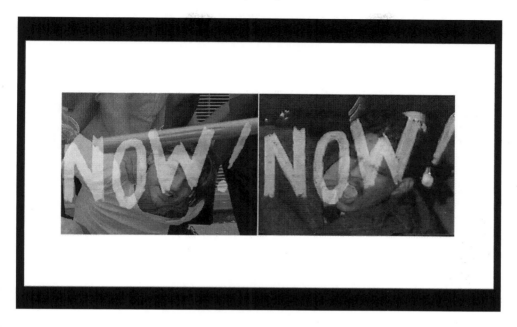

Figure 7.1 Alex Johnston, *NOW!, AGAIN!*, 2014, video, 5 min, colour, sound, videostill.
 Copyright: Alex Johnston.

where transitions that in literature took centuries have come about in a decade. In cinematic practice, particularly in Russia, this change-over has partially become established reality. Some of the players whom we meet in Russian films are not actors in our sense but people who portray themselves and primarily in their own work process. In Western Europe the capitalistic exploitation of the film denies consideration to modern man's legitimate claim to being reproduced.

(Benjamin 1969, 231)

Benjamin's belief that everybody should be subject to the process of film reproduction is not only a legitimate demand but also a potential starting point for the revolutionary criticism of social conditions. And it was directly realised in various social struggles at the same time as he was writing his epochal essay. The 1930s saw a boom in newsreel practices of the labour movements and trade unions in Germany (People's Film Association), the Netherlands (Association for Popular Culture), Britain (Workers' Topical News), the US (Workers' Film-Photo League, Nykino, Frontier Film Group) and elsewhere. The film activities of labour movements stood in opposition to the "official" news of big studios or state-owned information agencies. In them, the film image of the everybody, mostly represented in different forms of social unrest (strikes, workers' peace and hunger marches, rallies), relates to the endeavours of collective solidarity in the struggle for workers' rights, the equality of women and more decent life in general. As such, we can

consider them as forerunners of the key period of revolutionary newsreel activity in the 1960s, the epicentre of radical political cinema.

At the level of reflection, the key elements of the struggle with cinematic means and the image of the everybody in cinematic representation are illustratively summed up in the famous manifestos of Latin American cineastes who considered film-making to be one of the most appropriate weapons of class struggle. Among a number of their discussions on the strategies of guerrilla cinema and the position and image of humans in it, the most far-reaching is the manifesto of the Argentinean cineastes Octavio Getino and Fernando Solanas "Towards a Third Cinema" (2017). The text, which is exceptionally important both due to the logistic and operative instructions about the possibilities of resistance with cinematic means and due to the conception of a theory of a *third cinema*, also lists the most important hot spots of revolutionary cinemas across the world:

> Newsreel, a US New Left film group, the cinegiornali of the Italian student movement, the films made by the Etats généraux du cinéma français, and those of the British and Japanese student movements, all a continuation and deepening of the work of a Joris Ivens or a Chris Marker. Let it suffice to observe the films of a Santiago Álvarez in Cuba, or the cinema being developed by different film-makers in "the homeland of all", as Bolivar would say, as they seek a revolutionary Latin American cinema.
>
> (Getino and Solanas 2017, 1)

At the same time as being spread across the globe, most of the foregrounded production is characterised by a bottom-up process of creation—based on the principles originating in the activities of cultural, social and political activism. The origins of these film-activist groups were different, but they shared the tendencies of presenting situations, events and actors from their perspective. They were driven by collective self-awareness of the necessity for change. In order to realise this, they "highlighted the aesthetic appearance of their activities, connected it with the political message and invented new differences by staging particular filmic 'everyman' and 'everywoman'" (Schober 2013, 55). Among the above-mentioned activities, Newsreel, a group active in various hot spots in the US, perhaps left the greatest mark on newsreel practice:

> The 1960s and '70s brought the tendency to represent "history from below"— from the point of view of those who remained marginalized and dispossessed— to even sharper focus. The most notable example of collective filmmaking, for example, which avoids the promotion of the documentary filmmaker as an individual artist "free" to find in life what others find in fiction, is the American filmmaking group called Newsreel.
>
> (Nichols 2001, 152)[1]

Newsreel's activities were important not only due to the mode and organisation of production but also due to their revolutionising of the stylistics of guerrilla images of militant cinema. Taking their cue especially from the Cuban series ICAIC Latin American Newsreel under the direction of Santiago Álvarez, they radicalised the aesthetics of guerrilla film-making that took part in the middle of social

confrontations. The concept of the guerrilla image refers to the action imperative of aesthetic poverty related to filming in the heart of direct action (from strikes, rallies, protests, marches, barricades to the direct clashes between protesters and the police and the army). This is why the variety of images from this field is practically inexhaustible and corresponds to the multiplicity of perceptions and perspectives characteristic of encounters within the protesting masses. The limited means that the film-makers had at their disposal and the tendency to not only report on the struggle but also to stage some figures as "everybodies", which were filmed in accordance with the above-mentioned aesthetic principles of the guerrilla film-making practice and personified the struggle, had an effect on the development of a style in which, as Simon Hartog says, "immediacy of the 'Newsreel' makes the message clear, and its spontaneity makes it real" (2013, 79). Or as Robert Kramer, one of the key actors of the movement, defines Newsreel's aesthetics:

> Our films remind some people of battle footage: grainy, camera weaving around trying to get the material and still not get beaten/trapped. Well, we, and many others, are at war. [...] We want to make films that unnerve, that shake assumptions, that threaten, that do not soft-sell, but hopefully (an impossible ideal) explode like grenades in peoples' faces, or open minds like a good can opener.
>
> (Kramer 1968/1969, 47–48)

A detailed insight into the broad range of oppositional film-making shows that the figure of the everybody found in most of the above-mentioned productions is the image of a rebel, a protestor in the streets and parks, in front of the symbols of imperialism in clashes with the police or army, a factory worker on strike etc. Although the poor aesthetics prevents direct recognition, it is nevertheless clear which social groups the individuals belong to (workers, students, Vietnam veterans etc.), i.e. the figure of the societal other is represented as an "everybody" in high modernity too. The figure of the everybody thus belongs to a motif tradition that continues the sense of collective belonging originating in labour movements, feminist advocacy, anti-imperialist initiatives and the struggle of oppressed groups and communities for freedom and equality. These are images represented and distributed with the help of the medium of film, which were adapted to revolutionary activities. In this context, it is understandable that the authors who conceptualised new cinema also equated their activities of film renewal with the process of becoming a "new man"/"new woman". Their common vision was "creating political films in a political way".

At the same time, this is also a process in which films attempt to motivate viewers so that they become active protagonists who establish the same relationship with the film as a militant participant in the political process would. Both in individual art practice and group endeavours,[2] a series of styles and methods developed that served the goals of the social struggle, where up-to-dateness, credibility and directness of information are of exceptional importance. They achieved the counter-informative effect by transforming the established newsreel iconography and sign systems consolidated by the capitalist mode of production. In certain cases, cinematic social players and potential viewers even turned into creators. This happened, for example, in the works of the Medvedkin Group in France or in the

cooperation between the Detroit Newsreel Collective and the League of Revolutionary Black Workers on the film *Finally Got the News* (1970). The staging of an everybody figure was thus present in the strategies of solidarising, informing and raising awareness, but also in educating, organising and directly mobilising energies directed towards a transformation of society and cinema.

> The man of the *third cinema*, be it *guerrilla cinema* or a *film act*, with the infinite categories that they contain (*film letter, film poem, film essay, film pamphlet, film report*, etc.), above all counters the film industry of a cinema of characters with one of themes, that of individuals with that of masses, that of the author with that of the operative group, one of neocolonial misinformation with one of information, one of escape with one that recaptures the truth, that of passivity with that of aggressions. To an institutionalised cinema, it counterposes a guerrilla cinema; to movies as shows, it opposes a film act or action; to a cinema of destruction, one that is both destructive and constructive; to a cinema made for the old kind of human being, for them, *it opposes a cinema fit for a new kind of human being, for what each one of us has the possibility of becoming.*
>
> (Getino and Solanas 2017, 9)

It was only a quarter of a century later that the conditions re-emerged for the revitalisation of some of the politically committed film forms that had been used in the first part of the 20th century. The beginning of the millennium again saw the development of hot spots of more intense forms of social disobedience and mass protest, represented especially by the Occupy movements. At the same time, the global migrant tragedy and the eruptions of "local" uprising movements (such as those that spread across Slovenia in 2012 and 2013, or in the US with the protests against the violence against Afro-Americans such as the Ferguson unrest) presented an additional motivation for the revitalisation of certain seemingly extinct film genres, one of the key ones being the newsreel. I will discuss the above-mentioned new collectives and individual actors that most prominently foreground the transformed images of the everybody that replaced the heroic figures of the social struggles of modernism in more detail. I will thus focus on the American photographer and film-maker Jem Cohen, the French philosopher, activist and cineaste Sylvain George and the Slovenian ad hoc collective Newsreel Front, whose central figure is the visual artist Nika Autor. The films by these artists are characterised by two typical figures of the new everybody: First, the figure of a protestor who is no longer a representative heroic individual, but merely one of the 99% (sometimes additionally anonymised under the universal Guy Fawkes mask, denigrated by terms such as riff-raff, mob etc., or even criminalised). His or her social status is no longer as evident as it was in previous struggles, which were often class struggles. Second, the image of a migrant, a person whose identity is in transition, in a state in which he or she is stripped of both personal dignity and fundamental human rights.

Jem Cohen's newsreels provide testimonies about the happening in New York City's Zuccotti Park as one of the strongest world fortresses of the Occupy movement, while, uniquely, establishing a relationship with the history of film's intervention in the class struggle. During the occupation of the park, Cohen filmed *Gravity Hill Newsreels: Occupy Wall Street* (2011), a series consisting of 12 independent

short films. They were made with the intention of showing them before feature-length works at the New York IFC Center. Cohen establishes a connection with the history of newsreels through the tributes in the end credits of each film, where he cites the origin of their inspiration. The first is a homage to Dziga Vertov, while the following ones are tributes to famous names of political documentary cinema and (counter)information, such as Chris Marker, Joris Ivens, Santiago Álvarez, Agnès Varda etc. Although the films are conceived as episodes, they do not provide separate individual narratives about a certain problem. Rather each reflects a unique aspect of the protestors' everyday life. He achieves this with a specific way of filming the protestors, who are never really individualised, foregrounded or placed at the centre of the action, so that we sometimes do not know whether we watch the protestors or merely random passers-by. In this way of staging the figure of the everybody, the form of acting as non-hierarchical is highlighted. Even though Cohen generally uses the approaches of observational documentary filmmaking, his method is based on exploring the dynamics of the masses through the use of the shot/reverse-shot technique and on the contrasts in perspective, juxtaposing the monumental vertical lines of the architecture with the horizontal motion of the protestors. He achieves additional emphasis by the use of sounds, complementing the predominant ambient soundscape with the musical interventions of Guy Picciotto, which add semantic counterpoints to the visual and sound dimensions of the films. This is an aesthetic framework in which an individual encapsulates the symbolic figure of Guy Fawkes, since we cannot tell what social group or class they belong to—whether they are workers, officials, students or unemployed or homeless etc.

Among the different strategies of documenting the micro-dynamics of the occupation, one of the most incisive approaches is the foregrounding of the opposition between the imposing symbols of capital and the insignificance of an individual trying to resist it. This confrontation is reflected most subtly in *Gravity Hill Newsreel No. 2*. In the newsreel shot at a rally in Times Square, Cohen effectively takes advantage of the visual possibilities provided by the backdrop of "The Center of the Universe", which is full of visual attractions such as shiny advertisements, electronic billboards or the polished reflective surfaces of buildings. In a series of shots with which he captures the dynamics of the mass that seemingly aimlessly moves under the architectural colossuses, he sometimes uses the technique of an apparent split screen where half of the image is taken up by a building's reflective surface, which, on the one hand, doubles the images of the protestors and, on the other hand, "swallows" those who are disappearing around the corner. Levin (2017) analyses this as follows:

> One by one, each is swallowed up into the interstice separating it from its reflected double. Every time this happens, it registers as a rift in space marking an impossible elsewhere, a space of possibility held open for the 99% to appear (Figure 7.2).

Newsreel No. 6 ½ captures another strategy of interpersonal, public communication among the occupiers, the so-called human microphone or "the people's mike". Here, the participants are filmed without close-ups, from a certain distance, without any special foregrounding of the speaker. The protestors are often filmed from behind, or the camera finds other motifs, without people, so that the focus of

Figure 7.2 Jem Cohen, *Gravity Hill Newsreel No. 2*, 2011, video, 3.5 min, colour, sound, videostill. Copyright: Jem Cohen.

attention is on the speech. The people's mike is a method where the words of an individual speaker are repeated by everyone gathered around the speaker as if they were a chorus. This intensifies the spoken words and enables the people not only to hear the words but also to repeat them. In this way, the statements of an individual become the language of everybody, spreading with a different dynamics through the collective body according to the meanings, the weight of what is said and the urgency of reaction. The fact of a joint occupation thus no longer entails merely being together in a certain space–time frame of the protest and perhaps shouting slogans and watchwords, but also jointly developing certain rhetoric as a form of direct declarative democracy. As opposed to the film-maker's distinctly interventionist observation present in *Newsreel No. 2* or *No.4*, here we see a distanced, patient, steady camera at work, which is not seeking a privileged gaze but only assumes the viewpoint of one of the participants in the happening. The entire series is characterised by showing not the excesses that took place, but the atmosphere of the "preparations" and everything that separates the mode of occupation protests from other types of resistance. Cohen manages to represent the Occupy movement's endeavours by highlighting the main methodological and aesthetic elements of the project, when careful framing captures:

> the dynamics of social visibility set into motion by the protest. He tests the limits of a picture's capacity to visualize an emergent and still uncertain social collectivity, neither a mass nor a network of individuals—but instead, a gathering of untold potential, emerging through the process of negotiating its own mediation.
>
> (Levin 2017, 10)

In this sense, everybody is staged as a part of an undefined collective, based itself on a form of participatory democracy that is horizontal, inclusive and anti-hierarchal.

Sylvain George's film-making is most closely related to the migrant tragedy of the last decade, the uprisings and unrest that shook the French capital in 2008 (the mass demonstrations of undocumented immigrants, workers and students who protest in the streets of Paris, finally occupying the Hôtel du Ville) and 2016 (*Nuit debout* movement) and the 15-M occupation happening in Madrid's Puerta del Sol in May 2011. His "migrant" oeuvre includes three feature-length films: *The Impossible—Songs From the Protests/L'impossible—pages arrachées* (2009), *May They Rest In Revolt (Figures of War 1)/Qu'ils Reposent en Revolte (Des figures de guerres)* (2010) and *The Outbursts (My mouth, my revolt, my name)/Les Éclats (Ma Gueule, Ma Révolte, Mon Nom)* (2011). In them, we can observe both the broader aspects of "solving the migrant crisis" in Calais and the micro-dynamics of the lives of refugees waiting for their opportunity to illegally cross the Channel and get to the UK. They also examine the protests of the migrants and *sans-papiers* and their supporters, which are a consequence of the inhumane treatment and the ignorance of the authorities. In his trilogy, George provided a series of anthological images of the refugee tragedy and staged the motif of refugees and the figure of the migrant in a privileged way as new everybodies.

For his next project he travelled to Madrid to shoot an experimental newsreel about the 15-M movement in the spirit of Dziga Vertov and Robert Kramer. He was interested in whether, due to the specific way of using the methods of bottom-up democracy, the events that developed out of the so-called Arab Spring represented the first actual revolution in the 21st century. In Madrid he filmed a lot of documentary footage, which he edited into the newsreel *Towards Madrid: The Burning Bright—Scenes from the Class Struggle and the Revolution* (2013, Figure 7.3). George states:

> This film is definitely not exhaustive; it does not show all aspects of 15 de Mayo, it definitely does not "represent" anything that is or could still be 15 de Mayo as a whole. The film expresses, as a contra-reportage, political moments as full and complete as I have perceived and understood them. This is how I make my contribution to the "Spanish revolution" and more generally a process of emancipation more necessary than ever, in the balance of power established today on the entire planet, with the global systems of exchange, and the enforcement of the state of exception and the new media-ocracy, with laws derived through projected terrorism and the culture of fear.
>
> (quoted in Corneil 2015)

Here George combines guerrilla images shot directly in the centres of protest hot spots with various reflective interventions that take the form of unique *pillow shots* and contemplative digressions, with which he weaves a series of subtle connections between the present, the past and the future. In this way, the films display not only a dialogue with the newsreel tradition, which he declaratively refers to, but also to a broader tradition of revolutionary art and theory. He thus creates a spectrum of reference with which he tries to reflect on the relationship between current conflicts and the universal modalities of social protest.

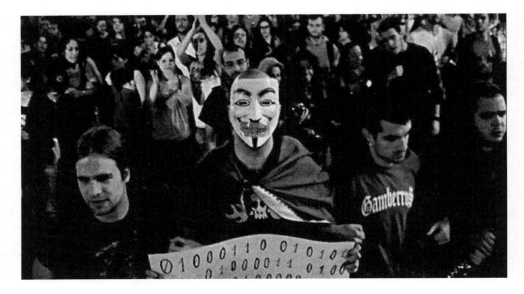

Figure 7.3 Sylvain George, *Towards Madrid*, 2013, video, 133 min, black & white and colour, sound, videostill. Copyright: Sylvain George.

George is a type of cineaste who in his texts reflects on his work and also on the broader spectrum of current political cinema. He examines the different forms of evocation, reference, allusion, dedication, quotation, tribute etc. with which he as a creator of new newsreels seek to draw attention to the universal dimensions of every confrontation, campaign and conflict that testifies to the necessity of entering the river of struggle in the moments of becoming aware that the previous struggle had been played. He uses aesthetic interventions such as *pillow shots*, musical inserts and sound digressions to establish areas of intertwining images that are not merely simple documentation of the happening, but also an attempt at reflecting its atmosphere, energy and meaning. He achieves this by foregrounding the opposition between the monumentality of architecture and the seeming ephemerality of the masses, using the divide between the sound and the visuality of the images via various editing techniques, which either broaden the field of the narrative and emphasise the temporal dimensions of the happening or concentrate the latter into meaningful charges of individual events. His fundamental tendency is the production of "violent images" (George 2017, 77),[3] that is, the establishment of a specific regime of visibility. It is a regime that facilitates a suitable representation of economically and politically ravaged countries, destroyed cities, "ghettoised" suburbs and especially the marginalised, bruised bodies in Calais, Paris, Melilla, Lampedusa, Baltimore etc. Crucial for this aesthetics is that underprivileged people are not considered victims without dignity and integrity, which is the predominant principle of the dominant, consensual, unequivocal aesthetics, but active agents of their endeavours for a better, more decent life. This is why his images give these people back their

dignity and respect and at the same time represent a struggle against conceal-ment, erasure and closure in invisibility.

The creative endeavours of Nika Autor and the Newsreel Front, whose name already reflects the commitment to this filmic tradition, have three main thematic emphases: Firstly, conveying the image of the marginalised, exploited and rightless victims of capitalism (such as seasonal workers united in the initiative Invisible Workers of the World). Secondly, examining the relationship between the current uprising movements and the history of protests of dissatisfied labour masses. Thirdly, representing the treatment of the refugee tragedy in Slovenia and on the so-called Balkan route, which reached its most horrifying dimensions in 2015 and 2016. The relationship between historical protest movements (against the exploit-ation of workers in socialism) and the current uprisings (against ruthless capitalism) is examined in *Obzornik 55/Newsreel 55* (2013). In one of the scenes, we see the event at the heart of a significant uprising in Maribor in 2012, which took place at the same locations as the 1988 workers' protests. For the film's reflection on the event, the film-maker, also a participant in the uprising, has to first identify her own position. She achieves this by asserting her own "recognition", individual self-awareness or intimate subjectivation—as a way of reshaping the experiential field. This is the basis for the realisation of the film's key endeavour: the performative act of naming the people of the resistance, which she belongs to and co-creates (as the off-voice states): "We are marching towards Liberty Square in the footsteps of the workers from 24 years ago. Where organised industrial workers marched, today there troops *the mob* forgotten by the state. *We.*"[4] The naming, which extends beyond its immediate meaning, must also receive its equally important visual expression, which is provided by the footage of demonstrations shot with a guerrilla approach, right in the middle of the action. Within the interweaving of such "mobbish" pictures and sounds, images from the centre of the uprising, the naming of a new type of people—the everyman of rebellious resistance—has char-acteristics similar to the action of the opposing side, which transforms the "pro-tests" into "resistance" by banning them. The performative aspect of the banning of the protest becomes its legitimation, as the film's narrator highlights: "With the excuse of the demonstrations being illegal, they finally give us the right to resist-ance, expression, political thought." So the interaction between self-representation and representation is achieved with an image whose potentiality does not involve merely the naming, but also the affirmation of the possibility of one's transform-ation. This is the transition from an individual to a community—from *I* to *we*, or in the diction of Jacques Rancière's (2005, 35–36) definition of political subjectifi-cation: "Descartes's *ego sum, ego existo* is the prototype of such indissoluble sub-jects of a series of operations implying the production of a new field of experience. Any political subjectification holds to this formula. It is a *nos summus, nos existimus.*"

Obzornik 62/Newsreel 62 (2015) deals with the paradoxical historical relation-ship between two Syrian artists hosted by the Museum of Modern and Contempor-ary Art Koroška at a big international exhibition in 1966 and the Syrian refugees that 50 years later flock to the border between Slovenia and Croatia (Figure 7.4). The result is the already often seen images from the heart of oppression, preven-tion, prohibition, annihilation etc., when the authorities (under the guise of follow-ing laws and regulations) systematically abuse the rights of "inferior"

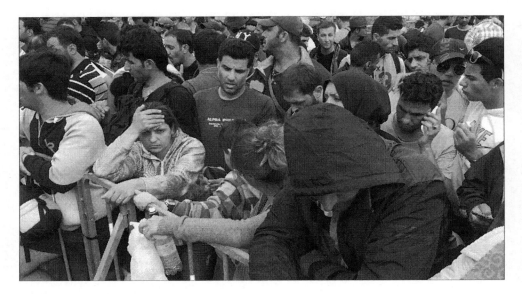

Figure 7.4 Newsreel Front, *Newsreel 62*, 2015, video, 11 min, colour, sound, videostill. Copyright: Newsreel Front.

representatives of humanity. The figures of rightlessness and powerlessness against armoured members of the special police unit increasingly often become an intolerable déjà vu as the off voice declares:

> Images are played. Once more. Worn. We've seen them a thousand times. Every time they say, illegal migrant, the one who is not and will not be, the word cuts the picture. Her silhouette is a disturbance. Cut. I see: Her. Cut. The story of hunting one's misfortune is a story about hunting an image, searching for an image in a worldlessness that looks more and more like the world. The main prize: *The Mob. Us.*

What *Newsreel 62* expresses is therefore the relationship between the unknown images of emancipation, that is, the works by the two Syrian artists, which represented the legitimate voice of the people, and the actual images of degradation, the Syrian refugees. These are the figures that become an emblematic picture of dehumanisation and, as such, representative figures of the "mobbish" image.

Obzornik 63—Vlak senc/Newsreel 63—The Train of Shadows (2017) is almost entirely dedicated to the refugee tragedy. This newsreel seeks to deconstruct the filmic representation of migration by using images of trains captured throughout film history. With them, it contextualises the phone footage taken by refugees from Afghanistan riding the undercarriage of a train as they clandestinely enter Slovenia (Figure 7.5). The image of refugees captured by themselves in the undercarriage of a train heading from Belgrade to Ljubljana this way becomes the point of departure for an essayistic journey into film history that

Figure 7.5 Newsreel Front, *Newsreel 63*, 2017, video, 38 min, colour, sound, videostill. Copyright: Newsreel Front.

takes us through a kaleidoscopic compilation of found footage and at the end brings us to the present. The last third of the film takes place at Belgrade railway station, which became the refugees' last refuge after the Balkan route had been shut down and from where the authors' of the phone footage managed to sneak into the train undercarriage. The key question that the film raises is about the role played by an image of a refugee that was shot by the refugee himself and which has not been subject to the usual media processes. This is the question of affirming the figure of a new everybody as a representative of the social groups that have arisen beyond the exploitative circle of the predominant media production. In our context, this implicitly means an affirmation of the image of a new everybody in a history in which the figures that rejected or problematised former states of consensus and ensured alternative representations of social relations have already been canonised. Such a belief is clearly echoed in the final dilemmas of *Newsreel 63*, whose epilogue questions the possibility of placing "an orphaned shot, without an official history [...] and without a legal future" within the existing history of cinema:

> Have they invented the history of film in which such a shot could be inscribed? It is not quite certain that it has the right to images that are not the images of its own situation. Images should have a history that is different from the situations they depict.

The foregrounded quandaries thus lead to the fundamental point of the film: "It is possible that the shot is the prophecy of a human memory yet to be socially and

politically achieved." The final thought—a paraphrase of John Berger's belief about the memorial potential of an alternative use of photography (cf. Berger 1991, 61)—is a demand that dictates the necessity of a proactive, creative relationship to the images whose origin and existence determines the notion of (deliberate or accidental) non-placement.

The works under consideration have brought us to "mobbish" and violent image characteristics of the new newsreels, which frame the current representations of the everybody. Here in this function we encounter a figure that is in a state of becoming imperceptible—so in the stage of becoming this entails the elimination of everything that refers to an individual's objective determinations, that connects them to social formations and moulds them according to the identification model of recognition.[5] At the same time, the production of images opposed to the consensus that the dominant media seeks to establish is also a process of developing a "'democratic' aesthetics" (George) with the fundamental demand to devise a community based on the possibility of self-expression, self-representation and self-reflection of everybody.

> Violent […] images contribute to the definition of a singular aesthetics, for a community without consistency, which is always open, maintained by one and the other, to a virtual infinity of others. A radical, wild community established and expressed through acknowledging the pluralism of life forms, through the demand for real equality, through the idea that every person is capable of knowing what suits them, of representing themselves […] So a community that tries to update the "democratic" aesthetics delineated in various periods by philosophers, among them Walter Benjamin, Jacques Rancière and others.
>
> (George 2017, 82)

The "orphaned" refugee footage from the train undercarriage in *Newsreel 63* did not just provide the possibility for filmic expression; in addition, especially the possibility of becoming the vehicle of self-expression doubtlessly also belongs to such a regime. Again and again, this reflects the fact that the paths of hope that individuals, families, groups, the bearers of mobbish images embark on fly under the radar of the predominant information systems and consensual aesthetic practices. Images of their struggle to contribute their share to new oppositional aesthetics. So every shot whose existence stimulates the necessary new reflection on the figure of the everybody, in order to grant it the legitimacy of individual expression, once again triggers the resistance impulse of the possibility of becoming a different, non-consensual community.

Notes

1 A detailed discussion of similar processes in post-nazi West Germany, Austria and Yugoslavia can be found in the subchapter "The Cinema Created from Below" of Anna Schober's *The Cinema Makers* (Schober 2013, 61).

2 Among them the most well-known collectives in France for instance are SLON/ISKRA, Les groupes Medvedkine, Le Groupe Dziga Vertov, Collectif Cinélutte, Cinéma Politique.

3 This term is taken from Sylvain George's conceptualisation, specifically his explication of the term *violent images* in "Zapiski: Nasilne podobe, migrantske podobe (o univerzalnosti

aktualnosti)". He thus defines them as "images of sovereign violence", "non-consensual images". For more details, see George (2017, 80).

4 It is worth pointing out that we also come across the diction that characterises the pro-testors as a mob in Cohen's *Gravity Hill Newsreel No.4*. Against the backdrop of the magnificent skyscrapers of Wall Street at night, we hear the voice of Eric Cantor, an American republican politician, lawyer and banker, saying: "If you read the newspapers today; I, for one, am increasingly concerned about the growing mob occupying Wall Street and the other cities across the country."

5 Paola Marrati pointed out that becoming is always a process of de-identification and de-figuration (2001, 213).

References

Benjamin, W., 1969. The Work of Art in the Age of Mechanical Reproduction [1936]. *In:* H. Arendt, ed., *Illuminations*. New York: Schocken, 217–252.

Berger, J., 1991. *About Looking*. New York: Vintage International.

Corneil, M. K., 2015. The Accumulation of Rage: The Cinematic Explorations—And Some Letters—Of Sylvain George [online]. Available from: https://wuxiablog.com/2015/11/05/the-accumulation-of-rage-the-cinematic-explorations-and-some-letters-of-sylvain-george/ [accessed 25 November 2018].

George, S., 2017. Zapiski: Nasilne podobe, migrantske podobe (o univerzalnosti aktualnosti). *KINO!*, 31/32, 75–83.

Hartog, S., 2013. Nowsreel or the Potentialities of Political Cinema. *In:* P. Bauer and D. Kidner, eds., *Working Together: Notes on British Film Collectives in the 1970s*. South-end-on-Sea: Focal Point Gallery, 72–83.

Kramer, R., 1968/1969. Newsreel. *Film Quarterly*, 22 (2), 44–48.

Levin, E., 2017. Social Media and the New Newsreel. *Media–N | The Journal of the New Media Caucus*, 13 (1), 5–18.

Marrati, P., 2001. Against the Doxa: Politics of Immanence and Becoming-Minoritarian. *In:* P. Pisters, ed., *Micropolitics of Media Culture: Reading the Rhizomes of Deleuze and Guattari*. Amsterdam: Amsterdam University Press, 205–220.

Nichols, B., 2001. *Introduction to Documentary*. Bloomington, Indiana: Indiana University Press.

Rancière, J., 2005. *Disagreement: Politics and Philosophy*. Minneapolis, Minnesota: University of Minnesota Press.

Schober, A., 2013. *The Cinema Makers: Public Life and the Exhibition of Difference in South-Eastern and Central Europe Since the 1960s*. Bristol: Intellect.

Solanas, F. and Getino, O., 2017. Towards a Third Cinema [online]. Available from: www.marginalutility.org/wp-content/uploads/2017/03/Towards-a-Third-Cinema-by-Fernando-Solanas-and-Octavio-Getino.pdf [Accessed 4 October 2018].

8 The Making of a *Common Woman* Figure

Convergence and Struggle of Visual Practices around Gezi's Icon

M. Ragıp Zık

The idea was as simple as that: an anonymous aunt sends a public message. This was the plan for launching the "One Minute of Darkness for Constant Light" campaign after a government scandal broke on 3 November 1996. A fatal car accident in Susuruk, a small provincial town in western Turkey, revealed close collaboration between a member of parliament, a high-ranking policeman and a paramilitary right-wing hit man who was on the wanted list of Interpol and the Turkish courts. Of the three only the deputy survived, and the juridical system hesitated to proceed further in investigating a state-involved network of corruption and organised crime. On 1 February 1997, by switching off the lights every day for a minute, the "Citizen Initiative for Light" launched a nationwide campaign to push the government to investigate the case. The initial idea was that "an anonymous aunt" makes a public call to action: "On February 1, 1997, we will begin to turn off our lights at 9 p.m. every night, until the members of the crime syndicate and its connections in the state are brought to court!" (Akay 2003, 10). Although the names of the organisers were no secret, the aim was to maintain an image of a leaderless campaign and have it owned by everyone. Eventually the call was not signed by an anonymous aunt but by "a citizen". The response was massive. With growing numbers every day, by 15 February 30 million people, almost half of the population at the time, were switching the lights in their apartments on and off (Akay 2003, 15). The action, which began silently, also went loud. People went on with making improvised noise by banging pots and pans through windows and on balconies. The protests ended after the government was forced to resign by a military memorandum following the National Security Council meeting on 28 February 1997, which is known as the "post-modern coup d'état". The legacy of the campaign, however, set a historic example for political mobilisation. A citizen call, or better a "call by nobody", had initiated Turkey's largest protest action ever.

In 2013, a decade and a half after this campaign, Turkey saw another series of general protests. Started as a sit-in protest to prevent the cutting down of a few trees at Istanbul's Gezi Park, the Gezi movement ("Gezi" for short) grew into a massive social movement. Both the 1997 campaign and the 2013 Gezi imagined a betterment in the ruling of the country and their approach to this was different from what Turkey had previously experienced. They established an accessible structure, claimed a leaderless movement and put no emphasis on the names. Besides,

similar to the "citizen call" or the idea of an "anonymous aunt", a number of name-less heroes appeared through Gezi, such as the *Lady in Red*, the *Standing Man*, the *Lady in Black* and the *Whirling Dervish in a Mask* among others. They helped to popularise the demands and actions. Compared to a citizen signing a demand, a major difference was that they were fully visual in their public presence.

Although their names were revealed and they even responded to a few curious inter-view requests, in public these "heroes" were known by their epithets. They barely appeared in any other form and did not claim any particular role. The ordinary—and often spontaneous—actions they took within the protest context could be assumed by anyone. Such figures, who are *nobody* but represent *everybody*, frequently emerge in politics. The images capturing or recalling the moment of their action are shared end-lessly on social media platforms and appear in other media outlets, although they claim no fame and no ownership of any particular heroic action. However, especially the *everybody* images that show ordinary people's acts in a situation of a clash or being a victim of violence evoke a great public reaction and mobilise public affects. So why and how do these images address the public? What do these figures mean for a movement? In what ways, if at all, do they become part of a protest iconography?

Michel de Certeau (1988) describes *everybody* (also referred to as *nobody* in his text) as an ordinary person in the society, a *common man* or *common woman*, who is capable of altering space as a resilient *topos*, in an abstract sense. Deleuze and Guattari (1987) extend this concept of spatiality to an affective dimension where several terrains intersect and open up for each other for the potential for *becoming everyone* (*devenir tout le monde*) (Deleuze and Guattari 1987, 279), where one element is drawn to the territory of another to generate a new unity. Therefore, *everybody* figures serve as gateways that can, even temporarily, connect the imaginary and desired with the experienced and suffered.

In the political mobilisation context such as Gezi, *everybody* figures mediate between the self and the other, the individual and the group and indignation and hope. However, a visual analysis may offer valuable insights to understand how these figures emerge and function. Although Gezi was elaborated in a number of studies (Gökay and Xypolia 2013; Özkırımlı 2014; Koç and Aksu 2015) and the prominence of visuals has been acknowledged in much of these insightful works, efforts to analyse these materials seem to be relatively rare, particularly in relation to periods extending the peak times of the protests. This tendency is not specific to Gezi either. The last decade has witnessed a number of social movements and pro-tests around the world, such as the Occupy movements, anti-austerity protests in Europe and the Arab Spring. Much research into these events mentions the import-ance of visuals, recognising their role in protests (Castells 2015; Kavada 2015; Papacharissi 2015; Treré 2015). A common practice in the studies on social move-ments, however, is often to place the photographs, designs, illustrations, images, symbols and icons to support logo-centric research outputs (Doerr and Teune 2008). The efforts to interpret the nuances of a dynamic environment focus mostly on the script. On the other hand, only a few scholars have conducted a visual-centred social movement study (Awad 2017; Doerr et al. 2013; Gerbaudo 2015; Neumayer and Rossi 2018). The studies based on visuals often consider *everybody* figures as powerful icons that popularise the protests. The ways in which they mobilise public feelings, however, remain as a topic to be addressed. Acknowledg-ing the value of script-based analysis in the field of social movement studies, this

chapter aims to contribute to the growing literature of visual research. A closer look at practices of image production and uses of *everybody* figures in a social movement context such as Gezi may offer valuable insights to understand the ways in which iconic political imagery mobilises public affects.

A Red Dress in a Green Park

Gezi started as a protest to reclaim a geographic territory, a public space (Kuymulu 2013). On 28 May 2013, a sit-in started in Istanbul's Gezi Park to protect some trees, before growing into a massive protest against government's overall policy. The local municipality had initiated the much-disputed plans to build a shopping mall in the park, as part of the urban transformation projects. A group of activists succeeded in stopping the bulldozers, which ended up with police intervention. As the tension escalated, Osman Örsal of Reuters news agency shot a photograph that went viral online and gained international recognition as Gezi's most well-known icon: the *Lady in Red* (Figure 8.1). In the photograph the first person to attract attention is a woman at the front. She looks irritated by something. A camera strap over her shoulder suggests she is a journalist or photographer. Slightly to the right the photograph shows what she is escaping from. A woman in a red dress is being pepper-sprayed in her face, with her hair blowing up due to the force of the spray. This is not accidental. The policeman opposite her seems to be deliberately discharging his spray at her. The woman on the left is also feeling the sting of the gas and trying to hold her breath. The policeman is backed up by a line of others with helmets and shields. It is not very clear whether he is attacking under orders. A few other policemen who may be his superiors as they are differently dressed, are not following the action. The grass and leaves with trees in the background show that the location is a park. A careful eye familiar with the environment would also catch the InterContinental and the Ritz-Carlton hotels in the background and understand that it is Gezi Park.

As the photograph became famous through extensive sharing on social media platforms, the identity of the woman in red dress was revealed. Ceyda Sungur, a research assistant at the Istanbul Technical University's Faculty of Architecture, maintained a low profile and rarely responded to interview requests from various media outlets. Still hardly known by her real name in public today, Sungur filed a complaint against the policeman while the protests continued. After a three-and-a-half-year court process, including his denied appeal, the policeman was granted a reprieve on his 20-month sentence, plus being ordered to plant 600 trees. On the other hand, the photograph appeared on several newspapers, magazines, activist websites and image archives. The *Lady in Red* triggered a strong reaction, resonating with society in several aspects. It went from being a journalistic photograph documenting an incident in Gezi Park to an *everybody* figure that promoted the politicisation process. Certainly, the use of the internet and accessibility of the photograph through multiple resources facilitated this transition. But what visual qualities in the photograph made this transition possible? What other practices influence this process of the *Lady in Red* becoming a mobilising agent?

The photograph documents the moment of a man's violent attack on a woman. Although Turkey does not have a good record in terms of women's rights and domestic (and public) violence, the visual representation of a man physically harming a woman can widely raise eyebrows and bring condemnation from many. However,

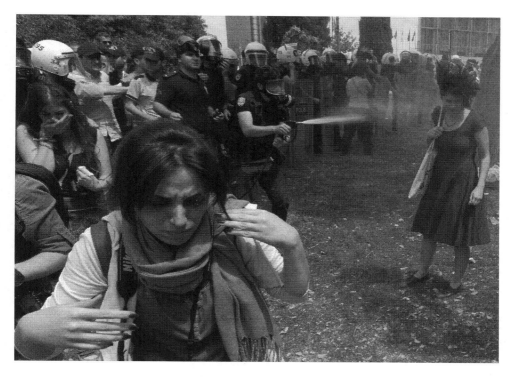

Figure 8.1 Osman Örsal, *Lady in Red*, A Turkish riot policeman uses tear gas as people pro-
test against the destruction of trees in a park brought about by a pedestrian project,
in Taksim Square in central Istanbul, 28 May 2013. Photo: Osman Örsal. Copy-
right: Reuters/Osman Örsal.

what a woman can be brought to symbolise for Turkey goes beyond this. This is
closely connected with how women are situated in society. In mainstream thinking,
women belong in the home, a private space away from public attention, often con-
nected to vulnerability and motherhood (Kandiyoti 1991). Pictorial and imaginary fig-
urations of women are constructed due to certain political orientation and agenda in
a way to represent the ideal (female) citizen. Constantly negotiated and contested, this
shapes the projections over how much the mainstream thoughts on the female body
can be transgressed.

The red dress in Örsal's photograph positions the woman (and the protesters) as
incarnating the social tension between the secular and the non-secular that the country
has suffered since its very foundation. The rapid secularisation of politics and public
life was associated with an embodiment of modernist ambitions in the female body.
The ideal woman of the new republic should have been like her Western peers;
unveiled, taking part in social events, interacting with men and, if possible, at work.
The summery red dress leaves the woman's neck, arms and legs uncovered, not to
mention that she is not wearing a veil. With a subtler reading, its colour can be con-
sidered almost erotic. Combined with her casual cloth bag, which can be related to

anything but protest equipment, she could even be going to a party after the park. Her outfit is an obvious sign of secular beliefs, which puts the photograph at the heart of an ongoing debate over government's increasing oppression of lifestyle and body politics. Although Erdoğan's Justice and Development Party has no official objections to secularism and its symbols, the intention to ban abortion, no commitment to preventing child marriages and reducing domestic violence, and senior government officials' commenting on how women should behave in public, among other practices and policies, have left the secular members of society unconvinced and strengthened their suspicion that the nation was at risk. Hence the red dress represents a tangible figure of the *common woman* with exclusively secular beliefs, while posing a non-secular attacker as her opposite, overlapping with a spatial contest between the allegories of the nation. The *Lady in Red* photograph becomes a domain where contesting imaginations meet each other violently.

It is also remarkable that the woman in red is standing still and doing nothing to avoid the irritating effect of the pepper spray, except for turning her head away with her eyes closed. She neither runs away nor uses her hands to cover the face. It is also possible that she was caught off-guard, but still, standing persistently under such attack elevates her victim status and shows her strong resistance. So a secular woman victim proves a resilient strength against a brutal attack by the police, a symbol of the AKP (Justice and Development Party) government which in many people's eyes has a track record of undermining secular democratic values. The photograph does not just catch the moment of a police attack on an off-guard citizen, but also a moment of a resistance that undermines the attacker. The photograph is part of a tradition of protest images that has been increasingly popular over time, particularly in the second half of the 20th century. Photographs of one person or a few physically vulnerable people standing against an overwhelming force built an image repertoire of regular citizens capable of standing against supposedly superior powers. Moreover, the photograph also departs from this tradition, with the casual passer-by position of the woman. While representing major socio-political tensions between two sides, the *Lady in Red* also challenges the usual composition of a lone protester against the police, as she looks like anyone but a protester prepared to clash.

Doerr and Teune (2011, 46) argue that the "images produced by social movements are part of the struggle over meaning." Anna Schober's (2019) remarks on *everybody* figures in the introductory chapter of this volume echo this argument: in her understanding *everybodies* address an audience as widely as possible and associate what is represented with authenticity and truth. Indeed, soon after the *Lady in Red* went viral and gained international recognition, senior government officers suggested that the protesters in Gezi Park represented marginal groups and not the whole of society, implying a certain tendency to commit crime. This strategy of demonising the Gezi movement was countered and altered by several tactics (de Certeau 1988) practised by the activists, including promoting the slogan "We are the people" through various means such as humorous illustrations, graffiti, banners and social-media hashtags. According to de Certeau, these tactics are modes that enact the resilient space that is immanent to *everyday life*. The *common man* and *common woman* hold an enormous potential to nurture and maintain ordinary practices that challenge established understandings and power relations (de Certeau 1988, 3). The visual embodiment of *everybody* figures also triggers a series of re-articulation and adaptation efforts, extending their circulation and public presence, which is further elaborated in the following.

Everybody Figures in Politicisation Processes

Photography has been involved in the creation of *everybody* figures in politicisation processes, particularly in the second half of the 20th century. Traditionally, photographs provided a record of events and the people involved (Barthes 1981), constituting a reality of the moment. Photography has been capturing the moments of protests since the 1871 Paris Commune (Memou 2017). The attachment of journalism to photography made it an indispensable part of the political struggle, which in turn, brought in a contention on the arrangement of the politics of the visual (Memou 2017, 2). An increasing number of iconic photographs of protests followed, such as Jeff Widener's "Tank Man" of the 1989 Tiananmen Square demonstrations and Marc Riboud's "The Ultimate Confrontation" of the 1967 demonstrations against the Vietnam War, in which a protester offers a flower to soldiers. These images evoked great public resonance and helped popularise the politicisation process. Even today, it is possible to find the traces of these iconic photographs in protests. Gezi's *Lady in Red* was identified as an iconic photograph in a number of photojournalism outlets as well. Hariman and Lucaites' definition might be helpful to define what an icon is:

> photographic images appearing in print, electronic, or digital media that are widely recognized and remembered, are understood to be representations of historically significant events, activate strong emotional identification or response, and are reproduced across a range of media, genres, or topics.
>
> (Hariman and Lucaites 2007, 27)

The emergence of such icons in Gezi was certainly not limited to photography either. Various forms of graphic design, and illustration in particular, were also a prominent practice. While the streets were daubed with graffiti, the social media was flooded with illustrations. Independent graphic designers, creative commercial agencies and amateurs drew several images about the ongoing events.

The last century saw an increase in the instrumentalisation of illustration, both as a critical artistic practice and a tool for propaganda (Lavin 2001). Some illustrations, especially editorial cartoons, rely on drawing publicly renowned people, whose visual properties such as clothing style, body type and facial features can be immediately distinguished due to their appearance on audiovisual means of mass communication. This type of visual production benefits from the existing visual information, which can be regarded as a convergence point between photography and illustration. The photographic appearances of famous people such as celebrities and politicians are captured and transformed into graphic comment. It is possible to criticise or promote certain ideas through these illustrations, due to the biography of what is drawn.

The contemporary protest scene sees a growing trend of bringing different visual production forms together. The illustrations make use of the photographs of non-famous people in particular, who might be still actively taking part in the protests. In the Gezi movement, this was a popular practice to promote *everybody* figures. Photographs of the *common man* and *common woman* were adopted and appropriated as illustrations. Such appropriations can be regarded as part of the meme-ification practice, which is gaining increasing popularity to visualise certain beliefs and ideas and circulate them rapidly.

Replicating the *Lady in Red*

Like its contemporaries such as the Arab Spring (Awad 2017), Gezi promoted images of the *common man* and *common woman* characters, the nameless heroes of the movement that marked iconic moments of protest. First featured in photographs, these non-famous *everybody* figures were widely used by amateur and professional graphic artists, who reframed them as illustrations or graphic comments. Appropriated versions focused on the affective potentials of photographs, making some qualities of the image more salient, while eliminating others. These illustrations were included in a number of image collections and archives of internet magazines and online news portals. Often without the knowledge of the illustrators, they also found their way into offline media, appearing in "special Gezi volumes" of magazines and decorating random items such as cups and T-shirts. The *Lady in Red* was one of these popular photographs. In the following I will focus on different appropriations and contestations of the original photograph.

The illustration *Venus* (2013, Figure 8.2) was inspired by one of the most famous paintings of the Renaissance era, Sandro Botticelli's *Birth of Venus* dated c. 1485–1486, commissioned by the Medici family. In her illustration, Gaye Kunt merged Gezi's protest context with Botticelli's painting. Here, unlike either the original photograph or Botticelli's painting, the *Lady in Red* by Kunt shows only one person. The upper half of the background, however, recalls the environmental concern of the Gezi movement, through the trees that were threatened in the park. The green in the original version resembles a silhouette of a tree growing from the woman's body. At the same time, it is possible to see the Venus as part of the nature, also similar to Botticelli. Botticelli's combination of nature and sensuality here helps accentuate the erotic aspect of the red dress. In Western bourgeois tradition, women have widely been depicted alone and as erotic objects vulnerable to the male gaze. Often nude, women are portrayed as submissive to male dominance (Schober 2013, 169–170). The original nudity here is covered with the red dress, although the stance and position of the arms are kept. Yet here it is not only being clothed that reverses the fragility of Venus. Her divinely beautiful face as in Botticelli's painting is also replaced with a black gas mask, in complete contrast to the original fragility and linking the illustration to the protest atmosphere. Widely used in Gezi against pepper spray and appearing in a number of images, the mask, per se, became a symbol of activism, resistance and protest. Together with the blood-type written on her arm, a regular practice of the Gezi activists, they recall other moments of brutal clashes in the course of the protests. Her casual passer-by look is maintained with a net shopping bag holding food and drink, although her cloth bag has been removed. Unlike Botticelli's Venus, whose hair is being blown by the breath of Zephyrus, the god of the west wind, the woman in the red dress was being blown by pepper spray, through the same direction. None of these characters is visible in the illustration, but the flying hair and the slightly leaning the figure recalls this. A more realistic *contrapposto* stance replaces Botticelli's almost impossible one. All these signs make the *Lady in Red* grounded in current reality. The people and other elements we see in Osman Örsal's photograph have been cleared from the illustration and the woman in the red dress appears as the sole figure. She is exposed to direct attention, minimising any distraction from other characters.

The illustration creates an interplay between the memory of Botticelli's fragile Venus and the reality of a resilient activist in Gezi. The illustration contributes to the success of the *everybody* figure by extending its circulation and increasing the

Figure 8.2 Gaye Kunt, *Venus*, June 2013, mixed media (watercolour, ink on paper and digital painting), 1800 × 2700 px. Copyright: Gaye Kunt.

potential and duration of public exposure. Moreover, it alters the sense of time and space by merging a timeless mythological figure with a protester anchored in a certain incident. It introduces the legacy of a Renaissance painting, embodied in the memory of a present-day event. By aestheticising the *Lady in Red, Venus* links to the efforts to constitute an "everybody", a *common woman* that anyone may sympathise with, by modifying the popular representation of female fragility.

Murat Başol's *Sıktıkça büyüyor* [*Grows as he sprays*] (2013, Figure 8.3) is another illustration appropriating the *Lady in Red*. In his work, Başol zoomed in on the two main characters in the incident, the policeman and the woman in red dress. The illustration keeps the casual passer-by look of the woman with her cloth bag over her shoulder and plain red clothing, while the policeman is drawn in black and white. Both of them stand on a green floor that recalls the park. The policeman on the left is drawn quite small compared to the woman, who becomes a superwoman, almost a monstrous creature. The policeman is pepper-spraying her, which makes her grow bigger. Becoming threatening and assuming intimidating dimensions, her face looks more masculine. The flying hair is reminiscent of the mythical Medusa. Unlike the popular depictions of the domestic woman, the Medusa poses a fatal danger to men with her venomous snakes in place of her

hair. The illustration catches and builds on the same aspect of the original photograph: Besides depicting a brutal attack, it implies an empowered and enabled people in protest. Despite all the violence, the police cannot suppress the protesters, as they grow to unmanageable numbers and influence. In this regard, Başol's illustration can be identified as more straightforward than *Venus*. It does not draw on the legacy of any particular famous artwork, at least not as explicitly as Kunt does. Instead, it makes an activist's desire to overcome the overwhelming government force very evident. The illustration focuses on a twofold relationship, implying that the protesters are stronger than the government forces.

Sıktıkça büyüyor builds on binary oppositions, which is quite common in iconic political imagery (Alexander 2012). Although the social engagement with images can go beyond the understanding of the binary exhibition of power and sensory experiences (Sonnevend 2012), such a representation of the victim-perpetrator relationship helped increase the pervasive use of the image. The illustration became popular online and was also printed on canvas before being used on a banner during street demonstrations. An anonymous photograph showed people in the city of Izmir using the canvas to take protest souvenir photographs in a parade at the

Figure 8.3 Murat Başol, *Sıktıkça büyüyor* [*Grows as he sprays*], 2013, computer-generated image. Copyright: Murat Başol.

time of the Gezi protests. A hole was cut out in the place of the woman in red's face, where anyone could insert their head and pose for the cameras. The illustration physically serves as a platform to become the woman in the red dress, to become *everyone.*

Both Kunt's and Başol's illustrations reconfigure the affective potentials of the original image. They omit or alter several other elements of the photograph, such as the policemen in the background, the people affected by the gas, the daylight, the woman's bag, the policeman and the discharge lines of pepper spray. Among these, the woman's red dress, by which she is always referred to, stays more or less untouched. The two illustrators focus on certain features of the photograph and condense the memory of the event into an *everybody* figure, to be evoked continuously in the present. In this sense, both illustrations are engaged in and perform a non-linear memory-building practice that appeals to a futurity (Massumi 2015). Besides depicting the incident as a record of experience, the illustrations envisage an action that anyone can take. Challenging the narrative of the tamed female body as an allegory of the nation, the illustrations alter its docile representations by blending the photograph in different ways; one with accentuated femininity and eroticism, the other with accentuated femme fatale archetype. The *Lady in Red,* as an *everybody* figure, promises the possibility of a territory where ordinary people can reconfigure power relations and stand against overwhelming physical aggression. It mediates between the individual and the cosmos (de Certeau 1988), expressing a call for participation and solidarity.

Along with several other replications of the *Lady in Red* by amateur and professional illustrators, Kunt's and Başol's illustrations were published both on printed and digital media outlets, and were posted online through various social media accounts. Far from being presented as an attachment to Örsal's photograph, they appeared as standalone images to commemorate the protests, while being included in image collections after Gezi. Shortly after the *Lady in Red* went viral on social media, more protesters joined the sit-in at Gezi Park. As various replications of the photograph were being released one after the other, the number of protesters in the park reached thousands in just a few days and the protests spread to other towns. It was then that Recep Tayyip Erdoğan, prime minister at the time, looked down on the protesters in his speech on 3 June 2013: "Pots and pans, the same old story", referring to the 1997 "One Minute of Darkness for Constant Light" campaign. The similarities between the outreach tactics of that campaign and the Gezi movement are possibly not coincidental. They both counted on *everybody* figures to address the public and disseminate political positions. The first relied on script, the second on both script and image—possibly more on the image.

Everybody Figures in Contest

As Gezi remained a prominent reference point in Turkey's contemporary political environment, its visual legacy became a contentious domain, particularly after the attempted military coup in 2016. When the soldiers blocked the roads in a number of towns on the evening of 15 July, they met with a massive resistance from people who President Erdoğan called on to oppose the soldiers. The clashes claimed more

than 300 lives, leaving one of the darkest pages of Turkish political history. The putsch was associated with Gezi by senior government officials and the mainstream media, claiming that the same mastermind orchestrated both. A sharp antagonism grew, with a contest over political symbols while aligning Gezi with the putsch and situating them both against democracy.

Accounts of national pride and victory such as the contributions of ordinary people to decisive victories over enemy powers were promoted by the mainstream media in the aftermath of the putsch, combining demonstrators with popular figures in national narratives. Once again, the present memory of the contracted past was enacted (and instrumentalised for a political agenda), which could also be observed in visual terms. The photographs circulated through the events and in the aftermath were very similar to but also contrasted with those of Gezi. They featured *everybody* figures, with women again being notable among them.

A photograph[1] was shot in the morning of 16 July, by Elif Öztürk of the state-run Anadolu Agency on the Bosphorus Bridge, where a deadly clash between soldiers and demonstrators had taken place in the previous night. Among men, a woman in a black chador with a Turkish flag wrapped around her walks towards a cheering crowd that is celebrating the failure of the putsch. She can be identified as a re-figuration of Nene Hatun, a heroine in Turkish historiography, often referred to for her courage during the 1877–1878 Russo-Turkish War. She was also selected as the first "Mother of the Year" in 1955, when Turkey joined the international community in marking the second Sunday in May as Mother's Day.

The photograph was accompanied by titles and comments on social media and online news platforms in a way that served the national narrative: fighting shoulder-to-shoulder with men against the enemy of the nation, brave Turkish/Anatolian women are also ideal mothers to bring up loyal and brave children.[2] One of the captions on the websites reads in Turkish: "The women who took the streets on 15 July as the FETO[3] attempted a military coup were as good as Nene Hatun and demonstrated the fearlessness of Turkish women."

The dissent called upon and the solidarity envisaged by Gezi's *Lady in Red* is starkly confronted by another type of *common woman* that emerges in the visuals after putsch. This *everybody* figure shifts the female body from a dissident role to a docile one as in the tradition of the allegories of the nation. The woman in the chador exclusively represents a non-secular side of the politics in the Turkish context and is hailed as a defender of the nation. Dismissed as an enemy on the other side, the dissident (and secular) female body of Gezi is suppressed and replaced by a patriotic one.

Conclusion

Everybody figures occupy a major position in today's iconic political imagery. Although their role is acknowledged, it remained taken-for-granted in social movement studies. As the activist practices of representation show a growing tendency to rely on unknown figures in their communication *tactics*, images featuring ordinary people in action become part of the visual protest repertoires. Social mobilisations rely on the images of *everybody* figures to resonate with the public due to the ability of these images to portray the *common man* and *common woman* in society. They appeal to shared values, traits and lifestyles through a set of visual codes and

sociocultural trajectory. Mediating between the particular and the universal, *everybody* images embody affective gateways for spatial reconfigurations by abstract means. As seen in Osman Örsal's *Lady in Red*, the image did not just capture a violent police intervention in a peaceful protest moment in Istanbul's Gezi Park, but also acted as a visual domain both to recognise the multidimensional reality of contentions in society and to urge everyone to overcome them. The circulation of the photograph by activist circles appealed to generating people's solidarity by mobilising public affects. The *Lady in Red*, as an *everybody* image, plays an intermediary role in this process, due to its potential to open up a territory to connect with a broader society, to *become everyone*.

Contemporary visual practices within the context of social movements commit to taking symbolic reconfigurations beyond the framework and outreach of photography. Several illustrations that appropriated the *Lady in Red* highlight some of the visual qualities while masking others. Such practices, which can be called a non-linear memory-building practice, add a temporal aspect to the capacities of *everybody* figures. While "actively contracting the past into the cut of the present" (Massumi 2015, 62), the images also aim for a futurity. The appropriations from photography to illustration can help maintain the protest memory in the present, create deliberate interplays across time and space and express an anticipation for resilient ordinary people uniting against the absolute control and domination of a space (Lefebvre 1991b). Emerging on both sides of the political divide, *everybody* figures are involved in this struggle over temporal and spatial configurations. Contesting visuals bring in another dimension of impeding this sequence and creating a contest between norms, values and memory-building practices.

However, an analysis merely of the semiotic resemblance of photographs and their certain appropriations among a variety of image adoptions in terms of potentials and capacities related to mobilising public affects may lead to hasty conclusions. Instead, this essay suggests considering the ways in which *everybody* figures are constructed and confronted in political context, as well as the convergence between photography and illustration in contemporary political imagery, which help to extend mediums and platforms of representation. The public presence and thus the affective potentials of *everybody* figures are extended through such appropriations, opening new territories of struggle over meanings and affirmations. These observations leave us with other questions: How long do *everybody* figures live after the peak times of social movements? Under what conditions are they revived? Are there non-famous figures that are appropriated across social movements in order to achieve non-reconciling political goals?

Notes

1 Elif Öztürk, Photo Id #:10257669 [online]. Anadolu Images. Available from: https://anado luimages.com/p/10257669 and https://twitter.com/lemyezelif/status/757486857714331652 [Accessed 7 April 2019].
2 See the following examples: www.tgrthaber.com.tr/gundem/tanklara-tufeklere-meydan-okuyan-kadinlar-136587 and www.dirilispostasi.com/15-temmuz/15-temmuzun-tanklara-toplara-meydan-okuyan-kadin-kahramanlari-5a78582018e540432e754bff [Accessed 19 January 2019].
3 In May 2016 the community network led by the Islamic cleric Fethullah Gülen, a former ally of Erdoğan and the AKP, was classified as a terror organisation and called FETO (the Fethullahist Terror Organisation).

References

Akay, E., 2003. *A Call to End Corruption* [online]. Minneapolis, Minnesota: Center for Victims of Torture. Available from: www.newtactics.org/sites/default/files/resources/Call-End-Corruption-EN.pdf [Accessed 11 October 2018].

Alexander, J. C., 2012. Iconic Power and Performance. *In:* J. C. Alexander, D. Bartmanski and B. Giesen, eds., *Iconic Power*. New York: Springer, 25–35.

Awad, S. H., 2017. Documenting a Contested Memory: Symbols in the Changing City Space of Cairo. *Culture & Psychology*, 23(2), 234–254.

Barthes, R., 1981. *Camera Lucida*. New York: Hill and Wang.

Castells, M., 2015. *Networks of Outrage and Hope: Social Movements in the Internet Age*. Cambridge: Polity.

de Certeau, M., 1988. *The Practice of Everyday Life*. Berkeley, California: University of California Press.

Deleuze, G. and Guattari, F., 1987. *A Thousand Plateaus*. Minneapolis, Minnesota: University of Minnesota Press.

Doerr, N., Mattoni, A. and Teune, S., eds., 2013. *Advances in the Visual Analysis of Social Movements*. Bingley: Emerald Group Publishing.

Doerr, N. and Teune, S., 2008. *Visual Codes in Movement: When the Protest Imagery Hits the Establishment* [online]. Protestkuriosa. Available from: https://protestkuriosa.files.wordpress.com/2008/05/doerr-teune.pdf [Accessed 3 February 2017].

Doerr, N. and Teune, S., 2011. The Imagery of Power Facing the Power of Imagery: Toward a Visual Analysis of Social Movements. *In:* K. Fahlenbrach et al., eds., *The Establishment Responds*. Basingstoke: Palgrave Macmillan, 43–55.

Gerbaudo, P., 2015. Protest Avatars as Memetic Signifiers: Political Profile Pictures and the Construction of Collective Identity on Social Media in the 2011 Protest Wave. *Information, Communication & Society*, 18 (8), 916–929.

Gökay, B. and Xypolia, I., eds., 2013. *Reflections on Taksim – Gezi Park Protests in Turkey*. Keele: Keele European Research Centre.

Hariman, R. and Lucaites, J. L., 2007. *No Caption Needed*. Chicago, Illinois: University of Chicago Press.

Kandiyoti, D., 1991. Identity and Its Discontents: Women and the Nation. *Millennium*, 20 (3), 429–443.

Kavada, A., 2015. Creating the Collective: Social Media, the Occupy Movement and its Constitution as a Collective Actor. *Information, Communication & Society*, 18 (8), 872–886.

Koç, G. and Aksu, H., eds., 2015. *Another Brick in the Barricade: The Gezi Resistance and its Aftermath*. Bremen: Wiener Verlag für Sozialforschung.

Kuymulu, M. B., 2013. Reclaiming the Right to the City: Reflections on the Urban Uprisings in Turkey. *City Analysis of Urban Trends, Culture, Theory, Policy, Action*, 17 (3), 274–278.

Lavin, M., 2001. *Clean New World*. Cambridge, Massachusetts: MIT Press.

Lefebvre, H., 1991b. *Critique of Everyday Life*. London: Verso.

Massumi, B., 2015. *Politics of Affect*. Cambridge: John Wiley & Sons.

Memou, A., 2017. *Photography and Social Movements*. Manchester: Manchester University Press.

Neumayer, C. and Rossi, L., 2018. Images of Protest in Social Media: Struggle Over Visibility and Visual Narratives. *New Media & Society*, 20 (11), 4293–4310.

Özkırımlı, U., 2014. *The Making of a Protest Movement in Turkey*. Basingstoke: Palgrave Macmillan.

Papacharissi, Z., 2015. *Affective Publics*. New York: Oxford University Press.

Schober A., 2013. *The Cinema Makers: Public Life and the Exhibition of Difference in South-Eastern and Central Europe Since the 1960s*. Intellect: Bristol.

Schober, A., 2019. Introduction. *In:* A. Schober, ed., *Popularisation and Populism through the Visual Arts: Attraction Images*. New York: Routledge, 1–17.

Sonnevend, J., 2012. Iconic Rituals. *In:* J. C. Alexander, D. Bartmanski and B. Giesen, eds., *Iconic Power*. New York: Springer, 219–232.

Treré, E., 2015. Reclaiming, Proclaiming, and Maintaining Collective Identity in the #YoSoy132 Movement in Mexico: An Examination of Digital Frontstage and Backstage Activism through Social Media and Instant Messaging Platforms. *Information, Communication & Society*, 18 (8), 901–915.

9 Duane Hanson's *Man on Mower*

A Suburban American Everybody in the Mid-1990s

Viola Rühse

Introduction

Duane Hanson (1925–1996) is well-known for his life-sized sculptures of often tired and slightly melancholic people that aim to represent the American "everybody", often from the middle classes. These sculptures are characteristic of Hanson's artistic work after 1970. They are made of fibreglass or bronze and are presented without pedestals in order to achieve a more realistic effect. The sculptures with carefully chosen props provide social commentary on American everyday culture and confront the viewer with the darker sides of the "American Dream". Hanson's works are very popular because of their special hyperrealism. They are expensive in the art market and many are held in museums[1] but the number of research contributions is still relatively limited. In particular, detailed analyses of individual works with special consideration of their significant sociological and critical aspects are often lacking. An interdisciplinary image-science approach is very useful for analysing Hanson's oeuvre.[2]

As an example, this chapter provides an analysis of Hanson's last work, *Man on Mower* (Figure 9.1), which he made shortly before his death from a cancer relapse in 1995. The bronze sculpture with accessories represents an obese middle-aged man in casual wear sitting passively on a riding mower. He can be considered to be a well-to-do suburban everyman of the 1990s. At his age, people can normally afford larger homes with more property and the necessary equipment for maintenance work—given a favourable economic situation. There are four copies of the sculpture, an edition of three in bronze and an artist proof made of autobody filler.[3] One copy has been in the Newark Museum since 2002.[4] *Man on Mower* is considered to be one of the artist's major works.[5] It has often been shown in exhibitions and was chosen for the cover of an important publication on Hanson with a *catalogue raisonné*.[6]

First, some general information about the sculpture, for instance the choice of the model and the foundry work, is presented. Then various iconographical elements of the work are analysed. The accessories and details of the sculpture (which have not been investigated in detail so far) relate to interesting socio-critical topics such as the American obsession with lawns and television sports, the problem of obesity, suburban sadness and the representation of the American everyman in the 1990s.

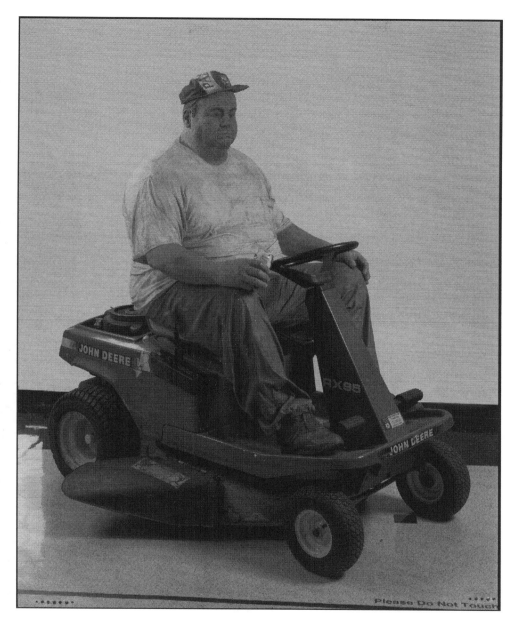

Figure 9.1 Duane Hanson, *Man on a Mower*, 1995, polychromed bronze with John Deere riding a mower and holding a can of Diet Sprite, 157.48 × 157.48 × 113.03 cm, purchase 2002 Helen McMahon Brady Cutting Fund 2002.11, Newark Museum, Newark, New Jersey. Copyright: Newark Museum, Newark, New Jersey.

The Sculpture-Creation Process

It is known that Hanson normally just imagined everyday scenes such as the *Man on Mower*. A further external cause, for instance, a picture in a newspaper, was not necessary for Hanson's everyday subjects (Chase et al. 1972, 167). After developing the initial idea for the sculpture, Hanson concentrated on the best possible execution over a longer time. He chose an old friend, the South Florida artist David Maxwell (1941–2006), as a model. Maxwell also posed for the sculpture *Slab Man* in 1974.[7] Since then, Maxwell had put on more weight—in one article he was characterised as an "imposing bear of a man" or a "mountain of a man" (Bege 2006)—which was well suited to expressing Hanson's particular artistic concept.[8] Hanson often uses family members, friends or closer acquaintances as models, which is helpful for creating a natural expression of the sculpted figure (Miro 1985). Hanson left Maxwell's beard out of the sculpture.

As a preparation for the foundry work, Hanson first created the body out of Bondo, a resin used for patching cars; the sit-on mower itself and the beverage can are real. Hanson had worked together with the Luis Montoya Sculpture Studio in South Florida for his works in bronze since the early 1980s and also chose this foundry for his last sculpture. *Man on Mower* was intended to be presented outdoors, so not only the body but also the clothing and hair were bronzed, rather than using real clothes like in many of Hanson's other works. The foundry work began in November 1995 and was finished at the end of 1996. Afterwards, Hanson's long-time assistant Tin Ly painted the three bronzes according to the deceased artist's specifications.[9] But it turned out that the oil paint used on the bronzes was not suited for an outdoor presentation, so the sculpture can only be shown indoors (Heinick 2009). The realistic effect would of course be greater outdoors.

The different versions of the sculpture vary slightly in the headwear, the cap design, the colour of the clothing, the series number of the sit-on mower and the type of soda drink. Thus each copy is unique, which can be advantageous on the art market. In this paper, the focus is on the copy in the Newark Museum in Newark, New Jersey, because the arrangement of accessories is particularly convincing.[10]

Lawns and Mowers

The riding mower in Hanson's sculpture is closely connected to the topic of lawns in general. In the 18th century, vast lawns in expansive parks and gardens in the English style indicated the wealth of landowners in Europe. Around 1800, vast areas of lawn also became more popular in the upper-class gardens in the US. Well-known is Thomas Jefferson's English-style lawn at his Monticello estate and 150 years later lawns developed further as a common visual attribute of suburban homes. Lawns were especially promoted by the architect Abraham Levitt, the "father" of modern suburbia in the US. According to Levitt, "A fine carpet of green grass stamps the inhabitants as good neighbours, as desirable citizens" (Levitt 1951). In the 1990s, lawns experienced a revival as part of the "second suburban sprawl" (Connor 1999). Green lawns are associated with a civilised mode of existence and beauty in the US and they also express American patriotism. These connotations are rooted in ideas of the 19th century, for instance in the aesthetics of the

American landscape designer Andrew Jackson Downing, who saw landscape architecture as an instrument of civilisation: "when smiling lawns and tasteful cottages begin to embellish a country, we know that order and culture are established" (Downing 1850, v).

The perfect lawn needs regular mowing, and it has become a common sight in suburbia over the last several decades. Lawn-mowing also has different connotations. For example, it signifies good citizenship, caring for the community and the family. It also implies discipline, conformity and a positive acceptance of norms. If a man mows the lawn, the traditional sex ratio is supported, because lawn-mowing is a traditional male behaviour (Jenkins 1994; Steinberg 2007). The man on the mower in the sculpture seems to take his mowing duties seriously. His long work pants and sturdy shoes are proper clothing for garden work.

In the 1950s, many older push mowers were replaced by power mowers, which were easier to use, offered more comfort and were time-saving. In the 1950s, the first sit-on mowers were available, but they were more expensive and a luxury good. With the expansion of suburban properties—houses and lawns as well—the suburban homeowners' limited time and greater disposable income in the 1990s, the sale of sit-on mowers increased in this decade. As a result, they were also used on smaller lawns even if a normal power mower would be sufficient for the size. They seem to be comfortable and aim to make mowing more an enjoyable leisure activity than a tedious household chore. In addition, they are much more expensive than a push mower and need more garage space. Riding mowers therefore represent an upscale consumer good and they became an important suburban status symbol in the 1990s and early 2000s (Fonda 2004).

Status Symbols and Indicators of the Fulfilment of the American Dream

Hanson's sculpture uses a particularly high-quality mower, a John Deere model, which can definitely be seen as a status symbol.[11] John Deere is a very popular US brand of agricultural machinery and lawn-care equipment among other things, known for quality and high prices. The positive brand relationship is fostered from early childhood, because there are also John Deere toys. In fact, the riding mower in the sculpture also more resembles a luxury toy for an adult. The smaller size of the mower underlines this, because it alludes to a fairground bumper car and is also more appropriate for smaller lawns. It is likely that a normal power mower could also be used for such a small lawn, so a riding mower is not really necessary and functions more as a status symbol. It is striking that the man's form merges with the mower's, similar to Hanson's earlier, consumer-critical 1972 sculpture of a woman with shopping bags.[12] This can be seen as a hint that the man is too much defined by the riding mower as a status symbol and that Hanson is critical of the materialism in the 1990s, which was understood as "a distinctive style of consumption that results when consumers believe that value inheres in consumption objects rather than in experience or in other people" (Holt 1995, 13). The frequently noticed tendency towards materialism in society in the 1990s was supported by the long economic expansion, with rising household incomes and more disposable income in the United States from March 1991 to March 2001, which was also fortunate for the second suburban sprawl in the 1980s and 1990s.[13]

A riding mower is regarded as the perfect addition—it is the icing on the cake, so to speak—to a suburban house and garden, which embodied the American Dream for ordinary people not only in the 1950s but also in the 1990s (Williams 1996). The phrase "American Dream" was coined by James Truslow Adams in his historical portrayal of the United States in *The Epic of America* (1931 [2012]). Adams characterises it, among other things, as a "dream of a better, richer and happier life for all our citizens of every rank" (1931 [2012], xx). He makes clear that the American Dream stands for a better life in material terms for many immigrants, but that actually liberty, equality and an opportunity for free development should come first. But according to Michael Ventura, in the mid-1990s, when the sculpture was made, the American Dream had "come to mean an ideal not of liberty but of prosperity" (Ventura 1995; see also Samuel 2012, 151). The American Dream was particularly expressed by ownership of a big suburban house with a lot of electronic gadgetry, which demonstrates that someone had been successful in moving up the social ladder and had arrived in the suburban middle class (Samuel 2012, 147). Thus the riding mower in Hanson's sculpture can be seen as an indicator of the American Dream in the 1990s. The social significance of a lawnmower was vividly described by Joel Garreau:

> The riding lawn mower has long been a barometer of the American dream, been a symbol of having arrived in the suburban middle class. It says, "I have so much lawn to mow, I need to sit down."
>
> It says, I've made it, I've escaped that funky old rowhouse neighborhood with the asbestos siding and yards like dirt-scabs. My land, my spread, not enough to plow, but way too much to mow the old-fashioned way. It says, I'm Jefferson's dream of the yeoman farmer. It says, I'm rich enough to not only raise a worthless crop, but to pay money for the privilege. It says, I'm a boy with a boy's rightful toys; a real American man.
>
> (Garreau 2008; see also Connor 1999)

Obesity

A simple push mower or even a manual mower rather than a high end gadget would be better for the physical condition of the man in the sculpture. He is overweight—a problem he shares with many Americans in recent years. His large stature is underlined by the smaller riding-mower model, which also emphasises his passivity and his physical limitations. In this regard, the can of Diet Sprite[14] in the version of the sculpture in Newark Museum is meaningful. On the one hand, the diet drink produced by Coca-Cola supports the American character of the work and the impression of ordinariness. Especially well-known are Andy Warhol's artworks with Coca-Cola bottles,[15] which make an everyday consumer product suitable as an art subject and according to the pop artist are intended to represent democratic equality:

> Everybody owns a piece of Coke. What's great about this country is that America started the tradition where the richest consumers buy essentially the same things as the poorest. You can be watching TV and see Coca Cola, and you

know that the President drinks Coca Cola, Liz Taylor drinks Coca Cola, and just think, you can drink Coca Cola, too.

(Warhol 1975, 100–101)

On the other hand, the sugar-free soft drink makes clear that the man wishes to lose weight and that Hanson is using the heavier male body not only for sculptural reasons but also as social comment. In the 1990s, the social problem of obesity was becoming clearer (World Health Organization 2017). Parallel to the increased obesity rates in the US (World Health Organization 2000), there has been a heightened social pathologisation of overweight bodies (Mason 2012). Traditionally, overweight bodies are connoted as bad and are associated with laziness and lack of discipline (Vigarello 2013, 34). Women are more pressurised and discriminated against (Fikkan and Rothblum 2012, 575), but an ideal body has become more important for men also since the 1980s (Gill 2008, 102–103).[16]

Alternative visual representations of fat men depicted in a positive way are rare. One historic example from the film sector is the comedian Roscoe "Fatty" Arbuckle, who subverted cultural norms with his infantilised heaviness and surprising agility (Kalte-necker 1996).[17] Sometimes politicians use their corpulence as an expression of their power and their vital force (Hornuff 2016). Neither option of representation applies to Hanson's sculpture of a white middle class everyman with a melancholic expression and passive body posture.[18] With his expensive riding mower the man does not demonstrate vital force, only purchasing power. In addition, he does not appear erotic, like a few weighty men, because he is not exposing his body in an emphasised way and he is not represented as a very self-confident person. With his *Man on a Mower* Hanson wants to highlight the contradictions in consumer culture and the affluent society.

Obesity was partly traced back to the prevalent sedentarism in society as a result of technological progress. Hanson's use of the riding mower is very illustrative of this seden-tarism. In 1995, health experts recommended increased physical activity combined with a sound nutritional plan, as weight loss cannot be achieved solely with sugar-free soft drinks. Lawn-mowing with a power mower or a push mower, in particular, is still con-sidered to be a good and helpful workout for obese people (Pate et al. 1995).

The Design of the Cap

In the context of the physical passivity of the man in the sculpture, the design of his cap is well-chosen. Normally, these caps provide protection against the sun and give a sporty appearance. The cap in the sculpture shows a pouncing cougar with sharp teeth and furi-ous eyes—the first logo of the Florida Panthers,[19] a Miami-based ice hockey team founded only two years before the sculpture was created. They wanted their first logo to demonstrate their ambitious attitude. At the time the sculpture was made, the Panthers were extremely successful and popular. They had reached the Stanley Cup Finals very quickly and attracted a lot of interest because ice hockey was a relative novelty in Florida with its subtropical climate. Additionally, other sports teams had not sustained such suc-cess for a longer time in Florida. The Florida Panthers were considered underdogs who were successful as a result of their hard work ethic. Thus their story was in accordance with the above-mentioned American Dream, which contributed to the team's popularity.[20] It had also had a positive impact on the sale of merchandise such as Florida Panthers caps. In general, these became popular in the 1980s as fandom articles worn in

the stands. In the 1990s, they had become normal street fashion items and were also an important part of identity politics (Patterson 2015).

The physical condition of the man on the mower makes it clear that he is not actively involved in ice hockey—a sport he supports according to the logo on his cap. With his untrained, overweight body, he is apparently only a passive participant in the professional sport in the stadium stands or at home in front of the TV screen.

Suburban Sadness

As a very energetic sport, ice hockey can be seen as a simple compensation and distraction for an unfulfilled life that is expressed in the sad facial and body expression of the man in the sculpture. He is shown immersed in himself with an intensely desperate expression, which is characteristic for Hanson's sculptures. It was particularly possible to achieve this effect with this individual because Hanson chose his models from his circle of friends and acquaintances. Hanson called the expression "quiet desperation" as a reminiscence of Henry D. Thoreau's novel *Walden; or, Life in the Woods* (Thoreau 1854, 10; Wohlfert 1978).[21] Even though he seems to have fulfilled the American Dream for himself with the expensive technological gadget, he is not shown as a happy "suburban cowboy" on his Deere riding mower.

The *Man on Mower* can also be seen as a visual expression of "suburban sadness," which the sociologist David Riesman had already diagnosed in 1958. According to Riesman, many people hated gardening work but took it up only as a matter of obligation to their neighbours (Riesman 1958, 391). In addition, Hanson's sculpture deconstructs some common beliefs connected with the American Dream: a suburban home and associated technological gadgets—even a Deere lawnmower—do not provide a sufficient cure for the alienation and emptiness in modern society that Hanson also accentuated in other works (Stillman 2008). He explained in an early interview:

> For me, I feel that I have to identify with those lost causes, revolutions and so forth. I am not satisfied with the world. Not that I think you can change it, but I just want to express my feelings of dissatisfaction.
>
> (Chase et al. 1972, 167)

Before the 1970s, Hanson's works were obviously political and criticised injustice and violence; afterwards he chose less offensive, but also crucial topics—even at the end of his life. Thus the garden topic in Hanson's sculpture does not have positive connotations as the kind of earthly paradise found in many impressionistic garden paintings (see i.e. Marley 2014). With its prevailing mood of spiritual unfulfillment, Hanson's secular sculpture also differs greatly from the religious meaning of former allegorical depictions of gardeners, for instance Christ as gardener of the souls who has opened paradise to the faithful again—for instance Lucas van Leyden's *Christ as Gardener Appearing to Saint Mary Magdalen* (1519, Figure 9.2).

Hanson's Compassion for Ordinary People and the American Everyman

A particular characteristic of Hanson's sculptures of ordinary people such as the *Man on Mower* is that Hanson is dealing with stereotypes but he develops them

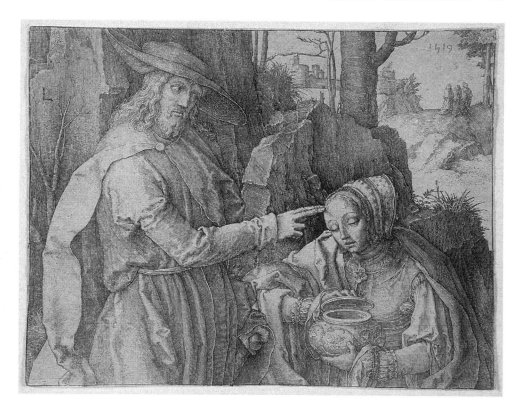

Figure 9.2 Lucas van Leyden, *Christ as Gardener Appearing to Saint Mary Magdalen*, 1519, engraving, 13.34 × 16.51 cm, Los Angeles County Museum of Art, Los Angeles, California. Copyright: Los Angeles County Museum of Art, Los Angeles, California.

from individuals and avoids clichés and exaggerations.[22] For instance, the man is shown with a Diet Sprite and not with a beer, he is wearing normal clothing instead of flip-flops and shorts and no t-shirt. He is obese but not excessively so. Hanson draws attention to critical issues but he avoids stigmatisation of overweight people that has worsened since the increase in obesity. For instance, the elevated position of the man on the mower has a dignified effect. It evokes the viewers' sympathy and compassion for Hanson's subject. This effect can be seen as one of Duane Hanson's particular achievements. The model in Hanson's last work, the artist David Maxwell, also highlighted it: "The point of Duane's brilliance was that he loved and understood people" (David Maxwell cited in Schwan 1998, 4D). The artwork may also influence the viewer's attitude to other obese people in reality. Despite some differences, Hanson can be seen as a forerunner of more recent artistic and activist endeavours that try to change problematic "obesity" discourses.[23]

With the choice of ordinary characters and the topic of alienation, Hanson's works can be seen as embodiments of the American everyman. The discourse of the

everybody has recently not only been shaped by literature and film/TV but also by fine art (Schober 2015, 260). With the focus on a white male suburban protagonist and his alienation and spiritual emptiness, Hanson takes up a very traditional issue that is well-known, for instance, from American postwar everyman novels before the 1990s (Knapp 2014, xviii).

But Hanson's protagonist is no longer so representative as a suburban everybody, because American suburbia has become more heterogeneous and transnational in contrast to the older, more uniform suburbs (Szélpál 2012). In addition, ethnically or culturally people have been used for the expression of the "everybody" in Europe even since the 1960s (Schober 2015, 241).[24] Hanson's well-considered choice of a white and male suburban protagonist refers to parallels between suburban everymen in the 1950s and the 1990s, such as their lawn obsession. But there are also differences, such as the larger property sizes and the increased materialism (Connor 1999; Samuel 2012, 147). Additionally, it is noteworthy that Hanson's compassionate attitude and use of only a little irony differs from the one in American "everybody" literature in the 1990s. According to Kathy Knapp, the representations of the protagonists are much more negative, pathetic and satirical:

> By the 1990s, however, in what amounts to a dystopian orgy of mass destruction, those writers who deigned to use the suburbs as their setting took it upon themselves to violently punish their alienated protagonists, whom they now characterized as plagued by self-pity, solipsism, deviancy, avarice, and cowardice. These stories send their entire worlds up in flames real and metaphorical.
>
> (Knapp 2014, xviii)

In contrast, Duane Hanson's works such as the *Man on Mower* are impressive because of their mild irony, their closeness to reality and the above-mentioned expression of a "quiet desperation". Even at the end of his life, Hanson paid attention to issues such as lawns, lawn care, the related ecological problems and their social and economic relevance, which gained further importance in the following years. Obesity and the lack of quality leisure time have also become more virulent issues than they were in the 1990s.

Outlook on the Third Millennium

Hanson's last sculpture draws attention to the importance of lawnmowers in American everyday culture. The integration of a Deere riding mower as a well-known status symbol in the work is a good choice because it is very representative of the increased level of materialism in the 1990s and it highlights the popularity of riding mowers at that time. Riding mowers have frequently been picked up in comics, individual cartoons and cartoon series. But lawnmowers in general are rarely to be found in high art, because they are considered to be prosaic and graceless. There have so far been only a few artists such as Hanson who have dealt with the highly symbolic potential of the lawnmower in an artistic manner.[25]

For instance, the Philadelphia-based artist Timothy Belknap created the special, playful sculpture *Mowing Towards Entropy* in 2011 (Figure 9.3). He dismantled a push mower and suspended a mobile of individual parts painted in many colours above the mower's chassis, which he painted white. Edith Newhall characterises the

work as "a vision of a lawnmower in rebellion, spewing its insides out instead of chomping up grass—and of the American dream of the perfect manicured lawn blown to smithereens" (Newhall 2011). Timothy Belknap's artwork seems to be a symbolic expression of the losses due to the consequences of the economic crisis in 2007. Although official data showed a modest economic recovery in 2011, more than a half of Americans thought that the US was still in a recession (Morgan 2011). Among other things, the unemployment rate was high and home values were still in decline.

The difficulties in the housing market also had a negative impact on the riding-mower industry (Garreau 2008). They did not sell well as expensive items, because of the decline in housing starts, and there were also many foreclosures in American suburbs. Thus many gardens were abandoned and even cheaper lawnmowers were not used on them. If Duane Hanson's *Man on Mower* can be seen as a sculptural statement on the affluent, but spiritually unfulfilled 1990s and the dark sides of the American Dream, Timothy Belknap's piece elucidates its explosion for many

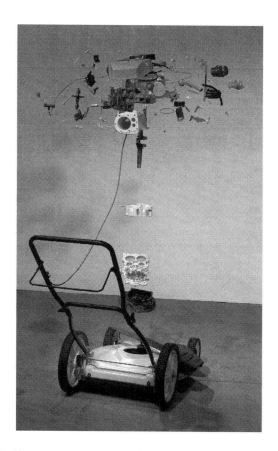

Figure 9.3 Timothy Belknap, *Mowing Towards Entropy,* installation with lawnmower, 2011, collection of the artist, Philadelphia, Pennsylvania. Copyright: Timothy Belknap, Philadelphia, Pennsylvania.

suburban middle-class people who suffered much from financial crisis (Pew Research Center 2015).

City centres have become more attractive than suburbs in recent years. According to Alan Ehrenhalt "the twenty-first century is emerging as an age of affluent inner neighborhoods and immigrants settling on the outside" (Ehrenhalt 2012, 32). It is to be expected that this new reality will have a significant influence on the iconography of the everybody, and that riding mowers will play a less important role in it after the passing of their heyday and their highly symbolic quality in the second half of the 20th century.

Notes

1 Approximately 139 of the 175 sculptures (with very limited original copies) are in museums worldwide (Heinick 2009). Some earlier prices are also mentioned in this article.
2 More frequently, general aesthetic issues such as Hanson's realism are discussed (see for instance Mansfield 2011). A rarer example of a detailed analysis of an individual work was submitted by Erica Doss (2006). An overview of image science theories and fields of analysis can be found in: Rimmele et al. (2014).
3 Buchsteiner and Letze (2007, 182), (*catalogue raisonné* no. 114). Hanson took also a polaroid photo (4.25 × 4.02 in.) for documentation purposes. It shows the painting of the artist proof in progress in 1995. The photo was on sale during a Duane Hanson exhibition at the Serpentine Sackler Gallery in London in 2015—www.artspace.com/dua ne_hanson/man-on-mower [Accessed 17 April 2017].
4 Another copy is in the Aïshti Foundation, Beirut (collection of Tony Salamé) (Swanson 2016).
5 Because of its size (157.48 × 157.48 × 113.03 cm) and the materials used, the sculpture is also one of Hanson's heaviest works, weighing ca. 450 kg (Schwan 1998, 1D).
6 Hanson's *Man on Mower* was first shown at the travelling exhibition "Duane Hanson: A Survey of his Work from the '30s to the '90s" at the Museum of Art, Fort Lauderdale; Flint Institute of Arts, Michigan; Whitney Museum of American Art, New York and Memphis Brooks Museum of Art, Memphis in 1998 and 1999. The sculpture is shown on the cover of the catalogue *Duane Hanson—Sculptures of the American Dream* (Buchsteiner and Letze 2007).
7 Duane Hanson, *Slab Man* (1974/75), vinyl resin and fibreglass, polychromed in oil, 180.34 × 130.81 × 39.69 cm, Stanford University, Cantor Arts Center.
8 Similar to Hanson, Maxwell preferred subjects of daily culture for his art. But he used another medium—painting—and is well-known for his pointillist technique. Maxwell was self-taught and quit his job as a floor finisher in 1988 to paint full time (Heidelberg 1988).
9 Hanson took a polaroid of the auto body filler version.
10 As explained below, the choice of a Diet Sprite can gives it a special significance.
11 He chose a John Deere RX73 mower that was sold from 1987 to 1990. Its appearance was intended to intensify the realistic effect of the sculpture.
12 Duane Hanson, *Lady with Shopping Bags*, 1972, polyester resin and fibreglass, polychromed in oil, with accessories (Buchsteiner and Letze 2007, 165).
13 The long economic boom was only briefly interrupted by the shutdowns in 1995, when some areas of government spending were temporarily reduced.
14 In the early 2000s, the soft drink was renamed Sprite Zero.
15 One of Warhol's artworks with Coca-Cola bottles is in the Whitney Museum of American Art, New York (*Green Coca-Cola Bottles*, 1962, acrylic, screenprint and graphite pencil on canvas, 210.2 × 145.1 cm).
16 For men, muscular bodies are more important than thinness.
17 Arbuckle's younger successors are corpulent comedians such as John Goodman and John Candy.

18 The artist's model, the artist David Maxwell seemed to be more good-natured and vivid in reality, but Hanson chose the particular representation.
19 The first logo of the Panthers from 1993 was changed significantly in 2016; previously there had been only a slight change in the colours (Creamer 2016).
20 Unfortunately, since the 1995–1996 season, the Florida Panthers have been less successful for some years.
21 Wohlfert (1978), Walden (1854, 10).
22 Only Hanson's works from the beginning of the 1970s are more satirical.
23 Recent artworks that support a fat-positive viewpoint are analysed in Snider (2012).
24 A discussion of Hanson's sculpture with regard to racial, gender and class questions would go beyond the scope of the present chapter.
25 Apart from Hanson's *Man on Mower*, another rare example of an artwork with a riding mower is Rubén Ortiz Torres' *Garden of Earthly Delights* (2002), an installation including a lawnmower and video (see Chavoya 2004). An unusual film masterwork centring on a lawnmower is David Lynch's *The Straight Story* (1999). It is based on the true story of Alvin Straight, who in 1994 drove on a lawnmower from Iowa to Wisconsin in order to see his sick brother. Straight's journey attracted a great deal of media attention in the mid-1990s, but there is no recognisable connection to Hanson's *Man on Mower* apart from the general reference to lawnmowers and suburbia.

References

Adams, J. T., 2012. *The Epic of America (1931)*. Piscataway, New Jersey: Transaction.
Bege, B., 2006. *Famous Artist David Maxwell Part 1* [radio report], 24 July. Available from: https://archive.org/details/Radioutlaw-FamousArtistDavidMaxwellPart1710-2 [Accessed 26 March 2019].
Buchsteiner, T. and Letze, O., eds., 2007. *Duane Hanson—Sculptures of the American Dream*. Ostfildern: Hatje Cantz.
Chase, L., Foote, N. and McBurnet, T., 1972. The Photo-Realists: 12 Interviews. *Art in America, Special Issue on Photorealism*, 60 (6), 73–89.
Chavoya, C. O., 2004. Customized Hybrids: The Art of Ruben Ortiz Torres and Lowriding in Southern California. *CR: The New Centennial Review*, 4 (2), 141–184.
Connor, T., 1999. For Him: The Perfect Lawn is a Status Symbol Again. *The New York Times*, 18 July. Available from: www.nytimes.com/1999/07/18/style/for-him-the-perfect-lawn-is-a-status-symbol-again.html [Accessed 26 March 2019].
Creamer, C., 2016. Florida Panthers New Logo Leaked. *Sportslogos.net*, 26 April. Available from: http://news.sportslogos.net/2016/04/26/florida-panthers-new-logo-leaked/ [Accessed 26 March 2019].
Doss, E., 2006. Duane Hanson's Woman Eating. *American Art*, 20 (2), 9–12.
Downing, A. J., 1850. *The Architecture of Country Houses*. New York: D. Appleton & Co., v.
Ehrenhalt, A., 2012. *The Great Inversion and the Future of the American City*. New York: Alfred A. Knopf.
Fikkan, J. L. and Rothblum, E. D., 2012. Is Fat a Feminist Issue? Exploring the Gendered Nature of Weight Bias. *Sex Roles*, 66 (9–10), 575–592.
Fonda, D., 2004. Splendor in the Grass. *Time*, 25 April. Available from: http://content.time.com/time/magazine/article/0,9171,629400,00.html [Accessed 26 March 2019].
Garreau, J., 2008. Deere John: It's Been a Good Ride. *Washington Post*, 19 July. Available from: www.washingtonpost.com/wp-dyn/content/article/2008/07/18/AR2008071802886.html [Accessed 26 March 2019].
Gill, R. 2008. Body Talk. Negotiating Body Image and Masculinity. *In*: S. Riley et al., eds., *Critical Bodies: Representations, Identities and Practices of Weight and Body Management*. New York: Palgrave Macmillan, 2008, 101–116.

Heidelberg, P., 1988. Award-Winner Stars in One-Woman Show. *SunSentinel*, 10 February. Available from: http://articles.sun-sentinel.com/1988-02-10/news/8801090409_1_daniel-art-gallery-paintings-art-professor [Accessed 17 April 2017].

Heinick, A., 2009. Duane Hanson in Paris: Verlorene Illusionen. *Frankfurter Allgemeine Zeitung*, 30 June. Available from: www.faz.net/aktuell/feuilleton/kunstmarkt/galerien/duane-hanson-in-paris-verlorene-illusionen-1815628.html [Accessed 26 March 2019].

Holt, D. B., 1995. How Consumers Consume: A Typology of Consumption Practices. *Journal of Consumer Research*, 22 (June), 1–16.

Hornuff, D., 2016. Bauchentscheidungen. Das politische Gewicht der Körpermitte. *In:* A. Schober and A. Langenohl, eds., *Metamorphosen von Kultur und Geschlecht. Genealogien, Praktiken, Imaginationen.* Paderborn: Wilhelm Fink, 105–130.

Jenkins, V. S., 1994. *The Lawn: A History of an American Obsession.* Washington, DC: Smithsonian Institution.

Kaltenecker, S., 1996. Fatty's Ass: Über Stummfilmkörper, Geschlechtsbilder und Roscoe Arbuckle. *Film und Kritik*, 3 (Doktorspiele: The Slapsticks of Roscoe Arbuckle), 47–59.

Knapp, K., 2014. *American Unexceptionalism: The Everyman and the Suburban Novel After 9/11.* Iowa City, Iowa: University of Iowa Press.

Levitt, E., 1951. Chats on Gardening. *Levittown Tribune*, 5 April, 8.

Mansfield, E. C., 2011. A New Parrhasius: Duane Hanson's Uncanny Realism. *In:* I. L. Wallace et al., eds., *Contemporary Art and Classical Myth.* Farnham et al.: Ashgate, 245–265.

Marley, A. O., ed., 2014. *The Artist's Garden American Impressionism and the Garden Movement.* Philadelphia, Pennsylvania: University of Pennsylvania Press.

Mason, K., 2012. The Unequal Weight of Discrimination: Gender, Body Size, and Income Inequality. *Social Problems*, 59 (3), 411–435.

Miro, M., 1985. Human Life Seems to Spring from Artist's Plaster Molds. *Detroit Free Press*, 26 February, B1.

Morgan, D., 2011. Most Americans Say U.S. in Recession Despite Data: Poll. *www.reuters.com*, 28 April. Available from: www.reuters.com/article/us-usa-economy-gallup-idUSTRE73R3WW20110428?feedType=RSS&feedName=domesticNews [Accessed 26 March 2019].

Newhall, E., 2011. Timothy Belknap Turns Everyday Objects into Sculpture. *The Philadelphia Inquirer*, 16 October. Available from: www.philly.com/philly/columnists/edith_newhall/20111016_Galleries___Timothy_Belknap_turns_everyday_objects_into_sculpture.html [Accessed 26 March 2019].

Pate, R. R. et al., 1995. Physical Activity and Public Health: A Recommendation from the Centers for Disease Control and Prevention and the American College of Sports Medicine. *JAMA*, 273, 402–407.

Patterson, T., 2015. The Common Man's Crown. *New York Times Magazine*, 1 April. Available from: www.nytimes.com/2015/04/05/magazine/the-common-mans-crown.html?_r=0 [Accessed 26 March 2019].

Pew Research Center, 2015. *The American Middle Class is Losing Ground: No Longer the Majority and Falling Behind Financially.* Washington, DC: Pew Research Center.

Riesman, D., 1958. The Suburban Sadness. *In:* W. Dobriner, ed., *The Suburban Community.* New York: Putnam, 375–408.

Rimmele, M., Sachs-Hombach, K., and Stiegler, B., eds., 2014. *Bildwissenschaft und Visual Culture.* Bielefeld: Transcript.

Samuel, L. R., 2012. *The American Dream: A Cultural History.* Syracuse, New York: Syracuse University Press.

Schober, A., 2015. Everybody: Figuren "wie Sie und ich" und ihr Verhältnis zum Publikum in historischem und medialem Umbruch. *In:* J. Ahrens, L. Hieber, and Y. Kautt, eds., *Kampf um Images. Visuelle Kommunikation in gesellschaftlichen Konfliktlagen.* Wiesbaden: Springer VS, 241–270.

Schwan, G., 1998. The Making of Duane Hanson's Last Sculpture. *The Palm Beach Post*, 14 January, 1D, 4D.

Snider, S., 2012. Fatness and Visual Culture: A Brief Look at Some Contemporary Projects. *Fat Studies: An Interdisciplinary Journal of Body Weight and Society*, 1, 13–31.

Steinberg, T., 2007. *American Green: The Obsessive Quest for the Perfect Lawn*. New York: Norton.

Stillman, N., 2008. Duane Hanson. *Artforum*, 46 (6), 290.

Swanson, C., 2016. Exhibition Shows What America Looks Like from Beirut. *Vulture* (online news portal), 22 July. Available from: www.vulture.com/2016/07/what-america-looks-like-from-beirut.html [Accessed 26 March, 2019].

Szélpál, L., 2012. Images of the American Suburbia. *Americana*, VIII (I).

Thoreau, H. D., 1854. *Walden; or, Life in the Woods*. Boston, Massachusetts: Ticknor and Fields.

Ventura, M., 1995. The Psychology of Money. *Psychology Today*, 28 (2), 50.

Vigarello, G., 2013. *The Metamorphoses of Fat: A History of Obesity*, translated by C. J. Delogu. New York: Columbia University Press.

Warhol, A., 1975. *The Philosophy of Andy Warhol*. New York: Harcourt Brace.

Williams, L., 1996. Testing the Resonance of the American Dream. *The New York Times*, 23 June. Available from: www.nytimes.com/1996/06/23/style/testing-the-resonance-of-the-american-dream.html [Accessed 26 March 2019].

Wohlfert, L., 1978. At Duane Hanson's Strange New Show, Only the Artist is Lying Down on the Job. *People*, 6 March. Available from: www.people.com/people/archive/article/0,20070327,00.html [Accessed 26 March 2019].

World Health Organization, 2000. Obesity: Preventing and Managing the Global Epidemic: Report of a WHO Consultation. *WHO Technical Report Series*, 894 (i–xii), 1–253.

World Health Organization. *Nutrition—Controlling the Global Obesity Epidemic*. Available from: www.who.int/nutrition/topics/obesity/en/ [Accessed 26 March 2019].

10 *Devenir Tout le Monde*

A Deleuzian Perspective on the Everybody between Political Practice and Visual Culture

Nina Bandi

Listening to the 1964 song "Man in the Street" by the Jamaican ska band the Skata-
lites one imagines some unknown person joyously walking down the street. It is not
so much the identity of this person that interests but far more the style of walking in
time with the beat that typically defines ska music. The Skatalites were at the origin
of the ska style, from which various different styles such as reggae/ragga and ska
punk developed. As much as ska has lived on until today in different forms, the ques-
tion is what types of this "common man" still walk the street, or rather what is it
that makes this common man such an appealing figure? Most recently in research on
populism one has seen a heightened interest in this figure. This seems to be a direct
consequence of the current political climate, in which not only but particularly West-
ern democracies are confronted with rising populism, especially on the right (Kalt-
wasser et al. 2017; Kriesi and Pappas 2015). The relationship between populism,
nationalism/right-wing parties and the figure of the common man which is appealed
to is contested depending on how populism is conceptualised. While I am sympa-
thetic to the critique of necessarily aligning populism with right-wing nationalism (de
Cleen 2017; Ochoa Espejo 2017; Stavrakakis et al. 2017), because it narrows the
focus and the frame of analysis on both phenomena, there is nonetheless a close con-
nection between right-wing nationalism and the invocation of the "man in the
street" figure. Right-wing populist politicians in particular make this strategic appeal
in their campaigning, and mainstream media outlets are willing and sometimes eager
to take up this supposedly neglected subject as a central trope (Weyland 2017). It is
this link that marks the starting point of this chapter, in order to propose a different
thinking of the figure variously called the "man in the street", the "common man" or
"everybody". Taking a closer look at this "common man", who is epitomised by the
"angry white man" in the United States for example (Kimmel 2013), it appears that
it is not so much an effective commonality as the joyous way of walking would be,
but that there are some specific features that characterise it. Let us first of all note
that this man in the street resonates as a male figure, notwithstanding the possible
neutral meaning of the word man. Furthermore, he is not only male, but also white
and possibly heterosexual. To substitute the category of the common man with the
concept of the everybody might at first sight help to enlarge the possible meanings of
this common denominator, at least on a semantic level. Yet we would have great dif-
ficulty finding the unifying terms with which to include and address each and every
one and ignore the clear delineations at work in these political discourses including
citizenship, gender, race, class and sexual orientation.

While it remains doubtful how a figure of the everybody might work in a non-exclusionary way on a political level, I would like to propose a philosophical detour that may provide a clue as to how such a figure can be thought of, imagined and addressed. In the second volume of *A Thousand Plateaus: Capitalism and Schizophrenia* (1980) Gilles Deleuze and Felix Guattari introduce the conceptual figure of the *devenir tout le monde*, to which I will dedicate a large part of this chapter. I will then seek to bring this "everybody/everything" closer to some political practices that we have observed in recent years. From there—without going into detail—I will highlight some examples from the visual arts. I thereby propose a reading of the "common man/woman" (or "wo*man") in the street that counters established images and favours the styled walker over the reifying identificatory logic of politics, although not ignoring the conditions of the emergent style.

I

The notion of the *devenir tout le monde* first of all poses a problem of translation. In colloquial French *tout le monde* is used to designate the entirety of a group of people in a non-specific way. However, the term does not prefigure what is included, whether it is about people, things or something else, in contrast to the English. Accordingly, the translation proposed in *A Thousand Plateaus* is everybody/everything separated by a slash. Whereas English defines a relationship to the body or a thing, the French term *monde* is less specific. In Deleuze's and Guattari's sense, *monde* may entail *a* world, or also many worlds. Not only but also in *A Thousand Plateaus*, Deleuze and Guattari regularly refer to the cosmos or the Cosmos. It is worth noting how this *tout le monde* relates to their understanding of the cosmos as something which somehow surpasses the world, an abstract machine, or a force of deterritorialisation. Deleuze and Guattari (1987, 280) write that *devenir tout le monde* "brings into play the cosmos with its molecular components." In their view, this relationship between *monde* and cosmos, however, is not primarily based on the meaning of the term *monde*, but most importantly stresses the process of becoming.

Devenir Tout Le Monde as a Process of Becoming

To be more specific, for Deleuze and Guattari, the becoming everybody/everything involving the cosmos and its molecular components is opposed to the everybody/everything that is the molar whole. In order to stress the aspect of becoming, making and creating, they continue: "Becoming everybody/everything (*tout le monde*) is to world (*faire monde*), to make a world (*faire un monde*)" (Deleuze and Guattari 1987, 280). Thus the fundamental distinction lies between becoming everybody/everything and [being] everybody/everything *tout court*. In Deleuze's (and Guattari's) philosophy the concept of becoming has a central role that is worth taking a closer look at, although within the scope of this chapter it is not possible to give a systematic overview, which is generally rare in secondary literature (see Bankston 2017; Lundy 2012). It will therefore suffice to extract some aspects that are relevant with regard to the figure of the everybody from a political and a cultural perspective.

As a starting point, in the way it is developed in *A Thousand Plateaus* the concept of becoming has one reference point in its deviation from structuralism and structuralist linguistics. Instead of looking at and focusing on structures and relations of resemblance and analogy, these are seen as problematic. Deleuze and Guattari (1987, 237) diverge from this, arguing that a correspondence between relationships cannot account for the process of becoming. Becoming thus entails a joining of forces that goes beyond or that is different from the logics of resemblance, imitation and identification. This gives an initial clue as to how to think the figure of the everybody not as a reductionist point of identification but rather as a cosmic force that escapes these common registers. Deleuze and Guattari write:

> Becoming produces nothing other than itself. We fall into a false alternative, if we say that you either imitate or you are. What is real is the becoming itself, the block of becoming, not the supposedly fixed terms through which that which becomes passes.
>
> (1987, 238)

It should be noted here that the term "real" is attached to the process of becoming and not to the structures and conditions by which this becoming happens.

The most characteristic aspect of the concept of becoming is its relation to time and subjectivity. Drawing on Henri Bergson and his idea of a coexistence of different times as durations Deleuze and Guattari (1987, 238) argue that becoming does not suppose the existence of a subject that exists apart from it. On the contrary, the subject is part of and only exists within the process of becoming. Furthermore, the terms or conditions on which the becoming happens are part of this process and cannot be looked at distinctly. As a last point, the process of becoming is not to be understood in terms of descent. Deleuze and Guattari (1987, 238) write: "Becoming produces nothing by filiation; all filiation is imaginary. Becoming is always of a different order than filiation. It concerns alliance." It is an alliance that does not start at a certain point, has no origin, no hierarchical point of origin but it passes through the milieu (as Deleuze and Guattari would say). This underlines that any idea of ancestry is discarded. Famously, it is not the tree that is firmly rooted in the ground but the rhizome that connects multiplicities. Referring back to the aspect of time, this goes with a non-linear relationship of time, neither thinking the present as a linear follow-up to the past nor the future as a linear continuation from the now. On the contrary, there can be packs of the past encroaching on the now.

How to conceive of the subjectivity of the figure of the everybody as this common man/woman in the street? A probable answer would work on the register of individuality or lacking individuality as the latter would be attributed to everyday people who lack representation exactly for this reason. In contrast, if focusing on the joyous walk in the street again, one could argue that it is exactly the style of walking opposed to any defining (individual) characteristic that is part of the becoming of the common man/woman. Individuality, which is not part of the Deleuzian (and Guattarian) vocabulary, would thus lead down a wrong track in looking at this figure, as it is much more a process of singularisation that always entails connections and associations that go beyond or only cover parts of an individuality.

In sum, the everybody/everything as a figure of becoming brings in a logic of creation, of joining different times together, a logic of multiplicity as opposed to the logic of the one, also in terms of subjectivity and the individual. Becoming evades the logic of representation, the image of thought (Deleuze 1994) that forestalls our thinking. For Deleuze and Guattari (1987, 239), "Becoming is a verb with a consistency all its own; it does not reduce to, or lead back to, 'appearing', 'being', 'equaling', or 'producing'." There is the difficulty that these concepts are nonetheless central in discourses on the visual and on subjectivity, and as a consequence seem to blur or lose their efficiency. For example, how to think the production of subjectivity through the gaze? In Deleuze's book on Francis Bacon, in which he develops a theory on painting and sensation, this is illustrated via the body and its becoming. The body does not appear but is revealed in the confrontation of bone and flesh, "when the two exist for each other, but each on its own terms: the bone as the material structure of the body, the flesh as the bodily material of the figure" (Deleuze 2003, 22). It is in this encounter that a figure is created, but not in terms of a spectatorship. Later I will turn to examples from the arts through which the process of *devenir tout le monde* can be thought of differently. But first there are some other aspects that are particularly relevant with regard to the everybody.

Minoritarian vs Majoritarian

In Deleuze's and Guattari's terms a becoming is by definition minoritarian as opposed to majoritarian:

> For the majority, insofar as it is analytically included in the abstract standard, is never anybody, it is always Nobody [written with an initial capital]—Ulysses—whereas the minority is the becoming of everybody, one's potential becoming to the extent that one deviates from the model. There is a majoritarian "fact," but it is the analytic fact of Nobody, as opposed to the becoming-minoritarian of everybody. That is why we must distinguish between: the majoritarian as a constant and homogeneous system; minorities as subsystems; and the minoritarian as a potential, creative and created, becoming. The problem is never to acquire the majority, even in order to install a new constant. There is no becoming-majoritarian; majority is never becoming. All becoming is minoritarian.
> (Deleuze and Guattari 1987, 105–106)

This highlights the fact that the opposition between majoritarian and minoritarian is not a quantitative but a qualitative one. The majoritarian is a model, a constant, and the minoritarian is always something that deviates from this model, it is an act of change, of modification of and within this homogeneous system. The constant can for example be the "average" adult, white, heterosexual European male who speaks a common language. Hence Deleuze and Guattari propose women or becoming woman as one of their primary examples of a becoming that is always minoritarian.

> Women, regardless of their numbers, are a minority, definable as a state or subset; but they create only by making possible a becoming over which they do

not have ownership, into which they themselves must enter; this is a becoming-
woman affecting all of humankind, men and women both.

<div align="right">(Deleuze and Guattari 1987, 106)</div>

Neither is it about a statistical frequency or about a biological, sociological or iden-
titarian definition of what a woman is or what becoming woman means. More
importantly, the becoming woman entails a giving up of ownership and control
over what it actually means to be a woman.

With regard to the question of the figure of everybody, we may note that it is the
everybody (*personne/tout le monde*) that is attached to the minoritarian becoming,
as opposed to the constant, to the model, where no creation takes place. An example
would be the casting of a vote in a referendum where you can say yes or no. The
minoritarian everybody, in contrast, is attached to that which creates. This relates
back to the very first quote about the making of world: "*Devenir tout le monde, c'est
faire monde, faire un monde.*" Creation is not attained by acquiring the majority. It
is about "continuous variation, as an amplitude that continually oversteps the repre-
sentative threshold of the majoritarian standard, by excess or default." As such one
"addresses powers (*puissances*) of becoming that belong to a different realm from
that of Power (*Pouvoir*) and Domination" (Deleuze and Guattari 1987, 106). It is
this continuous variation that constitutes the becoming minoritarian of everybody.

Becoming Imperceptible as the form of Ultimate Becoming

There is a final point to be made with regard to the *devenir tout le monde*. So far,
it has been shown that this figure raises the question of the becoming, and more
precisely a becoming that is by definition minoritarian. There is another form of
becoming, however, and this is becoming imperceptible. Becoming imperceptible,
for Deleuze and Guattari, is the ultimate becoming:

> If becoming-woman is the first quantum, or molecular segment, with the
> becomings-animal that link up with it coming next, what are they all rushing
> toward? Without a doubt, toward becoming-imperceptible. The imperceptible
> is the immanent end of becoming, its cosmic formula.

<div align="right">(1987, 279)</div>

The notion of the becoming-imperceptible relates to the figure of the everybody by
bringing in aspects of perception, be they visibility, audibility or recognisability.
Becoming imperceptible, not visible, not recognisable, thus evokes another problem
with regard to the figure of the everyone. The gesture of addressing each and every-
one seems to imply some kind of recognition, so is it exactly what the ultimate
becoming is opposed to? Interestingly, Deleuze and Guattari write about the diffi-
culty of being "like" everybody, *être "comme" tout le monde*, the difficulty of
becoming imperceptible, of becoming unknowable, even by your neighbours,
people you encounter every day. And this difficulty stems from the fact that this
"to be like everybody" entails a becoming, thus suggesting that the process of
becoming is not an easy process. "*Ce n'est pas tout le monde qui devient comme
tout le monde, qui fait de tout le monde un devenir*" (Deleuze and Guattari 1980,
342)/"Not everybody becomes everybody [and everything: *tout le monde*], makes

a becoming of everybody/everything" (Deleuze and Guattari 1987, 279). This last section, *"faire de tout le monde un devenir"*, points to an interesting reversal. There is really a capacity of making a becoming of everybody, but this possibility is limited because attaining non-recognisability is not a smooth process. To pass as a stranger even to someone living next door, it requires more than just self-sufficiently sinking into oneself. Becoming everybody is not a molar aggregate that one could easily hold on to. It is letting in indiscernibility, that which does not signify anything, which is not knowable, as well as the impersonal, that which is non-subjectified. This moment of non-personality or a-subjectivity relates to the non-individual perspective that I alluded to earlier. Individuals are easily traceable, but if we think of compositions and lines, this changes.

> By process of elimination, one is no longer anything more than an abstract line, or a piece in a puzzle that is itself abstract. It is by conjugating, by continuing with other lines, other pieces, that one makes a world that can overlay the first one, like a transparency. Animal elegance, the camouflage fish, the clandestine: this fish is crisscrossed by abstract lines that resemble nothing, that do not even follow its organic divisions; but thus disorganized, disarticulated, it worlds with the lines of a rock, sand, and plants, becoming imperceptible.
>
> (Deleuze and Guattari 1987, 280)

In this example the imperceptibility of the fish does not ensue from a dissolving of the fish but from a creating of a world with the surroundings, thus disarticulating organic functions and limits. Similarly, this can be observed in Bacon's paintings with regard to the head-meat relationship. The figure disappears, being returned to its material structure, this is the becoming-imperceptible (Deleuze 2003, 27).

There seems to be an ambiguity between the common man in the street, which is supposedly stripped of any specific characteristics, and the becoming imperceptible of the everybody, which calls for more than just ignorance and emptiness. In order to look more closely at this tension, I will focus on some political expressions that serve as a speculative opening to the thinking of the relationship between the figure of the everybody, populism and arts.

II

In the *Cinema 2*, writing on the difference between Western cinema and cinema from the global "South", Deleuze states:

> This acknowledgement of a people who are missing is not a renunciation of political cinema, but on the contrary the new basis on which it is founded, in the third world and for minorities. Art, and especially cinematographic art, must take part in this task: not that of addressing a people, which is presupposed already there, but of contributing to the invention of a people.
>
> (2000, 217)

For Deleuze the missing people and the invention of a people are a becoming, as opposed to addressing what is already there. Politically speaking this means questioning the existing (categories) and allowing to become. In the following I would like to investigate what this becoming might mean, by looking at recent political

practices that have mainly arisen as a response to the financial and economic crisis starting in 2007/2008, and in parallel to the surge of right-wing political parties.

While I focus on some rather specific political instances, it remains clear that this questioning of the existing, of the constant and the allowing of these processes of becoming take place within specific historical and political contexts which cannot be fully addressed here. Furthermore, what will become apparent is the ambivalence that resides within the addressing of this "missing people". The possible processes of becoming are never "pure", on the contrary, they illuminate the inherent problematics within the attempt of conceptualising the figure of the everybody in this way.

A first example is the so-called "human microphone" (Brunner et al. 2013). This emerged in 2011 within the Occupy Wall Street movement in Zuccotti Park in New York as a response to the local situation. The park is legally not a public space but privately owned and thus the use of any kind of amplifier such as a loudspeaker or megaphone is forbidden. As a result the people around the person speaking during the assemblies started to repeat what was said in order to make this single voice heard and to further its reach. This multiplication of voices not only led to a wider audibility but there was also a ritualistic aspect to this doubling and multiplication, as it was never just a mere repetition. This becoming of a common voice that is nonetheless multiple, open and modifiable, could well be read as an instance of a molecular becoming. Another example of such a practice of a singular but a non-individualising becoming is the figure of the standing man (Gambetti 2014) that emerged in specific circumstances in Turkey. It was after the police had raided Gezi Park and Taksim Square in June 2013 after weeks of protests against the construction of a shopping mall in the centre of Istanbul, for which a park would have been destroyed. What started with an action against the felling of trees became a much larger political movement against the politics of the government. After the raid, the police sealed off Taksim Square and any kind of gathering was prohibited. As a result, a Turkish dancer and performer decided to subvert the police restrictions and placed himself on Taksim Square, standing alone, facing the Atatürk Cultural Centre with its huge banner of the founder of modern Turkey. He remained standing there for hours, alone, which was a prerequisite for not being removed by the police. This figure became popular through social media and was then reused by other people in other circumstances and other places. An individual body became multiple, became everybody, became imperceptible not least to the police, in that it made protest possible in an unforeseen way, multiplying the claims and desires of much more than just this person.

The not merely numerical question of minoritarian and majoritarian becoming seems to be in play with the slogan "We are the 99%", which was widely used within the Occupy Wall Street movements especially in the United States. The slogan takes up the numerical element that inhabits representative democracies while at the same time demonstrating its insufficiency. While 99% is almost everybody, the question arises whether, by the way it has been used politically, it can be read as a minoritarian becoming of everybody in which the asymmetry between the quantitative and the qualitative is brought to a maximum. 99% refers to all who do not belong to the wealthiest 1%. If the minoritarian does not necessarily stand for a numerical minority, as has been said before, it does question the constant, majoritarian fact. The invocation of the slogan of the "99%", however, also

highlights the tension between the appealing invocation of the mere number that is supposed to count in a representative democracy and the problematic seeking of a common denominator or a commonality that omits categories like gender, race or class. In that sense, if the becoming minoritarian rests solely on the invocation of a number, it seems among other things that it lacks its transformative elements.

This last point is also relevant regarding my final example of a political practice, Black Lives Matter, a movement specific to the United States. Black Lives Matter emerged in 2012 after the killing of Trayvon Martin, a black 17-year-old, who was killed by a neighbourhood watchman in Florida while walking in the street—it was not a "common man in the street" but a black teenager. This case stands for a series of events in which young black men were fatally shot by police or security officers and more generally for anti-black racism—not only but also in US society. In most cases either there was no criminal prosecution or the perpetrators were acquitted, usually on grounds of self-defence even if their victims were not armed. This was also the case with Trayvon Martin in 2013. Originally functioning as a twitter hashtag, Black Lives Matter has become a political movement with increasing public and media attention. It has also become a national organisation, organised in local chapters and thus acquiring an institutional character. However, the movement remains hybrid, standing for an ongoing struggle against police violence and anti-black racism operating in different circumstances with a variety of political practices and joining different causes. Reactions to the Black Lives Matter movement have been varied. One comes mainly from white people opposing the blackness in the hashtag, which they regard as an excluding signifier. The #blacklivesmatter hashtag was thus quickly supplemented by the #alllivesmatter. What is ostensibly opposed here is an identitarian, differential position (blackness) versus a liberal inclusive one in which everyone is concerned. However, referring back to the *devenir tout le monde*, we can see, how alllivesmatter wrongly invokes a universal that still works on the register of denumerability:

> But what we are talking about is something else, something even that would not resolve: women, nonmen, as a minority, as a nondenumerable flow or set, would receive no adequate expression by becoming elements of the majority, in other words, by becoming a denumerable finite set. Nonwhites would receive no adequate expression by becoming a new yellow or black majority, an infinite denumerable set. What is proper to the minority is to assert a power of the nondenumerable, even if that minority is composed of a single member. That is the formula for multiplicities. Minority as a universal figure, or becoming-everybody/everything (devenir tout le monde). Woman: we all have to become that, whether we are male or female. Non-white: we all have to become that, whether we are whites, yellow, or black.
>
> (Deleuze and Guattari 1987, 470)

If we follow Deleuze and Guattari here, blacklivesmatter does not create the nonwhite as a new black majority, but as a minoritarian becoming of the everybody/everything. For Black Lives Matter, as the name suggests, one major issue is representation of blackness; however, its hashtag and the struggle it refers to denounce the majoritarian facticity of white supremacy. The figure of the everybody in the case of Black Lives Matter is not an unspecified common man in the street, on the contrary, it is the becoming of an everybody insofar as it questions the dominant logics of power and representation.

III

Taking up Deleuze's remarks in *Cinema 2* again: if the task of art is not to address an existing people but to contribute to their invention, what does it become in the context of the *devenir tout le monde*? How to invent a becoming of everybody? I will address two examples which in part address the question of what kind of imagery or practice around this becoming of everybody is created within or through the realm of the arts.

In a project spanning several years (2013–2018) in Philadelphia, US, the Dutch artist Jeanne van Heeswijk has addressed questions that have inspired her work for many years: the role of art in the collective imagining of a place, an environment, a community. With the involvement, contribution and participation of many different players, *Philadelphia Assembled* has become an expansive project that gathers, collects and creates voices, narratives and practices in order to think and work out different futures. While not entering into a debate over the inherent problematics of so-called socially engaged art and the interlinking with community building, it seems that in this project, there are a few elements that can be directly linked to a becoming of the everybody in the way we have addressed it so far. While the use of artistic means in order to support community building in supposedly destitute urban areas has been probed many times, what is remarkable in this case is not only the considerable time span but also the heterogeneous build-up of activities around the five topics of reconstructions, sovereignty, futures, sanctuary and movement. The question of who is addressed is turned into a process of activation of what is there in terms of histories, places and people via multiple subjectivities and times. It is not the local inhabitants suffering from processes of gentrification who are addressed, but it is they who address what their environment actually is and what kind of stories, past and present it holds in what could be called a minoritarian becoming of the common man/woman living in these specific areas of Philadelphia.

Acting in a completely different context is the work of the British artist Lubaina Himid, the winner of the 2017 Turner Prize. As an artist, but also as a curator and as a writer, she has been working for several decades on questions pertaining to the African diaspora and its role and visibility in relation to European culture and history. There is one piece on which I would like to focus in the context of this chapter, *Naming the Money* (2004). A hundred standing painted life-size figures, referred to by the artist as "cut-outs", fill the exhibition space, in the original setting spanning over several rooms. They—men and women—are dancers, viola da gamba players, mapmakers, shoemakers, dog trainers, drummers, ceramicists, herbalists, toy makers and painters. Each has a name, a voice; besides their name, they say what they are called, what they used to do and what they are doing now. Sometimes, they say what they are good at and what they like. They have a story; individual stories that nonetheless tell a collective story. On the one hand they point to the representation of black people within European culture and especially painting. On the other hand, and more importantly, the work allows the public in Himid's words to

> experience a world in which those who had contributed their everything were given a voice to say what it felt like to have come from somewhere else and

then be destined to spend their lives negotiating the dangerous political terrain working for nothing disguised as pieces of furniture and ornaments.

(Himid 2013)

It is in dialogue with the public that the question of the violent neglect and erasure of black subjectivity within European history comes to the fore, and the "cut-outs" develop a sociality inhabiting the space which testifies to this "unseen" life. It is in that sense that *Naming the Money* addresses the question of the invention of a people as a becoming through the assertion of the power of the nondenumerable. Opposing the reference of being the servile decoration and adornment, these black men and women become "everybodies" with a life, socially, culturally, economically. Listening to their stories it becomes clear that this process involves a constant struggle.

Those Who Are in the Street

The joyously walking man in the street—it makes you smile when thinking how easy that might be—enjoying the rhythm, the style; it is not. For some, it is utterly dangerous, for others, it is mostly a metaphor to advance a politics that is certainly not in the interest of those who *are* in the street. I have attempted to change the perspective and look at the everybody as a figure that actually has the potential to change. By focusing on the *devenir tout le monde* of Deleuze and Guattari my aim was to shift the emphasis with regard to the everybody to an active becoming of the everybody. The first point was to emphasise the becoming of everybody as opposed to being everybody, hence stressing the transformative process. Furthermore, I outlined the opposition between majoritarian facts and minoritarian becomings, suggesting that the process of becoming everybody is necessarily minoritarian. Becoming woman, becoming black, are examples and show how the process of becoming relates to domination and power relations. The third aspect was the imperceptivity, not only as something that cannot be seen, but also that is not recognisable, not discernible and which is not subjectivity-oriented. The examples chosen show variations in this becoming, the multiplication of voices and re-presentations, becoming black, becoming woman, becoming imperceptible, but also highlight the ambivalence that resides within the political claims emerging from the figure of the everybody.

References

Bankston, S., 2017. *Deleuze and Becoming*. London: Bloomsbury.

Brunner, C., Nigro, R., and Raunig, G., 2013. Post-Media Activism, Social Ecology and Eco-Art. *Third Text*, 27(1), 10–16.

de Cleen, B., 2017. Populism and Nationalism. *In:* Kaltwasser, C. R. et al., eds., *The Oxford Handbook of Populism*. Oxford: Oxford University Press, 342–362.

Deleuze, G., 1994. *Difference and Repetition*. Trans. Paul Patton. New York: Columbia University Press.

Deleuze, G., 2000. *Cinema 2: The Time-Image*. Trans. Hugh Tomlinson and Robert Galeta. London: Athlone Press.

Deleuze, G., 2003. *Francis Bacon: The Logic of Sensation*. Trans. Daniel W. Smith. London: Continuum.

Deleuze, G. and Guattari, F., 1980. *Capitalisme et Schizophrénie: Mille Plateaux*. Paris: Les Editions de Minuit.

Deleuze, G. and Guattari, F., 1987. *A Thousand Plateaus: Capitalism and Schizophrenia*. Trans. Brian Massumi. Minneapolis, Minnesota: University of Minnesota Press.

Gambetti, Z., 2014. Occupy Gezi as Politics of the Body. *In:* U. Özkirimli, ed., *The Making of a Protest Movement in Turkey: #Occupygezi*. Basingstoke: Palgrave Macmillan, 89–102.

Himid, L., 2013. Lubaina Himid in Conversation with Jane Beckett, 'Diasporic Unwrappings'. *In:* M. Meskimmon and D. C. Rowe, eds., *Women, The Arts and Globalization: Eccentric Experience*. Manchester: Manchester University Press, 190–222.

Kaltwasser, C. R. et al., eds., 2017. *The Oxford Handbook of Populism*. Oxford: Oxford University Press.

Kimmel, M., 2013. *Angry White Men: American Masculinity at the End of an Era*. New York: Nation Books.

Kriesi, H. and Pappas, T. S., eds., 2015. *European Populism in the Shadow of the Great Recession*. Colchester: ECPR Press.

Lundy, C., 2012. *History and Becoming: Deleuze's Philosophy of Creativity*. Edinburgh: Edinburgh University Press.

Ochoa Espejo, P., 2017. Populism and the People. *Theory & Event*, 20(1), 92–99.

Stavrakakis, Y., Katsambekis, G., Nikisianis, N., Kioupkiolis, A. and Siomos, T., 2017. Extreme Right-wing Populism in Europe: Revisiting a Reified Association. *Critical Discourse Studies*, 14(4), 420–439.

Weyland, K., 2017. Populism: A Political-Strategic Approach. *In:* C. R. Kaltwasser et al., eds., *The Oxford Handbook of Populism*. Oxford: Oxford University Press, 48–72.

11 Contagion Images
Faciality, Viral Affect and the Logic of the Grab on Tumblr

Elena Pilipets

Introduction: The Dynamics of Affective Contagion in Visual Social Media

This chapter is a theoretical and methodological exploration of viral images and memes revolving around Conchita Wurst's Eurovision victory on Tumblr in May 2014. It derives from the observation that today's visual social media practices shape and are shaped within the circulatory dynamics of affective contagion that digital popular culture generates on a daily basis. Facilitating the distribution of content within and across a variety of social media platforms, affective contagion can be understood as the main driving force behind two interrelated activities: the viral spread of images from context to context and the memetic practices of appropriation through which media users transform images and forward them around. By exploring visual and textual material using digitally mediated methods of data extraction and analysis, I highlight four multimodal scenarios of sharing, liking and tagging online visual content in the context of public (social) media events. These scenarios, in which contagion images operate as platformed, communicative objects of circulation, include (1) photographic remediation, (2) mundane imitation, (3) memetic commentary and (4) memetic play. Focusing on the interplay between the cultural relevance of Conchita Wurst's Eurovision event and the social medium of Tumblr, I provide a thick mediated description of what contagion images do as they spread, including a methodological discussion of the ethical and copyright challenges they entail for analysing dynamic media environments. Concepts of affect, virality and networked social life of visual content will be used to emphasise that the capacity of digital images to circulate and transform requires a more focused discussion of the value they acquire through mixed forms of social, cultural and technological engagement.

On social media, the 2014 Eurovision Song Contest victory of Conchita Wurst—Austria's most popular "bearded lady" personated by the recording singer and drag artist Tom Neuwirth—provoked a hypermediated body image event that I have discussed elsewhere in terms of queer workings of digital affect (Pilipets 2018). Starting with a series of embodied associations inscribed into Conchita's stage name, the controversial affective charge of this event resulted in a variety of media speculations: as the exemplary mentions returned by www.urbandictionary.com reveal, descriptions attached to the search term "Conchita" range between "Spanish slang for 'little cunt'" and a "sexy ass motherfucker" while, unsurprisingly, "Wurst" stands for both "a slang term for penis" and a "German word for sausage", which "can also be used like 'blah' or as an insult".[1]

Accompanied by multiple competing forms of mundane sexual and social expression, Conchita Wurst's Eurovision Song Contest victory produced a wide range of associated imagery that was dominated by user-generated content focusing on Conchita's body.

Analysing such body image events with a platform-specific view on their spreadability means taking into account their contagious capacity to incite imitation (Parikka 2007). The online practices—of sharing, liking, searching, uploading and downloading, commenting, appropriating, remixing etc.—through which images are distributed from context to context compose the dynamics of "platformed sociality" (van Dijck 2013) across different registers of communication and (sub)cultural belonging. Perpetuating the propagation of images through the network, the circulation-based workings of affective contagion are hybrid and atmospheric. The techno-social environments of engagement they involve contain a range of sensory investments—both singular and common, private and public—in a relational dynamic of transversal movement (Anderson 2009; Sharma 2013). As these environments resonate, generating intensive modes of platformed visual social encounter, they achieve a state that, even in its reproductive intensity, is never entirely tangible. Being constitutive of how affects operate within networked flows of digital media, this kind of always-on tension is accompanied by innumerable variations of mediated experience in which texts, images and bodies quickly become detached from their original contexts (Paasonen 2011; Senft 2008). Escaping the logic of "authorized" production towards more hybrid formations of the networked attention economy, visual media objects enter a web of exchange and circulation.

Contagion, in this sense, comes to act as a technique of attention capture, amplification and redistribution through everything we do, see or encounter on social media. As images become part of typically imitative patterns of platformed excitation and persuasion, they generate variously distributed environments of engagement, in which easy access to content does not automatically involve access to meaning (boyd 2017; Sampson 2012). Viral images that spread contagiously and eventually transform in their movement on and between social media platforms usually tell us little about the intentions of their previous users. Their meaning is rarely straightforward. The ways in which these images matter can be both subversive and/or reproductive. Alternating between fascination and repulsion, they produce nonsensical and unconventional appropriations, can be inspiring as well as involving racist and sexist tinges (Nakamura 2014; Phillips and Milner 2017). In addition to their "stance" (Shifman 2014), which unfolds contextually, images that we use to communicate online are usually accompanied by some sort of contradiction that shapes and intensifies their cultural relevance. In most of these scenarios (which tend to occur simultaneously), contagion images add and extract attention value in different affective registers of playfulness (Paasonen 2016). In other words, what becomes popular through affective contagion in visual social networks is often contingent, rambling across contexts, intense for some participants and extraneous for others. Analytically, I think contagion images as characteristic of the dynamics of networked repetition, which do not imply homogeneity but spread in a multiplicity of cognitive and sensory transmissions between humans and technologies. Seen methodologically, the high affective persistence of such imaging practices relies on the platformed affordances of social media use, which involve both intentionally acting participants and their viral encounters with variously mediated events and bodies. To exemplify these insights, I am focusing on the affective qualities of contagion images in the context of Conchita Wurst's Eurovision victory as it unfolded on the visual social platform Tumblr in May 2014.

The Faciality Machine of Platformed Communication and Its Contingent Affordances

While affective contagion does not exist completely free from mediated practices of meaning production, its forces cannot be reduced to its signifying effects. As a terrain of affective investment and visual social participation, today's media platforms are characterised by the following co-dependent affordances (or (inter-)action possibilities) (see boyd 2014, 10–14; Phillips and Milner 2017, 44–52)—archivability (the capacity to store and replicate content), accessibility (the ability to access content through digital practices of tagging and searching), scalability (the potential for viral circulation) and modifiability or modularity (the ease with which content can be remixed, replaced or transformed). Adding new dynamics to long-established practices of media appropriation, these affordances shape our everyday experience of many-to-many communication as increasingly contingent. Images that circulate virally translate users' multi-layered sense-making practices into complex social atmospheres of multiple competing potentialities. In facilitating these dynamics, affective contagion can be intimately linked to the shifts in immaterial labour and knowledge production, contributing to the contested ways in which events of popular media culture matter (Parikka 2007; Terranova 2004). Due to their increasingly porous environments, contextual practices of media use fold and mutate into continuous cascades of visual social adaptation. In their movement from user to user, images actively shape the communicative conditions under which linear concepts of control, authorisation and ownership become impossible to maintain. Performing as multi-sited aggregators of experience, they distribute both affect and meaning across a network of relations characterised by multiplicity and repetition. Digital images, in the words of Jodi Dean (2016), are less representations than communicative agents in themselves (see also Terranova 2004). In the interactive circuits of social platforms, our engagement with and through visual media translates into information for others to capture and process. Potentially reusable for purposes of algorithmic monitoring, content monetisation, political communication, academic research, public commentary or sheer fun, each contribution we make is secondary to its circulation.

Against this background, the practices of the exhibition of visual content on social media platforms are clearly a cause for concern. Particularly our faces, something we usually associate with privacy and personal expression, turn into popular visual objects of circulation: "To be common and reproducible is a characteristic of each of us, a realization we enact with every selfie and hashtag, even when we may not be fully aware that we are doing it" (Dean 2016, 8; for a discussion of selfies in the context of digital mediation see also Senft and Baym 2015; Warfield 2016). Faces, bodies and gestures become memes—mediated snapshots of shared experience through which visual and textual practices of networked communication overlap and combine in a series of contextual transformations. By focusing on different affective expressions, memes that bring images of faces into play through practices of networked appropriation perform a dual communicative function: they foreground the singular and simultaneously situate this singularity as part of a wider social collective, in which shared codes are communicated with different intentions (Shifman 2014).

Arguing that images work as amplifiers and modulators of affect, which, in its greatest intensity, is conveyed by the human face, Anna Gibbs (2001, 2002, 2010) similarly approaches the social circulation of faces as going beyond relations of

source and adaptation, signifier and signified. For Gibbs, visual practices are both shaped through and articulate affect as a vibrant arrangement of moods, sensations and intensities which takes place transversally across heterogeneous networks of media, bodies and things. As faces circulate, they also *modulate* and orchestrate affective experience as "characteristic ways in which one responds to particular affects with other affects—for one individual it might be shameful to be angry, while for another it might be exciting" (Gibbs 2002, 339). The resulting social production of the face or what Deleuze and Guattari (1987, 181) call "the faciality machine" underlines how the face becomes ubiquitous in its circulation, performing its function as a "deviance detector" (178). Deviances or "deterritorialisations" of affective expression always imply a "reterritorialisation" of the face—"the facialization of the entire body and all its surroundings and objects" (181). In the realm of memetic media, these dynamics of de- and reterritorialisation operate as mutually reinforcing. The possibility of (re-)using photographic images of others to publicly express personal feelings on social media creates a contagious atmosphere of platformed activities, which are technologically embedded, data-intensive and imitative. The face becomes a common memetic object of exchange, raising ethical and methodological questions about the distribution of visual material.

The fact of not being aware of what happens to images after we upload them on the Web underlines the importance of taking the visual into account as a dynamic site of variously situated networked practices which are contingent upon at least two things: first, images circulating on social platforms in the context of popular media events require approaches which are sensitive to the specifics of the event in question, including issues of context collapse, privately public communication and (sub)cultural formations of belonging and visibility (Baym and boyd 2012). Second, in investigating the ways in which images spread and transform as native digital objects we need to ask about the affordances and structures of the platforms themselves (Rogers 2013). Regarding the notions of ethics, creative property and copyright, internet scholars researching images in the context of social media communication recommend a case-based procedure corresponding to the particularities of questions to be explored (Markham and Buchanan 2012; Tiidenberg 2017). Focusing on how the public media event of Conchita Wurst's Eurovision victory was mediated through images that people chose to copy, post, remix, imitate and share on Tumblr, in the following analysis, I draw on Gillian Rose's (2016) discussion of digitally analysed visual material in research contexts where public and private spheres are difficult to separate. To provide a situated, thick description of this event through memetic appropriations of Conchita's face in May 2014 I also adapt Annette Markham's (2012) idea of ethical fabrication.

Conchita Memes on Tumblr: A Networked Atmosphere of Contagion

On Tumblr, which unlike any other platform is known for its strong affinity with identity fluidity and queer subcultures, faces of celebrities become the main site of contingency, opening users' affective investments to an ongoing play of iteration and alteration. Particularly worth mentioning in this context is that both Tumblr as platform and Eurovision as an event have been openly adopted by LGBTQ communities

as spaces of sexual expression and other alternative creative and interactive practices, which Angela Nagele (2017, 68–85) in her explorations of Tumblr's preoccupation with gender and identity fluidity describes as a subcultural digital fruition of Butler's (1990) *Gender Trouble* (see also Cho 2015; Highfield and Leaver 2016, 22; for a discussion of the concepts of subversion/performativity see Schober 2009). As Fink and Miller note with regard to the platform's "transmedia moments", on Tumblr:

> The image-oriented pages of transgender, transsexual, genderqueer, and gender nonconforming people have created intricate networks of digital self-representation. These networks connect Tumblr users who collectively oppose traditional systems of gender distinction and who are also queer in terms of their sexual practices and conceptions of sexuality. Through the site, these users, like others, circulate everything from fashion, pornography, and life updates to theory, protest, and event publicity.
>
> (Fink and Miller 2014, 52)

In this context, my decision to explore Conchita's Eurovision event on Tumblr by using digital methods of content extraction, organisation and analysis corresponds with my interest in moving towards more situated forms of knowledge about the infrastructures collapsing the public and the private (for a similar argumentation see Highfield and Leaver 2016; Pearce et al. 2018). Such experimentations are essential for practising in combination with qualitative research approaches, considering that, in most contexts, tagged visual content reveals additional user information not necessarily intended to be shared when posting memes or other ambiguous forms of public expression such as selfies. Accordingly, I treat all images reproduced, remixed and fabricated for purposes of this article in their ephemeral and yet sensitive involvement with the metadata they provide (Rose 2016, 293–295). This prevents attributing content to singular users, making it possible to explore the platformed patterns of visual social circulation instead (see visualisations in Figures 11.1–11.3).

In order to be able to situate the circulation of Conchita's body image within Tumblr's platform-specific communicative culture, visualisations in Figures 11.1–11.3 were created by querying the tags "Conchita" and "Conchita Wurst" using the DMI Tumblr tool, a script which interacts with the API (application programming interface) of the platform (Rieder 2015). A tag (if provided with #, a hashtag) on Tumblr is a textual form of metadata allowing Tumblr posts to be grouped and searched. By organizing, gathering and directing affects, bits of visual and textual information, political statements or jokes, and by circulating them within the dynamics of popular media events, tags serve not just as short textual descriptions of the image but as mediators of the event's network (Salovaara 2015). The circulation of images on Tumblr primarily relies on tagging practices as the main means of social interaction, in which specific modes of visual expression become searchable and accessible for subcultural bonding and communicative exchange. In this function, tags amplify and modulate affective intensities which are transmitted through visual and textual sequences of user interaction. In methodological terms, a co-tag network analysis of social media phenomena makes it possible to see the shifts in relations of relevance around a term, an image, an event, a body through a mediated lens of the platform. In this particular case, it also delivers a relational

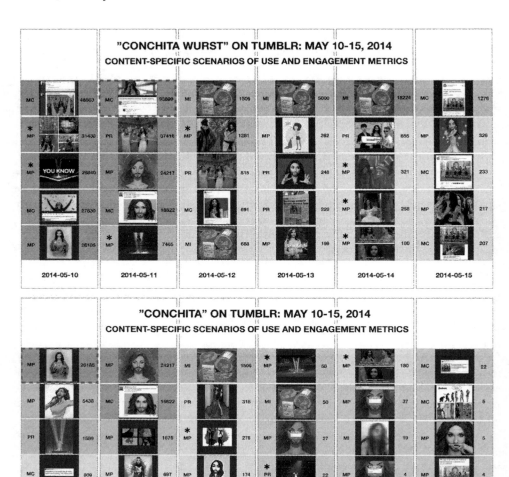

Figure 11.1 Conchita's Eurovision victory on Tumblr (most liked and shared visual content shared with the tags "Conchita Wurst" and "Conchita" over six days extracted with the DMI Tumblr tool, * stands for GIF; own visualisation structured in accordance with the count of notes on Tumblr).

view of associations and experiential qualities that Tumblr provides for various matters of Eurovision fandom. In other words, analysing Conchita imagery through users' tagging practices creates a snapshot of Conchita's Eurovision unfolding in

the flow of digital circulation. It captures its contagious intensity, "something about which many people have strong feelings" (Dean 2016, 5).

Figure 11.2 presents a network of connections that were most frequently made through the use of the tags "Conchita" and "Conchita Wurst" on Tumblr in May 2014. The size of nodes indicates the average degree of connectedness of each individual tag within the affective atmosphere of Conchita's Eurovision event. Edges, or connections, in the network indicate tag co-occurrence within Tumblr posts. That is, the more frequently any two Tumblr tags appear together in one post, the bigger the nodes and the stronger the link between them (see Burgess and Matamoros-Fernandez 2016). Tags in black with the strongest connections can be identified as main mediators of the network. In their capacity to hold users' participatory investments together, they appear as communicative vectors, which accumulate and direct both affect and meaning within the circulation of user-generated content. Connecting mentions of participating countries (e.g. "austria", "russia", "denmark", "france") with mentions of the event itself ("eurovision", "eurovision 2014", "esc", "esc 2014", etc.) and mentions related to Conchita's performance ("conchita", "conchita wurst", "rise like a phoenix"), these material-semiotic gatherings assemble the object of Conchita's body image within the annual Eurovision event. Tags in dark grey specify associations with its (potentially conflictual) "Europeanness" through ambiguous mentions of Conchita (such as "queen conchita", "queen of europe", "queen of Austria", "beard", "wurst") in the context of postings indicating a strong affinity of the network with Tumblr LGBTQ communities. Tags in light grey combine common expressions of this affinity (e.g. "drag", "trans", "lgbt", "lgbtq") with more specific content- and context-related descriptions of Conchita's performance ("beautiful", "funny", "personal", "art", "song", "phoenix", "winner", etc.) and fandom-based reverberations of Conchita's Eurovision message of tolerance and respect ("freedom", "love", "peace"). Operating as short hyperlinked annotations to posted images, such Tumblr tags mediate much of the visual social fan activities. In doing so, they actively contribute to the capacity of the network to sustain its atmosphere of spreadable visual social encounters, making different kinds of content more accessible within and beyond specific subcultural communities.

Taking into account the visual dimension of tagging practices on social media platforms poses methodological challenges regarding the ambiguous nature of copyright in the context of viral communication. Platform API queries retrieving images that have been tagged in similar ways reveal the contingency of visual material upon its cross-platform spreadability and users' site-specific adaptation practices (Pearce et al. 2018). Similarly, using a reverse image search to track each image back to its different locations rarely provides us with the information about the image's original source. Biased by the algorithmic logic of recommendation, services such as Google Image Search are more likely to give us an idea of how the image jumps between contexts (Halavais 2013; Nakamura 2014). When viral images are annotated, imitated and altered, their transformation into memes occurs in the service of public communication, making them fair use in some contexts of reproduction, but not in others (Milner 2016, 230–232; Highfield and Leaver 2016, 54–55). On Tumblr, the separation between content creators, replicators and curators can be blurred, leading to the need to acknowledge how the same image can perform different communicative work. For instance, many creative forms of expression are

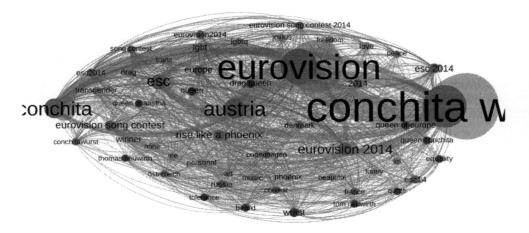

Figure 11.2 Combined Tumblr co-tag network for "Conchita" and "Conchita Wurst" (undirected graph with 54 nodes and 1196 edges, size encodes average weighted degree and colour modularity, extracted with the DMI Tumblr tool, own visualisation made with Gephi).

clearly intended for public circulation. Some of them can be even featured on Tumblr's login page, as in the case of Mario Manzanares' colourful Conchita sketch that was replicated a significant number of times, producing multiple personalised screen captures during the Eurovision week (see e.g. Figure 11.1, 24–05-11/ 24,217 notes and 24–05-14/37 notes).[2] Other publicly shared Tumblr products of vernacular creativity can be still tagged as "personal", indicating the circulation of the image for purposes of self-expression within specific communities (for a discussion see Tiidenberg 2015). Most of the time though, dealing with the fact that images circulating on Tumblr are *not always* necessarily Tumblr-native (consider screengrabs, modified stock image photos or typical memetic references) opens up the issue of multi-sitedness as intrinsic to the ethical discussion of content authorship. Against this background, beyond using digitally mediated approaches to structuring and analysing content in accordance with the platformed affordance of engagement metrics (Heine et al. 2016), my visualisations in Figures 11.1 and 11.3 draw on practical methods of data representation involving bricolage-style transfiguration of "original" images (Markham 2012). By organising my dataset through Tumblr's communicative attributes within a specific temporal framework, I shift the focus away from individual images to platform-specific patterns of circulation and content-specific scenarios of use.[3] Approaching the de-identified results as situated expressions of "how online images are *audienced* in different ways" (see Rose 2016, 297), I distinguish four overlapping scenarios of photographic remediation, mundane imitation, memetic commentary and memetic play. More specifically, my analysis is focused on exploring these scenarios as "composite accounts" (Markham 2012, 334) or fabricated material-semiotic interactions. Allowing for more than one interpretation, such mixed, visually oriented forms of mapping and qualitative analysis can be used to provide thick descriptions of social media events

as they unfold and shift. Rendered by the dynamics of platformed interaction and enriched through repeated investment in in-depth engagement with the data, the main contribution of this analytical process is that it highlights the multiplicity of the event.

Focusing on the period between 10 and 15 May 2014, Figure 11.1 presents engagement metrics and content-specific scenarios of use for 60 images that were most frequently liked, shared and reposted on Tumblr with the tags "Conchita Wurst" and "Conchita". The sequences of images per day are structured by the count of "notes".[4] Through notes, which list each user who has liked or reposted an item to their Tumblog, Tumblr creates "a record of every image's circulation" (Fink and Miller 2014, 612). The more the image circulates, the faster the note count will change over time, indicating the liveness of the image. In other words, while the overall number of likes and shares on Tumblr does not provide us with more information on how the image matters to and within specific subcultures, it offers a situated view on the unfolding of Conchita's body image event. Character-ised by a heavy overlap with the temporal dynamics of Eurovision 2014, the

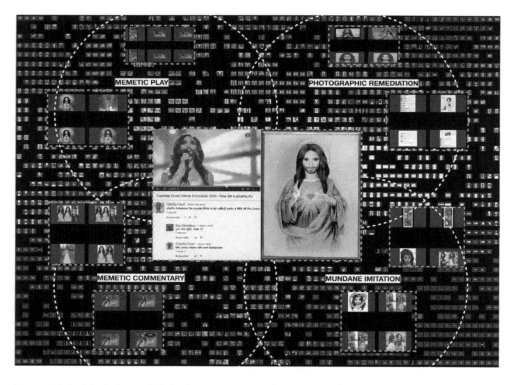

Figure 11.3 A bricolage of imitation patterns and scenarios of use related to the most circu-lated images tagged with "Conchita Wurst" (on the left, 93,699 notes, 11 May 2014) and "Conchita" (on the right, 26,183 notes, 10 May 2014) on Tumblr (own visualisation using image pattern screenshots made with ImageSorter).

circulatory dynamics of Tumblr engagement with Conchita imagery indicate the flattening of its resonance within the first five days after the ESC Grand Final on 10 May. On 12 May, the tags that were used most frequently in the first two days after Conchita's winning performance experienced a big decrease in engagement: from almost 94,000 notes for "Conchita Wurst" and 26,000 for "Conchita" down to 1,506 notes for both tags. Later short-lived attention peaks resulted in the high number of notes for individual images but were only loosely connected to the main Eurovision event.

Corresponding to the relational dynamics of the images within the dataset, the scenarios of photographic remediation, mundane imitation, memetic commentary and memetic play derive from the patterns of liking and sharing "popular" images on Tumblr to the same extent as they point towards less visible expressions of engagement frequently repeating across the network with minor variations (see the second half of Conchita's Eurovision week in Figure 11.1). Instead of operating with predefined coding categories, my attempt to include these voices by composing a bricolage out of the imitative patterns evident in the overall sample of 2475 images focuses on the overlapping layers of meaning between related visual social sharing practices (Figure 11.3). Approached in the context of viral circulation of two Tumblr images featuring hashtags "Conchita Wurst" (94,000 notes) and "Conchita" (26,000 notes), outputs from this visualisation provide a combined view of the common visual styles plotted with the help of ImageSorter.

Specified in relation to users' practices of screengrabbing photo- and text-based content from different media, the first scenario of *photographic remediation* is as much about the specific contextual use of images as it is about their ephemeral movement between media (Bolter and Grusin 1999). It emphasises that what we approach as tangible content is only a partial view of the outcome of our mediated interactions, which are highly contingent upon space and time due to the fact that new content can be added while old content seems to disappear or appear elsewhere in new forms. Dominated by photographic material from meme repositories and screengrabbed comments focusing on Conchita's body, practices of sharing and copying within this scenario indicate a distributive process, in which the event of Eurovision 2014 became part of a wider user-driven environment of self-expression and affective exchange. Constitutive of this environment, the second scenario of *mundane imitation* can be understood in its capacity to specify the incorporation of photographic remediation into embodied practices of everyday visual social exchange. Identified in accordance with the frequent appearance of selfies showing both female and male users wearing different improvised versions of a Conchita-style beard, the performative dimension of this scenario attributes imitation to the dynamics of "presencing" (Richardson and Wilken 2012) the event. Its alternative viral articulation includes smartphone images of various mundane objects of everyday consumption such as sausages, bananas, cakes, T-shirts, dolls, masks, etc. provided with patterns imitating Conchita's appearance and allowing for further connotations and fandom-driven practices of appropriation (see e.g. Adams 2014).

By adopting and co-opting Conchita's face into new templates through combinations of screengrabbing, captioning and imitation, the third scenario of *memetic commentary* offers sarcasm and irony as framing devices for self-reflection and (political) engagement with Eurovision-related issues such as nationalism and diversity. On Tumblr, these framings were centred around users' investment in the

process of rendering Conchita's contested body image as a shared means of opposition to both hetero- and homonormative gender and sexuality politics. Intermingling with the last scenario of *memetic play*, the continuities and discontinuities in relations of association can be observed in the important aspect of "commoning" (Dean 2016, 2) Conchita's face through cartoons, GIFs and other forms of memetic media. Due to their rhythmic, endlessly iterating movement, animated GIFs, for instance, were particularly interesting in their capacity to reference and change the most exciting moments of Conchita's Eurovision performance, creating multiple competing actualisations of the event (see Pilipets 2018). Usually building on existing content, the intrinsic contagiousness of memetic play, however imitative it may be, is thus not only about the reproductive process of copying (Goriunova 2014). Instead, it comes into force as a metamorphic series of material-semiotic appropriations, in which repetition and networking intensely coincide. A popular meme is always connected to other images. As it circulates, it transforms the affective atmospheres and the (sub)cultural environments that it conveys. In its capacity to affect new adaptations, it matters not as itself but as itself plus what Terranova addresses as "the kind of affect that [a digital image] packs, the movements that it receives, inhibits, and/or transmits" (Terranova 2004, 42). As I will show in the next section, in this process, two main resonating visions of Conchita were at play, feeding into the contested construction of Conchita as a "gay Jesus" (Figure 11.3).

Grab: The Beard Is a Strange Attractor

According to Jodi Dean (2016), in networked environments of visual social media, the face that once suggested a singular person's self-identification now flows in collective expression of common feelings. According to Theresa Senft (2008), once an image begins to travel around the Web, it is impossible to control where, when and how it will reappear. The main affective intensity that is at play in these two entangled dynamics is the mediated tactility of "the grab", which allows users not only to look at the images but also to capture, re-make and save them, tag them, combine, remix and "generate" them using online image archives, mobile communication devices and social platforms. The grab of visual social media is what engages the user with the affective qualities of popular memetic content. Rather than just presenting a form of voyeurism, digital images that grab us and that we grab in return serve as dynamic mediators of contact, combining the rhythmic excitation patterns of online communication with the maximisation of the visual resistance to signification (Paasonen 2011; Warfield 2016). In other words, the grab is what constitutes visual material in its capacity to accumulate affective value through circulation. Amplified through sharing on social media, what we express through images becomes "property belonging to the corporation who owns the platforms and traces our engagement" (Dean 2016, 7). At the same time, the various modulations of the same image play an important part in creating a contested techno-social arrangement of moods, intensities and sensations, which needs to be understood in its meaningful relations to the multi-layered (embodied, visual, textual, material) and spatially dispersed communicative practices.

Drawing on these assembled considerations, this section will show how the power of Conchita's face to grab attention, to touch and move in a variety of ways stems from its playful relationship with a specific, long-contested agent of sexual

and social attraction—the beard. The image of the bearded drag queen, as Antke Engel (2016) suggests, can be seen as a "paradoxical figure in itself, given that usually one is either bearded or drag queen". Presented at Eurovision as the main facial attribute of Conchita's body, the well-groomed, dark, masculine beard attracted the most attention, transforming itself overnight into a body image of imitation and counter-imitation: while both male and female fans celebrated Conchita's Eurovision victory by wearing fake beards, some Eurovision viewers shaved in order to prove they were not Conchita (Hodgson 2014; Tomchak and Zand 2014; Weber 2016). In the face of this contested event, the ambiguous sexuality of Conchita's body image became social in terms that go beyond its appropriation or rejection in the world of Eurovision fandom. Travelling through playful contexts of popular memetic media, it changed in relation to other powerful figurations of sexuality and sociality that do *not pass* as *either* masculine *or* feminine. Once a circus curiosity and the object of exhibition, the "bearded lady"—(un-)like "the beards of the 'white hipster' or the 'racialized-as-nonwhite Muslim'" (Weber 2016, 159)—came to act in its capacity to provoke and to excite, positioning the dynamics of gender confusion within the stylisation of Eurovision as an extremely camp political spectacle.

Figure 11.3 shows the multimodal outcome of this process in a juxtaposition of two most circulated Tumblr images that were shared with tags "Conchita Wurst" and "Conchita" in May 2014. The affective component of faciality plays an important role in both images, which combine the scenarios of photographic remediation, mundane imitation, memetic commentary and memetic play in various ways. The image on the left consists of two YouTube screenshots (including both image and text) that were Photoshopped into a single frame, exemplifying the affordance of modifiability as a possible result of searching for already available, replicated and commented content. It captures a close-up of Conchita's face during the final performance of "Rise Like a Phoenix"—a screen capture made by someone watching a YouTube video called "Conchita Wurst Winner Eurovision 2014—Rise Like a Phoenix Austria". A remediation of remediation, this image reanimates one of Conchita's many dramatic Eurovision moments: her face looks inspired, her eyes are turned upwards in a prayer-like manner. Illuminated with reddish stage lights, her tanned skin, glossy painted lips, long dark hair and manicured beard complement the overall appearance. As such, the image can be considered just another more or less officially mediated, viral version of Conchita's live performance. Yet what makes it memetic is the context provided by the second screen capture. Presenting a short interaction from the video's comment thread, it reads as follows:

> she/he (whatever the person likes to be called) looks a little bit like Jesus
> you are right, man:D
> like jesus mixed with kim kardashian

The merging of confusion and fascination in this short exchange about the ambiguities of Conchita's body image configures vernacular investments of association into this image through comparisons that mix figures as incompatible as Jesus (aka not only (hu)man but also the Christian God himself) and Kim Kardashian (aka not only female but also, well, Kim Kardashian—today's American dream

of celebrity lifestyle, massive make-up and outrageous sexuality). Taken together in one complex figuration of Conchita as both "neither/one thing nor/and another" (Weber 2016), the cultural belongings of these figures come into force through viral circulation of images in networks of visual social exchange. Intensified through digital affordances of accessibility and modifiability, the endless possibilities of remix that connect previously disconnected images and bodies create hybrid forms of association, in which different intertextual, textural and affective layers coincide. As Donna Haraway (1997, 179) has argued, such complex mediated figurations "turn bodies into stories and vice versa". Providing "performative images that can be inhabited" (Haraway 1997), they can be never made explicit in relation to their respective origins. The many contexts of their shared experience and cultural relevance would never belong to Conchita's image in a straightforward way. More likely, by remediating various imitative scenarios of memetic commentary, they will continue to reflect and project different intensities of users' involvement with the image into a network of potentially irreverent popular meanings.

The assembled playfulness that comes out of this network by means of association with other highly worshipped and/or outrageously sexual bodies is what constitutes the ambivalent atmosphere of Conchita's face within the main contingency of online communication: While the constant modification of memes continually turns the common into the uncommon and vice versa, what drives this dynamic is its recurrent contextual revision (Knuttila 2011). As noted previously, platformed formations of visual social practices facilitate the ease of image search, storage and remix, allowing users to manipulate easily accessible visual material without any indications of source or references to previous contexts of appropriation. As a result, images

> contain traces of countless iterations made by countless participants unknown to each other, all culminating in an image that *appears* singular, but in fact is the remix of a remix over the course of an untold number of months or years.
> (Phillips and Milner 2017, 49)

In this sense, while being analysed in its platformed specificity on Tumblr, Conchita's body image inevitably reveals connections to other sites of circulation. To the same extent as its capacity to pose questions of sex, gender and sexuality may contain obvious traces of embodied humour, welcome and even empowering in some internet communities, in others, the multiple trajectories of appropriation it affords may also be expressed through overspills of rejection, anxiety and hate. To provide an example alternative to Tumblr, I am drawing on a long and emotional analysis of Conchita's "homosexualist movement" that was published on 26 May 2014 by "The contemplative Observer", an anonymous WordPress blog traceable through a reverse image search of both images:[5]

> But the *much more* devastating aspect to this beard is something that has nothing to do with transgenderism, or homosexuality (other than confusing and denigrating the one by means of the other): it creates—especially in combination with his young even face, and the long, dark hair—the impression of another "Christ"! This is the *real* horror about this "Conchita Wurst", and

mind that "conchita" in Spanish slang means "little pussy", and "Wurst", meaning sausage, is clearly a sexual allusion too (he himself circumvents admitting the scandalousness of this "name" by saying that the name "Conchita", that indeed exists as a Christian name too, was brought to his attention by a friend from Cuba (!), and that by "Wurst" he merely means that it is "wurst"—meaning it doesn't matter—what gender you belong to or feel you belong to; in other words, he himself does NOT admit the obvious sexual allusions in "Conchita" and "Wurst", the latter, meaning sausage, definitely implying: "penis"). So, we have a most eccentric, homosexual "Christ" figure named Little-Pussy Cock!!! Can the denigrating of Christ get any more despicable and shocking than this? This "Conchita Wurst" victory may well mark the beginning of the maddest and bloodiest religious persecution the world has ever seen (his battle-cry, when receiving the Eurovision Song Contest trophy, "We are unstoppable", could have been already a chilling foretaste of what's to come).

(The contemplative Observer, 26 May 2014)

Inserted into relations of upset excitement and anticipation of further Conchita related "horror" and "devastation", Conchita's beard here is activated in its role as a "strange attractor" (Puar 2007, 175–183). Following Deleuze, Jasbir Puar describes how specific bodies and objects can become strange attractors "through centripetal forces to which the eye is instantly drawn" (Puar 2007, 181). Their anomalous power to grab attention, to provoke and to excite "is always at the frontier, on the border of a band or a multiplicity, it makes it become, it traces a line in-between" (Deleuze and Parnet 1987, 42). At the same time, strange attractors are used *within* communities to delineate relations of belonging (inside/outside) through competing investments of affect and interpretation that they evoke. Resonating between affective intensities of outrage about Conchita's presumed transgenderism, admiration for "his young even face, and the long dark hair", shock of "Little-Pussy Cock", "impression of another 'Christ'" and fear "of what's to come"—all these material-semiotic trajectories of attachment construct the beard as a point of fixation through which the density of Conchita's assembled body image event accumulates. This becomes particularly obvious in relation to the second image presented on the right. A viral Photoshop adaptation of the Sacred Heart icon, it overlays a stock photo of Conchita's face on the iconic reproduction of Jesus's body. Presenting users with a new "queer Christ", this product of memetic play was often shared in reaction to populist readings of Conchita's winning song "Rise Like a Phoenix".

Seen by many as an anthem promoting the uprising of the LGBTQ movement through the idea of Christian resurrection, the lyrics of this song (compared by many others to a typical James Bond theme) played an important role in Conchita's iconisation. As Limor Shifman explains, the power of iconic images stems from their capacity to "symbolize values and sentiments that transcend the specific event, as they are perceived as channels for greater truths about societies' fundamental structures, norms and paradoxes" (2014, 348). By evoking the hyperfeminised image of the Christian God through the transborder figure of disruptively masculinised bearded drag queen, the power of Conchita's face to channel a complex, crossed set of national, social and religious values was intensified even further through its viral circulation. Unsurprisingly, by jumping from context to context, the iconic image of "queer Christ" was engaged in a network of the most bizarre associations connected to two main antagonistic visions: on the one hand,

statements by Church leaders and politicians that were frequently used for populist commentary accused Conchita's "Jesus-like figure" of things like "causing Balkan floods" and subjecting children to a "hotbed of sodomy" (see Gander 2014). On the other hand, annotations that frequently appeared to support the image presented celebratory interpretations of Conchita's performance through the lens of Christianity and LGBTQ empowerment. One such annotation is offered on a "Jesus in Love Blog" that promises insights into "queer spirituality with LGBTQ saints, history and books".[6] It reads as follows:

> If Christ came back today, would s/he appear as a genderqueer person
> singing an upbeat song like Conchita's winning tune, "Rise Like a Phoenix"?
>
> I rise up to the sky
> You threw me down but
> I'm gonna fly ...

As Weber comments, it "is out of the ashes of this traditional, conservatively Christian vertical configuration of old Europe that Neuwirth/Wurst as Conchita Wurst rises like a phoenix as a secular symbol of a newly tolerant Europe" (2016, 186). Yet, while acting on behalf of an integrated European community, this symbol remains constrained within the specific national and gendered limits of what it means to be "European". Inscribed into the strange attractive force of Conchita's body image, the tensions between its various communicative functions suggest an affective atmosphere in which deviance is mobilised as a privileged vision of presumably exceptional European lifestyle diversity. Operating within these tensions, the contagious ability of the image to grab attention came to act as "more alluring, more powerful and more easily mobilized *both* by those who, for example, wish to resist hegemonic relations of power and by those who wish to sustain them" (Weber 2016, 44).

Conclusion: Contagion Images

Developing the idea of dividuality in the "Postscript on the Societies of Control", Deleuze compares its modulating operation that breaks down the classical distinction between human and nonhuman, mass and individual, difference and repetition with "a self-deforming cast that will continuously change from one moment to the other, or [...] a sieve whose mesh will transmute from point to point" (1992, 4). Today's digitally mediated visual social networks intensify these relations, proliferating immediate affective responses through rapidly spreading memetic images which can be temporarily linked to unfolding events and transformed over time. Merging with the networked flows of platformed (sub)cultural appropriation and user-generated content, traditional media events such as Eurovision take on viral dynamics, in which various capitals overlap and interact. Charged with affect and variously embedded in digital infrastructures of communication, images that we participate in spreading are more than intertexts of ambiguous origin. They are mutable, collective mediators of shared experience.

The involvement of these dynamics in emergent sensibilities that transverse strict identity categories and transform in relation to other dominant and deviant conditions of belonging can be seen as a multiple expression of singularity of our

embodied encounters with digital technologies. The everyday shifts in relations of relevance that emerge through repetition of these encounters reinforce or neutralise one another, shaping the ways in which we use media to communicate. This dispersive, "dividual" condition, in which "transmutable or transformable" (Deleuze 1995, 181) configurations of bodies and images are moving among a continuous range of different trajectories, lies at the core of what I have addressed as the contingent nature of viral memetic media. Following the amplification of material-semiotic dynamics that came to force within the circulatory "facialisation" of Conchita's body image event on Tumblr in May 2014, I have focused on the following interrelated qualities of contagion images:

- that in digitally mediated networks of visual social exchange an individual image may be reiterated in manifold forms without having a linear trajectory of reproduction;
- that the image amplifies its affective value in circulation, disturbing the binaries of source and adaptation with each new act of commentary, imitation and capture;
- and that the image's capacity to proliferate and change is embedded in platform-specific formations of viral memetic communication, in which different intensities of seeing/sensing/using/sharing/belonging are at play.

It is important to emphasise in this regard that contagion is neither a property of the image nor does it emerge exclusively through viral connections that can be rendered visible by counting likes and shares. Instead, I approach affective contagion as a *contingent quality of visual social experience* in digital networks that is shaped by what can be seen and what can be felt and *what could always have been experienced otherwise*. As multi-site viral products and practices of everyday media remix, contagion images are archivable, accessible and endlessly transformable in their connections to and disconnections from the embodied and technologically mediated user practices that enable them. The ways in which they attach to, detach from and reattach through other images and bodies disturb linear relations of signification. As Dean argues, their spread involves dynamics that are both singular and common: "faces are common and private, belonging to those others than their bearers. Circulating, they express the feelings of anyone" (Dean 2016, 6).

The transitive potentiality of contagion images comes to act less as a form of radical transformation than it does via contingent affective moments of circulation and memetic alteration. The exploration of complex mediated conditions of these moments requires both analytical and methodological approaches that would acknowledge the multi-dimensionality of the image as it unfolds in the course of its dissemination, creating variously modulated networks of affect and meaning. Opening up popular media events to multiple competing actualisations, viral images and their memetic appropriations repeat and remediate *disruption* on a daily basis. They come into force as eventful material-semiotic arrangements, enabling affective forms of connectivity that *both* intensify and shift dominant formations of meaning and belonging. Within the ongoing diversification of deviant visual social adaptations that deviate not in relation to some original source but in relation to one another, contagion images become atmospheric. They assemble and reassemble the cognitive, the embodied and the technological.

Notes

1 Available from www.urbandictionary.com/define.php?term=conchita and www.urbandic tionary.com/define.php?term=Wurst [Accessed 30 March 2018].
2 The adaptation of Conchita's body image by Mario Manzanares continues to circulate on other platforms with new captions (see e.g. www.deviantart.com/servetf08/art/God-Save-the-QUEEN-CONCHITA-453820020 [Accessed 30 March 2018]). Overall, five public creative adaptations of Conchita's image referenced in Figure 11.1 come from Tumblr artists using bricolage, remix and sketching in their work on the following Tumblogs: mariomanzanares (2014–05-11/24217 notes); powersimon (2014–05-10/5438 notes); deborahpicherillustra-tions (2014–05-13/262 notes); fauxfungus (2014–05-12/174 notes); strangelfreak (2014–05-11/697 notes). My decision to reference these images while de-identifying other clearly memetic forms of appropriation comes from the public nature of the work of Tumblr artists and the necessity of giving credit to such work while appropriating it in new contexts. Pub-licly shared visual material from the dataset that Tumblr users tagged as "personal" has not been reproduced in this article. The graphic in Figure 11.1 created by the author for analytical purposes is accessible on Tumblr under www.tumblr.com/blog/pilipetz-blog and contains links to the above-mentioned profiles.
3 In total, the main tag "Conchita Wurst" was attached to 1919 images, while the tag "Conchita" was co-shared with further 556 images or "photos" (other visual content cat-egories on Tumblr such as "videos" or "links" were filtered in order to keep the amount of data manageable).
4 The visual material attached to the tags "Conchita" and "Conchita Wurst" (Figure 11.1) on Tumblr in May 2014 was collected and organised with the help of the DMI Tumblr tool (Rieder 2015, available from http://labs.polsys.net/tools/tumblr/[Accessed 30 March 2018]) which retrieves posts tagged with a specific term and creates co-tag net-works and a tabular file containing basic descriptions of the retrieved data. The co-tag network in the Figure 11.2 was analysed using the open-graph visualisation software Gephi (available from https://gephi.org [Accessed 30 March 2018]). The bricolage of visual imitation patterns on Tumblr in the Figure 11.3 was created using the ImageSorter software (available from https://visual-computing.com [Accessed 30 March 2018]).
5 Available from https://thecontemplativeobserver.wordpress.com/category/conchita-wurst/ [Accessed 30 March 2018]. My decision to attribute the images to this specific curation site and to reference it for purposes of analysis comes from the explicitly public nature of the site as indicated on the Welcome page of thecontemplativeobserver. In comparison to Tumblr, where privacy might be expected, the site provides less unintended identifying details in its appropriation/analysis of the image, which has been already cited in other academic publications (see Weber 2016, 161).
6 Available from http://jesusinlove.blogspot.co.at/2014/05/sacred-heart-icon-of-bearded-drag-queen.html [Accessed 30 March 2018]. The site, which is curated by a lesbian Christian author, Kittredge Cherry, is another site identified through a reverse image search that I decided not to reference considering the author's status as a public figure.

References

Adams, W. L., 2014. Conchita Wurst Sausage: Austrian Butcher Introduces Meaty Treat [online]. *Wiwibloggs*. Available from: https://wiwibloggs.com/2014/05/13/conchita-wurst-sausage-butcher/ [Accessed 30 March 2018].
Anderson, B., 2009. Affective Atmospheres. *Emotion, Space and Society* 2, 77–81.
Baym, N. and Boyd, D., 2012. Socially Mediated Publicness: An Introduction. *Journal of Broadcasting and Electronic Media* 56 (3), 320–329.
Bolter, J. D. and Grusin, R., 1999. *Remediation. Understanding New Media*. Cambridge, Mas-sachusetts: MIT Press.
Boyd, D., 2014. *It's Complicated: The Social Lives of Networked Teens*. New Haven, Con-necticut: Yale University Press.

Boyd, D., 2017. Hacking the Attention Economy [online]. *Points*. Available from: https://points.datasociety.net/hacking-the-attention-economy-9fa1daca7a37 [Accessed 30 March 2018].

Burgess, J. and Matamoros-Fernandez, A., 2016. Mapping Sociocultural Controversies Across Digital Media Platforms: One Week of #gamergate on Twitter, YouTube, and Tumblr. *Communication Research and Practice* 1 (2), 79–96.

Butler, J., 1990. *Gender Trouble: Feminism and the Subversion of Identity*. New York and London: Routledge.

Cho, A., 2015. Queer Reverb: Tumblr, Affect, Time. *In:* K. Hillis, S. Paasonen, and M. Petit, eds., *Networked Affect*. Cambridge, Massachusetts: MIT Press, 43–58.

Dean, J., 2016. Faces as Commons: The Secondary Visuality of Communicative Capitalism [online]. *Open! Platform for Art, Culture & the Public Domain*. Available from: www.onlineopen.org/faces-as-commons [Accessed 30 March 2018].

Deleuze, G., 1992. Postscript on the Societies of Control. *October 59*, 3–7.

Deleuze, G., 1995. *Negotiations, 1972–1990*. New York: Columbia University Press.

Deleuze, G. and Guattari, F., 1987. *A Thousand Plateus: Capitalism and Schizophrenia*. London: Bloomsbury.

Deleuze, G. and Parnet, C., 1987. *Dialogues*. New York: Columbia University Press.

Dijck, J. van., 2013. *The Culture of Connectivity: A Critical History of Social Media*. Oxford: Oxford University Press.

Engel, A., 2016. Queer International Relations (III). A Post on Cynthia Weber's Queer International Relations: Sovereignty, Sexuality and the Will to Knowledge [online]. *The Disorder of Things*. 23 November. Available from https://thedisorderofthings.com/2016/11/23/queer-international-relations-iii/#more-14868 [Accessed 30 March 2018].

Fink, M. and Miller, Q., 2014. Trans Media Moments: Tumblr, 2011–2013. *Television and New Media* 15 (7), 611–626.

Gander, K., 2014. Conchita Wurst's Eurovision 2014 Win Caused Balkan Floods, Says Serbian Church Leader [online]. *Independent*. 22 May. Available from: www.independent.co.uk/arts-entertainment/music/news/god-punished-balkans-with-floods-for-conchita-wursts-eurovision-2014-win-says-serbian-church-leader-9419300.html [Accessed 30 March 2018].

Gibbs, A., 2001. Contagious Feelings: Pauline Hanson and the Epidemiology of Affect. *Australian Humanities Review* [online]. Available from: http://australianhumanitiesreview.org/2001/12/01/contagious-feelings-pauline-hanson-and-the-epidemiology-of-affect/ [Accessed 30 March 2019].

Gibbs, A., 2002. Disaffected. *Continuum: Journal of Media and Cultural Studies* 16 (3), 335–341.

Gibbs, A., 2010. After Affect: Sympathy, Synchrony and Mimetic Communication. *In:* M. Gregg and G. Seigworth, eds., *The Affect Theory Reader*. Durham and London: Duke University Press, 186–205.

Goriunova, O., 2014. The Force of Digital Aesthetics: On Memes, Hacking, and Individuation. *The Nordic Journal of Aesthetics* 47, 54–75.

Halavais, A., 2013. Search and Networked Attention. *In:* J. Hartley, J. Burgess, and A. Bruns, eds., *A Companion to New Media Dynamics*. Chichester: Wiley-Blackwell, 249–260.

Haraway, D., 1997. *Modest_Witness@Second_Millenium. FemaleMan_Meets_OncoMouse: Feminism and Technoscience*. New York and London: Routledge.

Heine, J. J., Hidding, N., Wissel, J., van Zoggel, M., Simons, D., and Geboers, M., 2016. *Engagement With Tragedy on Social Media: The Visual Language of Instagram and Twitter – Two Case Studies* [online]. Digital Methods Initiative Winter School. Available from: https://wiki.digitalmethods.net/Dmi/WinterSchool2016EngagementWithTragedySocialMedia [Accessed 10 April 2019].

Highfield, T., 2017. *Social Media and Everyday Politics*. Cambridge: Polity Press.

Highfield, T. and Leaver, T., 2016. Instagrammatics and Digital Methods: Studying Visual Social Media, from Selfies and GIFs to Memes and Emoji. *Communication Research and Practice* 2 (1), 47–62.

Hodgson, C., 2014. Conchita Wurst's Eurovision Win Slammed by Russia as Politician Brands It "the End of Europe". *Mirror*, 21 May. Available from: www.mirror.co.uk/tv/tv-news/russia-slams-eurovision-winner-conchita-3525396 [Accessed 30 March 2018].

Knuttila, L., 2011. User Unknown: 4chan, Anonymity and Contingency. *FirstMonday: Peer-Reviewed Journal on the Internet* [online], 16 (10). Available from: http://firstmonday.org/article/view/3665/3055#p9 [Accessed 30 March 2018].

Markham, A., 2012. Fabrication as Ethical Practice: Qualitative Inquiry in Ambiguous Internet Contexts. *Information, Communication and Society* 15 (3), 334–353.

Markham, A. and Buchanan, E., 2012. *Ethical Decision-Making and Internet Research, Recommendations from the AOiR Ethics Working Committee (Verison 2.0)* [online]. Available from: https://aoir.org/reports/ethics2.pdf [Accessed 30 March 2018].

Milner, R. M., 2016. *The World Made Meme: Public Conversations and Participatory Media.* Cambridge and London: MIT Press.

Nagele, A., 2017. *Kill All Normies: Online Culture Wars From 4chan and Tumblr to Trump and the Alt-Right.* Alresford: Zero Books.

Nakamura, L., 2014. "I Will Do Everything that Am Asked": Scambaiting, Digital Show-Space, and the Racial Violence of Social Media. *Journal of Visual Culture* 13 (3), 257–274.

Paasonen, S., 2011. *Carnal Resonance: Affect and Online Pornography.* Cambridge, Massachusetts and London:MIT Press.

Paasonen, S., 2016. Fickle Focus: Distraction, Affect and the Production of Value in Social Media. *First Monday* [online], 21 (10). Available from: https://firstmonday.org/article/view/6949/5629 [Accessed 30 March 2018].

Parikka, J., 2007. Contagion and Repetition: On the Viral Logic of Network Culture. *Ephemera* 7 (2), 287–308.

Pearce, W., Özkula, S. M., Greene, A. K., Teeling, L., Bansard, J. S., Omena, J. J., and Teixeira Rabello, E., 2018. Visual Cross-Platform Analysis: Digital Methods to Research Social Media Images. *Information, Communication & Society*. DOI: 10.1080/1369118X.2018.1486871.

Phillips, W. and Milner, R. M., 2017. *The Ambivalent Internet: Mischief, Oddity, and Antagonism Online.* Cambridge and Malden: Polity.

Pilipets, E., 2018. Queer Workings of Digital Affect: The Hypermediated Body of Conchita Wurst. *Transformations: Journal of Media, Culture & Technology* 31, 138–155.

Puar, J. K., 2007. *Terrorist Assemblages: Homonationalism in Queer Times.* Durham and London: Duke University Press.

Richardson, I. and Wilken, R., 2012. Parerga of the Third Screen: Mobile Media, Place, and Presence. *In:* R. Wilken and G. Goggin, eds., *Mobile Technology and Place.* New York: Routledge, 181–197.

Rieder, B., 2015. *DMI Tools: Tumblr Tag Network Analysis. Tumblr Tool. Computer Software* [online]. Available from http://labs.polsys.net/tools/tumblr/ [Accessed 30 March 2018].

Rogers, R., 2013. *Digital Methods.* London: MIT Press.

Rose, G., 2016. *Visual Methodologies: An Introduction to Researching with Visual Materials,* 4th Edition. London: Sage.

Salovaara, I., 2015. #JeSuisCharlie: Networks, Affects and Distributed Agency of Media Assemblage. *Conjunctions: Transdisciplinary Journal of Cultural Paricipation* 2 (1), 103–115.

Sampson, T. D., 2012. *Virality: Contagion Theory in the Age of Networks.* Minneapolis, Minnesota: University of Minnesota Press.

Schober, A., 2009. Irony, Montage, Alienation: Political Tactics and the Invention of an Avant-Garde Tradition (Part 2). *Afterimage: The Journal of Media Arts and Cultural Criticism* 37 (4), 15–20.

Senft, T., 2008. *Camgirls: Celebrity & Community in the Age of Social Networks*. New York: Peter Lang.

Senft, T. and Baym, N., 2015. What Does the Selfie Say? Investigating a Global Phenomenon. Introduction. *International Journal of Communication* 9, 1588–1606. Available from: https://ijoc.org/index.php/ijoc/article/viewFile/4067/1387 [Accessed 30 March 2018].

Sharma, S., 2013. Black Twitter? Racial Hashtags, Networks and Contagion. *New Formations* 78 (2), 46–64.

Shifman, L., 2014. The Cultural Logic of Photo-Based Meme Genres. *Journal of Visual Culture* 13 (3), 340–358.

Terranova, T., 2004. *Network Culture: Politics for the Information Age*. New York: Pluto Press.

Tiidenberg, K., 2015. Boundaries and Conflict in a NSFW Community on Tumblr: The Meanings and Uses of Selfies. *New Media and Society*. DOI: 10.1177/1461444814567984.

Tiidenberg, K., 2017. Ethics in Digital Research. *In*: U. Flick, ed., *The Sage Handbook of Qualitative Data Collection*. London: Sage, 466–479.

Tomchak, A. and Zand, B., 2014. *Russians Shave Beards in Eurovision Protest* [online]. BBCtrending, 20 May. Available from: www.bbc.com/news/av/magazine-27443936/bbctrending-russians-shave-beards-in-eurovision-protest [Accessed 30 March 2018].

Warfield, K., 2016. Making the Cut: An Agential Realist Examination of Selfies and Touch. *Social Media + Society* 2, 1–10.

Weber, C., 2016. *Queer International Relations: Sovereignty, Sexuality and the Will to Knowledge*. New York: Oxford University Press.

12 The Usual Difference

Everybodies as Participants in Contemporary Art and the Spectacle of Changing Relations

Elisabeth Fritz

Over a dozen people, uniformly dressed in casual grey shirts and trousers, are doing nothing other than trying to get into the field of vision of a camera looking at them from above (Figure 12.1). Each individual is claiming space by lying on the floor and pushing past, brushing aside or scrambling over someone else. The group is in perpetual motion, constantly changing its centre and arrangement within the circumscribed frame. This experiment enacts social interaction as a mere formal event. Detached from any other context or clue regarding a specific content, aim or outcome of the power struggle, the goal turns out to be simply to become visible within a certain area of media attention. Associations related to historical and recent images of people crowded together in confined spaces may come to mind, but do not lead to a definite conclusion. Those allusions range from crowded refugee boats to piles of human bodies in crimes of genocide and as far as Théodore Géricault's *The Raft of the Medusa* (1819).[1] The attraction of this featureless mass, whose anonymity is even increased by the fact that the actors' faces can hardly be seen from the overhead camera perspective, is based in the aesthetics of a moving arrangement—changing relations of rather similar individual elements within a collective whole.

The video installation work described, *TERRITORY* (2016) by the Berlin artist Yvon Chabrowski—to which I will return at the end of this article—can be situated within a current type of contemporary art that reacts to a general change in the understanding and discourses of participatory art. Based on the idea of integrating "real people" into the artistic process, figures of everybodies have been central to the conception of modern art since aesthetic programmes of realism emerged.[2] Claiming to establish a new kind of relationship between art and "real life", from the very beginning this approach has been related to ideas of political awareness and social engagement.[3] Images of the "common people" in 19th-century literary and visual arts include the working classes or views of daily city street life, but also prostitutes, orphans or homeless people. Realness in this context usually denotes the social contexts that were previously excluded from representation in the visual media. The authenticity of the people depicted is thereby defined by quality as well as quantity (Pethes 2004, 134f.): they are understood as "real" because of their status of usualness—by constituting most of society—as well as particularity—by being different, in terms of social hierarchy, from society's higher strata. Participants in artistic practices, aimed at integrating "real people" and "real life", are thus usually classified as "normal" with regard to the numbers in which they appear in society and as "other" with regard to their entitlement to become an object of or audience for art.

Figure 12.1 Yvon Chabrowski, TERRITORY, 2016, two-channel video installation, HD-loop, 21 min, colour, sound, life-size projection onto the floor, 280 × 498 cm (videostill). Copyright: Yvon Chabrowski/VG Bild-Kunst, Bonn 2019.

In the 20th century the integration of "real people" into the realm of art is no longer a question of representation, but concerns the concrete production process itself. Dada, constructivism or futurism apply strategies of audience activation by shock or provocation, thus tearing them out of a passive-receptive position, aiming to enhance the perception and consciousness of the viewers. Audience participation hence forms a key element in the aspired transformation of art into life praxis, which consequently includes a self-reflective and critical impulse concerning the institution of art (Bürger 1984). The avant-gardes no longer wish to act on a symbolic level, but rather to intervene directly in reality, shaking the concept of art to the very foundations. Within performative movements of the 1950s and 1960s, namely in situationism, happenings, fluxus or the "social sculpture" of Joseph Beuys, the concept of participation is finally formulated as a distinct genre.

Emerging in the final decades of the 20th century, participation had become *the* form of socially engaged art, connecting it to claims of political activism, community-building and the creation of public spheres. Whereas the positions of the avant-garde and neo-avant-garde did not differ as to *which* audience they wanted to address, but rather tended to enlarge it to potentially everybody in art's environment, in postmodernity a focus on certain sections of the population, or those who were previously excluded or marginalised within society and art, can again be

observed.[4] A key example of such art "in the public interest" is the exhibition *Sculpture in Action—Culture in Action* (1992–1993) in Chicago, curated by Mary Jane Jacob. The project invited artists to work together with local groups, classified by criteria of otherness, such as inhabitants of social housing, AIDS patients or teenagers from a Latin-American immigrant background. A conflation of aesthetic criteria of effect with socio-political criteria of effectiveness is explicitly stressed in the organisers' rejection of traditional concepts of the work of art and their turning to "real life" instead: "All the art in 'Culture in Action' is intended to lead away from the object into the lives of real people, real neighbourhoods" (Brenson 1995, 21).

With the mid 1990s, participation art associated with a political claim to the emancipation of everybodies—qualitatively and quantitatively understood—reaches a peak and finds an emphatic formulation in concepts like *New Genre Public Art* (Lacy 1995) or *Relational Aesthetics* (Bourriaud 2002). However, at this point critical voices start to question the implied concepts of community and site (Kwon 1996, 2002) or the "ethical turn" related to the "social turn" brought about by the political involvement of participation art (Bishop 2006, 2012).[5] Simultaneously, at the turn of the millennium art faces another challenge, triggered by the appropriation of its former monopoly on showing "real life" by the popular mass media. Documentary, realistic and participatory strategies, integrating "real people" into the visual production processes now wear the label "reality TV" and are no longer rated as forms of social emancipation. The omnipresence of everybodies in these media formats leads to a crisis of legitimacy of contemporary "reality art" (Karlholm 2005/2006). Besides an ongoing enthusiasm for and belief in the political potential of participatory art, previously common practices such as social interventions in local communities or the staging of sociability nowadays seem not only historical, but also rather paradoxical (Neuner 2007). In the following I would like to stress three main fields of critique that contemporary participatory practices are confronted with, and to describe exemplary artworks positioning themselves productively within them.[6]

Playing Roles of "Otherness": *Isola Bella* by Danica Dakić

One of the main reproaches of participatory art, including qualitatively understood "real people", thus marked by a certain trait or social status, is the fact that it may solidify concepts of difference and otherness rather than resolve them. Although artists are eager to act for the best interests of their participants—attributed to be victims and desired to be "healed" by art—"community-based" art may lead to preconceptions of an "other" that has been identified and selected by the artist in advance (Kwon 1996, 150). Hence, whereas socially engaged projects aim at transgressing social borders, conversely they can produce an artificial classification, often revealing itself in creating two separate groups: the "real" participants and the observing audience. This is described by critics as a gap between "primary" and "secondary" audiences (Doherty 2007; Karlholm 2005/2006). Furthermore, given the fact that participatory artworks are nowadays often not intended to be viewed directly as a performance, but rather in the form of video documentation or installation, the distance between participating and spectating players might even be enhanced.[7]

Talking for or about everybodies as "others" without appropriation, differentiation and consequently degradation, thus becomes an important field of conflict for

contemporary participatory art. At this stage certain artists no longer share an unconditional faith in the empowering potential of visual media and performative practices, or try to solve its inherent conflicts, but in fact make the discrepancies outlined productive. One example in this context is the installation work *Isola Bella* (2007/2008) by the Bosnian artist Danica Dakić, which was created in an asylum for mentally and physically disabled people in Pazarić close to Sarajevo (Ortwig 2009). In a setting reminiscent of an old movie theatre surrounded by dark red curtains, the artist put a stage, a piano and some props, especially paper masks, at the participants' disposal. The background of the stage is filled with the reproduction of 19th-century panorama wallpaper showing exotic vegetation, as was associated with the paradisiacal Italian island of Isola Bella, thus also referring to the asylum's function as an "isle of shelter" (Dakić 2009, 49).

The video starts with a young man coming on stage asking: "Where's the audience?" "Where are the actors?"[8] The masked spectators, who later will also be the actors, now enter the auditorium and sit down on the seats there. The video then alternates between shots of the spectators and sequences showing the same people performing on stage, where they dance, sing, tell stories, play the piano, recite poems and enact pantomime or slapstick episodes. The half-masks represent typical carnival roles like an "Indian", an admiral, a rococo lady, a cat, a policeman or a king and give the whole situation an artificial and surreal character (Figure 12.2). As the masks are props

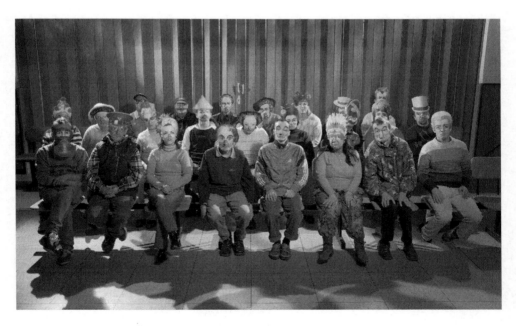

Figure 12.2 Danica Dakić, *Isola Bella*, 2007/2008, single-channel video projection, 19 min 8 sec, colour, sound; texts, masks, poster (still photograph). Copyright: Danica Dakić/VG Bild-Kunst, Bonn 2019.

of the scenes performed, but also function as attributes of the quietly sitting and staring auditorium: "the audience plays itself as something else—as a heterogeneous collective of mixed types" (Holert 2009, 10). This effect is supported by the complex montage of the video and audio track, which does not provide a coherent or synchronous narrative, but rather offers fragments within the interplay of shot and counter-shot.[9]

The participants in *Isola Bella* represent the role of both a "primary" and a "secondary" audience at the same time. In doing so they are consciously only partly playing the role of the societal other, and thus show that they are as capable of a distanced and critical reflection of their own visual representation as the later exhibition audience may be. Hence all of the roles depicted are interchangeable, serving like facets or different approaches to acting within a given situation. Instead of trying to show the supposed real life of these everybodies, Dakić chose a fantastic and illusionistic space, highlighting moments of artificiality and acting. However, she does not intend to produce an alienation of reality, but rather to create a setting that enables fiction, imagination and role-play and thereby makes them visible as a central part of social interaction in that real world. In relation to another video work by the artist and an exhibition series, both entitled *Role-Taking, Role-Making* (Buder 2005), the artist explicitly refers to socio-psychological concepts of role and the related question of "realness" in subjective performance. In sociological theories like those of Erving Goffman (1990) or Ralf Dahrendorf (2006) the social role is described as a dynamic bundle of norms, modes and expectations. As in a theatre play the attribution of authenticity to this role is a processual result of expression and perception, thus marking a scope of action rather than a fixed position. Wearing masks, in a literal and metaphorical sense, then is not seen as some kind of disguise or pretence overlaying the real face or essential core of an individual, but rather it determines the very existence of a socially acting *persona*—which, not by chance, is the Greek word for mask.

In the exhibition installation of *Isola Bella* Dakić gives explicit consideration to this topos of *theatrum mundi*,[10] as she recreates the same stage set as in Pazarić for the later, maybe "third", audience. Advertising posters, showcases with the masks and notes by the performers, which are installed in front of the entrance,[11] prepare the recipient for the expected spectacle and furthermore serve as evidence of the enacted experiment. Going through a curtain one takes one's place in the same seats that the participants are shown sitting on in the video. Staring back into the exhibition hall it seems they are inviting us to change places with them and become performers of the role of the "other" too. Instead of looking at disabled people in a Bosnian asylum with distance, empathy or curiosity, we are offered the chance to see ourselves in the place of these everybodies, as we all share the same disposition to imagine and play various roles in life.

Political Action as the Crisis of Community: *Communitas* by Aernout Mik

The question of role-playing is also addressed in the works of the Dutch artist Aernout Mik, who deals with the constitution of community and collective action in improvised situations. His art thereby reacts to another important point of critique of contemporary participation art, namely its implicit normative understanding of collectivity. Theories in the context of Bourriaud's *Relational Aesthetics*

(2002) emphasise the merely harmonic and sociable character of human interaction within participatory art projects. Bishop (2004, 2012) has criticised such an understanding as being essentialist, totalitarian and hegemonic, because it implies an identification of community with a homogenous, conformist and uniform group.[12] This contradicts more recent theories of community, society and hegemony based on the concept of antagonism and "radical democracy" (Laclau and Mouffe 2014). In this, conflict, disparateness, division and instability are not conceived as problems endangering democratic collectivity, but rather as its defining conditions. Following such an understanding, the visual manifestation of the impossibility of harmonious community, for example because of contentious social relations, "marked by sensations of unease and discomfort rather than belonging" (Bishop 2004, 70), may do justice to a real democratic collective.

In his art Mik uses staged crowds in a movie-like setting, where he works with a complete film team, but without a script, a casting of roles or a rehearsal. Instead the participants function like extras, instructed only by guidelines concerning the intended situation, which they then act out impromptu as a dynamic multitude:

> since they are [...] not really very specific roles, no one knows really how different he [or she] is from the other and what exactly he [or she] represents. [...] It is collective action that's really going on.
>
> (Mik cited in Kardish 2009, 15)

In contrast to the previously discussed work by Dakić, Mik does not want his participants to become characters and thus preserves them from concrete information or symbols to act with. This process of abstraction is even forced by the fact that the staged situations allude to political or social events known from media or collective memory, where a crowd of people gathers on issues of political interest or while dealing with cases of emergency.[13]

In the video installation *Communitas* (2010) Mik stages a spectacle of community as a situation of crisis. Three synchronised, *c.* 100-minute silent videos are projected on separate free-standing screens side by side one another in the gallery. They show a larger group of people in various different rooms of an official building, reminiscent of a theatre, a conference hall, a courtroom and a refectory. Rather solemn furniture, suspended banners with slogans and not least the actions of the crowd—such as voting by show of hands, or ballots, flag-waving and chanting, or panel discussions and speeches from platforms—allow the viewer to assume that the event presented is a kind of political meeting or occupation. Not least because of the simultaneous projection of three channels the viewer gets the feeling of leaps in time and fragments in the plot. Moreover, the videos do not show a specific start, goal or ending and neither can be read in the sense of one continuous coherent narrative. Furthermore, the loosely connected scenarios are interrupted by uncanny sequences, where everyone falls into a comatose sleep, scattered motionless over the desks, seats and floors (Figure 12.3). The crisis of interpretation finally also concerns the categorisation of the scene as documentary or fiction, given the mixture of styles.

Ambiguity determines the whole social constellation depicted in Mik's *Communitas*. Whereas firstly the content of the discussions remains obscure, because of the general lack of sound, also the slogans shown—seemingly Latin

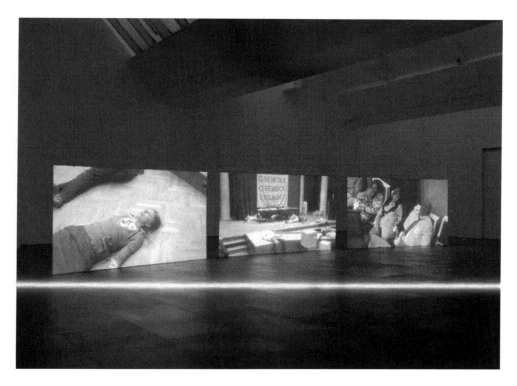

Figure 12.3 Aernout Mik, *Communitas*, 2010, three-channel video installation, ca. 100 min, colour, without sound, installation view: carlier | gebauer, Berlin. Photo: Florian Braun. Copyright: Aernout Mik/carlier | gebauer, Berlin 2010.

or Slavic terms like *Resistus, Democki, Okupacja* or *Equalitaz*—merely evoke but do not actually express political concepts. Even though there are moments where clear oppositions appear within the gathering—marked by different coloured banners or ballots as well as by the conspicuous differentiation between actors of European and Asian origin—a concrete political position or conflict of interest is never clearly defined. Altogether this gathering presents itself like a citation or model for a political event as practised by avant-garde groups like the Dadaists or the futurists (Höller 2011, 224). In addition, allusions to eastern Europe are related to the real location of the setting, namely the Palace of Culture and Science in Warsaw, built in 1955 in the style of socialist classicism and nowadays often the target of mockery and rejection. Moments of change in society are thereby strongly implied and may stimulate our collective memory, but without adopting a specific identity or form (Mik 2011, 211). Final conclusions about the scenes remain vague and are, if anything, only present in a latent sense.

The absence of structure, determination and hierarchy as it characterises the actors in Mik's video installation is also a central feature of the concept of *communitas* described by the Scottish ethnologist Victor Turner, to which the

title of the artwork directly refers. Turner's socio-anthropological theories of ritual processes (1995, 1982) describe social action in terms of theatricality and play, namely as "social drama". In this, *communitas* designates a liminal state of society, where all normative mechanisms of bonding and differentiation, such as classes, castes or ranks, are given up or become interchangeable. Thus "in such rites, with a 'moment in and out of time'" something higher is revealed: "a general social bond that has ceased to be and has simultaneously yet to be fragmented into a multiplicity of structural ties" (Turner 1995, 96). This kind of collective experience, not yet determined with regard to content or the distribution of positions, enables all participants—at least symbolically—to be part of designing an upcoming social order and to adopt any possible role within it.

Turner's concept of *communitas* is also reminiscent of more recent philosophical concepts of community as a non-identical, blank or "improper" social constellation (Esposito 2010). Jean-Luc Nancy in his book *Being Singular Plural* (2000) describes community as the "being-with" of people, signifying not a meeting based on an antecedent characteristic, but rather a co-existent plurality, simultaneously present within a certain time and space:

> *We* can never simply be "the we," understood as a unique subject, or understood as an indistinct "we" that is like a diffuse generality. [...] "one" is not "with" in some general sort of way, but each time according to determined modes that are themselves multiple and simultaneous (people, culture, language, lineage, network, group, couple, band, and so on).
>
> (Nancy 2000, 65)

Within the theoretical framework outlined in the video installation, *Communitas* shows that community in the sense of a contentious, different and yet equal multitude can be created within participatory art. In it, social action is reduced to itself, without given interests, roles or groups, although existing memories, images and habits may interfere in the dynamics of the happening. By loss of concrete characteristics, Mik's everybodies present a liminal moment of chance within the realm of social negotiation and political action.

"People are the Ultimate Spectacle":[14] *They Shoot Horses* by Phil Collins

Since "common people" have become an integral part of contemporary visual culture, participatory artistic practices at the turn of the 21st century find themselves in a dilemma: instead of their former identification with socio-political engagement and thus a quite opposite self-understanding to that of popular entertainment, they are now tending to converge with the commercial media industry. Regarding the (secondary) art audience of videos showing "real people" staged to act for a camera, Dan Karlholm asks:

> This public views real people who do real things on video recordings, not unlike consumers of so-called reality TV, which is the entertainment industry's response to a similar lure of the real.
>
> (Karlholm 2005/2006, 124)

Other critics, such as Diedrich Diederichsen (2008, 256f.) or Nina Möntmann (2006), have discussed artworks by Vanessa Beecroft, Candice Breitz, Artur Żmijewski or Santiago Sierra in relation to theories of biopolitics, as formulated by Michel Foucault and Giorgio Agamben. They criticise the exposure of bodies in their mere physicality as "bare life" instead of subjective individuality. (Every-) bodies may thus be understood to function as interchangeable, undifferentiated objects, props or extras, exploited as just another kind of material to produce art. They serve "as building blocks of a thoroughly abstract 'social sculpture' that will be beyond any individual's grasp [...]. They become actor-puppets in a play with a script unknown to them" (Karlholm 2005/2006, 123).

A sophisticated artwork dealing with the question of how contemporary art is entangled in the cited "lure of the real" and may thus not be immune to the risk of degrading its participants to some kind of working material or living fetish object, is the video installation *they shoot horses* (2004) by the British artist Phil Collins. It was made as part of an artist-in-residence programme at the Al-Ma'mal Foundation for Contemporary Art in Jerusalem, which explicitly aims to stimulate public and international communication with Palestine, especially by creating workshops for young people on site.[15] In this context Collins might have been expected to work with local teenagers in the traditional understanding of socially engaged community-based art—by benevolently intervening in their real life or creating supposedly emancipatory representations of that life. Yet, instead of visual documentation, and far from images of everyday life in the Middle East that the media usually show, the artist chose the language of modern popular culture, which seemed far more effective to him. In his project-description text, preserved in the artist-in-residence archives at Al-Ma'mal Foundation, Collins puts it this way:

> Something so dumb and frivolous which spoke precisely about exhaustion, collapse and heroism but in a palette of Pop Idol colours. When we think of Palestine it never seems to be in reference to modernity, or culture; in fact, it's relentlessly positioned as uncivilised.[16]

More precisely, Collins organised a dance marathon for which he cast and paid Palestinian teenagers to dance continuously and without a break for eight hours to a mix of pop music. The camera recorded them frontally from a fixed viewpoint for the whole time. In the installation the videos of two cycles of the marathon, in groups of four or five people, are projected on adjacent walls in real time in approximately life-size (Figure 12.4). One complete screening might thus fill the entire opening hours of a museum or one working day.[17] At the beginning the adolescents start their dance movements euphorically, sing and shout along or interact with each other, but as time passes we gradually observe exhaustion, boredom and half-heartedness in their performance. If she or he is willing to stand in front of them for a longer time, eager to see the whole video, the viewer—after maybe moving to the beat of the music—might feel distressed and the need to sit down and rest, like the dancers.

With the motif of the dance marathon and most directly with the title, Collins relates to a cultural practice common in the US of the 1930s, hence the golden era of cinema concurrent to the Depression (Martin 1994). *They Shoot Horses, Don't They?* was originally the title of a 1935 novel by Horace McCoy and was filmed

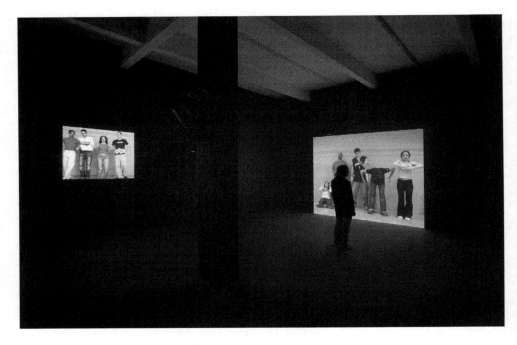

Figure 12.4 Phil Collins, *they shoot horses*, 2004, two-channel video installation, 420 min, colour, sound (installation view: Kunst Halle Sankt Gallen, 2006). Copyright: Shady Lane Productions.

by Sydney Pollack in 1969 (Diekmann 2005), which became an important reference point for the post-1968 cinema movement (Schober 2013, 139). It tells the story of Robert and Gloria, who participate in a dance marathon, where a group of unemployed women and men not only want to win the prize money, but also want to be discovered as the next Hollywood star by the film producers present. The story shows the increasing exhaustion or breakdown of the participants, who alternate continuously between nearly two hours of dancing in front of a coming and going paying public and ten-minute pauses in a small backstage area. After five weeks, 879 hours, the competition is cancelled because of a murder in the hall. Gloria, now without any future prospects, asks Roberts to shoot her, which he does, later justifying it in court as a *coup de grâce*, comparing his partner to a hopelessly injured horse.

The spectacle of the dance marathon, as described by McCoy, is almost scarily reminiscent of later reality-TV formats showing the confinement of "ordinary people" inside an enclosed space for a long time, in a kind of social experiment to see how they deal with an extreme situation of physical and psychological stress. In Collins' *they shoot horses*, too, dance does not signify a relieving form of collective or individual expression,[18] it is rather characterised as isolating, automated and competitive behaviour, put up for observation for

payment. Its visual attraction lies in watching everybodies flagging, failing and breaking down and not in regarding special talents or refined artistic techniques. In doing so the artist by no means seeks to avoid closeness to historical or contemporary popular culture. He is not claiming to create some kind of oppositional "safe space" within art. Precisely in that he finds a way to address the exhausting and stressful situation of young women and men in Palestine, which is hard to endure and seems to have no end (see Bishop 2012, 226f.). Likewise Collins portrays them as part of global media culture, wearing the same clothes and listening to the same music as other teenagers do. The installation is thus nonetheless site-specific and critical and at the same time invites us to a form of spectatorship that is not merely full of pity or consternation, but rather provides an entertainment spectacle. Ultimately the critique formulated by this artwork does not primarily concern certain socio-political problems rather than an unreflected concept of art's critical potential to react to such.

Conclusion

All the artworks I have described can be characterised as media experiments in which anonymous and indifferent "real people"—qualified as such by their usualness and the always particular difference they incorporate—are staged interacting within a given setting of time and space. Their action is observed on camera and then presented as a *social spectacle* in an exhibition context. In the legacy of Guy Debord's *The Society of the Spectacle* (2010) spectacularity is usually defined as the ultimate enemy of high art, demonised as a dulling and blinding effect of capitalist economics.[19] By contrast the projects discussed use the spectacle as a critical practice, by literally demanding that the viewer takes a stand in relation to the images projected.

Coming back to my introductory example from Yvon Chabrowski, I have so far held back a major part of the works' description: the installation setting and its relation to the viewer. In *TERRITORY* we are confronted with two not entirely coherent, partly overlapping, partly fragmentary video recordings of the experiment, projected life size onto the gallery's floor (Figure 12.5). The spectator has to decide either to watch from a distance or stand on or between the projections. Also in the other video installations discussed, artistic strategies such as multi-channel projection, discontinuous narration or the installation design physically address the recipients, not letting them off the hook and precluding a linear, identical or differential observation of "real people". In doing so the artists presented take part in the production of contemporary everybody figures and at the same time reflect discursive changes that have taken place since the onset of postmodernity, dealing with questions of sameness, differentiation, singularity and collectivity. Critical reproaches of the distinction between primary and secondary audiences, the artificial creation of harmonious communities or the puppet-like instrumentalisation of the participants are not dismissed; the artists rather seem to add fuel to those inherent conflicts of participation art. The way we relate to one another socially and politically is thereby revealed to be a spectacular aesthetic constellation that affects our reasoning as well as our senses—and is always open to be rearranged in new constellations.

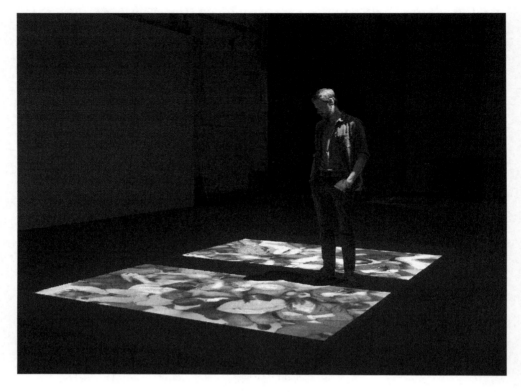

Figure 12.5 Yvon Chabrowski, TERRITORY, 2016, two-channel video installation, HD-loop, 21 min, colour, sound, life-size projection onto the floor, 280 × 498 cm (installation view). Copyright: Yvon Chabrowski/VG Bild-Kunst, Bonn 2019.

Notes

1 Géricault's work was an important influence for the artist Yvon Chabrowski, as she told me. Further information on her work *TERRITORY* is available from: www.chabrowski.info/works/territory/ [Accessed 22 January 2018].

2 Whereas beforehand I have discussed this type of figure in the context of contemporary art mostly by the terms "real people" or "common people" (Fritz 2014a), I would like to extend it here to the concept of the "everybody"—described by Anna Schober in the introduction to this volume—as a type of figure that is used in a variety of political and social discourses but also in the visual arts to appeal to an audience and to testify to the reality of what is being portrayed. This understanding especially highlights the mediating function that such figures assume by interrelating not only the usual and the particular but also the self and the other.

3 For an overview of the history and theory of art in relation to social change in the 19th and 20th centuries see the comprehensive anthology edited by Bradley and Esche (2007). Compare also Clark (1982).

4 Schober (2015) has described a similar development regarding the figure of the everybody connected to political claims, switching from terms of national, sexual or class identity in the first half of the 20th century to cultural or ethnic "others" in the course of its second half.

5 In her book Bishop (2012, 3) modifies the concept of the "social turn" and puts it more precisely as a "social *return*". She thus now outlines a more general development and ongoing history within the course of the 20th and 21st centuries and not only focuses on the art of the 1990s and 2000s as in her former article (Bishop 2004).

6 In my book *Authentizität—Partizipation—Spektakel* (Fritz 2014a) I discuss the phenomenon of "media experiments with 'real people'" in the broader context of art, the social sciences and popular culture in the 20th and 21st centuries. My following remarks are extrapolated from there (esp. 36–67 and 242–248).

7 Bishop (2012, 219–239) proposes a provisional typology of what she calls "delegated perfomance", used by artists to "outsource" authenticity. In that she distinguishes actions performed by delegated professionals or non-professionals within gallery spaces from "situations constructed for video and film" (226). The works I discuss in this article all belong to this later type.

8 The people in the subtitled video speak in their mother tongue, Bosnian.

9 The sequential character of the montage, showing discrete moments and not one continuous narrative is highlighted by the fact that the scenes are labelled with prime numbers.

10 The *theatrum mundi* is an old topos within social theory, describing the constitutive theatrical character of society and human interaction. For an overview of the history of this concept see Konersmann and González García (1998).

11 My description of the installation is based on the exhibition of the work in the Generali

12 Bishop (2004), for example, compares the work of Rirkrit Tiravanija to that of Santiago Sierra, preferring Sierra because of his antagonistic approach.

13 Wolfgang Kemp (1973) analysed the beginnings of representations of the crowd in art history during French Revolution in relation to questions of social order and distribution. He shows that, while shifting between an amorphous totality and the plurality of distinct singular elements, these images also function as a "promoter of art".

14 The quotation can be found as a slogan on a poster for the movie *They Shoot Horses, Don't They?* (Sydney Pollack, US 1996).

15 The goal of the residency at Al-Ma'mal Foundation is described as follows: "This program serves as a meeting place for artists, facilitating creative encounters and discussion forums that are open to the public community, thus activating communication between Palestine and the international world. In order to further encourage this exchange, Al-Ma'mal invites the artists in-residence to contribute to the Al-Ma'mal Workshops program, working primarily with youth on creative projects." Available from: www.transartists.org/air/al-mamal-foundation [accessed 9 March 2018].

16 Available from: http://almamal.blogspot.de/2010/08/phil-collins-they-shoot-horses.html [accessed 9 March 2018].

17 During the recordings there were some unplanned technical interruptions, thus in the final version the videos do not take the complete eight, but circa seven hours.

18 Such a political understanding of neo-avant-garde dance art, transcending the individual subject in order to become a collective body, has been described by Anna Schober (2004) regarding Brazilian artists in the 1960s. I have also briefly discussed this in the context of an analysis of the video installation work *The Buzzclub, Liverpool, UK/Mysterywordl, Zaandam, NL (1996–1997)* by Rineke Dijkstra (Fritz 2014a, 76–81).

19 For a review of "spectacle" as a central aesthetic category in history and theory beyond Debord's pejorative and restricted view see Fritz (2014a, 2014b) and Frisch et al. (2018).

References

Bishop, C., 2004. Antagonism and Relational Aesthetics. *October*, 110, 51–79.

Bishop, C., 2006. The Social Turn: Collaboration and its Discontents. *Artforum*, 44 (2), 178–183.

Bishop, C., 2012. *Artificial Hells: Participatory Art and the Politics of Spectatorship*. London: Verso.

Bourriaud, N., 2002. *Relational Aesthetics* [*Esthétique relationelle*, 1998]. Dijon: Les Presses du Réel.

Bradley, W. and Esche, C., eds., 2007. *Art and Social Change: A Critical Reader*. London: Tate.

Brenson, M., 1995. Healing in Time. *In:* Sculpture Chicago, ed., *Culture in Action: A Public Art Program of Sculpture Chicago curated by Mary Jane Jacob*. Seattle, Washington: Bay Press, 16–49.

Buder, M., ed., 2005. *Danica Dakić: Role-Taking, Role-Making*. Exhib. cat. Kulturzentrum Sinsteden, Rhein-Kreis Neuss, Rommerskirchen (11 December 2005 – 19 March 2006). Nuremberg: Verl. für Moderne Kunst.

Bürger, P., 1984. *Theory of the Avant-Garde* [*Theorie der Avantgarde*, 1974]. Minneapolis, Minnesota: University of Minnesota Press.

Clark, T., 1982. *Image of the People: Gustave Courbet and the 1848 Revolution*. London: Thames & Hudson.

Dahrendorf, R., 2006. *Homo Sociologicus: Ein Versuch zur Geschichte, Bedeutung und Kritik der Kategorie der sozialen Rolle 1958*. 16th ed. Wiesbaden: Verl. für Sozialwissenschaften.

Dakić, D., 2009b. Ulrike Groos and Tihomir Milovac in Conversation with Danica Dakić. *In:* D. Dakić, S. Folie, and U. Groos, eds., *Danica Dakić*. Cologne: Walther König, 40–52.

Debord, G., 2010. *The Society of the Spectacle* [*La société du spectacle*, 1967]. Repr. Detroit, Michigan: Black & Red.

Diederichsen, D., 2008. *Eigenblutdoping: Selbstverwertung, Künstlerromantik, Partizipation*. Cologne: Kiepenheuer & Witsch.

Diekmann, S., 2005. Tanz/Sport/Arbeit. Anmerkungen zu Sydney Pollacks "They Shoot Horses, Don't They?" *In:* C. Brüstle, ed., *Aus dem Takt: Rhythmus in Kunst, Kultur und Natur*. Bielefeld: Transcript, 45–65.

Doherty, C., 2007. The New Situationists. *In:* P. Pakesch and A. Budak, eds., *Protections: Das ist keine Ausstellung*. Exhib. cat. Gutshaus Kranz am Landesmuseum Joanneum and Steirischer Herbst, Graz (23 September – 22 October 2006). Cologne: Walther König, 63–77.

Esposito, R., 2010. *Communitas: The Origin and Destiny of Community* [*Communitas. Origine e Destino Della Communità*, 1998]. Stanford, California: Stanford University Press.

Frisch, S., Fritz, E., and Rieger, R., eds., 2018. *Spektakel als ästhetische Kategorie: Theorien und Praktiken*. Paderborn: Wilhelm Fink.

Fritz, E., 2014a. *Authentizität – Partizipation – Spektakel: Mediale Experimente mit "echten Menschen" in der zeitgenössischen Kunst*. Cologne: Böhlau.

Fritz, E., 2014b. Towards a Critical Mode of Spectacularity: Thoughts on a Terminological Review. *Esse: Arts + Opinions*, 81, 4–11.

Goffman, E., 1990. *The Presentation of Self in Everyday Life* [1959]. London: Penguin.

Holert, T., 2009. A Politics of the Figure. *In:* D. Dakić, S. Folie, and U. Groos, eds., *Danica Dakić*. Cologne: Walther König, 9–17.

Höller, C., 2011. Demokratie wagen: Christian Höller über Aernout Mik bei Carlier | Gebauer, Berlin. *Texte zur Kunst*, 81, 222–224.

Kardish, L., 2009. Aernout Mik: An Introduction. *In:* L. Kardish, ed., *Aernout Mik*. Exhib. cat. Museum of Modern Art, New York (6 May – 27 July 2009). New York: Museum of Modern Art, 13–23.

Karlholm, D., 2005/2006. Reality Art: The Case of Oda Projesi. *Leitmotiv* [online], 5, 115–124. Available from: www.ledonline.it/leitmotiv/Allegati/leitmotiv050508.pdf [Accessed 8 Mar 2018].

Kemp, W., 1973. Das Bild der Menge (1789–1830). *Städel-Jahrbuch*, 4, 249–270.

Konersmann, R., and González García, J. M. 1998. Theatrum Mundi. *In:* J. Ritter, ed., *Historisches Wörterbuch der Philosophie*, 10. Basel: Schwabe, 1051–1054.

Kwon, M., 1996. Three Rivers Arts Festival. *Texte zur Kunst*, 23, 149–151.

Kwon, M., 2002. *One Place after Another. Site-Specific Art and Locational Identity.* Cambridge, Massachusetts: MIT Press.

Laclau, E. and Mouffe, C., 2014. *Hegemony and Socialist Strategy: Towards a Radical Democratic Politics.* 2nd ed. London: Verso.

Lacy, S., ed., 1995. *Mapping the Terrain: New Genre Public Art.* Seattle, Washington: Bay Press.

Martin, C., 1994. *Dance Marathons: Performing American Culture of the 1920s and 1930s.* Jackson, Mississippi: University Press of Mississippi.

Mik, A., 2011. Entretien d'Aernout Mik: Avec les Commissaires de l'exposition. *In:* L. Coelewij, M. Gili, and S. M. Schmidt, eds., *Aernout Mik: Communitas.* Exhib. cat. Jeu de Paume, Paris (1 March – 8 May 2011), Museum Folkwang, Essen (29 October 2011 – 15 January 2012), Stedelijk Museum, Amsterdam (4 May – 24 August 2013). Paris: Steidl et al., 211–212.

Möntmann, N., 2006. Community Service. *Frieze: Contemporary Art and Culture*, 102, 37–40.

Nancy, J.-L., 2000. *Being Singular Plural [Être singulier pluriel, 1996].* Stanford, California: Stanford University Press.

Neuner, S., 2007. Paradoxien der Partizipation: Zur Einführung. *31. Das Magazin des Instituts für Theorie*, 10/11, 4–6.

Ortwig, J., 2009. Isola Bella. *In:* Dakić, D., Folie, S., and Groos, U., eds., *Danica Dakić.* Cologne: Walther König, 68–77.

Pethes, N., 2004. *Spektakuläre Experimente: Allianzen zwischen Massenmedien und Sozialpsychologie im 20. Jahrhundert.* Weimar: VDG.

Schober, A., 2004. Hélio Oiticica's Parangolés: Body-Events, Participation in the Anti-Doxa of the Avant-Garde and Struggling Free from it. *theory@buffalo*, 9, 75–101.

Schober, A., 2013. *The Cinema Makers. Public Life and the Exhibition of Difference in South-Eastern and Central Europe since the 1960s.* Bristol and Chicago: Intellect.

Schober, A., 2015. Figuren "wie Sie und ich" und ihr Verhältnis zum Publikum in historischem und medialem Umbruch. *In:* J. Ahrens, L. Hieber, and Y. Kautt, eds., *Kampf um Images: Visuelle Kommunikation in gesellschaftlichen Konfliktlagen.* Wiesbaden: Springer, 240–270.

Turner, V., 1982. *From Ritual to Theatre: The Human Seriousness of Play.* New York: PAJ.

Turner, V., 1995. *The Ritual Process: Structure and Anti-Structure* [1969]. New York: Aldine de Gruyter.

Index

Locators in *italics* refer to figures.

Printed in Great Britain
by Amazon

38069316R00126